The Creation of Art

Although creativity, from Plato onwards, has been recognized as a topic in philosophy, it has been comparatively neglected in recent philosophical aesthetics. In this new collection of essays a distinguished group of philosophers of art redresses this trend. The subjects discussed include the nature of creativity and the process of artistic creation; the role that creative making should play in our understanding and evaluation of art; relations between concepts of creation and creativity; and ideas of tradition, metaphor, genius, imagination, and genre.

This is an important collection that will be of interest to philosophers of art as well as theorists in art history, cinema studies, and literary criticism.

Berys Gaut is Lecturer in Moral Philosophy at the University of St. Andrews.

Paisley Livingston is Senior Lecturer in the Department of Philosophy at the University of Copenhagen.

The Creation of Art

New Essays in Philosophical Aesthetics

Edited by

BERYS GAUT

University of St. Andrews

PAISLEY LIVINGSTON

University of Copenhagen

PUBLISHED BY THE PRESS SYNDICATE OF THE UNIVERSITY OF CAMBRIDGE
The Pitt Building, Trumpington Street, Cambridge, United Kingdom

CAMBRIDGE UNIVERSITY PRESS
The Edinburgh Building, Cambridge CB2 2RU, UK
40 West 20th Street, New York, NY 10011-4211, USA
477 Williamstown Road, Port Melbourne, VIC 3207, Australia
Ruiz de Alarcón 13, 28014 Madrid, Spain
Dock House, The Waterfront, Cape Town 8001, South Africa

http://www.cambridge.org

First published 2003

Printed in the United States of America

Typeface ITC New Baskerville 10/13.5 pt. *System* LATEX 2$_\varepsilon$ [TB]

A catalog record for this book is available from the British Library.

Library of Congress Cataloging in Publication Data

The creation of art : new essays in philosophical aesthetics / edited by Berys Gaut,
Paisley Livingston.
p. cm.
Includes bibliographical references and index.
ISBN 0-521-81234-8
1. Art – Philosophy. 2. Creation (Literary, artistic, etc.) 3. Aesthetics.
I. Gaut, Berys Nigel. II. Livingston, Paisley, 1951–
N71 .C754 2002
700′.1–DC21 2002067420

ISBN 0 521 81234 8 hardback

BFT EP/BP

Contents

v

Acknowledgments

Early versions of some of the papers included in this collection were presented in May 2000 at a colloquium co-organized by the editors and sponsored by the Department of Philosophy, The University of Aarhus, Denmark. We are grateful for financial support and other assistance provided by The University of Aarhus and by members of the Philosophy Department there, and in particular, Dr Hans Fink. We also thank Stephen Davies and Dominic Lopes for helpful comments on the volume.

One of the contributors, David Novitz, was unable to attend the conference in Denmark due to his long and painful struggle with multiple myeloma. Although a period of remission allowed him to complete his paper, he passed away prior to the publication of this volume. David was well known amongst philosophers and aestheticians for his creative contributions to the field, and we dedicate the present volume to his memory.

Introduction

The Creation of Art: Issues and Perspectives

Berys Gaut and Paisley Livingston

1. THE OCCLUSION OF CREATION

Although the creation of art is a topic that should be a central one for aesthetics, it has been comparatively neglected in recent philosophical writings about art. In one basic usage, the creation of art is simply its making, and all artworks, however derivative or uninspired, are created. There is also a richer, evaluative sense of "creation," in which mere making does not suffice for the creation of something. A manager of a factory who, showing a visitor around, announced proudly, not that "here we make plastic spoons," but "here we *create* plastic spoons," would sound risibly pretentious. Creation in this richer, evaluative usage is a special kind of making, a making that involves a significant degree of creativity, and is contrasted with the kind of routinized making that mass production exemplifies.

In respect of the making aspect of creation, there has been, ever since the rise of formalism and then of (post-)structuralism, a powerful current that has dismissed attention to the processes of making as irrelevant to philosophical aesthetics, theories of criticism, and criticism itself. There has also been a counter-current that has argued that this inattention is a deep mistake, and proponents of such theories as intentionalism have argued for the necessity of construing the artwork as the product of the artist's actions. But even this tradition, as some of the essays in this volume imply, has not always scrutinized artworks with that attention to the details of their

1

making which adequate answers to these philosophical issues would demand.

Although the subject of the making of art has not achieved the full degree of attention it merits, it is in respect of the creativity aspect of our topic that the neglect is particularly striking. Creativity was, from Plato onwards, a recognised issue for investigation in philosophy, and its investigation has at times played an important role in aesthetics; but it has in recent times been underemphasized. Our point here is not that nothing has been written on the topic in the last few years – indeed, we will review some of this recent work in the next section. Yet compared to the vast amount of work that has been done on such subjects in aesthetics as the definition, interpretation, and evaluation of art; the features specific to different arts; and even on specialized subjects such as fakes, tragedy, the paradox of fiction, gender, genre and so on; creativity has been neglected. And when it has been discussed, it has often been in terms of creativity in general, embracing the sciences as well as the arts, so that its importance for aesthetics has not always been brought out.

This situation is strikingly odd, in respect of both aspects of our topic. Works of art, unlike natural objects, are after all *works*, the products of makings; and art is often supposed to be a paradigm of creative making, the human practice that most clearly exemplifies the creativity that is more obscurely at home in other fields. There is in fact a long tradition of analogising the artist to God the creator: indeed, Milton C. Nahm has argued that it is the "great analogy" that has influenced thinking about art since classical times.[1] Though clearly not all or even the majority of artworks are creative, the view that there is a special connection between art and creativity is independent of this claim, and merits philosophical investigation as to its truth and import. And further impetus for a philosophical investigation is imparted by the observation that a central term in the evaluation of artworks is "creative." There are, in fact, a host of important and interesting questions that can be, and intermittently have been, asked about the role that creative making should play in our understanding and evaluation of art, as the next section will illustrate in some detail. The neglect or obscuring of these questions can only impoverish aesthetics.

These observations raise the question of why the issues surrounding the creation of art have suffered this relative neglect in philosophical

aesthetics. We suggest that a central reason lies in the influence, to which we have already alluded, of formalist, structuralist, and post-structuralist currents during large parts of the last century.[2] The neglect was not confined to philosophy; indeed, the situation in philosophy was influenced by powerful currents within criticism and literary theory. The turn away from research into the making of art had a variety of motivations and rationales, only some of which involved the real and perceived foibles of the "life and works" biographical approach that many critics were eager to supplant. In the New Criticism's break with both common-sense biographical criticism and those versions of biographical criticism based on existentialism, hermeneutics, and phenomenology, a leading idea was that an appropriate form of aesthetic appreciation requires the critic to focus entirely on the finished text's or other artistic structure's inherent, artistically relevant features. (Typically, no distinction was drawn between the text or structure and the work of art.) Facts about the text's provenance were to be set aside, especially whenever such facts were a matter of the "private" psychology of the creator, held to be unknowable or irrelevant. A salient example is W. C. Wimsatt and Monroe C. Beardsley's criticism of John Livingston Lowes' painstaking attempt to reconstruct Samuel Coleridge's creation of "Kubla Khan," which attempt had been partly motivated by the poet's own strikingly mystifying account of the poem's origins.[3] The anti-intentionalists claim that although Lowes presents us with a "glittering parade" of information about Coleridge's sources and imagination, this sort of critical discourse leads us away from "the poem itself" and so is critically irrelevant.

Structuralist and post-structuralist theorists and critics were sharply critical of many aspects of New Criticism, beginning with the emphasis on aesthetic appreciation and the so-called autonomy of art, but they reiterated the attack on biographical criticism's assumption that the artist's activities and experience were a privileged critical topic. Roland Barthes hyperbolically evokes a liberating mode of reading in which the text "is read without the father's signature" – where the father in question was thought to be the repressive concept of the author-proprietor of the work, wrongly projected onto the text by non-progressive readers.[4] Ironically, these anti-humanist critical trends, which by the 1980s had become hegemonic, did not in fact

fully free criticism from the notions and values that had been asso-
ciated with creativity at least since Romanticism. Instead, interest in
creativity reappeared, sometimes with a vengeance, in the context of
reflections on the critic's own achievements: Geoffrey H. Hartman's
Derrida-inspired book, *Criticism in the Wilderness*, is an influential exam-
ple of a case in which a prominent professor of literature proclaimed
that the critic's own artistic ambitions should replace the scholar's
more traditional epistemic aims.[5] Within the post-structuralist move-
ment, critics or communities thereof were said to play the active role of
endowing texts with meaning and value, thereby constituting those
"signifying practices" of which a culture is composed. In some of the
bolder speculations, it was the reader and not the author who was
thought to do the job of endowing a text with its very status as litera-
ture. Thus Barthes wrote that "only the critic *executes* the work."[6] And
as Stanley Fish put it, "it is not that the presence of poetic qualities
compels a certain kind of attention but that the paying of a certain
kind of attention results in the emergence of poetic qualities."[7] Any
"piece of language" can become a member of the class of literary texts
provided that some sufficiently influential group of readers provides
the requisite poetical attention. And anecdotal self-reference became
a veritable mannerism in the vein of criticism marketed as the New
Historicism. Having rightly castigated biographical critics for seeking
to explain what happens in fictions by identifying anecdotal sources in
the author's childhood and fantasies, the post-structuralist critic comes
full circle by inserting the story of her own private life into "readings"
of the work of art.[8]

The influence of these tendencies in criticism helps explain the ne-
glect of the topic of the creation of art within philosophical aesthetics.
New Criticism revitalised formalism within philosophy, Beardsley play-
ing a prominent role here. The belief in the autonomy of art and
the anti-intentionalist stance inevitably made inquiry into creation
and the creative process seem aesthetically irrelevant. Philosophers
had previously often discussed the creative process in art as central
to the process of understanding art, R. G. Collingwood's theory of art
as expression being perhaps the most influential of these twentieth-
century theories.[9] In a paper on the creation of art, Beardsley attacked
Collingwood's theory, but more importantly, having developed his
own thoughts on the process of artistic creation, concluded that such

theories have no bearing at all on understanding or evaluating art-works. Creativity is, rather, a property of the art-object, and the only kind of aesthetically relevant creation occurs in the audience's response to the work: "In the experience of a melody, creation occurs before our very ears."[10] Although formalism concentrated on the nature of the art object, already in Beardsley's invocation of the audience we see an indication of a tendency that Richard Wollheim identified as the "principal target" of his 1968 book, *Art and Its Objects*: "the tendency to conceive of aesthetics as primarily the study of the spectator and his role: that is to say, his responses, his interests, his attitudes, and the characteristic tasks he set himself."[11] Other instances of that tendency are not hard to find: the Institutional Theory of Art, for instance, held that what makes an object an artwork is having conferred upon it the status of candidate for appreciation by some person acting on behalf of the artworld.[12] Such persons might be artists, but they could also be dealers, curators, journalists, spectators, and so on. As in post-structuralism, creation was divorced from any necessary relation to the artist.

The situation in philosophy has, however, been materially different from that in criticism in one respect, since reflection on the importance of the making of art has never been as neglected as it has been at times in criticism. Indeed, the importance of the idea that artworks are made has received strong support in the recent work of intentionalists of various kinds, as well as from supporters of historical definitions of art, and theorists who hold that works are action-types. But despite this resurgence of interest in artworks as made objects or as intentional actions or performances, the issues surrounding creation, particularly in respect of creativity, have not enjoyed that prominence which they deserve once the importance of the activity of creating artworks is acknowledged.

2. ARTISTIC CREATION: THE STATE OF THE DEBATE

To set the scene for the papers in this collection, we now review some of the philosophical work that has previously been done on the issues concerning creation, in the evaluative sense that includes creativity. The following is not, however, intended to be a comprehensive survey either of the topics discussed or of what has been written on

them by philosophers. In the course of it, we also draw on some of the voluminous psychological writings on creativity, where they help to fill out or illuminate the philosophical discussion. As Robert S. Albert and Mark A. Runco observe in a recent survey of the history of psychological research on creativity, nearly every major twentieth-century psychologist has explored the topic, and at present "the field can only be described as explosive."[13] We examine six topics, and we also briefly indicate where the papers in the volume engage with these issues; the papers will be summarized separately in the next section.

(a) The Making of Art

An aspect of the creation of art, in the basic sense of the making of art, has been discussed in the context of a debate about what is involved in correctly interpreting art. Anti-intentionalists, such as formalists, hold that the intentions involved in the making of art are irrelevant or peripheral to correctly interpreting art. So details of the act of creating a work, though possibly of interest in themselves, have no bearing on the correct interpretation of the work. The anti-intentionalist holds that mere scrutiny of the art-object independently of knowledge of its generative conditions suffices to interpret it. This position has been attacked on numerous grounds. It has, for instance, been argued by Kendall Walton that the categories under which we perceive art are in part fixed by the generative conditions, including intentions, of the work. And Guy Sircello has argued that there is a conceptual relation between a work expressing something, and the artistic acts performed in the work.[14] The anti-formalist thesis that in looking at art we are looking at artistic actions is pursued by Patrick Maynard in the present volume.

Intentionalists, unlike formalists, hold that reference to intentions is essential in fixing the correct interpretation of works. Since intentions figure in the process of making the work, to understand a work must for the intentionalist be in part to reconstruct the process of its making. Wollheim holds that "The task of criticism is the reconstruction of the creative process, where the creative process must in turn be thought of as something not stopping short of, but terminating on, the work of art itself."[15] Within the intentionalist camp, there is an important

distinction. Actual intentionalists, such as Richard Wollheim, Gary Iseminger, Noël Carroll, William Irwin, and E. D. Hirsch, hold that it is the historically real intentions of the actual artist that determine correct interpretation of works.[16] They differ on how wide the notion of an intention is to be drawn (for instance, Wollheim understands it broadly, to include any mental state that causally generates a work of art); but they agree that it is the actual mental states of the artist that matter for the interpretative task.[17] Proponents of different versions of hypothetical and fictionalist intentionalisms, such as Jerrold Levinson, William Tolhurst, and Alexander Nehamas, on the other hand, hold that it is the hypothesized or imagined intentions of the artist as a critical construct (variously called the "implied," "postulated," or "constructed" author) that determine correct interpretations. These hypothesized or imagined intentions may differ from what are known to be the real intentions of an author, because certain evidence about real intentions is excluded in principle – for instance, information drawn from private diaries may be ruled out.[18] The two kinds of intentionalists have different views about the creative process: actual intentionalists think of the process as the actual historical events that terminated in the production of the work; hypothetical intentionalists, in contrast, regard the creative process, insofar as it bears on the issue of interpretation, as itself a hypothetical construct. One issue concerning the creation of art, then, concerns how relevant the details of the actual creative process are to determining the correct interpretation of works. Paisley Livingston discusses this issue in the present collection.

A second respect in which issues about the making of art have entered into philosophical discussion concerns ontology, the question of what kind of thing an artwork is. A central debate here surrounds the status of those artistic structures (such as musical compositions and literary texts) which, as kinds or types, may be held to be universals and hence timeless – and therefore not the sort of thing that can be created by someone at a particular time and place. Yet this view stands in apparent contradiction to the common opinion that artworks are, in fact, created in particular socio-historical contexts. Various strategies for attempting to resolve this paradox are explored in the literature. Some writers attempt to defend a nominalist conception of artworks. Others accept Platonist tenets while denying that the commonplace

about works being created expresses any genuine insight. Peter Kivy, for example, doubts that there are widespread, informative intuitions linking great music and creation, and holds that artistic achievement is better explicated in terms of discovery and selection – which may or may not be called "creative" in the sense of worthwhile and innovative. A composer can plausibly be said to discover or select – but not to create – a previously existing musical Form.[19] Another strategy is to accept both premises of the paradox of artistic creation and conclude that what gets created – a work of art – must be more than an artistic structure, a move which Stefano Predelli usefully labels the "Argument from Creation."[20] An example is Jerrold Levinson's contention that musical works are initiated types, that is, they are sound structures (or more precisely sound/performing-means structures) that are indicated by a composer at a time or in a specific cultural context.[21] There is little agreement, however, as to whether such a position genuinely allows for artistic creation in a suitably robust sense: Levinson contends that it does, while Kivy, Predelli, Currie, and others contest the point.

This question about the ontology of art has a close analogue with a question about the ontology of fictional characters, which, if viewed as collections of abstract properties or traits, similarly seem to be universals, and thus to encounter the same problems concerning the possibility of their creation. Peter Lamarque discusses the latter issue in the present volume and defends a view that allows fictional characters to be created in a straightforward sense.[22]

(b) Defining "Creativity"

Turning more closely to the evaluative sense of "creation," the next issue concerns what precisely is meant by the term "creativity." There is a broad consensus that creative products and acts must exhibit originality and be valuable. Kant captured this dual condition when he defined "genius" as a matter of exemplary originality, a view that Paul Guyer discusses in the present volume. Mere originality does not suffice for genius, since there can be, Kant remarks, original nonsense, which he saw in those Sturm und Drang artists who strove after originality while lacking talent to produce something worthwhile (an observation that resonates in the context of some recent art movements). Exemplarity

of artworks is a matter of their serving as a standard or rule for art, and is thus a mark of their value.[23]

The correctness of the dual condition of originality and value has been widely, though not universally, accepted by philosophers. For instance, Carl Hausman, in developing criteria for creativity, bases them on the observation that "creativity occurs on condition that a new and valuable intelligibility comes into being."[24] Psychologists have also generally agreed that creativity involves at least these two constituent factors.[25] The first condition corresponds to the platitude that no matter how useful an instance of routine problem-solving may be, it cannot be creative. One way in which psychologists have specified this condition is to add that if a novel and valuable idea or "response" is creative, it must be addressed to a task or problem that is "heuristic rather than algorithmic."[26] The second condition expresses the thought that a wholly new yet useless or destructive invention cannot be creative, since truly creative innovations must be valuable, useful, appropriate, or adaptive.

Within this broad consensus there are, however, disputes. A first source of disagreement concerns what to say about independent discoveries. When a chess master invents an effective chess opening, the likes of which has never been seen by informed experts, it is uncontroversial to deem this a creative contribution to the game. What, however, if a precocious young player independently rediscovers the same opening some years later, without knowing of the earlier invention? Some have held that such an achievement would not be a creative one. As psychologist Colin Martindale expresses this position, "Were someone to rediscover the theory of relativity, we would think the person to be quite clever but not creative because the idea has already been discovered."[27] Mihály Csikszentmihályi agrees, and goes on to claim that it follows that the creative process takes place outside the person, in the interactive system where ideas and artifacts get made and appreciated.[28] Other psychologists, however, deny that any absolute form of novelty should be deemed necessary to creativity. They prefer to investigate creativity as a species of innovative thinking or problem-solving located within the creative agent (or group of collaborating agents).[29] George Mandler, for example, claims that "from a psychological point of view, the focus of interest is, of course, a creative or novel act by an individual, whether or not

the same novelty has been produced by any or many other individuals before."[30]

One response to such disagreements is to distinguish between different senses of "creativity." Margaret Boden distinguishes historical from psychological creativity (H- and P-creativity, as she calls them). An idea is P-creative if it is valuable and "the person in whose mind it arises could not have had it before"; the relation holds whether or not the idea has ever been had before.[31] To be H-creative, the idea must be not only P-creative, but also must never have been had by anyone else in all of human history. This is, we may note in passing, a rather strong condition, and weaker, tradition and context-specific alternatives could be formulated.

Boden's reference to ideas that could not have been had before brings us to a second source of disagreement about creativity: how to specify the degree of originality that it requires. If originality simply meant that something is new in some respect or other, then almost any idea or product would count as original. Boden's modal condition attempts to specify the relevant difference. It does not express some form of metaphysical necessity, but rather a relation between the valued idea and the generative rules that structure a person's productive activities. For example, Boden holds (pace Chomsky) that the generation of previously unheard-of well-formed phrases in English is not an instance of P-creativity, because such utterances are covered by the grammar of the language, and thus in a sense could have been produced before. Genuine P-creativity requires a "change of conceptual space" in which something emerges that would have been impossible had the agent's activity remained determined by the generative rules which obtained before. It requires dropping one or more of the rules that structure the conceptual space; and the "deeper" the rule that is dropped (i.e., the more fundamental the role which the rule plays in structuring the system), the more radically P-creative is the result.

David Novitz has criticized this criterion. Goodyear invented vulcanisation by dropping various substances into liquid rubber until he came across the correct one by trial and error. He altered the conceptual space for thinking about rubber, but his achievement was not creative; so satisfaction of the modal criterion is insufficient for creativity. Nor is it necessary: Jenner invented vaccination and should be counted as creative, but there existed no conceptual space concerning vaccination

prior to his invention. Instead, Novitz has proposed that creativity is, roughly, a matter of a recombination of ideas that is surprising to those suitably informed about the field, and which is intended to be and is of benefit to some.[32] Novitz refines and elaborates on his proposal in the current volume.

Finally, there is a dispute about the correctness of the value condition for creativity. Does not it make sense to say that creativity is sometimes a bad thing? The cartoon from *The New Yorker* illustrated in Patrick Maynard's piece in this volume suggests just that. It is also sometimes alleged that contemporary art is suffering from too much creativity, leading to vacuity and triviality.[33] And Paul Feyerabend has labelled creativity "a dangerous myth" reflecting a misconception about our degree of independence from nature and of the possibilities of innovation by individuals.[34] Supporters of the value condition seem simply to assume its correctness, but these kinds of attack suggest that there is philosophical work to be done here. (Stein Haugom Olsen queries the central importance that creativity has been given in art in the present collection.) And even if the value condition is correct, there is an issue about its relation to moral value. Novitz, in elaborating the value clause in his account of creativity, contends that there can be no truly creative but immoral acts. A mad scientist who invents a new device for destroying the world would not be creative, but at best "ingeniously destructive." This opens space for a further question about the definition of "creativity" and its cognates – is the value condition subject to moral constraints?

(c) Creativity and Aesthetic Value

If creativity is a value, there is still a pressing issue to be decided: is the creativity evinced in artworks an *aesthetic* value? Given the originality component in creativity, one can also put the question this way: is originality an aesthetic value? It is common to praise artworks for their originality; and many aestheticians have agreed that originality is indeed an aesthetic value.[35] But this has often been denied; formalists, for instance, usually hold that originality is not an aesthetic value.[36] This rejection fits snugly with their view of art; for if one's conception of an artwork is that it is properly to be understood and evaluated independently of its generative context, then originality should not be

held to be an aesthetic value; for originality depends on the work's relation to prior works (or on whether the artist knew that there were other similar works already made).

There are also arguments against the aesthetic relevance of originality that do not rest on any specifically formalist presuppositions. Bruce Vermazen offers a dilemma: to say that something is original may be simply to hold that it is new with respect to some property, or to say that it is new with respect to some property and that this property is an aesthetically valuable one. In the former case, newness per se is not aesthetic merit, since there can be original nonsense. In the latter case, the original work has aesthetic merit, but only because it trivially follows from the aesthetic merit of the property, and nothing about its merit follows from the newness clause. Vermazen considers the objection that originality supervenes on newness and the aesthetic property, and that it confers a separate value on the work. But he dismisses this: in a series of Frans Hals portraits in his mature style, the first in the series has no additional aesthetic merit, simply by being the first, compared to any later portrait in the series. The originality of works may have historical value, in telling us something about the history of painting, but originality is not an aesthetic value.[37]

Frank Sibley has similarly distinguished between evaluatively neutral and evaluative uses of "originality," and holds that originality in the former sense has no aesthetic merit, both because it is easy to produce original but worthless works and because there can be original movements in art, such as Cubism and twelve-tone music, that include both valuable and worthless works. With regard to the evaluative usage, he notes in the same way as Vermazen that it trivially follows that original works are valuable, but only because of the aesthetic value of the property in respect of which they are original. He also argues that there is such a thing as intrinsic aesthetic value, for otherwise one would have to judge that people with only minimal aesthetic experience, such as knowledge only of the Bible or *Paradise Lost*, would be incapable of genuine aesthetic appreciation. Since this kind of aesthetic value is an intrinsic property, and originality is not, originality cannot be an aesthetic value in this sense. However, he holds that there are also in-context aesthetic judgements, concerning whether a work has value given the audience's context (Bartók's music may speak more

to our times than does Mozart's, for instance), and that, in this usage, originality is sometimes an aesthetic value.[38]

It has sometimes been conceded that originality is not an *aesthetic* value, if aesthetic properties are construed as properties that are directly perceivable and inherent in the artwork. But this is consistent with holding that originality is an *artistic* value, understood as a value that lies in the relation of the work to other works, as do properties such as distinctiveness of vision.[39] It has also been held that works are achievements, not autonomous objects, and that part of their achievement may lie in the originality of the work. Jerrold Levinson in the present volume pursues some of these lines of thought in his response to Jon Elster's discussion of ways in which the effort to be original may detract from the power to create, Elster's thesis being that originality has "no intrinsic relation to aesthetic value."[40]

(d) The Possibility of Explaining Creativity

There is a long tradition in philosophy of holding that creativity cannot be explained. The first discussion of creativity in Western philosophy we owe to Plato. Consider the following quotations from him: "a poet is a light and winged thing, and holy, and never able to compose until he has become inspired, and is beside himself, and reason is no longer in him"; "if any man come to the gates of poetry without the madness of the Muses, persuaded that skill alone will make him a good poet, then shall he and his works of sanity with him be brought to nought by the poetry of madness . . ."; and "when a poet takes his seat on the Muse's tripod, his judgment takes leave of him. He is like a fountain which gives free course to the rush of its waters . . .".[41] These remarks express an inspiration view of creativity combined with a derangement view. The inspiration view holds that the god breathes creativity into the poet: it is not the poet who writes the verses, but the god through him. As such, there is no *human* explanation possible for the nature or excellence of the verses; divine forces are at work. And the derangement view (that the poet is mad) entails that there is no explanation of creativity available that appeals to the poet's rational agency, for the poet is deeply irrational. Plato's views on creativity, which had immense influence on the Western tradition, particularly on the Romantics, thus close off the possibility of these sorts of explanations. A contemporary

echo of this kind of position is found in Kivy's declaration that talk of inspiration or "poppings" is preferable to discourse about a "creative process" that remains essentially unknown.[42]

Kant also held that the operations of genius are inexplicable, but on different grounds. This emerges in his argument that fine art is possible only as the product of genius. Any art must proceed according to rules, but in the case of fine arts, arts of beauty, these rules cannot be determinate (other than rules for mere academic correctness): they cannot be "based on a concept of the way in which the product is possible." The reason is that there can be no rules for judging whether something is beautiful, and therefore there can be no determinate rules for the production of beautiful things (otherwise rules of judgement could be derived from rules for production). But then fine art cannot devise such rules, nor can the ability to produce fine art be taught by means of such rules, nor can the artistic genius himself understand how he proceeds by appealing to such rules (and in this he differs from the scientist). How, then, are rules given to art? The answer can only be that it is nature in the artistic genius that gives the rule to art.[43] Kant means by "nature" here supersensible nature,[44] which lies beyond the bounds of possible experience, and therefore of causal laws which govern experience. So it also follows that one cannot give these kinds of causal explanations of the making of creative works. Kant's basic claim, then, is that because there are no determinate rules for creativity in art, there can be no explanations available to us of such creativity in art. So even the artistic genius does not know how he proceeds: "no *Homer* or *Wieland* can show how his ideas, rich in fancy and yet also in thought, arise and meet in his mind; the reason is that he himself does not know, and hence also cannot teach it to anyone else."[45] Kant thus links the absence of (determinate) artistic rules to the inexplicability of creativity. Ted Cohen explores, criticises, and develops some of Kant's claims in the present volume.

Another reason given for holding that creativity is inexplicable is that the explanation of some phenomenon entails that one can predict its occurrence; but if its occurrence is predictable, the phenomenon cannot be truly creative, for what is creative is original and hence unpredictable.[46] Indeed, if one could predict the occurrence of some creative result, such as a particular line in a poem, it would be the predictor, not the poet, who would be its creator.[47] It

has also been held that creativity is a matter of origination, and as such cannot be explained by anything prior to it (this is connected to the idea of creation occurring ex nihilo, as in God's creation of the universe). And it is sometimes maintained that the creative event is unique, and that one can only explain repeatable events.[48] To the latter, it has been objected that natural events also are not repeatable, since while similar events may occur again, the very same event does not occur again; so in this sense one can explain non-repeatable events.[49]

Psychologists writing on creativity have, on the other hand, almost invariably assumed that creativity is explicable (we shall examine some of their proffered explanations in the next section). And there is a tradition in philosophy that agrees with them, a tradition that stretches from Aristotle's understanding of creation as the rational imposition of form on matter, continues through Friedrich Nietzsche's explanation of creativity in terms of the expression of the will to power, and descends to the present day in Boden's belief that one can employ computational models to explain the occurrence of creativity. In the current volume, David Novitz takes up the issue, arguing that creativity is susceptible to certain sorts of explanations but not to others.

(e) The Creative Process

Even those who believe that creativity cannot be explained can allow that there may be true descriptive generalisations, empirical or a priori, about the creative process. We briefly examine first some of the work by philosophers on the creative process, and then discuss theories developed by psychologists, some of which are fully fledged explanatory theories.

As noted earlier, Plato takes inspiration to be the crucial component of the creative process and holds that the poet is in a passive state, awaiting the divinely sent creative impulse, and not knowing what he is doing in creating a work. This view of the creative process was a key component of the Romantic view of creativity as essentially mysterious, and was given a secular twist in Freudian psychology, where the unconscious came to play much the same role as the gods did for Plato.[50] More recently, Harold Osborne has offered a defence of the inspiration model. He argues that aesthetic properties are emergent, that

is, are dependent on non-aesthetic properties but are not deducible from them by rules. Because they are emergent, it is not possible to plan the aesthetic properties of a work, nor therefore to reason consciously about how to produce them. So the initial intuition that is the source of the work can only be unconscious, and this, he argues, explains the sense the inspired person has of being guided by forces outside his conscious self.[51]

A somewhat different model of the creative process is to be found in Kant. For Kant the appreciation of the beautiful consists in the free play of the imagination and understanding in the viewer's mind. Here "free play" means that the interaction is not rule-governed. The creative genius, as the producer of beautiful art, expresses the free play of imagination and understanding in his art. In particular, he produces aesthetic ideas, presentations of the imagination to which no determinate concept is adequate.[52] Thus Kant's theory makes imagination the central creative faculty. Popular usage sides with him in this, as when we use "imaginative" as a virtual synonym for "creative." This linking of imagination to creativity is investigated by Berys Gaut in the present volume.

Collingwood also links the creative process to imagination, but in a different way from Kant. For Collingwood, creation is a voluntary, conscious, but non-technical making, that is, it is a kind of making which is different from that involved in craft. The creative process is an expressive process, involving having an emotion, initially felt as an obscure disturbance, which the artist then clarifies through artistic expression, until the artist becomes aware at the end what it was he or she was feeling. Thus an artist cannot aim at a predetermined end in creating art; an artist cannot, for instance, set out to produce a tragedy or a comedy, since that would be to have a determinate emotional result in view. And Collingwood takes the product of this creative process in the case of art to be an imaginary object, for this is what he holds the artwork to be.[53]

Vincent Tomas develops an important line of thought by arguing that creative activity "is not a paradigm of purposive activity." The creative artist cannot envisage the final artwork as a goal to which his creative actions are a means, for if he did envisage the final result at the start of his actions, his creative activity would already be complete: "To create is to originate. And it follows from this that prior to creation

the creator does not foresee what will result from it."[54] In this view he echoes Collingwood's claim that the creative process does not proceed by implementing an already envisaged goal, but Tomas grounds the claim on the concept of creativity, not on that of expression. Tomas also argues that the creative process, in respect of the elaboration of the initial inspiration, must also be subject to critical control, through the exercise of critical judgement by the artist about the work, for otherwise the process could be mere free association, or passive imagination. But this does not entail that the creative process is teleological. Tomas is followed in this view by Beardsley, who distinguishes the finalistic (teleological) theory of creativity from the propulsive theory. The latter holds, correctly in Beardsley's view, that the initial idea or inspiration of the artwork (the "incept") controls the later development of the artwork by causal rather than by teleological means.[55]

Other philosophers are sceptical of whether anything general, informative, and true can be said about the creative process or how this might connect with creative results. Francis Sparshott, for instance, suggests that the expression "the creative process" gets used in two significantly different ways. Either it refers to the various sorts of different processes whereby some sufficiently original item is generated, or it is used to refer to some single kind of process that tends to yield original products. Insofar as original works are often created, the former usage is sometimes warranted, but it does not follow from this that the expression has any application in the latter sense, since there may be no one pattern whereby novelty emerges.[56] So linguistic usage gives no warrant for supposing that there must be a single unique mechanism underlying creativity.[57]

Psychologists who write on creativity have, in contrast, generally but not universally held that there are identifiable psychological mechanisms which produce creative results, and that one can produce explanatory theories of these mechanisms.[58] A recurrent motif in the psychological literature is the delineation of four stages said to be typical of creative work.[59] The first stage of the creative process is *preparation;* this is a sometimes lengthy process of apprenticeship during which the agent acquires knowledge and skills relevant to a given practice or domain, eventually leading to a situation in which the agent is in a position to attempt some task characteristic of that domain. For example, through reading and discussions, someone acquires a

knowledge and love of poetry, and having learnt about poetic tradi-
tions, begins to work on a sonnet. The second stage is *incubation;* at
one or more points in the process of creation, the agent's attention is
diverted away from the problem at hand. Yet unconscious work on the
problem continues, perhaps in a freer and more associative mode. For
example, having struggled with the composition of the poem for days,
the writer stops working on the text and attends to other things. The
third stage comprises *illumination;* suddenly the agent becomes aware
of promising ideas and possible solutions that seem to have "popped"
into view. For instance, our writer wakes up one morning with new im-
ages, themes, and phrases for the poem in mind. The fourth and final
stage is *verification;* the ideas acquired in the moment of illumination
are subjected to critical evaluation and improvement; for example,
the writer rejects some of the inspired insights while retaining and
revising others. It has frequently been added that these tidy demarca-
tions are "ideal-typical" and that in actual episodes of creativity, such
moments overlap and blend.[60] What is more, instead of involving four
successive stages, the process would normally be recursive, particularly
if one were to examine any significantly extended period in the life of
a creative artist or scientist.

Several psychologists have developed theories that attempt to ex-
plain or describe what goes on in the moments of incubation and
illumination in particular, those components of the process that seem
most mysterious and resistant to explanation.

Donald Campbell holds that the creative process functions accord-
ing to principles of blind variation and selective retention in a quasi-
evolutionary manner.[61] Creativity requires a "blind" production of
ideas in the sense that the organism's response to some problem will in-
volve unpredictable trials that are independent of each other and not
generated through a rational anticipation of how certain desired re-
sults might be obtained. For example, some random event in the envi-
ronment can, when noticed by chance, suggest a solution to a problem.
Some innovative and useful random variants of this sort are selected,
while others are not. In Dean K. Simonton's development of this kind
of model, the contention is that the creative process must contain
a component capable of generating "free ideational variants," a pro-
posal that would appear to receive ample anecdotal illustration in the
introspective reports proffered by a wide range of creative individuals,

including Henri Poincaré, William James, and Albert Einstein – the latter having stated that "combinatorial play seems to be the essential feature in productive thought."[62]

Other psychologists have made proposals in the associationist vein, an early instance being Charles Spearman's emphasis on creativity as novel combinations of ideas.[63] An influential example is Sarnoff A. Mednick's definition of the creative process as "the forming of associative elements into new combinations which either meet specified requirements or are in some way useful. The more mutually remote the elements of the new combinations, the more creative the process or solution."[64] In Mednick's terminology, creative persons have flat (i.e., non-stereotypical) associative hierarchies, which means that they are more likely to make uncommon responses to words or problems. Other neologisms figuring in this context are Albert Rothenberg's "homospatial thinking" and Arthur Koestler's "bisociation," both of which refer to the making of new combinations and connections.[65] Proposals about the nature of creative incubation include the idea that this process involves "spreading activation," "contextual fluctuation," memory distortion, dynamic analogising, and the "restructuration of problem representations" – the latter expression being central to Gestalt theorists' discussions of the topic.[66] This has also been an area within which a variety of psychoanalytic and Jungian models of unconscious process have been developed, as it has been tempting to suppose that Freudian notions of such "primary processes" as condensation and displacement can be used to track at least some of the creative transformations wrought by unconscious cognition.[67] Associationist proposals have had a renewed hearing as a result of cognitive psychology's attempts to model unconscious cognitive mechanisms using connectionist models.[68]

Finally, some psychologists have held that there is no unique process that should count as "the creative process"; in line with Sparshott's claim noted earlier, they contend that no simple or uniform process or mechanism underlies creative thinking. For instance, psychologist Robert W. Weisberg discusses cases such as Pablo Picasso's creation of *Guernica* and artistic breakthroughs by Picasso, Alexander Calder, and Jackson Pollock, and reaches the conclusion that these are too varied to be explained by a single mechanism. Some creative work is best explained in terms of the retrieval and application of previously acquired

knowledge and experience, and this in the absence of the sorts of radical "restructurations" upon which proponents of Gestalt psychology, as well as old and new associationists, have insisted.[69] For example, Weisberg contends that, far from resulting from some "seething cauldron" of chaotic trial and error, Picasso's *Guernica* was an extension, application, and refinement of his works of the 1930s. It is only when we are oblivious to the artist's own context and prior productions that the artist's creative work can be misunderstood as a free and random breaking away from past work.

(f) Tradition and Rules

What is creative is, in popular usage, often contrasted with what is traditional and what is rule-bound. It is perhaps unsurprising that philosophers and other investigators have often rejected these contrasts as too simple.

Kant's identification of genius with exemplary originality does in one way sunder the creative act from tradition, for he holds that the genius gives a new rule to art. But, in another way, his position connects creativity to tradition, since the new order of art may lead to the founding of a school, which copies the work of the master. But when the next genius appears, another new rule is given to art, and the process of upheaval recommences. With a nod to Kant, Osborne has urged a similarly complex relation between the creative work and tradition: to be judged as creative, an innovative work must not be completely confinable within the principles of excellence that can be derived from prior art, but it must be coherent with them, in the sense that new, modified principles of excellence emerge that cover both the previous and the new art.[70]

Other contemporary investigators who have explored concepts of tradition and their relation to artistic creation include Harold Bloom and Göran Hermerén. The latter stresses the difficulties of providing a precise conception of tradition, especially with regard to the problem of individuating one tradition from another. He tentatively proposes that two artists, or works of art, belong to the same tradition just in case they satisfy at least one of the following conditions: (1) they have been influenced by the same master or group of artists; (2) one of them has either directly or indirectly been influenced by the other; (3) their work exemplifies similar approaches or solutions to artistic problems;

(4) they have basic theoretical presuppositions and norms in common; (5) their work has gone through similar crises leading to similar sorts of revisions and changes; or (6) they "use the same standards of rationality."[71] More simply, Hermerén claims that artists work within a tradition in that they "do not start from scratch; they take over rules, codes, conventions, ways of doing things from their predecessors."[72] This process, however, involves both the adoption and the violation of norms. As Renaissance scholar Michael D. Bristol has stressed in his analyses of Shakespeare's debts and contributions to tradition, the theorist of literary tradition must "recognize that change as well as stability are necessary features both of the process of transmission and of the values handed down."[73] In the present volume, Noël Carroll and Stein Haugom Olsen also argue that creativity should not be opposed to tradition in the way that popular usage suggests.

The emphasis on such notions as rules, norms, and conventions in the unpacking of the concept of artistic tradition raises many issues, beginning with whether and in what sense it is correct to think that genuinely creative artistic activity involves the following of rules.[74]

Kant is often thought of as believing that the creative process is not rule-governed in any way; but his position is in fact somewhat more complex than this. He writes that "Genius is a *talent* for producing something for which no determinate rule can be given, not a predisposition consisting of a skill for something that can be learned by following some rule or other. . . ."[75] But he also holds, as we noted earlier, that art always proceeds according to rules, and that through the genius, nature gives the rule to art. So, there are some rules (though not determinate ones), but fine art cannot devise or explain them; rather, it is nature that gives them to art. Rules in this sense are to be abstracted from the products of genius, which are exemplary for later artists; in reflecting on the works of the genius, his followers can infer some rules for producing works in his style (these are in Kant's terms, "reflective" judgements, which proceed from the particular to the general).[76]

In contemporary philosophy, two contrasting theories have been advanced about the relation of creativity to rules. Boden's theory of creativity, discussed earlier, maintains that radical creativity requires the overturning of at least some rules – those which structure the conceptual space that is revolutionized by the creative act; and the deeper the rule that is discarded or transformed, the more radical is the creativity.

In contrast, Jon Elster maintains that creative artistic action is always a matter of a local maximising of aesthetic value, subject to certain constraints. These constraints may be imposed on the artist (for instance, censorship laws), or they may be chosen by the artist from pre-existing constraints (for instance, a composer decides to write a piece in sonata form), or they may be invented by the artist (for instance, Picasso and Braque's invention of Cubism). But whatever the status of the constraints, creative action is governed by them. A variety of artistically relevant goals are, Elster suggests, advanced in this manner. One is that of facilitating communicative co-ordination with the public. Elster also conjectures that inspiration, which he defines as the rate at which ideas move from the unconscious into the conscious mind, is "an inversely U-shaped function of the tightness of the constraints" within which the artist is working.[77] In contrast, originality for Elster is a matter of changing the constraints, which in some contexts may even detract from creativity and the artist's effort to realize aesthetic value.[78] In the present volume, Jerrold Levinson provides a critical commentary on Elster's theory; and George Wilson's account of Josef von Sternberg's creativity in respect of his transformation of generic constraints also probes the relation between rules and creativity.

3. THE ESSAYS IN THE COLLECTION

We turn now to discuss the essays in this volume in more detail. The first three focus chiefly on the issue of the making of works of art and their represented objects. Peter Lamarque argues that it is possible genuinely to create a fictional character. In so doing, he rejects the positions of eliminativists, who deny that fictional characters exist at all, and of Meinongians and possibilists, who argue that fictional characters are eternal. Lamarque argues instead that fictional characters are initiated types, that is, types that begin to exist only when initiated by intentional human acts, specifically fictional narratives. He also argues that characters' identity is interest-relative, so that there is sometimes no determinate answer to the question of whether one character is the same as another, or whether a character could have originated in a different narrative from that in which it did originate. Lamarque also shows how narrative detail can create complex characters and ground aesthetic interest in them and their world.

Patrick Maynard notes that any account of creation requires an account of production, and develops a detailed account of drawing production, based on the work of John Willats. The case of drawing is particularly interesting for the purposes of the present volume, for it is often said that drawing shows the creative process at work. The upshot of his discussion, Maynard argues, is that many drawings present their visible elements as drawn, that is, as effects of actions guided by certain purposes, made by certain means. We can learn to see the drawn marks as marks of these actions; so we can, for instance, come to see the quality of mind in a Rembrandt drawing. This kind of perception differs from the way we see natural objects, and shows that looking at artworks is properly informed by an awareness of their status as intentionally produced objects, as created objects.

Paisley Livingston also focuses attention on the process of making in the visual arts. He discusses *pentimenti*, painted-over areas that show that the painter changed his or her mind about what to paint in the course of painting the picture; and he discusses in particular the example of Vermeer's *Young Woman Reading a Letter at an Open Window*. Livingston argues that widespread critical interest in the existence of *pentimenti* provides a basis for an argument in favor of a moderate version of actual intentionalism. Any other theory, including that of hypothetical intentionalism, cannot do justice to the specificities of the making of a picture, leaving ambiguities in interpretation open which can be resolved only by appeal to the intentions of the actual artist as revealed in the process of picture-making.

The remaining papers focus predominantly on the issue of creativity, and between them take up all of the issues mentioned earlier. Paul Guyer discusses some of the major writers on genius in the eighteenth and early nineteenth centuries, drawing out their views on the definition of and value of creativity. Earlier writers such as Du Bos and Gerard thought of genius as a rare talent for making discoveries or inventions, which would be accepted by all. Guyer argues, though, that in the work of Kant and Mill there was a major shift in the conception of genius. Kant understands genius as exemplary originality; and for him the genius is an artist who expresses the free play of imagination and understanding in his work and thereby elicits the same free play of the cognitive powers in his audience. This conception grounds the view that the audience's response is both active and varied within this free play;

and the claim that the genius can awaken others to their own originality and so give a new rule to art grounds a view of art as a practice of constant upheaval. Together with Mill's account of the expression of individuality, and in particular of genius, as being a good in itself, we are led to something close to the modern conception of creativity.

Ted Cohen discusses Kant's argument that there are no rules for the creation of fine art, since there are no rules for judging something beautiful; Kant concludes that fine art is the product of genius. Cohen criticises Kant's related claim that genius is not to be found outside art and that Newton, for instance, was not a genius. But he also argues that something can be rescued from Kant's views. It may well be that certain created objects which are inexplicable, in the sense of resisting demonstration or paraphrase, such as rich metaphors and some works of art, cannot be the products of rule-governed procedures of making. To make, and perhaps even to appreciate, such objects, a touch of genius is required.

Berys Gaut also focuses on issues to do with the creative process, examining whether there are any close connections between imagination and creativity, as has often been maintained, not least by Kant. He argues that such connections do exist; in particular, he holds that imagination is suited by its nature to be the vehicle of active creativity. And he argues that metaphor-making is a paradigm of the use of imagination in creativity, displaying the creative person's capacity to link together diverse domains into surprising but apt connections. He also argues that Kant's views on genius, as involving the expression of aesthetic ideas, are closely related to this latter claim.

David Novitz discusses whether creativity can be explained. He denies the possibility of action-guiding explanations (of the "how to be creative" kind), because there are so many ways to be creative that any principles would have to be unhelpfully abstract. He also rejects explanations in terms of causal mechanisms, because of the multiple realisability of creative actions. He argues, however, that biological explanations, which explain the function of creativity as fostering innovation and so promoting survival, are successful, as are social explanations, which explain the differential degree of creativity in various societies by social factors. Novitz also revisits his Recombination Theory of creativity, amending it to hold that creative acts must be intrinsically as well as instrumentally valuable, and argues that there are moral constraints on what counts as creative.

Stein Haugom Olsen raises questions about the value of creativity and about its relation to personality and convention. He argues that creativity is not an essential feature of art, or indeed a pre-eminent value: for instance, Austen, Dickens, and Eliot were greater novelists than Defoe, Fielding, and Richardson, yet it is the latter group who were more innovative in their development of the novel. Nor should we associate creativity, as is commonly done, with the type of personality that loves disorder and rejects conventions, for writers such as Trollope and Ibsen were epitomes of bourgeois conventionality in their private lives. Indeed, one should not in general regard convention as the enemy of creativity: on the contrary, in the absence of the constitutive rules of the social practice of literature, literary creation would not be possible at all.

Noël Carroll similarly holds that tradition should not be opposed to creativity. For creativity in the descriptive sense (the production of new and intelligible works), tradition is indispensable, since it is a condition for rendering works intelligible that they be related to a background of prior works, and the tradition shows what are the live options for an artist at a time. Even revolutions in art proceed by repudiating only some, generally recent, tendencies in the tradition, in order to rediscover other, generally older, aspects of the tradition. And to call a work creative in the evaluative sense is to ascribe to it a value derived from the value it has for the tradition in which it was created. So tradition is indispensable for creativity.

Jerrold Levinson critically discusses Jon Elster's theory of creativity. Elster holds that all artists aim to maximise artistic value – however they understand it – by deploying constraints; Elster rejects the view that rules or conventions are the enemy of creativity (as in their different ways do Olsen and Carroll as well). Levinson raises questions about Elster's claim that artists always aim to maximise artistic value – they may have other aims, such as achieving specific effects, for instance – and holds that Elster's account of creativity makes artistic production too rational a process. He agrees with Elster that action subject to constraints often is creative, but also argues that sometimes the violation or reinterpretation of constraints can be a mode of creativity. And he also challenges Elster's view that originality is not an artistic value in a work. For Levinson, then, the process of artistic creativity is too complex and varied for Elster's theory to be an entirely satisfactory account of it.

Finally, George Wilson illustrates how apparently highly formulaic, and even seemingly bad films, may be in fact surprisingly creative, and that this creativity may rest in part on their exploitation and manipulation of their formulaic character. Examining the last three films Josef von Sternberg made with Marlene Dietrich, Wilson argues that they systematically heighten, exaggerate, or extend generic features and familiar narrational constraints, and exploit the star's persona in complex ways, to serve the novel function of grounding a distinctive kind of self-consciousness that renders the films artistically interesting and ambitious. Creativity in such cases can derive from the manipulation of constraints and established practices rather than from their outright violation or abandonment, and originality may lurk in places that the casual viewer is inclined to overlook or dismiss.

Taken together, then, the papers in this collection address in their different ways the issues about creation that we noted in section 2; and they open up further routes for exploration of these and related topics. Through the variety of their responses and the high quality of their answers, the papers well illustrate our conviction that the issues surrounding the creation of art deserve far more sustained attention than they have generally earned within the field of contemporary aesthetics. We trust that this volume will play a part in a resurgence of interest in these matters.

Notes

1. Milton C. Nahm, *The Artist as Creator: An Essay of Human Freedom* (Baltimore: The Johns Hopkins University Press, 1956); see also his "Creativity in Art," in *Dictionary of the History of Ideas*, vol. 1, ed. Philip P. Wiener (New York: Charles Scribner's Sons, 1968), pp. 577–89.
2. A fully fledged explanation is not our aim here. Other contributing factors might include behaviourist inclinations related to various epistemic and metaphysical worries about the status of mental entities.
3. John Livingston Lowes, *The Road to Xanadu: A Study in the Ways of the Imagination* (Boston: Houghton Mifflin, 1927); William K. Wimsatt and Monroe C. Beardsley, "The Intentional Fallacy," *Sewanee Review* 54 (1946): 468–88; reprinted in *Philosophy Looks at the Arts*, ed. Joseph Margolis (Philadelphia: Temple University Press, 1987), pp. 467–80.
4. "De l'œuvre au texte," *La Revue d'esthétique* 3 (1971): 225–32; translated as "From Work to Text," in *Textual Strategies: Perspectives in Post-Structuralist Criticism*, ed. Josué V. Harari (Ithaca, N.Y.: Cornell University Press, 1979), pp. 73–81, at 78.

5. *Criticism in the Wilderness: The Study of Literature Today* (New Haven, Conn.: Yale University Press, 1980).

6. "From Work to Text," p. 80.

7. *Is There a Text in This Class?* (Cambridge, Mass.: Harvard University Press, 1980), p. 326.

8. We do not mean to deny, however, that post-structuralism was motivated by some important insights, such as that artists enjoy no infallible self-knowledge, and so criticism cannot be based entirely on their pronouncements; that artists' creative activities depend crucially on a complex range of external conditions; and that narrow construals of aesthetic value, which rule out ethical and political issues, are incorrect. There has also emerged more recently in France a vein of criticism dubbed "la critique génétique." Though at times appearing to be a continuation of the post-structuralist interest in the reader's "creative" exploration of textuality, on other occasions the genetic critic's explicit concern has been to return to more traditional issues to do with the nature of authorship and the writerly process. Such an emphasis is explicit, for example, in Pierre-Marc de Biasi's survey of genetic criticism's methods and ambitions, *La Génétique des textes* (Paris: Nathan Université, coll. "128," 2000), pp. 6–8.

9. R. G. Collingwood, *The Principles of Art* (Oxford: Oxford University Press, 1938).

10. Monroe C. Beardsley, "On the Creation of Art," *Journal of Aesthetics and Art Criticism* 23 (1965): 291–304, at 302. John Hospers has also argued that knowledge of the creative process is completely irrelevant to judging the artistic quality of a work, since its quality is to be judged by what we observe in the work, not by anything to do with the work's genesis; see his "The Concept of Artistic Expression," *Proceedings of the Aristotelian Society* 55 (1954–55): 313–44 at 320–4.

11. *Art and Its Objects* (Cambridge: Cambridge University Press, 1968; 2d ed. 1980), p. 228.

12. See, for instance, Arthur C. Danto, "The Artworld," and George Dickie, "The New Institutional Theory of Art," both reprinted in *The Philosophy of Art: Readings Ancient and Modern*, ed. Alex Neill and Aaron Ridley (New York: McGraw-Hill, 1995), pp. 201–23.

13. "A History of Research on Creativity," in *Handbook of Creativity*, ed. Robert J. Sternberg (Cambridge: Cambridge University Press, 1999), pp. 16–31, at p. 17.

14. Kendall Walton, "Categories of Art," and Guy Sircello, "Expressive Properties of Art," both reprinted in Margolis, ed., *Philosophy Looks at the Arts*, pp. 53–79 and 400–420, respectively.

15. Richard Wollheim, "Criticism as Retrieval," in *Art and Its Objects*, 2d ed. (Cambridge: Cambridge University Press, 1980); reprinted in *The Philosophy of Art*, ed. Neill and Ridley, pp. 406–14, at p. 405.

16. E. D. Hirsch, Jr., *Validity in Interpretation* (New Haven, Conn.: Yale University Press, 1967), and *The Aims of Interpretation* (Chicago: University of Chicago Press, 1976); William Irwin, *Intentionalist*

Interpretation: A Philosophical Explanation and Defense (Westport, Conn.: Greenwood Press, 1999); Noël Carroll, *Beyond Aesthetics: Philosophical Essays* (Cambridge: Cambridge University Press, 2001); Gary Iseminger, "An Intentional Demonstration," in *Intention and Interpretation*, ed. Iseminger (Philadelphia: Temple University Press, 1992), pp. 76–96; "Actual vs. Hypothetical Intentionalism," *Journal of Aesthetics and Art Criticism* 54 (1996): 319–26.

17. Richard Wollheim, *Painting as an Art* (Princeton, N.J.: Princeton University Press, 1987), pp. 18–19; and E. D. Hirsch, *Validity in Interpretation* (New Haven, Conn.: Yale University Press, 1966).

18. William Tolhurst, "On What a Text Is and How It Means," *British Journal of Aesthetics* 19 (1979): 3–14; Jerrold Levinson, "Intention and Interpretation: A Last Look," in *Intention and Interpretation*, pp. 221–56; Alexander Nehamas, "The Postulated Author: Critical Monism as a Regulative Ideal," *Critical Inquiry* 8 (1981): 133–49.

19. Peter Kivy, *The Fine Art of Repetition: Essays in the Philosophy of Music* (Cambridge: Cambridge University Press, 1993), chaps. 2–3; another philosopher who defends a Platonist conception of musical works as norm-kinds is Nicholas Wolterstorff, "Toward an Ontology of Artworks," *Nous* 9 (1975): 115–42.

20. Stefano Predelli, "Musical Ontology and the Argument from Creation," *British Journal of Aesthetics* 41 (2001): 279–92.

21. "What a Musical Work Is," reprinted in his *Music, Art, and Metaphysics: Essays In Philosophical Aesthetics* (Ithaca, N.Y.: Cornell University Press, 1990), pp. 63–88. Another theory in the ontology of art which distinguishes between the artistic structure and the work is that of Gregory Currie, *An Ontology of Art* (New York: St. Martin's Press, 1989).

22. The relevance of the making of art is not confined to these topics. For instance, as noted earlier, the Institutional Theory of Art holds that the making criterion is irrelevant to something's status as an artwork; historical-intentionalist definitions, in contrast, hold that it is the maker's intentions that specify something as art.

23. Kant, *Critique of Judgment*, trans. Werner S. Pluhar (Indianapolis: Hackett, 1987), section 46, Ak. V, 307–8.

24. Carl Hausman, "Criteria of Creativity," in *The Concept of Creativity in Science and Art*, ed. Denis Dutton and Michael Krausz (The Hague: Martinus Nijhoff, 1981), pp. 75–89, at p. 77.

25. Psychological definitions of creativity along these lines have been numerous. Several of them are lined up by Richard E. Mayer, "Fifty Years of Creativity Research," in Sternberg, ed., *Handbook of Creativity*, pp. 449–50. A typology of definitions is provided by C. W. Taylor, "Various Approaches to and Definitions of Creativity," in *The Nature of Creativity*, ed. R. J. Sternberg (Cambridge: Cambridge University Press, 1988), pp. 99–121.

26. Teresa M. Amabile, "Within You, Without You: The Social Psychology of Creativity, and Beyond," in *Theories of Creativity*, ed. Mark A. Runco and Robert S. Albert (Newbury Park, Calif.: Sage, 1990), pp. 61–91, at p. 66.

27. "Creativity and Connectionism," in *The Creative Cognition Approach*, ed. Steven M. Smith, Thomas B. Ward, and Ronald A. Finke (Cambridge, Mass.: MIT Press, 1995), pp. 249–68, at p. 250.

28. See his "Society, Culture, Person: A Systems View of Creativity," in *The Nature of Creativity*, ed. Sternberg, pp. 325–39. Novelty and the recognition of value, both of which are deemed essential to creativity, are said necessarily to involve the domains and fields within which persons are active, which in turn is held to imply that an adequate investigation of creativity requires a systems-theoretical, interactionist approach. This broad, socio-historical approach to creativity is seconded by Emma Policastro and Howard Gardner in their "From Case Studies to Robust Generalizations: An Approach to the Study of Creativity," in *Handbook of Creativity*, pp. 213–25.

29. See Raymond S. Nickerson, "Enhancing Creativity," in *Handbook of Creativity*, pp. 392–430.

30. "Origins and Consequences of Novelty," in *Creative Cognition*, ed. Smith, Ward, and Finke, pp. 9–25, at p. 10.

31. "What Is Creativity?" in *Dimensions of Creativity*, ed. Margaret A. Boden (Cambridge, Mass.: MIT Press, 1994), pp. 75–118, at p. 76; see also her monograph, *The Creative Mind: Myths and Mechanisms* (London: Weidenfeld and Nicolson, 1990).

32. David Novitz, "Creativity and Constraint," *Australasian Journal of Philosophy* 77 (1999): 67–82. Note that, though we are discussing Boden's and Novitz's theories in the context of the definition of "creativity," they both think of their theories as having an explanatory dimension as well.

33. This kind of allegation is made by Edward Halper, "Is Creativity Good?" *British Journal of Aesthetics* 29 (1989): 47–56.

34. Paul Feyerabend, "Creativity – A Dangerous Myth," *Critical Inquiry* 13 (1986–7): 700–711.

35. For instance, Wollheim, *Art and Its Objects*, section 62, who claims that originality is one of highest values of art; and John Hoaglund, "Originality and Aesthetic Value," *British Journal of Aesthetics* 16 (1976): 46–55.

36. For instance, Monroe C. Beardsley, *Aesthetics: Problems in the Philosophy of Criticism*, 2d ed. (Indianapolis: Hackett, 1981), p. 460.

37. Bruce Vermazen, "The Aesthetic Value of Originality," *Midwest Studies in Philosophy* 16 (1991): 266–79, at 271–2.

38. F. N. Sibley, "Originality and Value," *British Journal of Aesthetics* 25 (1985): 169–84.

39. Levinson, "Artworks and the Future," in his *Music, Art, and Metaphysics*, pp. 179–214, at pp. 183–4. One could also hold that there is a broader usage of "aesthetic" in which the aesthetic value of an artwork is to be identified with its artistic value, and the artistic value of a work is understood as the value it has qua artwork; see, for instance, Berys Gaut, "The Ethical Criticism of Art," *Aesthetics and Ethics: Essays at the Intersection*, ed. Jerrold Levinson (Cambridge: Cambridge University Press, 1998), pp. 182–203, at p. 183. One could then hold that originality is an

aesthetic value in this broader usage. For background on conflicting contrasts between "aesthetic" and "artistic," see Carolyn Korsmeyer, "On Distinguishing 'Aesthetic' from 'Artistic,'" *Journal of Aesthetic Education* 11 (1977): 45–57; and Bohdan Dziemidok, "On the Need to Distinguish between Aesthetic and Artistic Evaluations of Art," in *Institutions of Art: Reconsiderations of George Dickie's Philosophy*, ed. Robert J. Yanal (University Park: Pennsylvania State University Press, 1994), pp. 73–86.

40. Jon Elster, *Ulysses Unbound: Studies in Rationality, Precommitment, and Constraints* (Cambridge: Cambridge University Press, 2000), p. 180.

41. Respectively, *Ion*, 534b; *Phaedrus*, 245a; and *Laws*, 719c, in *Plato: The Collected Dialogues*, ed. Edith Hamilton and Huntington Cairns (Princeton, N.J.: Princeton University Press, 1961).

42. Kivy, *The Fine Art of Repetition*, p. 68.

43. *Critique of Judgment*, section 46, Ak. V, 307–8.

44. Ibid., section 57, Comment I, Ak. V, 344.

45. Ibid., section 47, Ak. V, 309.

46. See Hausman, "Criteria of Creativity," pp. 88–89; and his *A Discourse of Novelty and Creation* (The Hague: Martinus Nijhoff, 1975). Hausman believes, though, that a looser kind of explanation, which he calls an "account" and which does not require prediction, is possible for creativity.

47. John Hospers, "Artistic Creativity," *Journal of Aesthetics and Art Criticism* 43 (1984–5): 243–55, at 248.

48. I. C. Jarvie, "The Rationality of Creativity" in *The Concept of Creativity in Science and Art*, ed. Dutton and Krausz, pp. 109–28, at p. 112. Jarvie employs in addition three other arguments to show that creativity is inexplicable.

49. Hospers, "Artistic Creativity," 247. Hospers, though, concurs with Jarvie's conclusion that one cannot explain creativity.

50. See Sigmund Freud, "Creative Writers and Day-Dreaming," reprinted in *The Philosophy of Art*, ed. Neill and Ridley; and Ernst Kris, *Psychoanalytic Explorations in Art* (New York: International Universities Press, 1952).

51. Harold Osborne, "Inspiration," *British Journal of Aesthetics* 17 (1977): 242–53, at 249–52.

52. Kant, *Critique of Judgment*, section 49, Ak. V, 313–14.

53. Collingwood, *The Principles of Art*, especially chapters 2, 6, and 7. However, since Collingwood thinks that one can create a disturbance in the same sense in which one can create an artwork, it does not follow on his view that every act of creation produces an imaginary object.

54. Vincent Tomas, "Creativity in Art," *The Philosophical Review* 67 (1958): 1–15.

55. Beardsley, "On the Creation of Art." However, Hospers in "Artistic Creativity," p. 245, argues that there is no real difference between the two kinds of theory. Haig Khatchadourian, in "The Creative Process in Art," *British Journal of Aesthetics* 17 (1977): 230–41, accepts that there is a genuine difference, and maintains that the creative processes of different artists vary in the degree to which they conform to the finalistic or propulsive theories.

56. "Every Horse Has a Mouth: A Personal Poetics," in *The Concept of Creativity in Science and Art*, ed. Dutton and Krausz, pp. 47–74, at p. 61. Jarvie in "The Rationality of Creativity," has proposed, in similar fashion, that one distinguish between creativity as a subjective notion, which applies to mental processes and people, and creativity as an objective notion, which applies to products. He argues that any adequate account of creativity must be based on the latter notion. For a similar distinction between objective and subjective usages, see John White, "Creativity," in *A Companion to Aesthetics*, ed. David Cooper (Oxford: Blackwell, 1992).

57. In "Artistic Creativity" John Hospers also rejects all general theories of creativity, targeting in particular Freudian, problem-solving, and expression theories.

58. A possible exception to this rule is the cryptic theorising of Jacques Lacan, which replaces biographical, psychoanalytical investigation with a speculative discourse on the workings of impersonal, quasi-linguistic structures.

59. The stages are often attributed to Graham Wallas, *The Art of Thought* (London: Jonathan Cape, 1926). An example of the many applications and elaborations of Wallas's stages is George F. Kneller's *The Art and Science of Creativity* (New York: Holt, Rinehart, and Winston, 1965). Francis E. Sparshott attributes this model of the creative process to Robert Graves, T. S. Eliot, and "a host of romantic writers," in his "Every Horse Has a Mouth," p. 62. He also criticises the claims of the model to have true empirical content, holding that it in part reflects a set of necessary conditions for creativity and in part is grounded on a metaphor of giving birth, propped up by selective use of evidence.

60. Catharine Patrick, "Creative Thought in Artists," *Journal of Psychology* 4 (1937): 35–73.

61. Campbell, "Blind Variation and Selective Retention in Creative Thought as in Other Knowledge Processes," *Psychological Review* 67 (1960): 380–400.

62. Cited in Dean K. Simonton, *Origins of Genius: Darwinian Perspectives on Creativity* (New York: Oxford University Press, 1999), p. 29. For an array of autobiographical material provided by scientists, writers, and artists, see Brewster Ghiselin, *The Creative Process* (New York: Mentor, 1952).

63. *Creative Mind* (London: Macmillan, 1931).

64. Mednick, "The Associative Basis of the Creative Process," *Psychological Review* 69 (1962): 220–32, at 221.

65. Rothenberg, *The Emerging Goddess: The Creative Process in Art, Science and other Fields* (Chicago: University of Chicago Press, 1979); Koestler, *The Act of Creation* (New York: Macmillan, 1964), and, for a more concise presentation, "The Three Domains of Creativity," in *The Concept of Creativity in Science and Art*, ed. Dutton and Krausz, pp. 1–17.

66. For background see Stellan Ohlsson, "Restructuring Revisited: I. Summary and Critique of the Gestalt Theory of Problem Solving," *Scandinavian Journal of Psychology* 24 (1984): 65–78, and "Restructuring

Revisited: II. An Information Processing Theory of Restructuring and Insight," *Scandinavian Journal of Psychology* 25 (1984): 117–29; Kenneth S. Bowers, Peter Farvolden, and Lambros Mermigis, "Intuitive Antecedents of Insight," in *Creative Cognition*, ed. Smith, Ward, and Finke, pp. 27–52; Roger Schank and Peter Childs, *The Creative Attitude* (New York: Macmillan, 1988); S. M. Smith and E. Vela, "Incubated Reminiscence Effects," *Memory and Cognition* 19 (1991): 168–76.

67. See, for example, Silvano Arieti, *Creativity: The Magic Synthesis* (New York: Basic Books, 1976), for an attempt to integrate psychoanalytic insights into this problem-solving model of stages of the creative process. Invaluable background is provided in L. C. Whyte, *The Unconscious before Freud* (New York: Anchor Books, 1962).

68. The idea of translating Mednick and Simonton's intuitions into Parallel Distributed Processing models "without loss" is floated by Hans Eysenck, *Genius: The Natural History of Creativity* (Cambridge: Cambridge University Press, 1995), p. 192; the proposal is developed in some detail in Martindale, "Creativity and Connectionism," in *Creative Cognition*, ed. Smith, Ward, and Finke, pp. 249–68.

69. *Creativity: Beyond the Myth of Genius* (New York: W. H. Freeman, 1993); "Case Studies of Creative Thinking: Reproduction versus Restructuring in the Real World," in *Creative Cognition*, ed. Smith, Ward, and Finke, pp. 53–72. For Weisberg's specific criticisms of the "associative-combinatorial" tradition, see his review of Simonton, "An Edifice Built on Sand?" *APA Review of Books* 45 (2000): 589–93. Weisberg's discussion of *Guernica* might be usefully contrasted to Rudolf Arnheim's *Picasso's "Guernica": The Genesis of a Painting* (Berkeley: University of California Press, 1962).

70. Osborne, "The Concept of Creativity in Art," p. 227.

71. Göran Hermerén, *Art, Reason, and Tradition: On the Role of Rationality in Interpretation and Explanation of Works of Art* (Lund: Royal Society of Letters, 1991), p. 97.

72. Ibid., p. 94.

73. Michael D. Bristol, *Shakespeare's America, America's Shakespeare* (London: Routledge, 1990), p. 40.

74. For a philosophically oriented collection of papers on these notions, see Mette Hjort, ed., *Rules and Conventions: Literature Philosophy Social Theory* (Baltimore: The Johns Hopkins University Press, 1992).

75. Kant, *Critique of Judgment*, section 46, Ak. 307–8.

76. Ibid., section 47, Ak. 309–10; Kant also holds that there are determinate rules for producing work in respect of its academic correctness.

77. Elster, *Ulysses Unbound*, p. 212.

78. Ibid., pp. 221–27.

How to Create a Fictional Character

Peter Lamarque

THE ISSUES

If you hold an eliminativist view of fictional characters, in other words, if you hold that fictional characters have no reality whatsoever and that apparent reference to them can be eliminated, then presumably you hold that no-one does or ever could create a fictional character. I take this to be one implication of the eliminativist theories of philosophers like Bertrand Russell, Nelson Goodman, and Kendall Walton. Of course these philosophers need not deny that authors engage in creativity. According to the different theory on offer, it could be admitted that authors create things like sentences, descriptions, stories, Pickwick-pictures, props in games of make-believe. But it could not be admitted that they create fictional characters, because, on these views, there are no such things.

Even among theorists who do admit some kind of being to fictional characters, it is not universally agreed that fictional characters are created. On Meinongian theories, for example, which see fictional characters as instances of non-existent objects, two factors count against the characters being created: the first is that they cannot be brought into existence (a requirement, it would seem, for creation)[1] because they do not exist, they are *non-existent* objects, the second is that as non-existent *objects* they are eternal and timeless. There are other views which take fictional characters to be timeless, and thus uncreated: the view that they are unactualized possibilities, for example, or the view

that they are kinds or sets of properties. However, a different strand of realist theories of fictional characters, originating with Kripke, and developed recently by Nathan Salmon and Amie Thomasson,[2] does allow for the literal creation of characters, as abstract artifacts. The idea is that fictional characters are not just created entities but essentially created, coming into existence only as a result of the mental and physical acts of an author and enjoying the same kind of existence as other abstract artifacts such as theories, laws, governments, and literary works.

I will not be summarizing the now substantial literature on the ontology of fiction, but I do want to address some of the intriguing and difficult metaphysical questions that arise. To grasp the nature of creativity in fiction we need a reasonably secure conception of fictional characters themselves and their identity conditions. After all, if I create a fictional character and it turns out – as it inevitably will – to have features in common with other fictional characters, just how creative have I been? Have I produced something new or just a variant on something old? Did Shakespeare *create* his central characters or just rework those of his sources? How similar can characters become yet remain distinct? How, for that matter, do you count characters? If an author writes, "A crowd of a hundred people gathered outside", and says nothing more about the crowd, has he created a hundred characters? It might seem obvious that he has not, but it is not clear exactly why not. What conditions must obtain for a character to be introduced in a narrative?

But I don't want to get stuck on the metaphysics of fiction, interesting as it is. For there are clearly literary considerations, too, about the creation of fictional characters. The literary approach can seem curiously at odds with the metaphysical enterprise and each can have the effect of undermining the other. Character has been an unpopular and discredited conception for a generation of literary critics, and even for a short period, that of the Nouveau Roman of the 1950s and 1960s, among authors themselves. Why is that? To what extent does this reaction depend on a certain conception of character and indeed of character-based criticism? There seems to be an irresolvable tension between realist assumptions about characters as persons-in-fictional-worlds and literary assumptions about characters fulfilling narrative roles. Yet there is no

metaphysical reason why these two aspects shouldn't co-exist. More on that later.

METAPHYSICS AND CHARACTER IDENTITY

Let us turn first to the ontological question of character creation. How important is it to preserve the intuition that fictional characters are literally created? Certainly we talk as if they were. We attribute part of the genius of Dickens to the creation of, say, Nicholas Nickleby and David Copperfield, or the genius of P. G. Wodehouse to the creation of Jeeves and Bertie Wooster. But everyone, eliminativists, Meinongians, possibilists, have their own story about how to accommodate this intuition of creativeness so the artifactualists cannot win the argument on this alone. We need to probe deeper to see what hangs on the issue, clarifying, among other things, exactly what a story-teller needs to do – on any account – to bring a character to the light of day.

Let me lay out my own metaphysical stall, then I will elaborate and set it in context. In the expression "fictional character" it is helpful to assign different roles to the two terms. Not all characters are fictional, and character, in its general sense, is an abstract concept, designating a type, a more or less specific set of characteristics realizable in individuals. To say that a character is *fictional* is not to say something about its existence but something about its origins, namely, that it originates in fiction, in a narrative of a certain kind.[3] It can be misleading, I believe, to attend too early in a metaphysical enquiry to the complex fictional characters of the nineteenth century realist novel, where a remarkable experiment took place in trying to depict in immense detail the inner life and motivation of fictional personages rather than merely their outward action and speech. We get a quite different perspective if we focus instead, at least to begin with, on, say, the simple characters of the folktale. In his classic study of the fairy tale, Vladimir Propp outlines the distinct roles that characters, or character-types, perform in different tales. Take, for example, the villain who enters at a set point in the narrative (never right at the beginning but usually, as Propp describes it, when an "interdiction is violated"). "His role," Propp writes, "is to disrupt the peace of a happy family, to cause some form of misfortune, damage, or harm. The villain(s) may be a dragon, a devil, bandits, a witch, or a stepmother, etc."[4] With characters

of this simplicity, interesting and important observations arise about character identity. There is clearly a sense in which *the same character*, for example the villain, occurs in different stories, even though taking different forms. So to add to my first two suggestions, namely that fictional characters (*a*) are types, and (*b*) originate in fictional narratives, I add a third, that (*c*) they possess an identity which is, as I shall put it, interest-relative.

INTEREST-RELATIVE IDENTITY

Let me develop this latter idea a bit further. The suggestion is that there is no absolute answer to the question of whether two fictional characters are the same, only an answer relative to the discourse-based interests of those raising the question. Relative to a study of the morphology of the folktale, there are a comparatively small number of recurrent characters – the villain, the donor, the magical helper, the dispatcher, the hero, the false hero, and so on. These crop up over and over, and it is important to identify the same character, or role, in different manifestations. However, relative to a study of individual stories, different characters fulfilling these roles can be identified and distinguished – the dragon, the witch, the stepmother, and so forth.

One way of looking at this interest-relativity of character identity is by pairing sets of essential and inessential, or contingent, properties. For the morphologist, interested in identifying the same "villain" character across works, being a villain is deemed an essential property, while being a dragon or witch is inessential. On the other hand, for those concerned with individual story analysis, or story identity, both being a villain and being a dragon become essential while no doubt some more minor points of detail remain merely contingent. It should not be assumed that a norm of character identity is that maximal type to which all relevant narrative detail is deemed essential. Take sequences of novels – the Holmes stories, the Palliser novels, the Jeeves stories. It seems entirely acceptable to say that the very same Holmes or the very same Jeeves would have existed even if only one novel had been written in each series. It is not essential to Jeeves that he perform all the rescue missions described in the total oeuvre, so not all of the properties of the Jeeves-character are essential to it.

Yet another way of viewing the matter might be in terms of the nesting of character-types. Each character – and this holds for characters of any degree of complexity – can be broken down into character-types from the most general to the highly specific. Judgments of sameness or difference will be relative to the appropriate level of specificity in this hierarchy of types. Relative to literary history, very broad identity claims might be made about characters: to take the familiar example, the same Dr. Faustus crops up in works by Christopher Marlowe, Johann Wolfgang von Goethe, and Thomas Mann, where the essential identity criteria reside in a small cluster of Faust-characteristics.[5] But relative to an analysis of the individual works (and authors) the characters differ as the identity conditions become more demanding and the set of essential characteristics expands. Again, the amateur detective character-type is exemplified by Sherlock Holmes, Hercule Poirot, Miss Marple, and Lord Peter Wimsey. Are they the same character? Relative to some interests, yes: relative to most, no, because the set of essential characteristics is normally taken to be fuller than just the single trope of *inspired-amateur-detective*. The same goes for the character-type *unhappily-married-adulterous-and-doomed-woman*: Emma Bovary, Thérèse Raquin, and Anna Karenina are the same type (thus the same character) under a broad cultural perspective; different of course under other, more refined, perspectives.

Note that the four (fictional) amateur detectives, or indeed the three (fictional) doomed women, do not stand to the character type in the way that, say, Tony Blair, John Major, and Margaret Thatcher stand to the type British prime minister. For the latter, unlike the former, are *instances* of the type and do not owe their identity to it. We could identity the three individuals independently of the type they instantiate and the type is not essential to them (which is not to say that they might not instantiate some types, like human being, essentially). It would be absurd to suppose that under any description, or relative to any interests, these three people are the same, even though the same description truly applies to them. But it is quite different for characters, at least on the hypothesis that they are abstract entities. Although characters per se can have instances in the real world, *fictional* characters cannot, because even were someone to instantiate the Emma Bovary type in the real world she would not *be* Emma Bovary, lacking the fictional origins. We might of course describe her as *an* Emma Bovary, using the

name as a general term. In any case, if Emma Bovary, as a character, is a type, no human being could be Emma Bovary because no human being can be (as opposed to instantiate) a type.

Now we can return to the creation question. A number of significant points begin to emerge. First there is an inverse relation between the generality of character specification and the creativity attributable to the story-teller. The unadorned characters *amateur detective, adulterous wife*, or plain *villain* are not the products of creative acts. The reason is that at this level of generality the characters or types are well known. No special imaginative effort is required to bring the concepts to mind. We would call these stock or stereotypical characters should they be introduced in a narrative with only limited further specification. If creativity is linked to specificity, then specificity must be linked to narrativity, for it is only through narrative detail that characterization can develop. So we have a nice dovetailing of creativity with narrativity.[6]

There is obviously a literary angle on the relation between creation and narration, to which I will return, but there is a metaphysical angle as well. I suggested earlier that what makes a character fictional is its being anchored to a fictional narrative in which it originates. One metaphysical motivation for this is what might be called the Levinson point, after Jerrold Levinson's well-known discussion of the ontology of musical works.[7] There is a telling, though not entirely straightforward, analogy between the ontology of music and the ontology of fictional characters.

Levinson sought to resist a certain kind of Platonism about music, defended by philosophers like Nicholas Wolterstorff and Peter Kivy, which sees musical works as eternal sound structures discovered but not created by composers.[8] Levinson offers an impassioned defense of the importance of creation in art, and in musical composition in particular. "There is a special aura," he writes, "that envelops composers, as well as other artists, because we think of them as true creators".[9] But the argument from creativity, as Levinson realises, is not decisive against musical Platonism, and it cannot be decisive either against Meinongians or possibilists or those who see characters merely as eternal types. After all, those philosophers who deny that fictional characters are created have, as I suggested earlier, their own accounts of creativity. Wolterstorff, for example, proposes that although authors

merely "select", but do not create, the "person-kinds" (as he puts it) that are the components of fictional worlds, perhaps "a person-kind is not properly called a 'character' until some work has been composed of whose world it is a component".[10] Terence Parsons takes a similar line, suggesting that while characters cannot be brought into existence, "we might say, I suppose, that the author makes them *fictional* objects, and that they were not fictional objects before the creative act".[11] The arguments seem ad hoc, resting on decisions about how we might use the terms "character" and "fictional". For the artifactualist, taking the Levinson line, fictional characters are *essentially* created. Their origins in intentional acts are *necessary* to their identity. Although I think that is right it needs careful refinement, especially if we accept the interest-relativity of characters.

This is where Levinson's second argument against musical Platonism comes in. The argument, I think, applies only obliquely, but intriguingly, to fictions. This is the argument that musical works must be essentially grounded in a historical context (indeed to a specific creative act), as two identical sound structures "selected" at different times would have different aesthetic and artistic properties. Here is an example from Levinson: "Brahms's Piano Sonata op. 2 (1852), an early work, is strongly *Liszt-influenced*, as any perceptive listener could discern. However, a work identical with it in sound structure, but written by Beethoven, could hardly have had the property of being Liszt-influenced. And it would have had a visionary quality that Brahms's piece does not have".[12] Levinson invites us to conclude that the Piano Sonata is *essentially* by Brahms and an identical sound structure written by Beethoven would be a different work in virtue of having different properties.

How might that apply in the fiction case? Well, suppose that the character of Bertie Wooster miraculously manifested itself, via a suitable narrative, in the early nineteenth century. Would we say that the character had different properties in this context – given its different historical and contextual relations – and thus was not strictly the *same character* as appeared in the twentieth century? But we have seen that this question – about identity – admits of no absolute answer and will rest partially on the degree of specificity demanded of the characterization. There seems no reason why the type *feckless upper-middle-class man of leisure* should not exist in the 1820s, indeed there are many

instances of it. Even the more specific type *feckless upper-middle-class man of leisure named Bertie Wooster, with a butler named Jeeves, a best friend Bingo Little, and an elderly aunt of whom he is terrified* does not yet depend on a precise historical or cultural context. In fact there is no reason why nearly all the internal, or constitutive, properties of Bertie Wooster, up to quite a high level of specificity, should not have been characterized a hundred years before P. G. Wodehouse wrote his novels. Of course, whether they could have been characterized in the Middle Ages, say, is more problematic given some of the historically determined features of the characterization. But could not a futuristic Wooster narrative have appeared in the 1420s?

The crucial application of the Levinson test lies not with the internal, or what Parsons calls "nuclear", properties of a character, in other words properties like *being a man of leisure, being a detective, being a villain,* but with the external, relational, or "extra-nuclear" properties. Extra-nuclear properties are those which apply literally to a character, as an abstract entity. Nuclear properties might serve to constitute or delineate a character, but they cannot literally be *possessed* by a character, for an abstract entity cannot be a man or a villain. *Being essentially created* is an extra-nuclear property, as is *being created in the twentieth century* or *being conceived by P. G. Wodehouse.*

What Levinson's argument forces us to address is the question whether, or to what extent, character identity rests with extra-nuclear as well as nuclear properties. For Levinson, facts about origin affect musical work identity because they affect aesthetic or artistic properties. Undoubtedly something similar is true for literary works. The Bertie Wooster novels would not be the same *works,* that is, would not retain their work identity, even as word-for-word facsimiles, if they had appeared in the Middle Ages or even just a hundred years earlier.[13] As with Pierre Menard's *Don Quixote* the works would have, for example, different stylistic and meaning properties given the different cultural settings. At least some of these differences will manifest themselves as differences in extra-nuclear properties of the Wooster-character itself. For does not the character possess culture-specific properties: being a humorous comment on post–First World War upper-middle-class life, expressing nostalgia for an age of wealth and leisure, being a satire on class attitudes in 1920s Britain, and so on? To the extent that these properties are held to be essential to the Wooster-character,

then that character could not be identical with the nineteenth-century manifestation – and Levinson's argument would go through for fiction.

But should extra-nuclear properties count in the identity conditions of characters? Of course some will be shared by all fictional characters: including, if it is one of their properties, being created. But what about historically specific properties? Again much will depend on the level of specificity. Many different characters can parody the follies of 1920s England or symbolize decadence or call to mind a lost age. The question really becomes whether narrative-specific extra-nuclear properties are in the identity conditions of fictional characters. But there will be no general answer to that given the interest-relativity of character identity. In other words, it will depend on what demands are placed on the delineation of a character and what ends are thereby served. The matter soon becomes an issue for the literary critic, for whom, as we shall see, literary properties of characters assume more importance than they do on metaphysical accounts. But we should note that if characters can be distinct merely in virtue of narrative-specific properties, in other words, appearing in this narrative rather than that, then borrowed and barely altered characters become new characters (in their new setting) and the creation of characters, the bringing of new ones into existence, is all too easily achieved.

We cannot quite leave the matter there for it brings us back once again to the relation between fictional characters and fictional narratives. Nearly everyone, from eliminativists to artifactualists, recognizes some connection between characters and narratives. For eliminativists there is nothing more to characters than the narratives that describe them; for Meinongians and possibilists, characters have their essential being independently of narratives but narratives are the principal means by which we come to know them. For artifactualists, like Salmon and Thomasson, fictional characters are created through the creation of narratives. As Thomasson sees it, the existence of the former is dependent on the continued existence of the latter, with the implication that characters can go out of existence when their grounding narratives are lost or there are no longer competent readers for them or no appropriate memories of them.[14]

Although I think fictional characters are dependent on narratives for their existence – in much the way that Thomasson describes – the

closeness of the dependence will vary according to the specificity of the characterization. *Fictional* characters (although not characters per se) are, I suggest, what Levinson has called "initiated types", that is, those which "begin to exist only when they are initiated by an intentional human act of some kind".[15] However, I do not share Thomasson's view that they are essentially tied to, or (in her terms) "rigidly dependent on", a particular author and a particular narrative. It seems to me that it is not essential to the Sherlock Holmes-character that it was created by Conan Doyle, and certainly not essential to the villain-character in Russian folktales that it was the product of a particular individual's intentional acts. But the matter grows complicated, again, as we reach more and more specific levels of characterization or, as I have put it, place increasingly demanding conditions on character identity. The historical and cultural conditions in which a character is initiated are probably always essential to it, even in simple cases like the folktale villain; I say "probably" because we might have to admit a level of abstraction where a stock character is truly universal or ahistorical. As we refine the conditions and identify a character more and more closely with a particular literary work, we will anchor it more and more tightly to the facts of its origin.

Could Emma Bovary have originated in a different novel? Even a novel by a different author? By Zola, perhaps, Baudelaire, Proust, even? There is no determinate answer because there are no determinate, non-relative criteria for the identity of the Emma Bovary-character. Note that this position can be maintained even if you hold, as seems plausible, the necessity of origins for (some) literary works.[16] Even granting the Levinson and Thomasson view that the novel *Madame Bovary* is essentially by Flaubert, we should leave room in principle for the possibility of the Bovary-character's appearing, even originating, in another novel, perhaps by another author, just as most of Shakespeare's main characters appear in antecedent texts.

CHARACTERS AND INDIVIDUATION

To create a fictional character you need to create a narrative in which the character appears. Fictional characters must be tied, if not to a particular narrative, then to some narrative or other. But what is involved in creating a character through a narrative? Suppose a narrative simply

states, "Three men entered the room". Have three characters thereby been created? The question recalls the case of the hundred-strong crowd. According to John Searle, all that is needed to create a fictional character is to "pretend to refer to a person".[17] Have we pretended to refer to three persons? Even if so, we have not, I suggest, created three characters. The reason is that we have not provided conditions for individuation. A minimal requirement for character creation is that means are provided for distinguishing one character from another. Even a narrative that consists only of the sentence "A man and a woman entered the room" has satisfied this base condition. Here are two characters distinct from one another in virtue of possessing different properties.

What even this impoverished narrative allows – another crucial feature of character initiation – is something akin to *indexicality*. A reader of the narrative or someone reporting it can refer to *that* character – the man – as opposed to *that* character, the woman. Yet it would be wrong to suppose, in line with an earlier point, that because only general terms, "a man", "a woman", are used in the narrative then any individual satisfying those predicates automatically instantiates them in this context. The narrative is not about just *any* man or *any* woman, in spite of its failing to provide more specific information. A deep referential opacity follows from the intentionality of fiction.[18] This reinforces the idea of fictional characters being essentially grounded in narratives. Each fictional narrative invites its readers to make-believe or imagine that the character descriptions are instantiated by some unique individual or that the fictional proper names refer uniquely. Of course individuation is normally secured by the use of proper names. But proper names are not a condition for character creation. Once a fictional character is individuated within a narrative it can become an object of reference in non-fictional contexts, as happens when well-known characters take on a life of their own as cultural paradigms.

What I will call individuation-via-indexicality is one way in which mere free-floating or universal character-types are distinguishable from *fictional* characters in spite of an apparent co-extensionality. The villain character or the amateur detective or even the Emma Bovary character can exist independently of any narrative and could be multiply instantiated, but *that* villain, *that* detective, and *that* Emma Bovary

are products of this or that narrative. They are created because they are grounded.

It is common to associate the creation of fictional characters with the imagination. But while fictional characters do rest on the intentional acts of those who write fictional narratives there is no necessity that they be objects of the imagination. Of course they might be, in the case of complex creations, but where imagination is needed is in the reader's response in making believe that an individual instantiates the character.[19] It is obvious, though, that in novels or dramas of any complexity a reader's response to character and the implied conception of character identity rest on much more than this limited imaginative exercise. That brings us squarely to the literary dimension of character. Before we turn to that, let me briefly summarize the metaphysical story so far.

If we reject, as I think we must, the eliminativist program – for which there seem no satisfactory candidates[20] – and admit the reality of fictional characters as abstract entities, then the most promising metaphysical picture is this: that fictional characters are initiated types, grounded in acts of story-telling, that is fictional narratives, although not essentially bound to any one, even if tied to a reasonably determinate historico-cultural context. Their identity is interest-relative depending on the demands placed on their identity conditions, which in turn determine the extent of their essential properties. As *characters* per se, and thus types, they are not created, for sets of properties exist just to the extent that the properties themselves exist, an existence which in the case of universals like *being a detective*, or *being a villain*, seems to be eternal. However, as *fictional* characters they are created, to the extent that their grounding narratives are created, and to the extent that they can be individuated in a quasi-indexical manner by pointing to the source narrative. So even a minimal fictional character, whose only properties are *being a bald man*, is created just in case it makes sense to say of the character that he is *that* bald man. The distinction between the character per se (in this case *being a bald man*) and the *fictional* character (*that* bald man in such-and-such a story) is akin to the distinction offered by Levinson between a "sound structure *simpliciter*" (which he, and others, hold can preexist acts of composition) and a "sound-structure-as-indicated-by-X-at-t" (which comes into being through an act of composition).[21]

THE LITERARY DIMENSION

The literary dimension of fictional characters casts a somewhat different light on the question of their creation. For over fifty years there has been a deep skepticism about the importance of character in literary studies and the relevance of character-centered criticism. Partly this has been methodological, urging a change of emphasis toward more formal properties of texts, but partly also, more recently, epistemological. The postmodernist attack on character has been motivated by a general anti-humanism which seeks to undermine notions like the self, the subject, autonomy, human nature.[22] By a curious reversal, rather than seeing fictional characters as human beings, postmodernists have come to see human beings as more like fictional characters: diffuse, uncentered, lacking unity, constructs of discourses. Jean-François Lyotard offers a plausible version:

each [self] exists in a fabric of relations that is now more complex and mobile than ever before. Young or old, man or woman, rich or poor, a person is always located at 'nodal points' of specific communication circuits, however tiny these might be. Or better: one is always located at a post through which various kinds of messages pass.[23]

Other versions are more extreme in denying the autonomous self: "The notion of the 'self' – so intrinsic to Anglo-American thought – becomes absurd. It is not something called the self that speaks, but language, the unconscious, the textuality of the text".[24] However, whatever one makes of this view of the *self*, it can hardly serve to dislodge the concept of fictional character, given that it takes the phenomenon of fiction as a kind of paradigm.[25] The very ideas of existing in a "fabric of relations" or speaking through the "textuality of the text" applies par excellence to fictional characters and should be the starting point for any serious consideration of literary character.

The literary dimension of character creation begins, as the metaphysical dimension ended, with the embeddedness of fictional characters in narratives. But literary creativity moves well beyond the initiation of types and introduces complex questions of literary value. My own focus will be restricted to the role and nature of narrative detail in relation to literary characters. On the metaphysical story the accumulation of detail in characterization is explicable in terms

of the increasing specificity of character types. The more properties attributed to a character the fuller the type and perhaps the richer the imaginative possibilities it affords. But literary creativity does not increase merely in proportion to the piling up of detail or the specificity of characterization. A character does not get richer, deeper, or more interesting in virtue of having more detail ascribed to it. In formulaic narratives like the Holmes or Wooster stories the large number of specific incidents accumulated through the series serves little to develop either character. That is why I suggested that there is a great deal of non-essential or contingent detail about such characters that has no bearing on character identity. Holmes' identity as a character would not have been affected if there had been, say, no "case of the speckled band".

But with literary fiction things are different, or at least attention toward detail is differently directed, and this for three reasons: first, details of characterization are seen as having an aesthetic function; second, characterization acquires an evaluative (including moral) dimension as well as a purely descriptive one; and third, characterization, and the development of character, is subject to interpretation, introducing another layer of indeterminacy.

These are large issues, but I hope enough can be said in a few paragraphs to throw at least some light on the literary, rather than merely metaphysical, demands on character creation. Literary creativity is explicable not just through clichéd notions of rounded characters and psychological depth, for literary value resides in the integration of many facets of a narrative, not least the way in which formal textual features, subject matter, and broader thematic content cohere.[26] The metaphysical picture suggests that detail simply adds to a store of information about a fictional world. The literary picture suggests, in contrast, that much detail performs a functional, not factual, role.[27] Take this literary critical analysis of certain details in *Our Mutual Friend* (the critic is J. Hillis Miller):

> To see a Veneering dinner party reflected in "the great looking-glass above the sideboard," to see the vain Bella admiring herself in her mirror, or to see Fledgeby secretly watching Riah's reflection in the chimney-glass is to witness a concrete revelation of the way the lives of such people are self-mirroring.... Mirroring brings to light the vacuity of people whose lives are determined by money. Each such character is reflected in the blankness of

the glass, and can see others only as they are mediated by the reflected image.[28]

Here narrative detail is assigned an aesthetic function, drawing out a motif in the novel, thus connecting diverse episodes with each other, rather than merely adding information. Or rather it does both: Bella's vanity, part of her identity as a character, is reinforced by her preening in front of a mirror, but the mirror shows us something broader about the novel's themes.

Detail alone is not enough to bring originality to a character. The critic Marvin Mudrick famously attacks Jane Austen's creative achievement in the characterization of Darcy in *Pride and Prejudice*. For Mudrick, "she borrows him from a book; and, though she alters and illuminates everything else, she can do nothing more with him than fit him functionally into the plot". He becomes "the conventionally generous and altruistic hero . . . fall[ing] automatically into the grooves prepared . . . by hundreds of novels of sentiment and sensibility".[29] Here, if Mudrick is right, is a different kind of lack of specificity, not a dearth of factual detail, but a failure, as one might say, of embeddedness. Darcy, on this account, is no more than a character-type, contributing little to the "fabric of relations" that makes the novel distinct and valuable.

I have not said much about the linguistic aspect of character creation. From the metaphysical point of view, as emphasized by Thomasson, characters come into being through the performative acts of authors, rather as do marriages, contracts, and promises.[30] The literary perspective, on the other hand, highlights not merely the representational or descriptive aspect of these acts but the full utilization of linguistic resources. The creative achievement is fundamentally a linguistic one, and we praise writers for what they can do with language. Obviously vividness and clarity of description aid vividness and clarity of characterization. But at a literary level something more interesting is going on. For literary description embodies not just facts but values, attitudes, and figurative meanings. The critic Dorothy van Ghent in her discussion of *Tess of the d'Urbervilles* stresses what she calls Hardy's "symbolic use of natural particulars". She writes:

the chattering of the birds at dawn after the death of Prince [Tess' horse] and the irridescence of the coagulated blood, the swollen udders of the cows at

Talbothays and the heavy fertilising mists of the late summer mornings and evenings, the ravaged turnip field on Flintcomb-Ash and the visitation of the polar birds. All of these natural details are either predictive or interpretive or both, and prediction and interpretation of events through analogies are the profession of magic. When a piece of blood-stained butcher paper flies up in the road as Tess enters the gate of the vicarage at Emminster, the occurrence is natural while it is ominous; it is realistically observed, as part of the "given", while it inculcates the magical point of view.[31]

In such an atmosphere of symbolic meaning, a curious phenomenon occurs in literary characterization, which complicates the metaphysical account: nuclear properties, those belonging to a character as *person in a world* intermix with extra-nuclear properties, those possessed by characters as *abstract constructs*. When Alec d'Urberville appears, in the episode of the planting fires, with a pitchfork among flames, he is both a human being fighting a fire and also a symbol of evil: both a person, we might say, and a fictional character. It does not seem quite enough to say that the one is make-believe, the other a real, if abstract, entity, for on the literary perspective the two are not so obviously distinguishable.

Finally, the constructedness of character is emphasized by the role of interpretation. On the metaphysical story, character identity is relative to demands made on the inclusiveness of the set of essential properties. There is not always a determinate answer to whether two characters are the same or different. A comparable indeterminacy is a consequence of divergences among literary interpretations. At the simple level of imaginative supplementation of fiction there are always alternative, well-grounded ways of filling in missing detail. But again more inter-estingly, the very identity of a character, in the sense of what essential properties belong to the character, might depend on more global in-terpretative judgments. With characters like Raskolnikov, Hamlet, or Meursault, where the central crux concerns motivation, part of the literary creativity resides in setting up a narrative context in which competing but plausible interpretations can foreground deep, diverg-ing facets of human nature. In one of the few insightful passages in his book *Faultlines*, Alan Sinfield remarks tellingly:

Character criticism depends in actuality not on unity but on superfluity – on the *thwarting* of the aspiration to realize unity in the face of material resistance. That is why 'stereotypical' characters, who do have a certain unity, are thought unsatisfactory, and why when characters gain an appearance of unity through

closure at the end of the text they become suddenly uninteresting.... Hamlet tantalizes traditional critics: they cannot get him to add up without surplus. But this is not because there is insufficient subjectivity in the text for them to work on, but because there is too much. The text overloads the interpretive system.[32]

Under the literary gaze fictional characters – or those with literary stature – assume an increasingly fragile constitution. They come to look indeed more and more like the postmodernist version of the self. Indeterminate, deeply implicated in textual and narrative strategies, the product of interpretation at nearly every level, imbued not only with human qualities but also with symbolic and value-laden properties, perspectival in nature,[33] ascribed functional and teleological roles, sometimes naturalistic, sometimes self-consciously artifactual, it is surprising that they retain their remarkable capacity to engage the imagination, to steer us into the make-believe of a world containing real human beings. Perhaps the greatest creative achievement of the writer is to perform a conjuring trick of such a startling kind, as Theseus says, giving to "airy nothing /A local habitation and a name".

Notes

I am especially grateful to Paisley Livingston for his comments and advice on this essay.

1. In fact not everyone does accept this point about creation; it is explicitly rejected, for example, by Harry Deutsch in "The Creation Problem," *Topoi* 10 (1991): 209–25, as part of an argument for a modified Platonism about fictional characters.
2. Saul Kripke, "Reference and Existence: The John Locke Lectures for 1973" (unpublished); Nathan Salmon, "Nonexistence," *Nous* 32.3 (1998): 277–319; Amie Thomasson, *Fiction and Metaphysics* (Cambridge: Cambridge University Press, 1999).
3. For more details on this view of fictional characters, see Peter Lamarque, *Fictional Points of View* (Ithaca, N.Y.: Cornell University Press, 1996), esp. Ch. 2, and also Peter Lamarque and Stein Haugom Olsen, *Truth, Fiction, and Literature* (Oxford: Clarendon Press, 1994), Ch. 4.
4. Vladimir Propp, *Morphology of the Folktale*, 2d ed. (Austin: University of Texas Press, 1968), p. 27.
5. The case is discussed in my *Fictional Points of View*, p. 49; see also Nicholas Wolterstorff, *Works and Worlds of Art* (Oxford: Clarendon Press, 1980), pp. 148–9.

6. For an account of narrative, see my "Narrative and Invention," in *Narrative in Culture*, ed. Cristopher Nash (London: Routledge, 1990). In the present context very little theoretical sophistication is presupposed in the concept as used. Narrative, in this sense, implies any "story-telling," that is, tensed discourse where events are related.

7. See Jerrold Levinson, "What a Musical Work Is," and "What a Musical Work Is, Again," in *Music, Art, and Metaphysics* (Ithaca, N.Y.: Cornell University Press, 1990).

8. Wolterstorff, *Works and Worlds of Art*, pp. 62–73, and Peter Kivy, "Platonism in Music: Another Kind of Defense", *American Philosophical Quarterly* 24 (1987): 245–52. For a more recent defense of austere musical Platonism, see Julian Dodd, "Musical Works as Eternal Types", *British Journal of Aesthetics* 40 (2000): 424–40. For criticisms of Dodd and a defense of Levinson, see Robert Howell, "Types, Indicated and Initiated", *British Journal of Aesthetics* 42 (2002): 105–27.

9. "What a Musical Work Is", p. 67.

10. Nicholas Wolterstorff, *Works and Worlds of Art*, pp. 144–5.

11. Terence Parsons, *Nonexistent Objects* (New Haven, Conn.: Yale University Press, 1980), p. 188.

12. "What a Musical Work Is," pp. 70–1.

13. For a discussion of indiscernibles cases and work-identity, see my "Aesthetic Value, Experience, and Indiscernibles", *Nordisk estetisk tidskrift* 17 (1998): 61–78; "Objects of Interpretation", *Metaphilosophy* 31 (2000): 96–124; and "Work and Object", *Proceedings of the Aristotelian Society* 102 (2002): 141–62.

14. Amie L. Thomasson, *Fiction and Metaphysics*, pp. 10–11.

15. "What a Musical Work Is," p. 81.

16. In "Work and Object" I argue that whether or what origins are essential to a work's identity will depend on what is required for an appropriate response to, or experience of, the work. An adequate appreciation of Beethoven's Third Symphony requires knowledge that it is *by Beethoven*, but for less complex or iconic works such knowledge (of origins) might not be required for full appreciation.

17. John Searle, *Expression and Meaning* (Cambridge: Cambridge University Press, 1979), pp. 71–2.

18. The point is developed in Lamarque and Olsen, *Truth, Fiction, and Literature*, Chs. 5–6.

19. The importance of the imagination in *responses* to fiction is a common element in the theories of Kendall Walton, *Mimesis as Make-Believe* (Cambridge, Mass.: Harvard University Press, 1990); Gregory Currie, *The Nature of Fiction* (Cambridge: Cambridge University Press, 1990); and Lamarque and Olsen, *Truth, Fiction, and Literature*.

20. For a survey of such theories, see my "Fiction" in *Handbook of Aesthetics*, ed. Jerrold Levinson (Oxford: Oxford University Press, 2003), pp. 377–91.

21. Levinson includes in his identity conditions of a musical work the "performing-means structure" essentially associated with the work: e.g., being performed on instruments of a particular kind. Is there anything

parallel in the case of fictional characters? Is there, for example, any medium specificity for character identity? It might seem obvious that characters like Bertie Wooster or Nicholas Nickleby can retain their identity when realized in different media: the *very same* Wooster can appear in drawings, movies, cartoons, and sculptures. Perhaps, though, the matter is not always so clear-cut. Might it not be that a cartoon character, such as Mickey Mouse, is *essentially* a cartoon character, so that were a human being to act out the character on the stage or in the movies we should say that this is a *rendering* or *version* of Mickey Mouse but, in some sense, not "the real thing"? Another problematic factor is the degree of specificity that different media afford. To portray a character onstage or in a movie is to present the character with a plenitude of (at least physical) properties, such that the height, weight, dimensions, movements, etc. of the character are all perforce made explicit and determinate. In a literary narrative a writer can be more selective about what details to reveal or imply. Although audiences of stage or cinema are quite sophisticated in discriminating between merely contingent properties associated with the human actor and properties genuinely attributable to the fictional character, nevertheless visual media always have the capacity to be more specific in the delineation of character than purely literary media. One consequence of this is that the indexicality requirement I have described in character-identity conditions is far easier fulfilled in visual than in literary media. If the narrative mentioned earlier, "Three men entered the room," fails to create three characters in its literary form, because of the failure of individuation, it might well do so in a visual form. But this asymmetry has an unexpected knock-on effect. It seems to imply that the visual narrative and the written narrative cannot be identical narratives, for one contains individuated characters which do not appear in the other. To produce the *same* narrative, with its radical indeterminacy, would require quite radical and unfamiliar visual effects. Perhaps this reinforces the notion that dramatizations of literary works are not only difficult in practice but, in some sense, impossible in principle. I am grateful to Paisley Livingston for inviting me to reflect on these matters.

22. I discuss the matter further in *Fictional Points of View*, Ch. 1.

23. Jean-François Lyotard, *The Postmodern Condition: A Report on Knowledge*, trans. Geoff Benington and Brian Massumi (Minneapolis: University of Minnesota Press, 1984), p. 15.

24. Alice A. Jardine, *Gynesis: Configurations of Woman and Modernity* (Ithaca, N.Y.: Cornell University Press, 1985), p. 58. Similar views can be found in Hélène Cixous, "The Character of 'Character'", *New Literary History* 5 (1975): 383–402.

25. For a more detailed argument on these lines, see Lamarque, *Fictional Points of View*, Chs. 1 and 12.

26. For a general overview of this conception of literature, see my "Literature," in *The Routledge Companion to Aesthetics*, ed. Berys Gaut and Dominic McIver Lopes (London: Routledge, 2001), pp. 449–61.

Drawings as Drawn

An Approach to Creation in an Art

Patrick Maynard

While an account of creation in any art could not reduce to an account of production, it requires one. "No creature can create," and "I do not create, I only invent"[1] – but, if we choose to speak about the "creation of art," for example, about the creation of drawings, we must surely consider their production, and in the right way: that is, consider drawings as drawn. The obstacles to this seem daunting. Where will we find even a relevant general account of drawing production?[2] Finding that, if production is not necessarily creation, what can we say about how drawing allows, even encourages, creativity? My aim is to make a beginning of a relevant account of drawing production, in terms of what has recently become available theoretically. Since much of that theory is *spatially* based and there is much to depictive drawing that is not, we will need to introduce some nonspatial considerations, as well. Only then will we be in position to consider how such an account of drawing production might begin to help us understand its creation. As I will attempt far less theorizing about creation than about production, I begin by simply pointing in one direction where I think we find the former.[3]

Perhaps the quickest way to understand what creativity means to us is by considering uncreative situations. These tend to be ones – for example, work situations – that people find lacking in scope for their capacities, ones where only a few of their capacities, or parts of themselves, are called upon, and then narrowly. By contrast, both production and appreciation of artworks typically require wide access

to mental, psychic, and physiological resources. People often say that
they come to artworks because the act of appreciation calls on so many
aspects of themselves; and it seems distinctive of all the arts, in both
their production and appreciation, that there is no limit to what may
be called upon. Works of art tend to inspire us to activity and partic-
ipation rather than passivity, partly because they demonstrate to us
our abilities to summon diverse parts of ourselves in order to provide
meaning, in activity that brings those parts into a whole. They thereby
show that no aspect of us or of our lives need be irreparably lost or
devoid of value, since in principle any may be mobilized for mean-
ing in the understanding of an artwork. In order to understand how
this happens, for example with drawing, we need better to understand
what is involved in drawing's construction or production, and thereby
in its appreciation, for different kinds of drawings.

1. DRAWING: EXTENDED STUDIES

We begin concretely, from what is unquestionably visible in a draw-
ing as a marked surface before us, independent even of its depicting
anything. A young child makes drawing marks. Such are physical, in-
tentional activities; we see children doing them, trying to. John Willats
has observed that while, strictly, such marks will always have some no-
ticeable breadth (be two-dimensional – 2D)[4] – at least by the third
year they will vary dimensionally: that is, as to what Willats calls their
effective extendedness (Fig. 1). Some may be virtually (not really) *unex-
tended*, or oD: spots. Most will be effectively 1D: *lines*. Others might be
noticeably 2D: say, blobs of paint. Keeping these formative factors in
mind, consider such markings now in terms of *picture primitives*, the
elementary form-making units in pictures. We well know that children
do not just attempt to make marks of these various dimensions, they
also attempt to draw *shapes* by their means. What is 'shape' in drawing?
Much of the first six sections of this essay addresses that question.

 While a classification of picture primitives, like that of marks, can
also be made in terms of dimensions of extendedness (often cor-
responding to the marks' extendedness), primitives do not always
correlate simply with the effectively o, 1, and 2D physical marks just
noted. Continuous, curving lines can be formed by chains of straight
marks or by dots; also, quite visible skips in physical marks do not always

FIGURE 1. Child's drawing (in marker pen): two years, ten months old.

register with us as breaks in lines. A particularly important example of this mark/picture-primitive distinction concerns 2D *"regions"* (essential to our account from now on; Figs 1, 2). Willats observes: "regions in a picture may be realized physically using patches of paint or blobs of ink, or blank areas enclosed by an outline, thus it is crucial to observe the distinction between the *marks* in a picture and the more abstract notion of the *picture primitives* represented by these marks."[5] The examples of patches, enclosures, fillers are important. A child who marks out a region with a large patch of paint may also, given only a crayon, indicate such a region with scribbled lines, and we should think of the child here as drawing the *same* things by different means and motor actions. And, gaining the important ability to make a closed line on a surface – that ability upon which so much of what we come to do with drawings depends, ever after – a child may use such an unfilled enclosure simply to define the region.

Willats enriches his dimensional extendedness descriptions of picture primitives to take note of another obvious fact about regions. Not all drawn regions have the same dimensional *emphases*. For example, some may be shaped differently from others, say, elongated where

FIGURE 2. Child's drawing ('tadpole' figure): three years old.

others are fairly symmetrical. So, in addition to effective extendedness, it is useful to have a secondary notation for this kind of emphasis. Thus Willats suggests that we qualify the dimensional label (or index) with an *index of extension*.[6] Fairly symmetrical regions, whether round or square (like those for eyes in Fig. 1), are alike notated as "2_{11}." "2" is for the dimension, 2D, while the subscript "1"s show that both dimensions are about equally stressed (although one might use fractions or decimals for finer discrimination). By contrast, markedly oblong 2D regions might be notated as "2_{10}," the subscript "0" beside the "1" registering relative lack of emphasis in one of the two perceptually effective dimensions.

In summary: allowing picture primitives a maximum of two dimensions on a surface, they may be classified (omitting fractional emphases) as *four*: 0D (dots), 1D (lines), 2D (regions whether indicated

FIGURE 3. Iznik Mosque Lamp. The Metropolitan Museum of Art, The Edward C. Moore Collection, Bequest of Edward C. Moore, 1891 (91.1.95).

by dots, lines, splodges, etc.), together with zero and unit salience 2D subscripts. We will later see how, as parts of drawings, these "picture primitives" may be pictorially important and interesting in themselves, as well as for what they lead to. So also are the physical markings upon which they rely, and also the relationships between the marks and regions. Here we need to remind ourselves how some cultures carry these factors to the highest artistic levels, keeping in mind that not all have been so interested as has been the West in developing figurative depiction to enhance their visual imaginings (Fig. 3). And of course modern Western art proved that no theory of drawing production entirely focused on figurative values would be satisfactory – especially not for creativity.

For these reasons we have put off depiction at the outset of an account of drawing production. But, of course, while still valuing the marks and shapes made with them, throughout history these kinds of markings and picture primitives have tended to acquire great interest as tools for figurative depiction. Before considering how such simple resources may be applied to produce depictions, let us note that so far we have gone along with a general trend of considering drawing in terms of certain spatial characteristics, and will so continue a while as we enlarge that list. Where we have differed is in taking dimensionality as the basic space idea, whereas most accounts, while exaggerating a "pictures are 2D, 'reality' 3D" conception, say no more about that, and go straight to the topic of shape as outline or contour.

2. DEPICTIVE DRAWING

How should we approach the production of figurative depictions by means of pictorial shapes? The first step might seem obvious. Considering only extensiveness, 'logically,' a 2_{11} region might be used to represent, denote, stand for a 2_{11} shape – the face of someone or of a thing, a wall, a tabletop, etc. However, since our topic here is depiction, general terms like "represent," "stand for" will not suffice, for, in order to consider drawings as depictions, we need to consider depiction's specific perceptual, visual nature. In what ways are figurative depictions visual? Not simply because they require visual access. It is crucial at this point to avoid the familiar philosophical trap of treating depictions as just one kind of things called "representations," generically understood in terms of systematic correlations between so-called symbolic and other orders of elements – notably, according to some function, such as projection. (This is what "representation" usually means in semantics and philosophy of mind.) That has proved to be a seriously misleading way of thinking about depiction, which is, instead, an appeal to our visual imagination, frequently summoning us to transfer routines of environmental visual perception to a different task.[7] For example, working toward shape as contour, there is a real, vexed empirical research question about *perception*, about how contour outlines work so well in depicting borders.[8] That is a question of which of our environmental perceiving abilities we bring to bear upon, or transfer

to, the distinctive activity of perceiving outline drawing, an ability that seems based on (though not restricted to) some very general, familiar capacities that we have for perceptual transfer.

Regarding transfer generally, I can only attempt to demonstrate it briefly by one very familiar kind of example, which might be called "physiognomic," for spontaneous 'faces in strange places' imagining effects (Fig. 4), which seems to underlie much depictive recognition. No-one suffers illusion in these situations, nor is the phenomenon one of noticing common properties or of correlating elements, perhaps according to some projective rule – to cite just a few influential approaches. It seems more plausible that here, rather as in metaphor, we apply a visual recognition schema for one thing, partly to organize our perception of another. Should this idea of "transfer" seem unclear for depictive contexts, consider another example from the decorative arts (Fig. 5). We see in this effective use of what is called "a creative idea" – of visual wit – how our recognitional abilities for one sort of thing, a ball of wool, are accessed in the perception of something different, a plastic bottle, thereby helping us to recognize the bottle for what it *is*, a container for wool soap – not a ball of wool. This effect, neither illusion nor mere likeness, also happens to be a *decorative* use of depiction (cf. Fig. 3), so the question may be asked, what is its general applicability? After all, most modern depiction is not decorative in this way. Indeed, this is an important aspect of modern depiction; for who sees the images in newspapers or on TV screens as decorating them? I suggest that while decorative depictions such as our example clearly exhibit transfer, nondecorative depictions do so, also – just not so obviously. After all, even where the marked surface retains little identity except as a ground for the depictive marks, there is still at least one description of the physical vehicle that does carry much interest: as a *picture* – a perfectly ordinary "nominal" or categorial classification, like "tree" or "table," that we use for a common kind of marked surface in our environment. Instead of thinking, like many theorists, of depictions primarily as triggers for environmental seeing routines, we shall need to think of environmental scene, feature, object, and so forth as recognitional capacities being put to work, often through what I am calling transfer, in a certain kind of activity: the perception of depictive pictures *as* pictures.[9]

FIGURE 4. Spectre: cardboard packing for 'Starfit' can opener.

3. SHAPES

With this caution about the perceptual aspect of depiction, we return to our study of the spatial aspects of drawing production, continuing with children's productions. Young children often supply "post hoc attributions" of depictive meaning for their markings. Nevertheless, although they continue to mix their marks with such categorical declarations and titles, they soon develop graphic skills for inciting spontaneous perceptual imaginings. To understand some of the representational challenges here, let us think – still only spatially – about the natures of the things and situations that we try to depict, but only by means of what we have called "dimensional picture primitives." These, real or purely imaginary – observed, wished, fancied, or feared – usually also have spatial dimensions and kinds of extendedness. Indeed, they

FIGURE 5. Author's rendering of Ken Cato Design Co. packaging for liquid water-softener for woolens (1980).

usually feature a famous third dimension. Here, again, regarding the spatial features that our spatial picture primitives depict, Willats suggests that we use a notation of dimensional indices.[10]

As examples for the child's first depictive projects, with their syntax of picture primitives, consider persons – a frequent subject of representation (Fig. 1). Freckles or bits of earth may be taken as oD or small 2D items; hairs as lines (1D); flushed cheeks as 2D; ears and eyes as either 2D or flattish 3D things; heads usually (but not necessarily) as volumetric 3D entities. With such 2D and 3D things we have, as we did with picture primitives, questions of salience.[11] After all, 3D things such as legs and arms are significantly like spaghetti and unlike other 3D things such as heads and apples, in being most saliently extended along one dimension. Willats suggests that we note the former limbs as 3_{100} to show that, while they are considered distinctly 3D, only one of the three dimensions is salient. Ears however might be considered as

3_{110}, heads as 3_{111} for their salient extensions, and fractional subscripts are optional.

Three-year-olds usually have a repertoire of four picture primitives for representing the seven degrees of extendedness noted, and producing that seven by those four primitives would seem a trick. However, picture primitives are *primitives:* that is, basic units for use in combination and, as ever, relationships multiply meanings. Pictorial neighborhood – context for relative sizes, positions, juxtapositions of marks – can give different dimensional interpretations to the same picture primitives, always remembering that interpretation is a two-way affair. Once a mark is taken as indicating a certain kind of scene, adjacent marks are subject to drawing index interpretations based on their likely scenic meanings. A classic case in child drawing is shown in the early "tadpole" (Fig. 2, top), where eyes (scene 2_{11}) within a head (scene 2_{11} or 3_{111}) are clearly indicated by the sizes and locations of several 2_{11} enclosure markings.

Of course, even if dimensionality and extendedness are fundamental spatial categories of representation, they are not the only important ones. Before turning to contour, we should enrich the account with *topological* and other characteristics denoted by the protean term "shape" – always keeping in mind our elementary trio of (1) marks, (2) primitives, and (3) depicted objects or features. That rendering topological characteristics – notably those having to do with depicted *connectedness* – is a basic shape value in drawing is clear from observation, where we find even very young children, as they master their first drawing marks, not only repeating them but relating them on the surface: notably, joining the marks. When they relate their marks, it seems no wonder that children derive their first powers for evocative, non-categorical depiction. This we see already in the "tadpole," where enclosure primitives placed inside a large 2D primitive depict eyes being within a body (or on it). Next, the lines proceed outward from that main enclosure, due to their topological relationships depicting another crucially important kind of connectedness: *attachment.*

Although topological interests clearly define certain kinds of drawing (Fig. 6), theoretical appreciation of topological values in all kinds of depiction remains undeveloped.[12] Still, we must turn from these important issues to a wider topic of shape. We have already considered the idea of shape as overall proportion, via the saliency

FIGURE 6. Bowline knot diagram.

subscripts. For example, "2_{10}" and "2_{11}," as applied to both picture and scene primitives, signify a narrow and a full region, and such would normally be considered as "differently shaped." Equally, however, "shape" in a pair of lines or regions might differ with regard to change of direction in what is perceived as the *axes* of the objects, a standard example being the strong shape difference we see between squares and diamonds, though they are merely rotations of one another.

Among lines (1D), curved ones will be seen as having different shapes from straight ones; one dimension up, a straight 2_{10} (a carrot) and a curved 2_{10} (a banana) will strike us as differently shaped. Once we mention axes, the large, interesting topic of *symmetry* arises.[13] Also, as we further open up the resources of shape, we would have to note how "pointed," "round," and so on are shape descriptions of a kind we did not consider when describing children's extensional shape primitives or their topological characteristics. Yet children's developing control of all these factors at each of the mark, primitive, and object/feature

FIGURE 7. Detail from Mayan Codex-style vase (8th c.), rollout photograph © Justin Kerr, shown in color as file no. K1196, "Kerr Vase Archives", *www.mayavase.com,* and in Michael Coe and Justin Kerr, *The Art of the Mayan Scribe* (New York: Harry N. Abrams, Inc., 1998), title page. The scribal god Pawahtún demonstrates prognostication, "breath lines" showing glyphs that he reads. (Painted with brush-pen like that thrust into his headdress.)

levels greatly increases their depictive repertoires. As shapes of any of these kinds form a very large topic, which would soon engulf our project, let us restrict the discussion to a sufficiently daunting one, which any theory of drawing is bound to address: *contour.*

4. SHAPE AS CONTOUR

Dent becomes bent when push comes to shove, as "bent," like "twisted," has a different connotation from "dented." This is not simply a matter of scale; the former descriptions have to do with a shift in the axes of objects (often suggesting process); the latter, more with local variations.[14] When terms like "dented," "bumpy," "jagged," "smooth" signify what we call the contours of objects, things become very interesting for drawing and for any plausible account of it. We are most familiar with contour shape through a line, notably an enclosure (index 2) usually called an "outline," when used in a way remarkably different from anything so far described. Its universality is indicated, for example, by highly sophisticated eighth-century Mayan brush-drawings (Fig. 7).

Contour requires another of our 'drawing distinctions.' It is standard to distinguish merely occluding contours from true edge contours (both exemplified in the loin cloths of Fig. 7).[15] In children's drawings, contour or "outline" of either sort may come about when, for example, a long region (2_{10}) rather than a single line is used to represent a leg, which, as Willats remarks, "brings closer the possibility of matching the shape of the region" to that of the limb it depicts.[16] Since the region is indicating the extendedness (and direction) of the limb, the lines put down to enclose the region may take on auxiliary functions, as well. For example, local variations in regions can come to depict local variations in the shape of the limb. Developmentally, this opens new avenues to drawing through the depiction of local shapes of objects by means of characteristic outlines of aspects or of faces of objects. This seems to be occurring in the four-year-old's drawing of a parrot, which began with the beak (Fig. 8).[17] A next, fateful, stage with contour in some traditions is what is called (a bit misleadingly) *projection*, including *perspective*. Misleadingly, because the useful heuristic ideas of projection typically employed have in most cases neither practical nor psychological reality, either for draughters or for viewers, and throughout this account we are interested in the realities of drawing production.[18]

Please notice how late in the account perspective and other forms of projective drawing are being introduced. Regarding perspective, almost as important as *what* you say is *when* you say it. The norm in psychological, philosophical, and like studies is to go at pictures from the start via contours – indeed, perspective contours, given that that standard exposition of perspective itself is as contour. It is not only that contour virtually defines drawing for many, but projection – even perspective projection – often defines depiction itself, sometimes explicitly, though most often implicitly.[19] Indeed, absent any real theory for approaching our topic in proper order, it is common to find theorists parachuting in entire so-called theories of representation this way. But that makes no sense. Notably, it makes no sense for real actions of drawing, which begin with making marks, also none for understanding drawing's development, different uses – creative uses – its capacities to call on many aspects of us to provide meaning.

This is not to denigrate projective drawing. I hazard that projective contour drawing – perceptually depictive or not – may be the most important kind to the modern world. How important? Just as we might

FIGURE 8. Child's drawing (parrot): four years, three months old.

divide countable things into the artificial and natural, so we might divide them between the drawn and not drawn. Nearly every artifact today has first to be drawn in order to be made. Modern designs have to be spatially exact, so that engineers, designers, and architects can think with them, and also give clear instructions for making different components from them, often at scattered sites.[20] With apologies to Ferlinghetti, we can even say, of its pictures, that the modern world is a *drawn* world, whereas the "gone world" was not. Fortunately, the projection family of contour drawings is an already well systematized aspect of our topic, far too large for treatment here, where our aim is to get that important material into proper theoretical position, given its historical tendency to skew the entire topic.[21] To see how well we have set aspects of drawing in their working places, we need now to take a closer look at a familiar kind of particular example, testing what we have considered about drawing production, and developing that in the direction of creation.

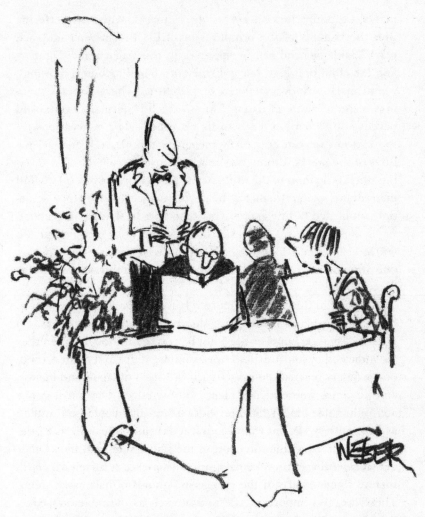

"I hope you've noticed that our menu is refreshingly devoid of creativity."

FIGURE 9. Robert Weber cartoon, "I hope you've noticed...," *The New Yorker*, 11 October 1999, p. 74. © The New Yorker Collection 1999 Robert Weber from cartoonbank.com. All Rights Reserved. [for: 1999 10 11 074 RWE .HG Menu]

5. THE CARTOON CONNOISSEUR

Consider a cartoon (Fig. 9) that reminds us that creativity is not always desirable – even that there can be too much of it for art.[22] When, following our procedure, we begin by first considering the picture's

marks, we notice how all are visible, as marks. Without interfering with the visibility of the primitives or of the things depicted, each mark stands out and can be counted. In this way it is like Figure 7 and the child drawings, but unlike Figure 6 and technical drawings, where marks are overwhelmed by primitives. The children's drawings made us aware of extendedness, which is normally overlooked because our attention tends to fix on other shape conceptions. In the cartoon we can also easily recognize the oD, 1D, and 2D natures of the marks, although as in what is usually called a "line drawing" the 1D do most of the work. At the picture-primitive level we find many drawn regions (depicting heads, menus, jackets, tabletop), sometimes indicated by line enclosures, sometimes by shaded 2D patches. At its most relaxed, a congeries of lines indicating a region at top left indicates something like an entranceway. Let us next consider, only dimensionally, the relationship of these primitives to what they depict.

What are in this kind of picture relatively oD *objects* (waiter's eyes, bits of the woman's jewelry) are shown by relatively oD marks. oD *features* of objects however need not be marked by dots, as often they are indicated by line junctions: for example, at tips and corners (note our ordinary real-feature words, such as "tips") of lapels and menus, and junctions where menus meet clothing edges. One small stroke above the male diner's head provides a *mark* that could be classified as either oD or 1D, but which has clear 1D (line) meaning as a *primitive*, since it shows the direction of the waiter's left cuff line. Other 1D scene entities fit several categories. There are relatively 1D *objects* such as fingers, parts of the eyeglasses, strands of hair, plant stems. There are also important 1D *features*, such as the tabletop's edge; there are 1D occluding contours. (The markings for the woman's dress might define regions of reflection and shadow or decorative pattern or fold contours.) The main line depicting the waiter's head reviews some of our main distinctions. As one of three 1D marks defining the region that depicts the head, it describes a continuous occlusion contour, but its beginning describes hair (an object), as well.

In this cartoon there is much significant depiction done with 2D regions, notably depiction of surfaces (menus, tabletop) and faces (the waiter's shirt and jacket), all of which tend toward rough 2_{11} symmetry.

A small region brings the lady's wrist out from her shoulder. With contrasting application, a constellation of oD, 1D, and little 2D marks indicates a region that will depict a potted plant, itself comprising leaves and twigs of about the same extensional indices. Now for the famous topic of *depth*. In *3D* extensions, the table is a floppy class 3_{111}, featuring a 2_{11} face for its top, while the waiter's and male patron's heads have classic egg shapes (which might be written: $3_{1,2/3,2/3}$). Indeed, still thinking of 'space' as merely extendedness, most of the drawn scene itself appears within a globular (3_{111}) space. That is partly because the marks and picture primitives within it themselves join, partly because of the overall 2_{11} shape they make on the page. "Joining" reintroduces the subject of topological values, though we must again restrict ourselves to a few observations. Within the overall grouping just noted, we easily see a number of subgroupings, at *each* of the mark, primitive, scene-feature, and object levels. Beginning with the last: as often, getting a joke entails imagining a situation, which means immediately grouping the stereotyped protagonists – waiter with dining couple studying menus – with just enough mise-en-scène to show the sort of place they are in: cartoonists have to be good at that. For such stage setting we need also some secondary groupings: here a "sitting down" set of four diners, whose defining regions also have the topological character of contiguity – and note how, given context, the region suggesting a fourth diner is indicated by the barest hint of a curved physical mark. Then there is the solicitous standing waiter, echoed by the sketched framing above.

Following extendedness and topology, we briefly note other types of shapes considered earlier. As far as the *depicted* shapes go, 2_{11} extensions predominate, with squarish true contours (menus, shoulders, jacket bottom) – with exceptions, like the bow tie. By contrast, this helps the woman look alert, spiky. Her depicted form, more than those of the others, exhibits a variety of oD, 1D, 2D, 3D shapes. She and her chair back provide examples of local variation in true and occlusion contours. For example, of the three 2_{10} (region and feature) noses in the picture (pointing different ways), hers clearly represents a profile or side-shape, also an occluding contour shape (pointed), as does the rest of her silhouette, with its meaningful local shape variations and physical mark variations. Her head and neck are shaped (like the waiter's arm) not only in extendedness but also in the *axis* shape sense

of "bent," as is the 'canoe' back of her chair, which presents another clear index 2_{10} region, and feature.

6. COMPOSITION AND PICTORIAL SPACE

With just that much detail we can now offer some generalizations about how this particular kind of picture is drawn, also about what we *do* as we recognize its depictive content. We observe how drawn regions and scene objects/features closely correspond dimensionally. There is even a prevailing matchup at the mark level, partly because (aside from some infilling), almost all the marks are used to define either objects (strands of hair), edges (of menus), or occlusion contours (of sleeves, heads, cloth folds). As with our child drawings, identify a mark in the picture and you can usually *name* the independently identifiable object or feature that it is used to depict, whereas, as we all know, in many drawings single lines may pick up parts of contours of a number of things.

Still, there are significant line marks and regions in this picture that do not correspond to anything "nominal," indeed, not to anything figuratively depicted. For example, a long implied line runs stepwise from the sketched framing, down the waiter's and diner's left sleeves, through the contour of the middle tablecloth fold. This crosses a horizontal $2_{1,1/4}$ region, which, in turn, takes in not only the regions defining the diners but also those for the potted plant and the waiter's trousers. That horizontal contains a dark subregion of continuous vertical marking-strokes, joining what depicts the trousers and the diner's jacket, thus forming a unit that 'contradicts' definition of the separate things that the regions are depicting. At the basic mark level, that region is again divided into four rough squares of types of marking for infilling regions – corresponding, at the depictive level, to plant, waiter's trousers and diner, distant diner, lady diner. None of these fit categorial classifications.

Perhaps in considering mark, region, and feature/object groupings this way, our examination of space in pictures verges on what are normally called matters of pictorial "composition," another example of which might be the long-line primitive (made by separate marks), which like a loose but still binding thread runs down the doorway, forms the plant, picks out the left contour of the tablecloth, where

it is crossed by other lazy 1D's defining the table, sometimes indicating true edges of objects (tablecloth bottom, table edges), sometimes occluding contours (fabric folds).[23] While not (as such) depicting, they still strongly influence the depiction. We know how important these types of marks and of picture-primitive units are when depiction serves decorative design, but they also contribute greatly to the organization of depiction, and most competent picture making relies heavily upon them. Indeed, seeing how they can constitute *non*depicted units alerts us to how the same devices work to constitute the units that are depicted: how they depict them *as* constituted units, with such nominal classifications as heads, jackets, tabletops, social groupings, and so forth.

With this introduction to composition we begin to work our way from "drawing" as mark making toward *dessin, disegno, dibujar*: design, connoting higher-level tasks than those of depicting features, objects, situations – that is, the making of a whole thing of a certain kind, of drawing or designing *a picture*.[24] An important part of that task is the rendering of what is called "pictorial space," and, given our focus on spatial issues, a few words about that large topic are in order. By "pictorial space" is usually meant not just shapes (at all our three levels of marks, picture primitives, depicted objects, or features whose extensivenesses and other modes we just considered) but their organization. For example, unlike our orthographic Mayan Figure 7, which uses many of the same devices, the cartoon is of the perspective type. We see diminution in the hem of the tablecloth and the diner behind. Foreshortening is most marked with the tabletop, for it is only by interpreting that distinctly 2_{10} drawn region projectively that it depicts a 2_{11} (round) feature. The point of that could be said to be to convey depth in the depicted scene – that is, getting us to imagine it in 3D space – which is correct, with qualification. The use of perspective concerns not only the relationships of what is depicted but also those of the marks and primitives. Therefore, "perspective" should be thought of not only in terms of 3D effects, but also compositionally: as a way of organizing the 0D, 1D, and 2D spaces, at each of the mark, primitive, object/feature levels.[25]

Regarding depicted 3D characteristics, we just considered two classic types associated with linear perspective: foreshortening (the tabletop) and relative image size (relative density of textural and other

gradients). To this pair is often added *overlap* or *occlusion* – also emphasized by the Mayan in Figure 7 – however depth does not depend entirely on this trio. We already saw with the children's pictures and with the cartoon characters' heads how 3_{111} effects can be gotten without them. Add that not only regions, but also marks in drawings produce figure/ground spatial effects on surfaces, and we begin to see the depth resources available before any broader "pictorial space" system is brought into play. Of course, as is often noted, even lacking the full environmental cue complement of binocular convergence and disparity, motion parallax, and so on, drawings can produce strong 3D effects via one or more cues from among our perspective trio, and we can note all at work in this cartoon, giving it a recognizable pictorial space similar to some pictures, different from others – including many cartoons.[26]

Earlier I called the result of this a "systematic spatial organization." Perhaps a more precise expression, reinforcing the distinction between space as shapes of things and features (in the various senses considered) and space as relationships of such shaped entities, would use a standard classification of grouping scales as nominal, ordinal, interval, metric, or ratio.[27] We had earlier thought about space nominally, that is, as to whether shapes yield depicted features and things (including volumetric or 3_{111} ones) falling into clear categories: recognizable shapes, faces, edges, corners, and substances such as sleeves, menus, tables, noses. By introducing "spatial organization" (for example, perspective) we just added another set of scales. Thus, of the cartoon we can say that projective (perspective) depth cues provide a sequential 3D spatial ordering of the categorized features and objects suggested by the marks and regions. That grouping is spatially *ordinal;* thus a transitive relational scale is introduced, including relationships of betweenness. The nominally classified dining couple look like they are behind the table, the waiter behind them, the other diners behind the waiter – such is basically what "spatial organization" means here. True, our Mayan drawing shares that, but perspective in Figure 9 also produces an *interval* scaling, a proportional sense of how far one thing is behind another. Unlike anything in the Mayan image, the waiter appears *closer* to the man than does the diner at the next table to the waiter; the space separating the woman's menu and the next table seems more than double the distance from the menu to

the front edge of the table, and so on. Such interval scalings (presupposing ordinal and, to an extent, nominal scales) are combined in 2D directions along the picture surface as well, so that, as diagonal distance proportions are perceived, we get a "pictorial space" being built up, a sense of which carries through space: the empty parts of the drawing. Finally, we have a pretty good 'absolute' sense of distances and sizes, thus a *metric* scale. That is enhanced by an important factor too large for us to explore here: the imagined distance relationship (if any) from the viewer. While the cartoon puts viewers at a certain spot in its open fictive space, the closed space of the pot painting provides no common "floor."[28] Such differences have afforded great scope for creative use.

All that is part of what we mean by drawings' different "pictorial spaces." We note that there are costs as well as benefits with the addition of each scaling level. Many cartoons use oblique projective systems; in ours, choosing perspective presented the problem of a large foreground region denoting the table, which might entail distracting table and human legs (a standard challenge for Last Suppers!),[29] although – as in many cartoons of the genre – throwing a cloth over it turns it into a compositional asset: a large 2_{11} region establishing volume, with anchored horizontality, foil for what happens in the 2_{10} region above it. While all this may appear to be quite abstract, I suspect that we form quick impressions of the presence and absence of such scalings as part of a picture's style. Thereby what is called the "look" of such pictures is explained in terms of what we must do in *looking* at them, as different kinds of depictions require different recognitional activities.[30]

For example, while nominal categorizing usually underlies spatial scalings, that is a matter of degree, since artists can indicate spaces with a few deft marks before they have fully suggested objects. Much abstract or nonfigurative drawing is built on the fact that complex dynamics of higher scales can occur with little of the nominal, object-nameable. As for the figurative depictive, even in cartoons (designed for quick recognition), self-observation regarding mark, primitive, feature and figurative recognitions will confirm that these are *processes*, including hypotheses and corrections, as perception is built up. Just as it may take a while fully to get a joke, it may take a while fully to take in a scene in a drawing. Works of art "sustain recognition," their 'full' seeing sometimes needing repetitions, over years. Museums exist because

there are 'second lookers,' and any account of drawing as creative art must consider this.[31]

7. BESIDES SPACE

Most of this account of depictive production has been based on visible spatial properties – notably on the shapes (of various kinds) and placements of marks, picture primitives, depicted objects and features. Indeed, overwhelming theoretical work on drawing construes it as an essentially spatial task, takes space projectively, gets to projection through perspective. Having criticized the last two assimilations, it is time to address the first. Not even our amplified spatial approach would be adequate to a basic theory of drawing or depiction, for we have already considered facial and other depiction effects, which child draughters catch before they have mastered much spatial rendering (Figs. 1 and 2), and which are obviously much in play in the faces and bodily attitudes of sophisticated drawings like our cartoon. Indeed, subtle effects in depiction of action and attitude in our Mayan Figure 7 – like Paleolithic drawings twenty-five thousand years earlier – refute depictive cultural relativisms fashionable in our time.[32] There would be other important factors to consider before we could claim the beginning of a drawing theory. For example, it is often stressed that marks, regions, and so on have expressive lives of their own, independent of any level of figurative depiction. Designers know how the "shapes on a page" are active in themselves. As a tiny instance, consider "abstractly" the sunburst of diagonal lines round the waiter's chit in the cartoon (Fig. 9) – those forming his fingers (joined by the little one we noticed for the left cuff), the five describing his lapel and jacket edges, those for his right elbow (extended by the plant), another for the diner's glasses. These form a little system of radiation from a tipped central rectangle (made brighter by contrast effect with the picture's darkest region, below). Corresponding to no depicted features or things, this interacts with the wider system of verticals and horizontals, providing expression for the waiter's form. Again, shapes are usually active with the visual environment outside the pictorial design. For some, indeed, this dynamic aspect of drawing is the most important, especially for the topic of creativity, and, as indicated with Figure 3, great arts of non-, or not very, depictive natures exist.

Of course, tone comprises an important class of depictive resources not yet touched upon. Should it be objected that darks and lights get depictive meaning by their spatial distribution in pictures, we can reply that the marks are only visible because of tonal differences. Some are sure to suggest treating these tonal resources "photographically," that is, in terms of orderly projections of oD points of light (real or notional) from depicted objects to corresponding oD points on the picture surface. However this 'shades of perspective' remnant of the misguided pictures-as-projections model fails for our cartoon, which, while giving an overall sense of lit space and showing some local values, features (with the exception of the plant) neither shade nor shadow. It also fails for many standard uses of darks.[33] And even where in drawings line density does register degree of light, that is often accomplished by clear 1D shading strokes, not by oD points, and it would not only be arbitrary but often a misunderstanding of such pictures to understand modeling lines as representing arrays of oD illumination points.[34] It would be useful to add to our spatial account an independent set of principles of rendering by means of light and dark, notably with regard to illumination and shadow. Traditionally in the West, tonal principles have been systematized together with shape concepts. But there are other realms of rendering whose existence puts even more into question the spatial bases of most depiction theory. That the depiction of substances and processes are among these might be briefly indicated by asking what anything so far tells us about the effective depiction of atmosphere, substance, weight, life, moving water, or such effects as plant growth, waves, fire, leaf, or grass movement in the wind. Still, that much work done on spatial depiction may be all that is needed for the next step, from considerations of drawing production toward those of creation.

8. DRAWINGS AS DRAWN

At this point it might be objected that nothing so far has been specific to drawing. The analytic tools presented should – if they work for drawings – work as well for other kinds of visual depictions: graphics, painting, mosaic, tapestry, photography, relief carving, and so on. I believe they would, but drawing happens to make an extraordinarily good introduction to more general topics, and it is time to consider

why this is so. Recall that we began discussing drawing with the visible *marks*. Of course we see the marks that constitute paintings and other kinds of depictions as well; otherwise they would be invisible. However, we are not typically quite so aware of all the *individual* marks in paintings as we are with drawings – given a tendency of painters to cover their tracks. The "same" region outlined by dots, a line – closed or open – depicts differently: why else would Rembrandt have told his students not to enclose forms "with a single pull of the pen"?[35] We are also in position now to observe how typical it is of drawings that the point, line, and region picture primitives the marks produce may also be evident, as such. Indeed, that drawing primitives are typically more than visible – salient, even obtrusive – is what has made drawing so useful an introduction to our topics.[36] It is often observed that such awareness of marks and primitives – especially of regions on the picture surface – has advantages: obvious ones, for example, for the decorative arts considered earlier. Again, these picture elements' working multiple perceptual effects *aside* from figurative depiction is a central topic of much art criticism and connoisseurship – indeed, often at the expense of interest in their strictly depictive functions. Unfortunately, such discussions are usually based on the assumption of a simple perceptual dualism, an opposition between the marked surface and the depiction, and so go wrong in two ways. They go wrong by assuming a difference of just two things, whereas we have seen in detail how marks, picture primitives, features, objects, and so on form more complex hierarchical situations perceptually. The second oversimplification comes from treating these elements simply as rivals for our attention, when their relationships provide a rich field for artistic investigation. It is high time to abandon the 'ampersand aesthetics' of "form – *&* depictive content."

Having just compared perception of drawings with that of other depictions, regarding our awareness of marks and primitives, let us compare it with environmental perception. A big difference between depictive and ordinary perception looms when we compare our separate awarenesses of cues for object or space recognition in the two. We are all familiar with the experience of seeing a path, fence, or railway running into the distance while at the same time noticing its triangular projection, and there would be other interesting cases. But then, even when we are aware of a cue, it is something else to be aware

of its being a cue, as is characteristic of drawings. A main reason for the difference introduces a perhaps more profound difference, that the working of the drawing elements is often communicated to us by something we could not find in nature: the appearance of intentional depictive actions.[37] Emphasis on drawing actions should not seem sudden, as the account of drawing production has involved them all along. Whenever, rightly or wrongly, I have attempted to say how a depictive element works in a picture, I have been trying to explain why someone, child or professional, has *done* something. Therefore, given that the depictive principles presented are principles of depictive actions, we need to 'multiply' every principle so far offered by an action factor – multiply, not just add (ampersand), since this is not merely a question of increasing depictive repertoire, as one might add shading, local textures, or color to our cartoon. Seeing such depictive resources formatively affects their looks – or, as I have been putting this matter, affects the way *we* look at the picture. Drawing simply makes all this more evident. Thus, as we began from some visually evident spatial properties of the marks before us, then briefly recognized other characteristics, here is another visually evident aspect of the marks: we can hardly fail to notice in drawings, whether by children, technicians, or artists, that the marks look intentionally made – indeed, drawn. But since the nuances of Figures 7 and 9 indicate that any visible feature of a depiction might make a depictive difference (proof will be found in attempting to trace either), it follows that visible features registering the production of the image may make depictive differences. The implications of this are great.

Regarding the physical or motor aspects of production, it must be emphasized that seeing not just marks but markings is in no way special to depiction. After all, the surfaces of the world appear to us so much in terms of smears, imprints, spatters, cracks, cuts, scrapes, dents, bulges, and so on that it takes special training in, say, forensics, to describe it otherwise. Just as it is difficult to see a pattern of negative 3_{110} shapes in mud and *not* see it as marking an impression, a track, of a tire, going in a certain direction, turning, sinking, spinning, and so on – difficult, indeed, not to find those features more perceptually salient than is the 3D pattern – so it is often difficult to see drawing marks without seeing them as ones made by certain means. For example, we are aware that all the drawings shown here are made

by pencils, pens, or brushes that allow long, continuous marks, not just additive line primitives "made up of separate touches." Part of the importance of this is that individual marks are often seen as the basic unit of a drawing, sometimes setting the scales of detail and of distance.[38]

The fact that such visible "process history" happens, in the case of the drawing, to include actions – human ones – presents no special problem for perception.[39] Yet, important as they are for most depictions, we must not be carried away by such facture, process-history examples into a common 'brush-stroke fallacy' that overemphasizes the physical means and actions in drawings just considered (our earlier "draw/*dregen*" connotation) while obscuring the more important feature of visibly intentional action as a drawing resource (the "*dessin/disegno*" connotation). Although in many drawings it can be important that the marks (such as the short one over the diner's head) are seen as physical traces made in certain ways, not all drawings show their process histories to that extent. More important to our understanding of drawings is that, however physically executed, we see them as something done for a depictive reason – successfully or not. Thus we treat the child's big circle in Figure 1 in terms of topological containment, reserving judgment about it volumetrically. In Figure 9 we accept different drawing treatments of the waiter's lower sleeves, since (as experiment should show) extending the left one's little mark to match the right one's would be a mistake, the longer line suggesting false attachment to the diner's head. So we take an isolated stroke, barely large enough to indicate direction, as doing the trick. The same goes for other picture primitives. That is how the tablecloth right and chair can be suggested by a few marks, how the relation of curved marks defining menu and table edges closes the tabletop region, why the left turn of the tabletop's defining line's missing its vertical junction mark, and the 'transparencies' of the lady's menu and the gent's fingers present no perceptual problems, how we get her ear by inference: we see what the draughtsman is doing. The same goes for the nondepictive regions, divisions, patterns, as things done. For example, one such grouping constitutes the lady diner's menu, head, shoulder, as a triad of basic geometrical shapes, within which we also sense the results of physical actions: a change of drawing edge in forming her nose and

jaw, the hooked two-mark line (primitive) for the contour (feature) of
the back of the neck (object), crossed by a slight "bracelet" curve of
the necklace, indicating the widening volume it contours, stopped by
return to broader treatment in the next hook, the opposing curve of
the bodice side of the decorated triangle, backed by the hook of the
chair – there are lots of hooks in this picture. Although this particular
little rhythm is not itself depicted, its visible movement does depict –
as it must, to give the impression of a peering head, not merely the
space or shape of one.[40]

Such examples invite fresh objections. It will be pointed out that
what is perceptible may not be perceived, and that what is perceived
may not be used, but may be filtered as noise, or shunted off for other,
nondepictive – call it "expressive" – treatment. Again, would not the
'faces in strange places' examples show how depictive transfer can
occur, absent any question of depictive actions? Is not photography re-
plete with nonintentional depictive effects?[41] These points need not
be engaged here, since I have insisted throughout that a variety of quite
different factors in a given kind of picture (or in a given use of one)
may or may not be important. For example, we have seen how in some
pictures topological values are more important, while contour shape
prevails in others; that projection plus contour is a very common in-
terest, though physiognomic effects may be more important in others;
and so on. Similarly, in a given picture mark-making actions may be
more salient, with regions, contours, objects seeming to develop out of
their rhythms or coalescing out of their scratchings – or whichever of a
wide variety of descriptions might fit. Marking actions can be entirely
backgrounded, too, with line or region primitive-forming actions be-
ing emphasized, as to extendedness, or to shape quality, or contour,
and so forth. Whereas van Gogh or Shih-t'ao emphasize textural or
shaping strokes, Poussin, driving at sculptural volume, is heedless what
his drawing contours – even contour-making acts – may look like.[42] In
the children's drawings of Figures 1, 3, and 8 both mark and prim-
itive drawing actions will be main objects of (adult) attention, while
in engineering and architectural drawings (and Fig. 6) these are not –
indeed, those disciplines often actively suppress awareness of produc-
tion history.[43] The vocabulary of drawing elements developed here is
meant to help us articulate such different aspects that drawings can

thematize – and use creatively. Still, for creativity drawing action seems prime.

9. DRAWING AND CREATIVITY

It is often said that drawings appeal by their "intimacy" or "spontaneity," and that in them we "see the creative process at work." Loose expressions these, but not without point, which we are exploring, as we have moved from considerations of shape to those of shaping, with the thesis that not only is a salience of individual marks and picture primitives virtually definitive of drawing, it is typical of many drawings to present these visible elements *as drawn*: that is, as the effects of actions guided by the purpose of building a depiction – rather as speech is normally heard as utterance, not just intelligible sound.[44] I have suggested that it is remarkable how the very pictorial elements that we earlier considered as carrying spatial information in recognizing scenes should also carry information about how and why they were produced – for the very purpose of guiding recognition. The suave 1D stroke shaping the 2D contour of the waiter's head and suggesting a 3D 'egg'-shape contrasts with the heavier ones that do the diner's, and though there may thereby be transfer from those marks to the personae, that is far from all. For we do not simply see a line bearing the various shape characteristics earlier distinguished – not even just a line with physical production characteristics. We see a drawn line, that is, a line as turning in order to define a region, so as to suggest volumetric and physiognomic interpretations. Thus we experience not only (1) a curved 1D mark, or (2) an axis bent line, but also (3) one being attenuated and turned in its drawing, (4) in order to accomplish those depictive effects. That is, literally, what it looks like. But this is not the way we see the contours of a real head that indicate its shape and volume. The significance of this difference to the topic of creativity might be great. For if perception of drawing as an activity is allowed into our experience of depictions at such basic levels as those of the physical marks and the indicated picture primitives, what limit can be set to intentionality there? All levels of depiction built on these perceptually fundamental elements might also be experienced in terms of actions. Aspects of our perceptual experiences of pictures would then radiate through the layers of interpretation of the picture built

on the marks, primitives, depicted scene features, objects, relations, and so on, and be modified by a wide range of the mental and psychological traits by which we qualify conceptions of things. As a rough test of that, consider a simple example of a sort we have been considering, cartoons.

Maybe a step toward saying how a drawing could be creative is saying how it could be funny. No trivial matter that, since a scandal of most approaches to depiction is that they provide little resource for accounting for how a *drawing* could be funny, or anything else. Regarding humor, such approaches might best attempt to tell how drawings can depict objects and situations that might turn out to be funny. To be sure, many captioned cartoons are a bit that way. (Food service being a cartoon genre, consider a relative of our example: waitress in greasy spoon offers couple "choice of a lethal injection or the three bean salad.")[45] Still, it is standard for cartoons that the drawings be humorous, not just the situations they depict. Cartooning is, after all, a kind of depiction, not of depicted things; cartoons are not depictions of clowns dressed up with false noses, on stage sets, lit and arranged so as to look ridiculous.[46] Mostly, what look ridiculous in them are not grotesques but normal creatures and their situations, given the graphic means through which we imagine seeing them. In short, although some humor in cartoons is to be found in the *what* of depiction, most of it is found in the *how*.

Our studies have at least started to account for that, having explained how some of the basic means by which drawings depict determine how the things and situations depicted are seen – that is, by which visual activities. For example, our ability to see people as comic, through metaphorical transfer of perceptual categories for all manner of other things, is perceptually widespread. Independent evidence for this exists in the vivid descriptions people find for human physiognomies, and in nicknames – themselves verbal metaphors, exhibiting transfer. It takes not much introspection to see how often one's environmental perceptual categories are enriched (or afflicted) by such imaginative transfers.[47] Thus cartoon ways of seeing are already there for the graphic drafter to explore, and recognizing a drawing as a cartoon prepares viewers for transfer activities. Again, with an intentional account we can begin to explain how, by indicating a head as an attenuated $3_{1,2/3,2/3}$ egg-shape (Fig. 9), via a loose enclosure, via a line, via

a quick mark – like the waiter's eyes, via two little v-dots – a cartoonist can make a joke of the very fact of this noble object being conjured through an 'egg-shape.' As in mime, it is usual for cartoons to seem funny by the fact that a trait – a nose on a face, the way people's legs bend, their facial expressions – can be rendered by such means. Yet these examples are overly simple, even for cartoons,[48] and the comic is only one conception we take of things.

To consider an example closer to creativity, on the position I am arguing, it entails no "pathetic fallacy" to see the quality of mind in, for example, a Rembrandt drawing that uses a number of the depictive devices we have considered. I have attempted to show that this is no more a subjective projection than is getting 2D shape or 3D volume from a 1D mark. For we might see, not only intent and control in the marks and what they shape, but also other qualities: the sureness of a line, its strength and warmth – marks understood by us as being produced with direction, touch, rhythm, emphasis, in order to portray. With the theoretical means for avoiding prevailing form/content dualisms in depiction, we can see how a region-bounding marked line, bearing all the visible traits of production, produces an occluding contour, which evokes a volumetric form (with Rembrandt, lit from a certain angle by a light of a certain quality) that is a woman's shoulder. Thus, in the drawing of a shoulder, visual perception is presented with what it could not find in nature: a visual cue indicating the occlusion border of a rounded surface that also carries action characteristics of the kinds just listed, for they are equally visible. As all these features call on a variety of capacities and experiences in perceivers, there may be no limit to the parts of our experience that might be summoned in the 'simple' act of seeing a line define a contour, to place a body in a space. Yet to our minds this is no muddle. Perhaps that is because part of visual experience being understood as of things and situations, and part being taken as the way these are being viewed, is a normal aspect of visual experience. Still, with a drawing, as opposed to a real scene, all this is brought to consciousness, as depiction allows people the remarkable experience of imagining seeing something as seen by someone else. Seen, how? If the experience of seeing simple, everyday objects with not only a great formal clarity and strength – in which every aspect seems to work with every other, but also with compassion – if that experience is an unfamiliar one, such a

drawing may well serve to introduce it to us. This may help to illuminate what is meant by creativity in drawing, also why such creativity is important.

Nowadays there is theoretical resistance to the idea of creativity in art. This is partly due to resistance to the idea of intentional action there, for whatever "creation" and "creativity" mean, they mean something intentional. Perhaps this resistance to what seems not only essential to, but evident in, most depictions draws comfort from the very perceptual complexity that it denies. For, as there seems to be no saying what aspects of a picture might not be made depictively meaningful, it becomes difficult to say anything systematic about the aspects that are.[49] Thus while connoisseurship makes telling individual demonstrations, from a great variety of closely examined cases, the very range and particularity of that evidence seem to suggest that our only general conclusion might be that it is all interestingly particular. Still, with what we *can* begin to theorize generally – at least regarding depictive production – I have attempted to locate and to defend an important site of creativity. We began with a remark made by Igor Stravinsky, rejecting the term "create." But that artist also remarked that "Chardin could display a richer representation of life in his kitchen than other painters managed with all of Versailles."[50] Whatever terms we choose to use, this is so blatant a perceptual fact that any account that fails to provide for it could hardly be called a theory of depiction – or of depictive production.

Notes

1. "*Nulla creatura possit creare,*" Thomas Aquinas, *Summa Theologica*, First Part, Question 45, Article 5; author's recollection of remark by Igor Stravinsky.
2. Perhaps a rhetorical question, given, e.g., the writings of such as Joseph Meder and Philip Rawson – the latter much cited in the following, which may be read as a more systematic lead-in to these more advanced works than they themselves provide.
3. For purposes of this essay, I will simplify, considering creativity simply as power of creative production.
4. The exposition now follows John Willats, *Art and Representation: New Principles in the Analysis of Pictures* (Princeton, N.J.: Princeton University Press, 1997), and Willats, "Drawing Systems Revisited: The Role of Denotation Systems in Children's Figure Drawings," in *Visual Order: The Nature and Development of Pictorial Representation*, ed. Norman Freeman and

M. V. Cox (Cambridge: Cambridge University Press, 1985), pp. 78–100; "The Representation of Extendedness in Children's Drawings of Sticks and Disks," *Child Development* 63 (1992): 692–710. The initial exposition parallels my "Drawing Distinctions I: The First Projects," *Philosophical Topics* 25.1 (Spring 1997): 231–53.

5. Willats, "Representation of Extendedness," p. 697, and *Art and Representation*, p. 100.

6. For "index of extension," see Willats, "Drawing Systems Revisited," pp. 91–2; *Art and Representation*, pp. 100–104, 367.

7. In my view, the only developed *theory* of depiction as a kind of representation is Kendall Walton, *Mimesis as Make-Believe: On the Foundations of the Representational Arts* (Cambridge, Mass.: Harvard University Press, 1990), notably ch. 8, whose sec. 1 deals with the issue of the perceptual beyond content and access, and whose sec. 2 focuses on the general topic of how depictions work to incite imagining.

8. For an up-to-date critical review of "theories of outline," see John M. Kennedy, Igor Juricevic, and Juan Bai, "Line and Borders of Surfaces, Grouping and Foreshortening," in *Reconceiving Pictorial Space?* ed. M. Atherton, H. Hecht, and R. Schwartz (Cambridge, Mass.: MIT Press, forthcoming).

9. This claim (which I argued in "Seeing Double," *Journal of Aesthetics and Art Criticism* 52.2 [Spring 1994]: 155–67) might appear paradoxical, and it may be asked, why say that we mobilize environmental seeing routines in order to perceive pictures, when the point of looking at pictures is to stimulate those very processes? In the first place, even were that so, there still would be no paradox, since we also work our cardiac systems in order to run, where the point of running is to work them. In any case, the idea that interpreting pictures has as its main point the stimulation of those processes is wrong and would not hold even for the children's drawings here considered. Much of the present essay is an attempt to argue for the autonomy of pictorial perception against a tradition of treating it as environmental perception under constrained conditions, against a powerful techno-economic movement toward reducing those "constraints."

10. Willats' picture ideas are influenced (via J. Peter Denny) by the linguistic cases, to which Stephen Pinker, for example, gives passing mention in *The Language Instinct: How the Mind Creates Language* (New York: W. Morrow and Co., 1994), p. 233.

11. Regarding habitual ways of thinking, although European languages do not have dimensional markers, we often group things that way: e.g., "3M" products have 2D salience: sandpaper, adhesive tapes, floppy disks.

12. Willats treats topological characteristics in *Art and Representation*, Ch. 3. See pp. 288–9 of that book and "Drawing Systems Revisited," p. 86, for credit to Piaget and Inhelder. I make a case for topological values in "Drawing Distinctions I." Topological values figure in the analysis of drawings in terms of T, L, Y, arrow, and end junctions in artificial intelligence and cognitive psychology. Figure 6 is a thing of T-junctions.

13. A classic work on symmetry analysis for drawing is Anna O. Shepard, "The Symmetry of Abstract Design, with Special Reference to Ceramic Decoration," *Contributions to American Anthropology and History* 9.44–7 (Carnegie Institution of Washington, 1948), pp. 209–93 (with, incidentally, interesting use of gender pronouns for that time).

14. See Michael Leyton, *Symmetry, Causality, Mind* (Cambridge: MIT Press, 1990).

15. I here distinguish these two more than Willats does. In "Drawing Systems Revisited" Willats treats them in one discussion, even suggesting that projection enters the picture before local shape, although in *Art and Representation* (p. 316) he is more circumspect.

16. Willats, "Drawing Systems Revisited," p. 96.

17. This pencil drawing began with the beak, named before completing, progressed to tree, nest, eggs. (Top "parrot" written by dictation, then copied.)

18. See Willats, *Art and Representation*, pp. 12, 38.

19. For a recent blatant, representative example, see Stephen Pinker, *How the Mind Works* (New York: W. W. Norton, 1997), pp. 215–16. I criticize the implicit appeals in "Pictures of Perspective: Theory or Therapy?" in *Reconceiving Pictorial Space?*

20. A short, readable, well-illustrated account of engineering design drawing is Eugene S. Ferguson, *Engineering and the Mind's Eye* (Cambridge, Mass.: MIT Press, 1992).

21. I have treated linear perspective at length in "Perspective's Places," *Journal of Aesthetics and Art Criticism* 54.1 (Winter 1996): 23–40, as well as in "Pictures of Perspective."

22. A point I owe to Richard Wollheim. The cartoon, by Robert Weber, appeared in *The New Yorker*, 11 October 1999, p. 74.

23. Compositional groupings need not be by (topological) continuities of marks or regions: the four 'egg'-heads also form a *similarity* group at each of the region, feature, and object levels – indeed, at the latter they provide a classic head rotation at three-quarters view, full-face, back, profile.

24. Philip Rawson, *Drawing*, 2d ed. (Philadelphia: University of Pennsylvania Press, 1987), defines drawing as "the underlying conceptual structure [in any work of visual form] which may be indicated by tone alone" (p. 1), while stressing that "there . . . lies at the bottom of every drawing an implied pattern of those movements through which it was created" (p. 15: qualified on p. 16). This and further references indicate how much my ideas owe to that remarkable book.

25. Overlooking that, discussions of the history of the systematization of perspective usually leave out its important 2D compositional effects – except when they stress (as they usually do) one rather blatant manifestation: convergences of parallel lines at vanishing points – which happens to be lacking in this cartoon.

26. Weber fades his background and other diners, while other contemporary cartoonists (say, also in *The New Yorker*) would not.

27. The following is an adaptation of James E. Cutting's application of measurement scales to pictorial space, in "Reconceiving Perceptual Space," in *Reconceiving Pictorial Space?*

28. See Rawson, *Drawing*, pp. 204–10. For recent psychological study of this, see H. A. Sedgwick, "Relating Direct and Indirect Perception of Spatial Layout," in *Reconceiving Pictorial Space?* with its bibliography.

29. I suggest a 'draw a *Cena*' exercise: see what you do about the legs and feet!

30. I offer as confirmation being able to identify that look: how many accounts of depiction get that far? I attempted to demonstrate the perspective look of a Dürer drawing that is actually in rather rough perspective in "Perspective's Places," pp. 30–1 (Fig. 5).

31. For the idea of "sustaining recognition," see Michael Podro, *Depiction* (London: Yale University Press, 1998). Meyer Schapiro is one writer who has well stated the hypothetical, communal nature of artistic perception: see Schapiro, "On Perfection, Coherence, and Unity of Form and Content," in *Art and Philosophy*, ed. Sidney Hook (New York: New York University Press, 1966), excerpted in Susan Feagin and Patrick Maynard, eds., *Aesthetics* (Oxford: Oxford University Press, 1997), pp. 347–50.

32. Photographs of the Grotte Chauvet pictures are available in Jean-Marie Chauvet et al., *Dawn of Art: The Chauvet Cave: The Oldest Known Paintings in the World*, trans. Paul G. Bahn (New York: H. N. Abrams, 1996).

33. This affords another opportunity to campaign for perceptual transfer: it is debated whether or not the dark contours we find here work as "luminance borders," taking advantage of our tendency to find boundaries of objects as they darken by curving away. Rawson discusses the variety of functions of darks in *Drawing*, pp. 121–3, 167–77.

34. Willats considers the oD approach to tone in *Art and Representation*, and gives this very reply (pp. 128–33).

35. According to Samuel van Hoogstraten: Rawson, *Drawing*, p. 102.

36. This discussion would require qualifications, regarding different kinds of drawings, paintings, graphics, etc. Also, there are well-known techniques, such as standing back, coming close, squinting, for suppressing some levels of pictorial perception to the advantage of others. There needs to be more discussion of how much seeing works of art normally involves accumulated flexings of the perceptual process through such activities.

37. One might characterize Berkeley's philosophy of perception as encouraging us to experience perception "pictorially," in this way: see, e.g., George Berkeley, *A Treatise Concerning the Principles of Human Knowledge* (1710), pp. 43–4, 147ff., 156.

38. For "separate touches" see Rawson, *Drawing*, p. 59; for an interesting account of marks and scale units, pp. 210–12, and his discussion, pp. 114–15, 210–13, of "line as touch."

39. "Process history" is a central concept in Michael Leyton, *Symmetry, Causality, Mind*.

40. Perhaps a modest example of Rawson's "implied pattern of . . . movements" (note 24, above). A further transfer, assisting this depiction, might

be found in the suggestion of bow and arrowhead in the shapes that form her jaws and nose. As in section 2 examples, this would not be a matter of noticing a likeness (how would that help?) or of "making an association," but rather of using our recognitional abilities for the shapes and actions of bow and arrow to help perceive part of a drawing. That such transfer might *itself* constitute a joke fits in with seeing a drawing as a cartoon.

41. "Nonintentional" here does not mean "unintentional," in the sense of accidental. Skilled photographers intend that the technology do things for them. Nevertheless, the long-standing ambivalence of attitude toward photographs, due to unclarity about the degree of intentionality in them, confirms the account. It is ironic to use photography as a counter-example, since an (apparent) lack of intentionality is precisely what has been considered an obstacle to its creativity all along.

42. See Rawson, *Drawing*, pp. 104, 237. Poussin's not being "a naturally gifted draftsman" is discussed in Martin Clayton, *Poussin: Works on Paper* (New York: Thames and Hudson, 1995), pp. 8–9.

43. Despite doctoring, some of the quality and direction of the grey pencil lines of Figure 8 are blurred by two levels of photomechanical reproduction.

44. Michael Podro has remarked that we need to "include the appreciation of intention, not as a further condition or stringency added to the feat of recognising a subject in or projecting a subject on the object, but as internal to that recognition. In this way depicting would be like talking or singing: in neither case do we want to say that we make or listen to sounds to achieve a further end of conveying or understanding something. Talking and singing are done in the sounds, and depiction is done in the lines and marks of pigment... [as we see once we distinguish] between the artist's *material*, the marks and surfaces he employs, and his *medium*.... If we identify the features of the object as lines drawn to show or define a form rather than as marks on a surface, the problem does not arise." Podro, review of Richard Wollheim, *Art & Its Objects*, 2d ed., *The Burlington Magazine* 124. 947 (February 1982): 100–102.

45. By Paul Steiner, also from *The New Yorker*. *New Yorker* cartoons may be sampled from the website http://www.cartoonbank.com, where over two hundred on this topic may be found via "Cartoon Search," to see how and to what extent the joke depends on the drawing. Waiter cartoons outnumber waitress by about four to one, and there is a restaurant/foodbar distinction. In restaurant drawings, oblique-edged, draped, round tables, as with the Weber, appear about twice as frequently as do square tables and orthogonal presentations combined.

46. There are cases of this, e.g., where one might not realize that Classical pot paintings and terra-cotta figurines are depictions of masked actors from comedy, rather than comical *pictures* of slaves, etc.

47. Representing that very mental process is itself part of the stock-in-trade of comic depictions in various visual media, from the comics' picture in the thought bubble over the head through cinema, etc.

48. Thus Philopon's famous *"poire"* lampoon of Louis Philippe: q.v., Gombrich, *Art and Illusion*, p. 344. The point can be taken further. It is standard for cartoons (e.g., by Roz Chast) to make fun not only of what they depict but of their very acts of depiction, of their own productive processes, often by regressive crudity of cartoon methods, including emphasis on ineptitude at the methods we have considered for spatially rendering shapes and dimensions by marks and primitives. The absurdity of the means of drawing lends itself to absurdity in what the drawing means. Draughters' ineptitude or banality can, however, be just that, as Art Spiegelman displayed in his homage to Charles Schultz, "Abstract Thought Is a Warm Puppy," *The New Yorker*, 14 February 2000, pp. 61–3.

49. A point stated by Michael Podro: "there is an infinite range of ways in which the painter's marks elicit recognition . . . and these are most often remarked upon in what are generally termed painterly effects" (*Depiction*, p. 7), and argued by him in a series of subtle and penetrating appreciations of individual works.

50. Igor Stravinsky and Robert Craft, *Retrospectives and Conclusions* (New York: Alfred A. Knopf, 1969), p. 83.

3

Pentimento

Paisley Livingston

In his 1996 entry to the *Dictionary of Art*, Jonathan Stephenson characterizes '*pentimento*' as follows:

Visible evidence of an alteration to a painting or drawing that suggests a change of mind on the part of the artist. In particular, it refers to previous workings [...] revealed by the change in the refractive index of oil paint that occurs as it ages: thin layers of paint that were originally opaque may become semi-transparent [...]. The term is also used to refer to such effects where they do not necessarily imply a deviation from the original intention [...]. Pentiments suggest that painters refined and altered compositions as they worked, and, for this reason, they are often cited as evidence of authenticity; similarly, they are less likely to appear in copies. The term is also used to describe the hesitant preliminary workings that show beneath some drawings.[1]

Some difficult conceptual issues can be discerned beneath the surface of this deceptively simple definition.[2] A first ambiguity here is between '*pentimento*' understood, on the one hand, as referring to actual "workings", that is, painterly gestures performed by the artist, and, on the other hand, to visible "effects" or "evidence" taken to suggest such workings or alterations. Additional ambiguities surround both readings. According to Stephenson, the term covers cases where what is revealed by the aging of paint does not involve a change of artistic intention that occurred during the making of the work, as well as cases where it does. In Stephenson's example of the former, planned sort of reworking, Pieter de Hooch painted the image of a chequered floor with the further intention of later covering over part of this floor with

various figures; years later the deterioration of the paint happened to reveal traces of his two-step procedure. Yet one may wonder why the critical term '*pentimento*', with its Italian sense of repentance, should be applied in a case where there was no change of mind on the part of the artist.

Another issue concerns the kinds of evidence deemed necessary for the term's correct application. Stephenson contends that a *pentimento* results from the aging of paint. It is far from clear, however, that this should be taken as a necessary condition. If '*pentimento*' refers primarily to the artist's activities and not to any specific sort of evidence regarding them, then the term may be appropriately applied whenever evidence of any kind reliably informs us about the right sorts of aspects of the creative process. Diaries, letters, and other documents sometimes provide good, but of course not infallible, evidence of an artist's shifting intentions. And more pointedly, there is the remarkable domain of *pentimenti* made visible to us by the technical examination of pictures. It is pertinent, but of course not decisive, to note here that the *OED* entry gives a 1966 example of the word '*pentimento*' used to refer to an image revealed by x-rays. Critics and curators do in fact sometimes refer to a *pentimento* "newly discovered" by means of infrared and x-ray examinations of a picture.[3] Such technical examinations of pictures have become increasingly frequent, yet the implications have rarely been mentioned in philosophical aesthetics.[4]

WHAT IS A *PENTIMENTO?*

My brief evocation of some definitional puzzles should convince us that what we have here is not a single pellucid critical concept but options for the construction of one or several notions. A first option would be to drop the evidentiary conditions and think of *pentimenti* as the reworking, deletion, or covering over of significant, provisionally completed (artistically or aesthetically relevant) features of a work. Another approach is to go resolutely epistemic and define *pentimento* in terms of one or more categories of evidence. A narrow version of this approach would make the aging of paint necessary to *pentimenti*, whereas a broader version would allow for other sorts of evidence. Finally, other definitional strategies could be based on combinations of the other two approaches, so that to speak of a pentiment would

require having certain kinds of evidence for there having been a certain sort of artistic reworking.

My own proposal is that the first of these three options is the best way to develop a useful and significant concept of *pentimento*, and I think this choice can be justified by reference to valuable critical practice. Assuming that our primary interest is in what the artist has created and how he or she has done so, it seems misleading to stipulate that the rather contingent process of the aging of paint or other materials should be decisive with regard to the application of the critical concept. The deterioration of paint is a rather slow and inconsistent, but also destructive and potentially misleading, guide to the makings of a work of art. Nor is it helpful to say that for one hundred years after a given painting's completion there was no *pentimento*, but that gradually after that time one came into being. And, more generally, whether we always happen to have evidence concerning particular aspects of a work's creation should not be taken as determining our more general conception of what can actually happen in the making of works of art. One might, of course, try to bolster the epistemic approach by means of some idealization of the evidence. Yet it is hard to say what sort of evidence, short of the kind that ideally yields omniscience, should serve as our standard.

I recommend, then, that we drop the epistemic clauses. This, however, is just a first step, and we must go on to say what sorts of activities, or features of artifacts, the term should then be used to identify. What, for example, should be said about the idea that there are planned *pentimenti*? There is, of course, a broad sense in which artists often plan on making whatever changes are required to complete a work, and in this sense most pentiments are probably covered by a prior plan. Yet the notion of intention employed here is too broad to be informative. I think we should take '*pentimento*' a bit more literally, so that the term singles out instances where the artist, looking at a partly finished work with a critical eye, comes to believe that something he or she has done is a mistake, or is at least not what is now most wanted, and it is this evaluative attitude that motivates the reworking in question. Such a process is significantly different from cases where a procedure on which the artist has already settled includes more or less routinely covering over or replacing part of what has been done. We certainly do not want to say that the planned painting over of a ground,

underpainting, or dead coloring counts as a *pentimento*. Yet if a change of mind is necessary, it is not sufficient, since it is plausible to hold that many such changes are too trivial to count as *pentimenti*. Consequently, the term should be reserved for cases where the artist reworks those parts of an artifact or design that have already been given some expressive or representational content within the context of the emerging work.

Given these reshapings, the notion of *pentimento* may be brought to light as follows: a *pentimento* is, first of all, an artist's intentional action of non-trivially reworking, replacing, or covering over some expressive or representational feature of an artifact or design that had previously and provisionally been established, either intentionally or not, by that artist as part of a work in progress. The reworking or replacing in question is motivated by the artist's dissatisfaction with the provisional results achieved so far, and the altering or replacement of those results amounts to a change of mind regarding the projected work's eventual features. The notion of reworking here covers both process and product: 'pentiment' refers not only to the prior, provisional creation of features, but also to the features thereby created, as they stand in relation to the artist's subsequent action of deleting, replacing, or covering them over. The 'non-trivial' clause in the definition admittedly introduces an element of vagueness, but the basic idea that there is a difference between minor or routine retouchings and *pentimenti* involving a significant change of mind is sound and can generally be applied in practice.

The notion of *pentimento* is reserved for alterations affecting the same work in progress by the same artist or cooperating group of artists. This point, which ought to be fairly uncontroversial, can be supported by a *reductio*. Assuming the contrary, as well as the plausible idea that artists are generally trying to make something better with each new work undertaken, it would be necessary to say that the artist's career is an unbroken succession of *pentimenti*, culminating, perhaps, in the one work that the artist never has occasion to regret. Yet if it seems right to observe that two different works cannot share pentiments, we must still acknowledge that notoriously difficult issues surround the individuation of works of art. The proposed elucidation is meant to rule out certain kinds of post hoc revisions and redoings, namely, those added at a time when the work of art has already been completed by the

artist, and this in a context where ulterior changes or revisions amount to the initiation of a new project for the making of a distinct work of art. Consider, for example, the case of an impoverished painter who cannot afford a new canvas and paints over a work he has finished but decided to abandon. Painting this image over, the artist starts in on what he conceives of as a new and different work; the underlying image does not, simply by virtue of its location on this stretch of canvas, have the status of a *pentimento* in relation to the later work. And it is worth noting that, should such latent imagery become visible as a result of the deterioration of paint, it could even look very much like something intended originally to have been part of that later picture, without in fact having been conceived of as such. It would seem to follow, then, that an artist's decisions about whether a work is finished, and about how his or her works and fragments are individuated, are essential to our recognition of *pentimenti*.[5]

Matters are not, however, always so straightforward. In some cases artists change their minds and go on successfully to revise a work that had earlier been deemed completed. In other cases, however, an attempted revision of this sort only produces a new and different work, albeit one that may bear a special relation to some work previously completed by the artist. Recognition of the importance of such relations between intersecting yet distinct works of art by the same artist can help us resist the temptation to think of them as attempts at the realization of some single, idealized work, as well as the temptation to elevate one, actual work as the culmination of an idealized process of creation, in relation to which the other, related works are viewed as drafts, trials, or deviations. The situation is further complicated by critical practices centered on the notion that a single work of art may have two or more versions displaying significant textual, structural, or compositional variations. Philosophers fond of citing Jorge Luis Borges' "Pierre Menard, Author of *Don Quixote*" have drawn from this story the lesson that a single text type or artistic structure may be correlated with two distinct works of art; they have, however, overlooked Borges' suggestion that a single work may have two distinct texts: at the top of the list of Menard's odd writerly achievements we find "a symbolist sonnet which appeared twice (with variations) in the magazine *La Conque* (the March and October issues of 1899)".[6] We need to distinguish, then, between cases where the artist's decision

to the effect that a work is finished does and does not effectively get overturned at some later point by the artist, who for some reason takes up the work again and makes revisions in it. Whether the work's title is altered or not, and whether subsequent revisions actually make the work better, are not the decisive criteria. Normally, the artist's decision that a work is finished will be binding if the artifact or performance has been made public, or again if events – artistic, cultural, and social – have significantly vitiated the context in which the work figures. Yet we are far from having a principled analysis of how such distinctions are to be drawn in practice.

PENTIMENTO ACROSS THE ARTS

Although it is somewhat fashionable today to stress differences between the various artistic media, I want now to consider the extension of the concept of *pentimento*, as sketched so far, across a range of art forms and media. Having deleted the evidentiary clause concerning the aging of paint, we are free to speak of *pentimenti* in works of literature, cinema, sculpture, dance, music, and so on. One could, perhaps, object that a writer's or composer's drafts and trials are not part of the final artistic artifact in the same way that covered-over layers of paint are part of a painting. Bluntly, then, a latent picture is detectable on the canvas, whereas film sequences shot, but left out of the final cut, are not part of the film presented to the public. This is correct, but need not be decisive in all critical contexts.[7] It may be more relevant to observe that a latent, painted-over depiction was not intentionally presented to the public, and that some film directors are quite eager to show us their rushes (and choose to include them, for example, in DVD versions of a film). So the "in the artifact" criterion may not be particularly helpful or decisive – unless, that is, one wants to organize things in service of a theory of appreciation according to which perception of a discrete text, artifact, or performance is sufficient – a theory, that is, the shortcomings of which are notorious.[8] Nor do we have here the makings of a useful distinction between, say, painterly and literary *pentimenti*. The technical examination of manuscripts sometimes reveals significant *pentimenti* in the form of erasures. The ink applied last can have more infrared reflectance than the ink it was meant to cover up, so that infrared can be used to detect material that has been

erased and written over, in either ancient palimpsests or more recent manuscripts.[9]

One may object, here, that the relevant difference has to do with the relative ease of epistemic access of *pentimenti*, and not a basic *pentimento*/non-*pentimento* contrast. Yet I see no decisive difference of principle with regard to the epistemic issue. If you have a decent edition and bother to read the introduction, you may easily come to know something about a writer's *pentimenti* as you read your copy of the text. It is also the case that there are bad editions, ancient texts about which we know very little, and readers who do not bother to read the critical introduction provided by a good edition. There are, it is true, painterly pentiments that almost any fool can see at a glance. Yet not all *pentimenti* in the visual arts are so readily accessible. Some are like the extra figure in the foreground of Johannes Vermeer's *View of Delft:* having stepped forth into visibility for a time, the extra man on the shore has been retouched back into obscurity, and is known only to those acquainted with the art-historical discourse. If there is a more important, medium-specific distinction with regard to pentiments, it does not involve epistemic conditions, but whatever conditions make the artist's productive or performance activities significantly irreversible. Thus it is only the arts of unanticipated, one-shot improvisation, whatever they may be, that are devoid of *pentimenti*. When the electric guitar virtuoso, spontaneously and without premeditation, improvises a transgressive solo version of the American national anthem, there may indeed be no looking back and no second try.

PENTIMENTO AND THE CREATION OF ART

What can reflection over the notion of *pentimento* contribute to our conception of the creation of art? I shall briefly take up two points in this regard: first of all, a better understanding of *pentimenti* can motivate and partly guide a sharpening of concepts of artistic intention; and second, it can shed light on relations between intentions and other attitudes at work in the improvisational *arpeggione* of artistic creation.

As I have construed it, the notion of *pentimento* entails that there are different kinds of intentions at play in the making of a work. A first distinction separates those intentions we frame but never act upon, and those that guide what we are doing, or are at least actually trying

to do. These different sorts of attitudes play very different roles in the lives of temporally situated agents.[10] An artist can, rightly or wrongly, be contrite about never having tried to realize some plan that had at some point been added to her agenda of future artistic schemes, but the regret specific to *pentimenti* concerns artistic features that have actually been created, sometimes at the cost of great time and effort. Yet this intention, which the artist has already acted upon, is itself distinct from those choices and operative intentions that subsequently lead to its overturning within the artist's emergent scheme. In a simple case, the former intention is replaced by what can be called a successive or final intention, whereby additional features of the work are used to replace or cover over previously created aspects. Thus the former, operative intention turns out not to have been decisive with regard to the completed work of art, even though the artist's acting on that intention may have constituted some of the artifact's properties. Although this former intention was acted upon, the results were deemed inadequate, either because they were perceived as not realizing the intention, or because that very intention was found lacking when compared to some other option that had subsequently come to mind. Here is where the notion of *pentimento* usefully requires us to bring in something more than the bloodless, cognitivist picture of intention that is often debated in the theory of interpretation. Most often, the artist's pivotal change of mind is also a change of heart: directing a critical gaze on her own emergent work, the artist tries to anticipate a discerning observer's eventual response, and evaluates the results achieved so far. So it is not only intentions that are at work in *pentimenti*, but desires, decisions, and emotions. Having settled on one artistic design, the artist finds that his or her motives shift in favor of another plan, and a pentiment is the trace of this change of heart. The claim is not that the artist intends to produce a pentiment in the sense of planning to do so, but that pentiments are the product of the shifting, effective intentions of the artist actively working with a medium.

PENTIMENTO AND INTERPRETATION

It remains to be shown that *pentimenti* are anything more than an obscure layer in the larger picture of art making and appreciation. It is

not hard to find examples of critics who have in fact made significant
and valuable interpretive use of what I am calling *pentimenti*. Herschel
B. Chipp's marvelous documentary study of the genesis of Picasso's
Guernica quickly comes to mind.[11] One of Marcel Proust's insightful
interpreters, René Girard, never tired of showing us ways in which as-
pects of the fragmentary novel *Jean Santeuil* had been taken up and
reworked in *À La Recherche du temps perdu*. Many critics have found
an artist's change of title revealing. Interpreters of Ingmar Bergman's
modernist masterpiece, *Persona*, have often woven into their readings
some consideration of the fact that the director initially called the
film *Kinematograf*, a title which, though it reliably points to an aspect
of the work's self-reflexivity, was set aside in favor of one that accu-
rately evoked the film's psychological thematics. What we with hind-
sight identify as Wagner's initial ideas for *Tannhäuser* were first meant
to bear the title *Der Venusberg;* Wagner's work in this vein was to result
in highly divergent libretti and scores, so that those who want to stage
or understand this work must find some strategy for dealing with the
resultant thicket of versions, performances, and/or works. The case is
extreme, but similar issues are raised by many other musical composi-
tions, such as Igor Stravinsky's *Le sacre du printemps*.[12] Virginia Woolf's
novel *The Years* started out, six years earlier, as "The Pargiters," and
the story of this arduous process of revision has been used to shed
new light both on the novel and on the book of criticism Woolf pub-
lished as a complement to it.[13] It has been contended that Flaubert's
juvenile fragment, *Mémoires d'un fou*, should be recognized as a draft
of *L'Éducation sentimentale*.[14] To mention but one other example of the
rich vein of research associated with "genetic criticism" in France and
elsewhere, new perspectives on Jean-Paul Sartre's autobiography have
been developed through careful investigation of the manuscripts.[15]
And as I have already indicated, art historians and critics of various
theoretical persuasions make frequent reference to the latent images
revealed by technical examination.

How does this vein of critical practice stand in relation to theoret-
ical proposals concerning what should and should not be recognized
as the legitimate objects of art criticism or interpretation? Where, for
example, does the appreciator attuned to *pentimenti* stand in the *bataille
rangée* waged between intentionalists and anti-intentionalists? Oddly
enough, those advocating views at either extreme in this debate can

agree to rule *pentimenti* out of court, the former because the bastion
of the higher intentionalism is final (expressive or communicative)
intent, and the latter because they do not think *pentimenti* figure
amongst the aesthetically or artistically relevant features of the arti-
fact itself.[16] Even the sort of hypothetical intentionalism advocated
by William Tolhurst may be hard to square with the idea that penti-
ments make a difference, since one normally does not, by virtue of
being a member of the artist's intended audience, have any evidence
about alterations the artist intended to conceal.[17] And there are also
problems, as I shall contend below, for other rivals to actualist inten-
tionalism, that is, the general thesis that uptake of aspects of the actual
artist(s)'s attitudes is necessary to the success of interpretive projects
aiming at elucidating features of the work of art's meanings qua work
of art.

Contra any theory of interpretation that rules pentiments irrele-
vant, I want to contend that knowledge of them can enhance our un-
derstanding of the work, taken as both process and achievement. More
specifically, recognition of *pentimenti* can contribute to our aware-
ness of the dynamic nature of those intentional and spontaneous
creative activities that begin with initial plans and conceptions, and
move through a practical and critical engagement with the medium
until a stopping point is reached by the artist. Yet contra the absolutist
versions of intentionalism, I acknowledge that it would be wrong to
assume that the abandoned contents and consequences of artists' for-
mer intentions determine what the completed works actually mean.
The suggestion, rather, is that in many cases this former content tells
us something about what the work was meant *not* to mean. As such,
the interpreter's awareness of this content provides a negative con-
straint, a constraint, however, that in some cases can be very helpful.
This would be so when the content in question is broadly compatible
with the directly exhibited features of the final artifact, in which case
this negative entailment could be a stitch that the anti-intentionalist
might miss.

The critical significance of pentiments can be evoked by referring
to another sort of interpretive strategy. I recall how Louis Marin, in his
ruminations over a picture or literary text in the seminar room, some-
times employed what he referred to as *la méthode de permutation*, which
was at bottom a readerly tactic stemming from the *explication de texte*

tradition. This was a matter of focusing on some feature of a text or picture and asking how the work's meanings would have been altered had some other possible feature figured in its place, the idea being that such counterfactual reasonings or "contrast arguments" can help us appreciate the very specific nature and meanings of the artifact's actual features. A similar process is set in motion when we learn about an artist's *pentimento*, but with a crucial difference. Instead of drawing a comparison between the artifact's features and imagined possibilities, we compare those features to options that were actively experimented with and then rejected by the artist. Seen at a time when the work has been finished, the *pentimento* shows us what was, so to speak, a close possible world – a world visited by the artist, but deliberately left behind.

A MUCH DISCUSSED PENTIMENT: VERMEER'S REGRETTED CUPID

With these more general issues in the theory of interpretation in mind, I shall now look a bit more closely at one example, namely, a significant and controversial pentiment in Johannes Vermeer's *Young Woman Reading a Letter at an Open Window*, also sometimes referred to as *Letter Reader* and as *Girl Reading a Letter at an Open Window* (Figs. 10, 11, and 12). The discovery of this pentiment was first published in 1978 by Annaliese Mayer-Meintschel, who correctly foresaw that knowledge of the painting's "slumbering" reference to a Cupid would contribute to the picture's "*Vieldeutigkeit und Suggestivität*".[18] Consider, first, some of Irene Netta's remarks:

X-radiographs of the painting show that the curtain on the right was not originally part of the composition. Instead, Vermeer initially included a large painting of a standing Cupid hanging on the back wall. It was the same Cupid we know from Vermeer's *Lady Standing at the Virginal*. As a love emblem this Cupid would inevitably have been an explicit allusion to the message of the letter the young woman reads. It refers to a particular emblem in Otto van Veen's *Amorum Emblematum* and reminds the viewer to have only one lover. The fact that Vermeer removed the Cupid to achieve the final composition testifies again to his intention deliberately to avoid any kind of symbolic reference or emblematic allusion that could open the depicted moment to other associations, such as a moralistic didactic meaning. Such an allusion would inevitably interfere with the quiet atmosphere and secluded privacy of the young woman.[19]

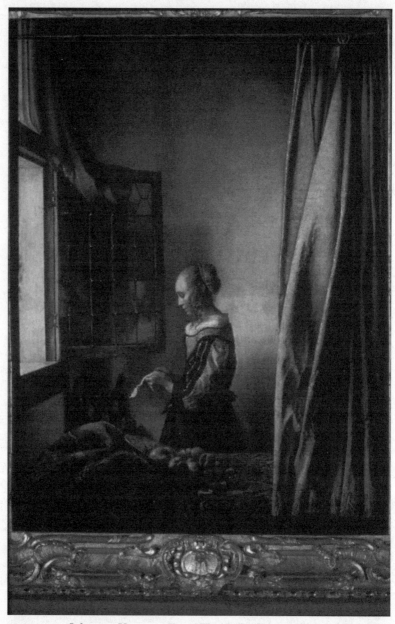

FIGURE 10. Johannes Vermeer, *Young Woman Reading a Letter at an Open Window*, ca. 1657, oil on canvas, 83 × 64.5 cm. Staatliche Kunstsammlungen Dresden, Gemäldegalerie Alte Meister.

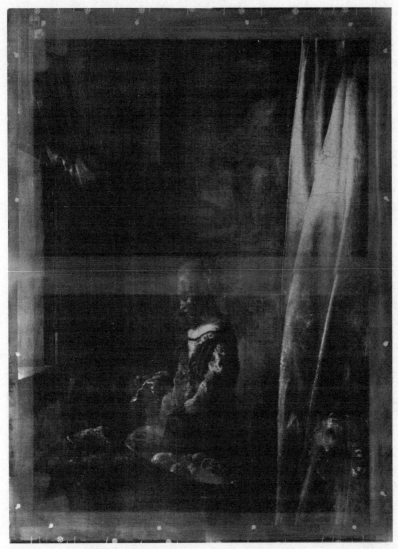

FIGURE 11. X-ray revealing *pentimenti* in Johannes Vermeer's *Young Woman Reading a Letter at an Open Window.* Courtesy of Staatliche Kunstsammlungen Dresden, Gemäldegalerie Alte Meister.

Another prominent Vermeer scholar, Jørgen Wadum, similarly adverts to the x-ray evidence of the artist's *pentimento*, this time focusing on the implications for our understanding of the picture's perspective design:

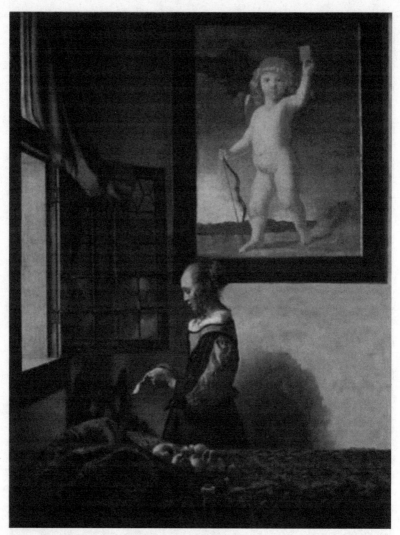

FIGURE 12. Prop for imagining a picture Vermeer was painting.

In the early *Girl Reading a Letter at an Open Window* the horizon is placed in such a way that it divides the painting in half. The vanishing point is placed between the girl's neck and the green curtain to the right. The reason for the position of the vanishing point behind the reading girl seems irrational, as it does not lead the eye of the spectator into the composition. At an early stage in the development of this picture, however, a painting of Cupid hung just above the vanishing point on the back wall. To stress the amorous content

of the letter, the orthogonals to the vanishing point would lead the eye of the spectator via the Cupid to the girl and back, which would be logical. But Vermeer has obscured the meaning by overpainting the Cupid, and leaves us only with a very naturalistic and sensual reflection of the girl in the leaded glass window. Despite the changes that Vermeer made to the composition, he did not alter the perspective design.[20]

Both critics do not hesitate to rely on the results of technical examination as they make claims about the painting's genesis and Vermeer's shifting intentions, and both clearly deem the latter relevant, perhaps even decisive, for our understanding of important aspects of the finished painting. Yet there are significant differences, especially if one seizes upon Wadum's remark about how Vermeer "obscured the meaning by overpainting the Cupid", which could be taken as implying that the work's real meaning, as determined by the latent emblem, is a fact somehow obscured by the artist's change of mind and subsequent refashioning of the picture. Yet one can consider that the x-ray evidence inflects our understanding of the picture without believing that it reveals a decisive, original intention. Netta contends, rather more plausibly, I think, that our knowledge of the artist's abandonment of the picture-within-the-picture serves to highlight qualities of the final work, which is not, as a result, best seen as illustrating some romantic episode or emblematical moral. Wadum makes a thought-provoking point in drawing our attention to ways in which the work's final perspectival design retains aspects of the earlier scheme, for the adding of the curtain and curtain rod only partly attenuates the high horizon and low viewpoint that were intially designed to lead the eye to the Cupid emblem hovering prominently in the background. It does not follow, however, that the artist's shift away from his former intention was incomplete, since there may be better ways to understand the decision to retain at least some of the implicit visual emphasis on the bare wall. For example, one may conjecture that if our attention is drawn to the wall, it is then effectively "bounced" back from this surface of confinement to the letter and window, the sources of illumination in this young woman's quiet drama. With regard to the overall effect created by the composition, Netta insightfully refers to the "intense aura of concentration" deliberately created by a composition in which the young woman's musing, expressive face, and its reflection in the window, focus the viewer's attention.[21]

Other prominent critics and scholars have made analogous claims about how our knowledge of the pentiment influences our understanding of the picture. In his survey of *pentimenti* in Vermeer's work, Arthur K. Wheelock comments that Vermeer was "distancing himself from the more narrative and anecdotal imagery of his contemporaries". The Cupid, which would have functioned as a commentary on the nature of the letter the young woman was reading, has been eliminated so as to "enhance the poetic mood of the scene".[22] A similar line of thought is advanced by J. M. Nash, who states that "By this erasure, Vermeer cancelled an indication that the letter being read is a love letter".[23]

There is, however, more to be said about this example, and I do not want to give the impression that everyone writing about this famous picture is in agreement. Daniel Arasse, for example, challenges the interpretations I have cited. He boldly assumes that a convention instructs us to read genre paintings of this sort in a highly specific manner, such that letters being read by young women would "usually be taken" to be love letters. In eliminating the Cupid, Vermeer did not "necessarily" exclude the amorous theme.[24] We readily concur that Vermeer's pentiment does not *logically* entail that he could not have finally intended his painting to carry implicitly those very meanings he had associated with the Cupid picture. A strategy of conventional implication that *p* could have been chosen in favor of the alternative strategy of more directly depicting or implying *p*. Yet one may still have serious doubts about the prior claim that Vermeer adopted a putative generic convention to the effect that all letters read by the young women of his time were billets-doux – either because one doubts the existence of any such convention or because, even if sufficient historical evidence for the existence of such a convention were to be found, one could still be loath to assume that Vermeer actually adopted it in this instance.

One critical strategy that is relevant in this context is that of searching for evidence in the rest of the artist's œuvre. How, one then asks, may this picture be viewed in light of similar iconographic and thematic material in Vermeer's other works? The dating of most of Vermeer's paintings is a matter of some guesswork, but there is some agreement that *Young Woman Reading a Letter at an Open Window* was painted some fifteen years prior to the creation of *Woman Standing at a Virginal*, in which the artist used – without apparent regret – the very

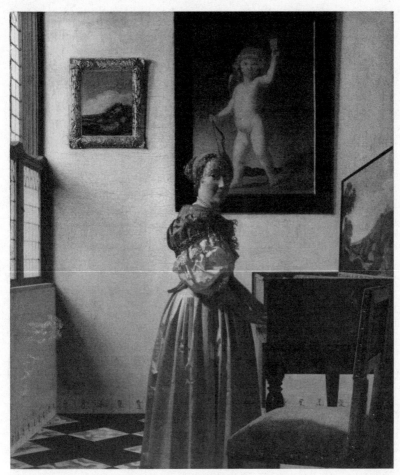

FIGURE 13. Johannes Vermeer, *Woman Standing at a Virginal*, ca. 1672, oil on canvas, 51.8 × 45.2 cm. The National Gallery, London.

Cupid motif that had been covered over in the previous painting (see Fig. 13). One may ask, then, how this Cupid picture-within-a-picture actually functions in the context of *Woman Standing at a Virginal*, an issue that may in turn have some indirect relevance to the counterfactual question concerning how the enframed Cupid *would have* functioned had the depiction of it been retained in *Young Woman Reading a Letter at an Open Window*. If we are tempted to tidy things up by guessing that the artist decided to paint over the Cupid so as to avoid repeating himself at some later point, that is, in order to save

that genial idea for a later painting, we should recall that he was not hesitant to take up such motifs more than once. The same Cupid painting – which may very well have belonged to Vermeer – is depicted on the wall of the *Girl Interrupted at Her Music* (though it should be added that the attribution to Vermeer is sometimes contested), and it is also found fragmentarily, with the variation of a mask by the Cupid's foot, in what may have been an earlier painting, *Woman Asleep*. Vermeer also twice used a single work, Dirck van Baburen's *The Procuress* (1622), as his motif for a picture-within-a-picture.[25] Just as it is difficult to generalize accurately about the relations between embedded and embedding pictures, which range from contrast to mirroring and parallelism, so is it very hard to provide a reliable schematic characterization of how *pentimenti* are motivated in particular instances. In light of such considerations, it is best to settle on the idea that in the context of painting *Young Woman Reading a Letter at an Open Window*, the artist found reasons to prefer the blank wall to the Cupid picture.

The nature of those reasons, however, remains a matter of some controversy.[26] The approach attributed to Whitlock, Nash, and Nette above has been challenged by Ivan Gaskell, who contends that the blankness of the card upheld by the Cupid in *Woman Standing at a Virginal* effectively negates the emblematic content taken for granted by many other interpreters. To function standardly as an emblem, Gaskell asserts, the card would have to display the numeral 1, thereby admonishing the viewer to have but a single lover. But since the card held up by this putto is blank, no such moral is conveyed.[27] Would this same picture-within-the-picture, then, have had no emblematic import had it hovered behind the young woman reading the letter at the window? This is dubious. Even if the painting-over of the Cupid picture is not best read as the cancelling of a simple and determinate moralistic message – Cupid's injunctions being more enigmatic than emblematic – it nonetheless indicates the painter's reluctance to insist on this particular budget of questions in this picture.[28] Such issues are raised, quite pointedly, in *Woman Standing at a Virginal*, both by the prominence of the Cupid on the wall directly behind her head, and by the woman's unusually direct and probing gaze. Commenting on the function of the picture-within-the picture in this context, H. Rodney Nevitt, Jr. plausibly writes that the Cupid directly greets us "to frame the woman's gaze as amorous".[29] With regard to our *Letter*

Reader, Nevitt comments that the removal of the Cupid produces a more generalized image of "privacy, absorption, and communication with an indeterminate other". At the same time, "the option to read an amatory theme into it remains very much in play".[30] In sum, in the case of the letter reader *sans cupidon*, our attention is free instead to linger on the delicate depiction of the young woman's reflection in the windowpane, with its gentle suggestion of the reflexive quality of her thoughts and feelings as she reads a letter that conveys to her some engrossing message from the world outside her window, the nature of which is simply not specified in any decisive way.

The example has the merit of illustrating some of the messiness and complexity of actual critical disputes. Yet it should not be forgotten that these dissenting commentators all agree that knowledge of the *pentimento* ought in some way to inflect our sense of the implicit content on which the artist finally settled, and is thus a useful clue to his more settled intuitions regarding the work.[31] And that is the point that needs to be kept in mind as we return to the implications for a more general theory of interpretation.

PENTIMENTO AND INTENTIONALISMS

Acknowledgement of the relevance of pentiments to appreciation broadly indicates acceptance of some form of intentionalism. But this is not particularly informative unless we can say which kind. I take it that all of the reasonable varieties of intentionalism underscore the importance of the interpreter's attunement to the artistic artifact's features, an attunement, however, constrained by awareness of the relevant features of the actual context of creation. Which features of that context are relevant, and, more specifically, which aspects of the creative process are pertinent, remains the crux. I have already taken my distance from the absolute intentionalist's idea that final intention alone determines a work's meanings and representational properties. A more moderate version of actualist intentionalism, to which I am sympathetic, holds that, for a central type of interpretive project, the artist's intentions are decisive as long as they mesh informatively with the features of the artifact presented to the public.

Yet there are rival versions of intentionalism, differing from a moderate, actualist intentionalism in at least two basic ways. A first sort of

divergence involves strictures having to do with the kinds of utterances that are supposed to be made about artists and their intentions, the basic idea being that fictions and 'as if' postulations are to take the place of assertions about actual artists, thereby granting interpreters a negative freedom from error as well as a positive freedom to imagine a wide range of meanings.[32] Yet such freedoms have their price: the interpreter cannot claim to be right about how the actual Vermeer made his picture, and cannot read the pentiment as a clue to the actual process whereby the painting was created. Such a goal is, I have suggested, a feature of critical practice that provides a constraint on the theory of interpretation, a constraint violated by fictionalist intentionalisms.[33]

The second way in which an intentionalism can diverge from moderate, actualist intentionalism is by placing some constraint on the kinds of evidence deemed legitimate and illegitimate. In Tolhurst's version of hypothetical intentionalism, the guiding principle is that the actual artist's intentions with regard to the audience settle the matter, the thought being that artists specify a boundary between relevant and irrelevant evidence in making a work for a more or less specific audience. Other versions of hypothetical intentionalism, such as the one fostered by Jerrold Levinson, drop the artist's intentions regarding the audience and strive to give a more direct and determinate characterization of the sorts of evidence interpreters ought to rely upon, a basic idea being that ideal evidence is not the same as the totality of evidence. The guiding thought here is the anti-intentionalist's worry that an interest in diaries and other sources of insight into the artist's "private" intents is a fallacy because it can draw attention away from the appropriate locus of attention, which is the finished artifact and relevant features of its public context. Claims about intentions are not only permissible but necessary, it is added, yet they must not be based upon or guided by evidence concerning the artist's private intentions as to a work's meanings, symbolism, or themes.

How do versions of hypothetical intentionalism fare with regard to the prevalent critical practice in which pentiments are taken as a valuable kind of evidence? Such interpretive practices are clearly at odds with Tolhurst's proposal, at least if we assume that Vermeer intended his audience to look at the picture under ordinary conditions. So either radiography is inadmissible, or, if we prefer to take actual, critical debate as our guide, we must abandon this version of hypothetical

intentionalism. Perhaps the advocate of this theory of interpretation can give us additional grounds for overlooking a vast category of evidence taken seriously by art critics and historians, but it is not clear what these reasons could be.

What about a version of hypothetical intentionalism in which a different boundary between admissible and inadmissible evidence is stipulated? Could there not be a version of hypothetical intentionalism which embraces pentiments as grist for the interpretive mills? Perhaps, but it is unclear how such a theory can be given a principled development. Levinson's hypothetical intentionalism does not, at least at first glance, look like such a theory. He flatly rules out evidence pertaining to the artist's private, semantic intentions, identifying as inadmissible "any fact about the author's actual mental state or attitude during composition, in particular what I have called his semantic intentions for a text".[34] This could be taken as ruling out pentiments insofar as they are thought to provide evidence as to what the artist may have meant, which has clearly been the use to which pentiments have been put in the specimens of Vermeer criticism documented above. Yet what if the pentiment is read, not as a fact about the artist's state of mind, but as a fact about meaningful features of the finished artifact? Such facts could then be used as legitimate evidence in conjectures about the hypothetical artist's meanings (i.e., what the actual artist "could have meant"), and hypothetical intentionalism could be squared with critical practice relying on radiography and similar technologies.

My response to this line of thought is that pentiments are not, in fact, bare radiographic facts of that sort. If we apprehend these hidden traces in pictures as features of the artifact alone, they remain ambiguous between actual *pentimenti*, which were motivated by and reflect an artist's change of mind, and something else entirely (such as the painting-over of a canvas for reuse in a completely distinct work of art). To refer accurately to a *pentimento*, the interpreter needs to recognize and be guided by the contents of an artist's actual, abandoned intention, as well as the successive intention to cancel or conceal that prior intention in the making of the same work. Such reference to actual attitudes and mental states during composition is necessary if the (technically) observable features of the artifact are to be disambiguated.

My point here may be amplified by elaborating further upon the sort of ambiguity which the published versions of hypothetical intentionalism cannot handle. In a range of standard cases, there is a central text, artifact, or structure, such as a stretch of canvas with paint on it, which has been fashioned and presented by the artist with the intention that it be contemplated or appreciated under certain circumstances. Such circumstances do not usually include the providing of evidence sufficient for the recognition of a *pentimento*, since quite often it is not the artist's intention to present revised features alongside those that were finally preferred to them. In this sense it does not matter whether the underlying content has been revealed by the aging of paint or the use of infrared reflectography, since both involve a kind of access significantly distinct from the circumstances envisioned by the artist. Yet another sort of case should also be envisioned. Some artists may already have devised multi-layered canvases with the expectation that critics of the increasingly dominant radiographic school may go on to detect them, and perhaps there has already been a show somewhere in which the public first sees the works under ordinary light and then with the aid of sophisticated scanners. It is not preposterous to think that a seventeenth-century artist could actually have anticipated that the aging of paint could at some point reveal the hidden layers on a canvas. What is more, the tradition of anamorphic images indicates an earlier interest in depictions requiring special techniques of viewing. So we can contrast three possible scenarios. In the one, the artist depicts a Cupid picture on the wall, then paints it over because he has decided that he wants his picture to be more ambiguous than the use of an emblematic device would have indicated. In the second case, the artist paints the Cupid over in the hope that it will someday be discovered and taken into account, at which point the work's intended, latent content would be known. Another scenario is one in which the Cupid was painted over as the artist changed his mind entirely about the sort of picture he wanted to paint and was only reusing the canvas, in which case the painted-over imagery was never conceived of as even potentially being part of the same work of art.

Now, Vermeer's intentions are in many ways a mystery, but I doubt there is anyone who would care to conjecture that he intended for us someday to discern the hidden Cupid. I also venture to say that no one will want us to imagine or hypothesize a Vermeer equipped

with any such unlikely – yet possible – esoteric designs. And why not? After all, there is some evidence, in the layers of the canvas, for such an attribution: the latent image is there, and we can coherently imagine an unusual artist who painted it with the intention that it be detected someday. Well, one very salient reason – and, I suspect, the only decisive reason – for not playing the interpretive game this way is that there are no good grounds for attributing an esoteric intention of that sort to the actual Vermeer. And were we to discover that he actually had, and acted upon, such an unusual intention, this would motivate a profound change in our understanding of the work. In such a case the informed interpreter should not substitute the intentions of a hypothetical artist who had only committed a *pentimento*, since such a move would amount to a misrecognition of the work's nature.

To restate the key point here, one can say that discovery of the hidden imagery, which critics of various persuasions clearly recognize as relevant to our appreciation of the work, raises the possibility of an interpretive quandary that is only resolved through reliance upon an assumption about the actual artist's effective intentions in making and covering over the latent image. If Vermeer's hidden Cupid is to be identified as a *pentimento* and not as part of some esoteric design, or as a trace of the recycling of canvas, we must be willing to settle on the corresponding assumption about the artist's attitudes during the making of the work, which means that we must be intentionalists of at least a moderate stripe, and not hypothetical intentionalists of either the Tolhurst or Levinson varieties.

One potential retort here is that evaluative considerations will take care of the specter of esoteric intentions. If we were to find out that Vermeer had such aims, we would overrule them because they diminish the value of the painting as standardly viewed. Yet such a move raises many hard questions. How do we establish that the Vermeer painting would have been less interesting or valuable had the putto not been a *pentimento* but an intentionally produced, latent feature of the work? Under what conditions would a work of art have been artistically worse had the artist completed it without *pentimenti*? Someone who thought they could give defensible answers to such questions could perhaps go on to develop an "optimific" line regarding the interpretation of *pentimento*, but I must say that I am not sanguine about the prospects.

I want to conclude these ruminations over the significance of penti-
ments with an author's genial evocation of a writer's struggle with the
creation of art. Here is George Orwell's fine description of Gordon
Comstock at work on the manuscript of his ill-fated *London Pleasures:*

A couplet, written a year ago and left as finished, caught his eye with a note of
doubt. He repeated it to himself, over and over. It was wrong, somehow. It had
seemed all right, a year ago; now, on the other hand, it seemed subtly vulgar.
He rummaged among the sheets of foolscap till he found one that had nothing
written on the back, turned it over, wrote the couplet out anew, wrote a dozen
different versions of it, repeated each of them over and over to himself. Finally
there was none that satisfied him. The couplet would have to go. It was cheap
and vulgar. He found the original sheet of paper and scored the couplet out
with thick lines. And in doing this there was a sense of achievement, of time
not wasted, as though the destruction of much labour were in some way an
act of creation.[35]

Notes

My thanks to Johanna Seibt, Gregor J. M. Weber, and Berys Gaut for helpful
comments on drafts of this essay.

1. Jonathan Stephenson, "Pentiment", in *The Dictionary of Art*, ed. Jane
 Turner (London: Macmillan, 1996), 24: 370.
2. Similar issues are raised by the definition proposed in Dawson W. Carr
 and Mark Leonard, *Looking at Paintings: Guide to Technical Terms* (Malibu,
 Calif.: J. Paul Getty Museum, 1992), p. 53.
3. See, for example, Peter Young and Ronald Parkinson, "Another Penti-
 mento in Constable's 'Leaping Horse'", *Burlington Magazine* 134 (1992):
 311. Similar usage is found often in Maryan Wynn Ainsworth et al., *Art
 and Autoradiography: Insights into the Genesis of Paintings by Rembrandt, Van
 Dyck, and Vermeer* (New York: The Metropolitan Museum of Art, 1982).
4. An important exception is Frank Sibley in "Why the Mona Lisa May Not
 Be a Painting", in *Approach to Aesthetics: Collected Papers on Philosophical Aes-
 thetics*, ed. John Benson, Betty Redfern, and Jeremy Roxbee Cox (Oxford:
 Clarendon, 2001), pp. 256–72. Sibley asks whether the critical pertinence
 of x-ray examinations of pictures supports the physical object hypothesis
 in the ontology of art and concludes that it does not, since "it is a purely
 contingent matter that earlier thoughts are hidden under paint" (p. 262).
 Another philosopher who takes up this issue is David Davies, "Artistic In-
 tentions and the Ontology of Art", *British Journal of Aesthetics* 39 (1999):
 148–62.
5. On the distinction between complete and incomplete works of art, see
 my "Counting Fragments, and Frenhofer's Paradox", *British Journal of
 Aesthetics* 39 (1999): 14–23.

6. Jorge Luis Borges, "Pierre Menard, Author of Don Quixote", trans. Anthony Kerrigan, in *Ficciones* (New York: Grove, 1962), pp. 45–56, at 46.

7. While revising this essay I discovered that this point was earlier expressed by Sibley in "Why the Mona Lisa May Not Be a Painting", in *Approach to Aesthetics*, pp. 256–72. Sibley does not use the word *pentimento*, but evokes the same sorts of genetic evidence, deeming them "matters important for appreciation" (p. 262).

8. See Richard Wollheim, "Art, Interpretation, and Perception", in his *The Mind and Its Depths* (Cambridge, Mass.: Harvard University Press, 1993), 132–43.

9. Joe Nickell, *Detecting Forgery: Forensic Investigation of Documents* (Lexington: The University Press of Kentucky, 1996).

10. For background, see Michael E. Bratman in *Intention, Plans, and Practical Reason* (Cambridge, Mass.: Harvard University Press, 1987), and Alfred R. Mele, *Springs of Action: Understanding Intentional Behavior* (New York: Oxford University Press, 1992).

11. Herschel B. Chipp, *Picasso's 'Guernica': History, Transformations, Meanings* (Berkeley: University of California Press, 1988).

12. Louis Cyr, "Writing *The Rite* Right", in *Confronting Stravinsky: Man, Musician, and Modernist*, ed. Jann Pasler (Berkeley: University of California Press, 1986), pp. 157–73.

13. Grace Radin, *Virginia Woolf's* The Years: *The Evolution of a Novel* (Knoxville: University of Tennessee Press, 1981).

14. René Dumesnil, "Appendice", in Gustave Flaubert, *Œuvres*, ed. Albert Thibaudet and René Dumesnil (Paris: Gallimard, 1952), 2:461.

15. Michel Contat, ed., *Pourquoi et comment Sartre a écrit "Les Mots"* (Paris: Presses Universitaires de France, 1996). For background to research in this broad vein, see Michel Contat and Daniel Ferrer, eds., *Pourquoi la critique génétique? Méthodes et Théories* (Paris: CNRS, 1998).

16. See, for example, Michael Hancher's defense of intentionalism built on "active intention", which he construes as the author's relevant self-understanding at the time of the completion of the work; "Three Kinds of Intention", *MLN* 87 (1972): 827–51.

17. William E. Tolhurst, "On What a Text Is and How It Means", *British Journal of Aesthetics* 19 (1979): 3–14. For discussion, with a focus on the version of hypothetical intentionalism defended by Jerrold Levinson, see my "Intentionalism in Aesthetics", *New Literary History* 29 (1998): 831–46; see also Noël Carroll's essays on these issues in his *Beyond Aesthetics: Philosophical Essays* (Cambridge: Cambridge University Press, 2001), pp. 157–214.

18. Annaliese Mayer-Meintschel, "Die Briefleserin von Jan Vermeer van Delft – zum Inhalt und zur Geschichte des Bildes", in *Jahrbuch der Staatlichen Kunstsammlungen Dresden* (1978–9), pp. 91–100, at p. 97.

19. Irene Netta, "The Phenomenon of Time in the Art of Vermeer", in *Vermeer Studies*, ed. Ivan Gaskell and Michiel Jonker (Washington, D.C.: The National Gallery of Art, 1998), pp. 257–63, at p. 260.

20. Jørgen Wadum, "Vermeer in Perspective", in *Johannes Vermeer*, exh. cat. (Washington, D.C.: The National Gallery of Art, 1995), pp. 67–79, at p. 73.

21. Irene Netta, "Time in the Work of Jan Vermeer and Bill Viola", in *Geschichten des Augenblicks: Über Narration und Langsamkeit*, ed. Helmut Friedel (Stuttgart: Hatje Cantz, 1999), pp. 156–64.

22. Arthur K. Wheelock, "*Pentimenti* in Vermeer's Paintings: Changes in Style and Meaning", in *Holländische Genremalerei im 17. Jahrhundert*, ed. H. Bock and T. W. Gaetgens, Special Issue no. 4 of *Jahrbuch Preussischer Kulturbesitz* (Berlin: 1987), pp. 385–412, at pp. 410–11. Citing Wheelock, Walter Liedtke restates this point in "Vermeer Teaching Himself", in *The Cambridge Companion to Vermeer*, ed. Wayne E. Franits (Cambridge: Cambridge University Press, 2001), pp. 27–40, at p. 38.

23. J. M. Nash, " 'To Find the Mindes construction in the Face' ", in *Vermeer Studies*, pp. 59–65, at p. 61. Similar claims have been made about pentiments detected in other Vermeer works, such as *Woman Asleep*. See Maryan Wynn Ainsworth et al., "Paintings by Van Dyck, Vermeer, and Rembrandt Reconsidered through Autoradiography", in Ainsworth et al., *Art and Autoradiography*: "These changes, revealed by a study of autoradiography and X-ray radiography together, constitute a major shift in representation from explicit to more implicit meaning" (p. 26).

24. Daniel Arasse, *Vermeer: Faith in Painting*, trans. Terry Grabar (Princeton, N.J.: Princeton University Press, 1994), p. 174.

25. Gregor J. M. Weber, "Vermeer's Use of the Picture-within-a-Picture: A New Approach", in *Vermeer Studies*, pp. 295–307.

26. Uncertainty about the artist's intentions is underscored by Eddy de Jongh, who argues tentatively for the possibility of an intended ambiguity. See his "On Balance", in *Vermeer Studies*, pp. 351–66.

27. Ivan Gaskell, "Vermeer and the Limits of Interpretation", in *Vermeer Studies*, pp. 225–34. See also his *Vermeer's Wager: Speculations on Art History, Theory and Art Museums* (London: Reaktion, 2000).

28. Some putti, it should be recalled, hold a book entitled *secretum neum mihi*. Support for the challenge to the idea that a single and sovereign meaning can be associated with cupid imagery can be found in Theresa Lynn Tinkle, *Medieval Venuses and Cupids* (Stanford, Calif.: Stanford University Press, 1996); and Wilfried Hansmann, *Putten* (Worms: Wernersche Verlagsgesellschaft, 2000).

29. H. Rodney Nevitt, Jr., "Vermeer on the Question of Love", in *Cambridge Companion to Vermeer*, pp. 89–110, at p. 98.

30. Ibid., "Vermeer on the Question of Love", p. 104.

31. It would be rash to claim that no-one has contested the very relevance of the pentiment, but I can attest that my own industrious survey of the literature has uncovered no such contentions; nor has anyone made the claim that what the x-ray reveals is not a pentiment (given my definition of the concept).

32. For background, see my "Intention in Art", *Oxford Handbook of Aesthetics*, ed. Jerrold Levinson (Oxford: Oxford University Press, 2003), pp. 275–90.

33. Fictionalist accounts of interpretation encounter another problem with regard to how we should interpret depictions of works of art embedded within a picture, in which case we would have to imagine two fictional artists having independently created the picture-within-the-picture.

34. Jerrold Levinson, "Intention and Interpretation in Literature", in *Pleasures of Aesthetics* (Ithaca, N.Y.: Cornell University Press, 1996), pp. 175–213, at p. 206. I make the common assumption that the account is at least a plausible basis for a general theory of artistic interpretation, and not one restricted to literary works.

35. George Orwell, *Keep the Aspidistra Flying* (London: Secker and Warburg, 1954), p. 42.

4

Exemplary Originality:

Genius, Universality, and Individuality

Paul Guyer

At the outset of the eighteenth century, genius was characterized sim-
ply as exceptional facility in perception and representation, where the
latter is the object of artistic production and the former its precon-
dition. As the century progressed, and as long into the nineteenth
century as genius remained a lively topic, it came to be characterized
as a gift for invention, leading to originality in artistic representation.
But only by a few, whom we might for this reason call philosophical
geniuses, were the implications of the new conception of genius fully
embraced. Immanuel Kant was the first to recognize that genius, as
exemplary originality, would be a stimulus and provocation to contin-
uing revolution in the history of art; and John Stuart Mill, inspired by
Alexander von Humboldt, was the first to argue that the expression of
individuality in such a form is good in and of itself. What led Kant to
his position was a distinctive conception of aesthetic experience and
thus of the aims of art; what led Mill to his was a distinctive conception
of the human good in general. In what follows, I will bring out what
is distinctive in their conceptions of genius by contrasting them with
those of other apostles of genius, such as Alexander Gerard, Samuel
Taylor Coleridge, and Ralph Waldo Emerson, whose conceptions of
genius were not in fact as radical as those of Kant and Mill. My purpose
is primarily historical, although it is of course motivated by the belief
that Kant and Mill jointly provide an analysis of both the costs and the
benefits of genuine artistic innovation and individuality that is worth
remembering in an age of perpetual revolution in the arts.

1. FACILITY

A conception of genius typical for the early eighteenth century may be found in the widely read *Critical Reflections on Poetry and Painting* by Jean-Baptiste Du Bos, which had already enjoyed five French editions beginning in 1719 before being translated into English in 1748.[1] Du Bos begins his second volume by recapitulating the argument of the first that we turn to art to have our emotions aroused and moved, so that formal and stylistic merits may be a necessary condition but are never a sufficient condition for our enjoyment of art. "The sublimity of poetry and painting consists in moving and pleasing," he writes, and " 'Tis impossible for either a poem, or picture, to produce this effect, unless they have some other merit besides that of regularity and elegance of execution. . . . In order to render a work affecting, the elegance of design and the truth of coloring, if a picture; and the richness of versification, if a poem, ought to be employed in displaying such objects as are naturally capable of moving and pleasing."[2] He then characterizes genius as the ability, innate as it will turn out, to discover moving and pleasing ideas for the content of such works, rather than the ability to represent such ideas correctly, which in his view can readily be acquired with due application:

The resemblance therefore between the ideas, which the poet draws from his own genius, and those which men are supposed to have in the situation in which he represents his personages, the pathetic [*sic*] likewise of the images he has formed before he took either pen or pencil in hand, constitute the chief merit of poems and pictures. 'Tis by the design and invention of ideas and images, proper for moving us, and employed in the executive part, that we distinguish the great artist from the plain workman, who frequently excels the former in execution. The best versifiers are not the greatest poets, as the most regular designers are far from the greatest painters.[3]

The use of "invention" in the second sentence of this paragraph might make it sound as if the genius is distinguished by his originality or expression of individuality, his creation of an idea that no one else has had before, but such an interpretation is belied by the first sentence, which characterizes genius precisely as the ability to conceive of the response which everyone ought to have in a represented situation. This ability may be rare, but there is nothing original or individual about what it discovers. This becomes even clearer a few pages later, when

Du Bos offers his official definition of genius as "an aptitude, which man has received from nature to perform well and easily that which others can do but indifferently, and with a great deal of pains"; that the ability may be rare, but that what it is an ability to discover is not in any significant sense individual is precisely what is implied when Du Bos continues, "We learn to execute things for which we have a genius, with as much facility as we speak our own mother-tongue."[4] Mother tongues are nothing if not common to entire populations. The assumption that genius is a rare ability but not an ability to do something rare is also evident in Du Bos's subsequent illustrations: generalizing from the ability to lead troops in war to "all other professions," Du Bos writes that

> Nature has thought fit to make a distribution of her talents amongst men, in order to render them necessary to one another; the wants of men being the very first link of society. She has therefore pitched upon particular persons to give them an aptitude to perform rightly some things, which she has rendered impossible to others; and the latter have a facility granted them for other things, which facility has been refused the former.[5]

Some people are born with an innate aptitude that will develop, under favorable circumstances, into the ability to lead troops; others, with a genius for the "administration of great concerns, the art of putting people to those employments for which they are naturally formed, the study of physic, and even gaming itself";[6] and some, as it turns out, with an aptitude for hitting upon ideas and images that can move and engage others. But just as there is nothing individualistic or idiosyncratic in what constitutes success in military leadership or civic administration, so – rare as his ability is – there is nothing individualistic in the moving ideas of the artistic genius as conceived by Du Bos.

This way of conceiving of genius would seem to have been quickly rejected in the second half of the century, but a change was not in fact immediate. The Scot Alexander Gerard, professor of moral philosophy and then divinity in Aberdeen and author of the prize-winning *Essay on Taste* of 1759,[7] published a lengthy *Essay on Genius* fifteen years later.[8] The work starts with a definition of genius and then devotes most of its length, first, to an analysis of the various faculties that comprise genius – in particular, the relation between genius and judgment – and,

second, to a contrast between the ways in which genius is manifested in natural science on the one hand and the fine arts on the other.[9] Gerard introduces his definition of genius by distinguishing it from a mere capacity for learning, which he says "is very general among mankind": "Mere capacity, in most subjects, implies nothing beyond a little judgment, a tolerable memory, and considerable industry. But true genius is very different, and much less frequent."[10] Instead, he states, "Genius is properly the faculty of *invention;* by means of which a man is qualified for making new discoveries in science, or for producing original works in art."[11]

The definition of genius as a faculty of invention, and in particular the contrast between making new discoveries in science and producing original works in art, might suggest that artistic genius is not only rare but also individualistic, that is, a capacity for the expression of unique ideas and points of view that might not immediately or indeed ever find wide acceptance, for any of a variety of reasons. However, the continuation of Gerard's argument makes it clear that he, like Du Bos, assumed genius to be a rare talent, but a talent for the production of works that would readily find wide acceptance. To be sure, genius not constrained by judgment runs the risk of idiosyncrasy: "Often, however, the bye-roads of association, as we may term them, lead to rich and unexpected regions, give occasion to noble sallies of imagination, and proclaim an uncommon force of genius, able to penetrate through unfrequented ways to lofty or beautiful conceptions. . . . The truest genius is in hazard of sometimes running into superfluities."[12] But this is only the occasion for genius "to prune the luxuriance, and rectify the disorder of its first conceptions. . . . Thus to render genius complete, fertility and regularity of imagination must be united."[13] And by "regularity of imagination," Gerard means precisely the ability of genius to limit its productions to those which can be understood and appreciated by the great majority even of those who do not themselves have the "fertility" of imagination to produce them. This is made clear a few pages later when Gerard writes: "In studying a work of true genius, when we attend to the multitude and variety of the materials, we wonder how the author could have found them all; and when we reflect how proper and apposite every part is, we are apt to think that it must have occurred to almost any person. Such is the effect of copiousness and regularity of imagination, united and harmoniously

exerted."[14] The contrast that structures these sentences clearly reveals Gerard's assumptions: the fertility of imagination that constitutes genius is rare, but it is a rare talent to invent conceptions which, once invented, "we are apt to think... must have occurred to almost any person," that is, conceptions that can be counted on readily to find wide acceptance, free of any taint of idiosyncrasy that might reduce their appeal to an audience limited by time, place, interest, or its own talent.

What accounts for Gerard's confidence that genius is a rare talent to produce widely and readily accepted inventions? The answer to this question must lie in an objective conception of the merits of works of art, and this is precisely what we find in Gerard in the form of the assumptions that works of art are essentially adorned imitations or decorated representations where the principles or mechanisms of both imitation and adornment are natural rather than conventional, and thus readily and widely shared. This conception of art emerges in the course of Gerard's contrast between the manifestations of genius in art and natural science. In the sciences, the end of genius is "the discovery of *truth*," and in art, "the production of *beauty*."[15] Scientific genius is characterized above all by "penetration... a force of imagination as leads to the comprehension and explication of a subject,"[16] in particular, an ability to discover causal connections that are not immediately apparent to all but that can be made apparent to all. By contrast, artistic genius is characterized by "brightness of imagination," which "fits a man for adorning a subject."[17] Gerard characterizes brightness of imagination in terms that foreshadow Kant's later description of the manifestation of genius in the production of aesthetic ideas: it is "such a strength of imagination as makes every present object suggest a multitude of ideas, and hurries the mind quickly from one thing, to others not very strictly connected with it."[18] This might suggest an inherent risk, or opportunity, for idiosyncrasy in works of artistic genius, but Gerard is not worried about such a risk because he believes that the principles of both representation and its adornment are naturally widely shared. He claims that "The fine arts are commonly called imitative"; some are "purely and totally" or "strictly imitative," such as painting; others, such as poetry, are less strictly imitative, "But even in cases where the arts are least imitative, it will appear on attention that this principle is predominant."[19] He then assumes

that we all naturally respond to imitations and their adornments in common ways:

In genius for the arts, resemblance, the predominant principle of association, continually operates along with all the other principles, and, by uniting its force to theirs, causes them [to] suggest only, and suggest quickly, such ideas as are conducive to the imitation or representation which the artist has in view. The attributes, qualities, and circumstances of any subject, are connected with it by coexistence, and are naturally suggested to the imagination by this relation: the predominance of resemblance as an associating principle in the poet or painter, will make these to be suggested, whenever they are necessary for marking distinctly the object which he describes or represents; and it will make those of them to occur most readily which are properest for this purpose, even though they themselves be remote.[20]

Artistic genius consists in the ability to discover representations and the associations among them which are naturally proper for their purpose. Thus, just as scientific genius consists in the unusual ability to penetrate to causal connections which, once seen, will be accepted by all, so artistic genius consists in the unusual ability to create representations which, once created, will be accepted and appreciated by all. Either form of genius is rare, but its effects are assumed to be universal.

For all the emphasis upon the individuality of genius in the half-century or so after Gerard's essay – that is to say, in the Romantic period – the underlying assumption that genius is a rare talent to create works whose appeal can safely be assumed to be universal remains constant. We may see this in two representative figures from the height of the Romantic period, Samuel Taylor Coleridge and Ralph Waldo Emerson. Coleridge in fact does not characterize genius in terms of invention at all, but rather as a talent to make what is timeless seem as if it is new and original. In his words, "the character and privilege of genius, and one of the marks which distinguish genius from talents," is the ability "To find no contradiction in the union of old and new; to contemplate the ANCIENT of days and all his works with feelings as fresh, as if all had then sprang forth at the first creative fiat. . . . To carry on the feelings of childhood into the powers of manhood; to combine the child's sense of wonder and novelty with the appearances, which every day for perhaps forty years had rendered familiar."[21] Genius is not a gift for discovery or invention so much as for rediscovery of what, in some

sense, has been felt all along. And Coleridge assumes that what the genius in this sense rediscovers has been felt not only all along but also by all, so that the rediscoveries of the genius can readily be communicated to all: "And therefore is it the prime merit of genius and its most unequivocal mode of manifestation, so to represent familiar objects as to awaken in the minds of others a kindred feeling concerning them which is the constant accompaniment of mental, no less than of bodily, convalescence."[22] And even more clearly than in the case of Gerard, Coleridge's confidence in the universal validity of the discoveries of genius seems to be grounded in an objectivist conception of beauty itself. For Coleridge, basing his conception of artistic genius on the model of William Wordsworth, art does not seem to be representation so much as a transparent medium through which the beauty of the natural world itself is directly communicated to the audience for art, and he certainly assumes that the sense for natural beauty is innate and universal:

And what then is the beautiful? What is beauty? It is, in the abstract, the unity of the manifold, the coalescence of the diverse; in the concrete, it is the union of the shapely (*formosum*) with the vital ... it is not different to different individuals and nations, as has been said, nor is it connected with the ideas of the good, or the fit, or the useful. The sense of beauty is intuitive, and beauty itself is all that inspires pleasure without, and aloof from, and even contrarily, to interest.... Believe me, you must master the essence, the *natura naturans*, which presupposes a bond between nature in the higher sense and the soul of man.[23]

What the genius possesses is the talent for using art to make the beauty of nature as fresh as it was for us all as children, where what appears beautiful to us as children and once again through art is necessarily the same.

Ralph Waldo Emerson reaches a similar conclusion by emphasizing the universality of the subject rather than the object, that is, by insisting on what he calls the "Over-soul" or common human capacity for experience and thought rather than by characterizing the appeal of the object in the experience of beauty. In his famous essay "Self-Reliance," first published in 1841, Emerson seems to be the spokesman for individuality and self-expression understood as nonconformity, thus suggesting that there can be no guarantee that works of genius, as products of self-reliance, will be received with universal approbation, indeed

perhaps even that genius implies the impossibility of universal appro-
bation, or even the necessity of disagreement: "Whoso would be a
man must be a nonconformist. . . . Nothing is at last sacred but the in-
tegrity of your own mind."[24] However, Emerson's explicit definitions
of genius stress precisely the confidence that the genius can have in
the universal acceptability of his ideas. Thus, Emerson begins the same
essay by stating that "To believe your own thought, to believe that what
is true for you in your private heart is true for all men, – that is genius.
Speak your latent conviction, and it shall be the universal sense; for
the inmost in due time becomes the outmost."[25] And, in a later essay,
Emerson states his view of genius more fully by stating that genius con-
sists of two abilities of equal importance: the ability to discover what
seem to be new ideas and the ability to communicate those discoveries
with complete success to others:

In the intellect constructive, which we popularly designate by the word Genius,
we observe the same balance of two elements as in intellect receptive. The
constructive intellect produces thoughts, sentences, poems, plans, designs,
systems. It is the generation of the mind, the marriage of thought with nature.
To genius must always go two gifts, the thought and the publication. The first is
revelation, which is always a miracle. . . . It is the advent of truth into the world,
a form of thought now, for the first time, bursting into the universe, a child of
the old eternal soul, a piece of genuine and immeasurable greatness. . . . But
to make it available, it needs a vehicle or art by which it is conveyed to men.
To be communicable, it must become picture or sensible object. The most
wonderful inspirations die with their subject, if he has no hand to paint them
to the senses. . . . The rich, inventive genius of the painter must be smothered
and lost for want of the power of drawing, and in our happy hours we should be
inexhaustible poets, if once we could break through the silence into adequate
rhyme. As all men have some access to primary truth, so all have some art or
power of communication in their head, but only in the artist does it descend
into the hand.[26]

But Emerson is confident that the power of invention which is one-
half of genius is rooted in the common human mentality that he calls
the Over-soul, and thus is necessarily accompanied by the power for
communication that is the other half of genius. He has faith that the
experience and minds of individuals share a common essence:

We live in succession, in division, in parts, in particles. Meantime, within man is
the soul of the whole; the wise silence, the universal beauty, to which every part

and particle is equally related; the eternal ONE. And this deep power in which we exist, and whose beatitude is all accessible to us, is not only self-sufficing and perfect in every hour, but the act of seeing and the thing seen, the seer and the spectacle, the subject and the object, are one.[27]

And the genius in particular is characterized by his access to this Over-soul: "The same Omniscience flows into the intellect, and makes what we call genius.... It is a larger imbibing of the common heart. It is not anomalous, but more like, and not less like other men. There is, in all great poets, a wisdom of humanity which is superior to any talents they exercise."[28] The genius can be self-reliant and noncon-formist in the pursuit of his ideas because he also enjoys a degree of access to the Over-soul, which guarantees that in due course what he discovers or invents in this way will be accepted by others whose access to the Over-soul may not be as ready as his but who are, in the end, part and parcel of the same Over-soul or have the same access to it. As with others in the tradition of genius going back to Du Bos, Emerson really treats genius as a facility of access to ideas that is rare but which accesses ideas that are universally valid. There is no idea that with the benefit of genius also come the costs, at the very least, of working with-out any guarantee of universal acceptance and, at the worst, of actual discord and upheaval in the history of the works of the imagination.

2. ORIGINALITY

But Kant's account of genius recognizes precisely these risks, indeed, it portrays them as inevitable accompaniments of genius. While Kant characterizes aesthetic judgment in general as a claim to the universal subjective validity of our response to the genuinely beautiful or sub-lime, he at the same time acknowledges that this universal subjective validity is an "idea" rather than an empirical reality; likewise, although he characterizes genius as "exemplary originality," he understands the sense in which the originality of genius is "exemplary" precisely as both a provocation to and a model for the originality of others, thereby guar-anteeing that the works of genius will not constitute a stable canon but a locus of constant upheaval.

Kant defines genius as "the talent (natural gift)" or "inborn productive faculty" "that gives the rule to art," or more precisely

"**through which** nature gives the rule to art."[29] Kant immediately provides what might seem to be a misleading explanation of why genius must be conceived of as faculty for giving a rule to art. "Every art presupposes rules which first lay the foundation by means of which a product that is to be called artistic is first represented as possible," he says, but

The concept of beautiful art does not allow the judgment concerning the beauty of its product to be derived from any sort of rule that has a **concept** for its determining ground, and thus has as its ground a concept of how it is possible. Thus beautiful art cannot itself think up the rule in accordance with which it is to bring its product into being. Yet since without a preceding rule a product can never be called art, nature in the subject (and by means of the disposition of its faculties) must give the rule to art, i.e., beautiful art is possible only as a product of genius.[30]

One might think, like Du Bos, that the rules in art concern only the techniques that must be mastered by any competent practitioner of a particular medium of art, whether genius or journeyman, and that genius should consist just in that gift of talent and inspiration by which the truly successful artist goes beyond the mechanical or technical rules of his medium – rules should be a necessary but not sufficient condition for artistic success, and genius should be that by which the artist breaks free of rules instead of being bound by them. But such a response to Kant's statement would misunderstand his position on several counts. First, since Kant treats art as a species of intentional and rational human production,[31] there must be some sense in which the whole of an artist's productive activity is guided by a conception of its desired outcome and the steps to be taken in order to achieve that outcome; a model on which part of the artist's work was guided by rules, but part, indeed the most important part, was left to anything like mere chance would not be a model of rational activity. Second, while a natural way of mapping a conception of artistic production as partly rule-governed and partly not on to the kind of mimetic or representational art that Kant takes as paradigmatic would be to treat the invention of the content for a work of art as a matter of inspiration but the mastery of the medium for its expression as a matter of mere convention, Kant makes it clear that, in truly successful art, genius lies in the invention of both the content and the form for its

expression; genius, "as a talent for art... presupposes a determinate
concept of the product, as an end, but also a representation (even if in-
determinate) of the material, i.e., of the intuition, for the presentation
of this concept."[32] But, third and most important, Kant supposes that
the pleasure in all beauty is intersubjectively valid – that is, that under
ideal conditions any beautiful object ought to please all observers of
it – and thus that a beautiful work of art, as the product of intentional
activity, aims to produce an intersubjectively valid response and judg-
ment; thus, a work of art aims to be a rule for all, something that all
ought to find beautiful or otherwise appropriately satisfying.[33] A work
of art must not just be produced in accordance with certain rules, but
must itself be a rule, something that all should find satisfying.

But why should genius be necessary to achieve such a result? Why
can't an artist simply follow known rules in order to produce an ob-
ject that will be exemplary, or itself a rule for the pleasure of all?
The answer to this lies in Kant's account of beauty itself, according
to which our pleasure in beauty lies not in the sheer fact of mimesis
or its adornment, as in a theory such as Gerard's, but in the free play
of the cognitive powers of imagination and understanding induced
by a beautiful object, a play that is experienced by us with a sense of
contingency, and thus precisely as the freedom of the beautiful object
from visible constraint by determinate concepts or by known rules for
its form and matter, which would play the same role as determinate
concepts. In the introduction to the *Critique of the Power of Judgment*,
Kant asserts his view first as a thesis about "subjective purposiveness" in
the representation of nature. Here he expresses his view by means of
his contrast between "determining" and "reflecting" judgment, where
the former seeks to find a particular to which to apply a given concept
while the latter seeks to find a concept that is not given to apply to
a particular that is.[34] In the case of the judgment of beauty, however,
the model of reflecting judgment must be understood loosely, because
reflection on the perception of the object leads to a sense of compre-
hension that cannot be captured by any determinate concept at all,
although on the basis of such an indeterminate comprehension of the
object the concept of beauty itself can ultimately be applied to it:

If pleasure is connected with the mere apprehension (*apprehensio*) of the form
of an object of intuition without a relation of this to a concept for a determinate

cognition, then the representation is thereby related not to the object, but solely to the subject, and the pleasure can express nothing but its suitability to the cognitive faculties that are in play in the reflecting power of judgment, insofar as they are in play, and thus merely a subjective formal purposiveness of the object.[35]

Kant then equates this "subjective purposiveness" with beauty, adding, what he will subsequently defend, that such a response is universally valid:

That object the form of which (not the material aspects of its representation, as sensation) in mere reflection on it (without any intention of acquiring a concept from it) is judged as the ground of a pleasure in the representation of such an object – with its representation this pleasure is also judged to be necessarily combined, consequently not merely for the subject who apprehends this form but for everyone who judges at all. The object is then called beautiful.[36]

In the central section of the "Analytic of the Beautiful" that he calls the "key to the critique of taste," Kant characterizes this play of cognitive faculties as a free play: "The state of mind in [the] representation [of a beautiful object] must be that of a feeling of the free play of the powers of representation in a given representation for a cognition in general," and again adds that, since a judgment of beauty claims universal validity for the pleasure in such a state of mind, "This state of a **free play** of the faculties of cognition with a representation through which [a beautiful] object is given must be able to be universally communicated," that is, "valid for everyone."[37] A successful work of art is thus one which pleases us precisely because both its content and its form induce a free play of our imagination and understanding in a way that cannot appear to be dictated by any determinate concept or rule, but which is nevertheless itself a rule or norm for everyone in the sense that, under ideal circumstances, it should please everyone by inducing the same pleasure in the free play of these cognitive faculties. In natural beauty, such as that of a flower or a sunset, it is the form of an object produced by nature without human intervention that induces this free play of imagination and understanding; artistic beauty must be both produced by rational human activity and not produced in accordance with a visible rule, so Kant construes it as the product of nature working through the medium of a human being to produce

something that is not visibly rule-governed but yet is itself a rule for the pleasure of all.

This analysis of artistic beauty entails that truly successful art must always possess what Kant calls "exemplary originality":[38] originality, because the successful work of art can never appear to have been produced in accordance with a rule but must always strike us with an element of contingency or novelty; yet exemplary, because it must at the same time strike us as pleasing in a way that should be valid for all. Originality by itself, to be sure, is easy to achieve: just make something that departs from all known rules and models. Of course, in this way a lot of nonsense will be produced, so what Kant calls "original nonsense" is easy to come by. The trick is to produce exemplary originality, objects which, "while not themselves the result of imitation ... must yet serve others in that way, i.e., as a standard for judging,"[39] or objects that strike us as original in appearing to depart from known rules and models but which can themselves be pleasing to all or a rule for all. Thus, in Kant's view, all truly successful art must be the work of genius.

This characterization of successful art makes the reception of art a delicate matter. First, since the essence of the response to any form of beauty is the feeling of the free play of imagination and understanding, a successful work of art must be an expression of the free play of imagination and understanding that has occurred in the artist, but yet leave room for a sufficient degree of free play of imagination and understanding in the members of its audience for them to take pleasure in the object – which depends, after all, precisely on their experiencing of the freedom of their own cognitive powers, not on their knowledge that the artist exercised such freedom. The work of art must be the product of intentional activity, and must be recognized to be such by the audience if it is to be classified and thus understood and appreciated as a work of art at all; and yet the artist's intention for his work cannot appear to dictate the response of its audience completely, for that would eliminate the audience's sense of the free play of its own imagination and thus block the very effect – of beauty – that the artist aims to achieve. This is why Kant says that "the purposiveness in the product of beautiful art, although it is certainly intentional, must nevertheless not seem intentional; i.e., beautiful art must be **regarded** as nature, although of course one is aware of it as art."[40] That is, the artist must both have and be recognized to have a hierarchy of intentions in

his production of a work – the intention, for example, to write a string quintet in sonata form, in the key of A major, and on the theme of the song *Die Forelle*, but above all the intention to please by inducing the free play of imagination and understanding in his audience – but precisely because of the aim of the last of these intentions, none of the other intentions that go into the production of the work can be such as fully to determine the character of the audience's response to the work. In order to produce a genuine response to beauty, the artist's overarching intention for his work must be to leave his audience a significant degree of freedom from the constraint of his intentions.

Now, in his examples Kant stresses only the most obvious consequence of this, namely, that the artist must not visibly manipulate his audience, like the jolly landlord who tricks his guests by hiding in his bushes a mischievous youth who can imitate the lovely song of a nightingale.[41] Of course, deception is something that can displease us on moral grounds alone, and no doubt our moral displeasure at outright deception or manipulation will block any favorable aesthetic response we might otherwise have to an object. But Kant's fundamental analysis of beauty imposes a more subtle constraint on successful art: certainly the artist, like anyone else, must forego outright deception or manipulation, but even once he has satisfied that basic moral constraint he must still create a work that is both an expression of his own freedom of imagination and understanding and also leaves room for the free play of imagination and understanding in his audience. This means that each member of the audience must be able to contribute something of his own to the reception of a work of artistic genius, and thus that there can never be complete uniformity in the synchronic or diachronic reception of a truly successful work of art. Precisely because what must be universal in the response to a beautiful work of art is the feeling of the free play of the cognitive powers, the exact form this free play takes in each respondent to the work cannot be felt to be the same by all respondents. This consequence of Kant's theory of genius is not implied by any of the other theories we have considered.

Second, Kant's account of genius entails that there must be a history of constant tension between the work of one successful artist and that of other equally successful artists, for to other artists what will be exemplary in the genius's work is not so much the product as the

originality of its production, which will be both encouragement and
provocation for other artists to depart from the path set out by the
first rather than to remain within it. A work of genius will be exem-
plary in a twofold sense: it sets a "standard or a rule for judging" itself,
to be sure – that is, it claims that all properly equipped and situated
observers ought to find it satisfying; but it also sets a standard for orig-
inality that other works and other artists can satisfy only by departing
from the model of the first. Works of genius, Kant says, must serve
others "as a model not for **copying** [*Nachmachung*] but for **imitation**
[*Nachahmung*]," that is, as a "product, against which others may test
their own talent" or originality.[42] Or, to put the point another way, "the
rule must be abstracted from the deed" or action (*Tat*): it is the genius's
productive activity rather than his product which must be the model
for other artists. This is the case, of course, because, in order for them
to achieve beauty, their works too must appear to their audience to be
free from constraint by rules, including the rules that might be set by
the successful works of previous geniuses and that can be presumed
to be known to their audience.

In this way the product of a genius (in respect of that in it which is to be
ascribed to genius, not to possible learning or schooling) is an example, not
for imitation (for then that which is genius in it and constitutes the spirit of
the work would be lost), but for emulation [*Nachfolge*] by another genius, who
is thereby awakened to the feeling of his own originality, to exercise freedom
from coercion in his art in such a way that the latter thereby itself acquires a
new rule, by which the talent shows itself as exemplary.[43]

The successors to a genius thus have the doubly difficult task of staking
out room for the freedom of their own imagination and understanding
from domination by their predecessors while at the same time leaving
room for the free play of imagination and understanding in their
audience – an audience that will in fact include not only the mere
consumers of their art, who are never, given Kant's account of aesthetic
response as free play, mere or merely passive consumers, but also those
producers of art who will succeed them as they have succeeded their
own predecessors.

This double task is difficult to accomplish, and the true genius is
always a rare "favorite of nature." Leaving aside the question of how
often works of genius will find their ideal audience, ready to meet the

freedom of the artist's imagination and understanding with that of their own, Kant suggests that the majority of artistic producers following and responding to any example of genuine genius will fall into two camps: on the one hand, there is likely to be a "school" of followers, other artists seeking "a methodical instruction in accordance with rules, insofar as it has been possible to extract them from those products of spirit and their individuality," who may well descend to mere "aping" (*Nachäffung*), copying "everything, even down to that which the genius had to leave in, as a deformity," and even more likely losing the very spark of originality that made the work of genius exemplary in the first place; on the other hand, work of genius will also inspire "**mannerism**," that is, "mere **individuality** (originality) in general, in order to distance oneself as far as possible from imitators, yet without having the talent thereby to be **exemplary** at the same time."[44] In other words, since works of genius are naturally models and provocations for others yet genius is rare, the majority of what is inspired by works of genius is likely to consist of work that is exemplary but lacking originality on the one hand, or original without being exemplary – original nonsense rather than exemplary originality – on the other.

So Kant's theory of genius does not suggest, as its contemporaries did, that genius is simply a rare capacity to discover ideas and forms for their expression which, once discovered, will be understood and appreciated by all in exactly the same way. Kant's story is more complex. First, while every work of art, in striving for beauty also strives for universal validity, at the same time, since beauty itself depends on the feeling of the free play of the cognitive faculties of its perceiver, every successful work of art must also generate a variety of responses. To be sure, such variety in the *content* of different individuals' responses to the same work of art might be compatible with a uniform *level* of satisfaction in the work, but in practice even that will undoubtedly be difficult to attain. Second, as someone who must be both exemplary and original, an artistic genius will provoke three kinds of response among his or her artistic successors: a school of copiers, for whom the work will be exemplary in everything except its originality; mannerists, who will be provoked to originality without producing anything exemplary; and, in rare cases, other geniuses, whose work must necessarily depart from that of their predecessors in some essential respects. Thus, Kant's conception of genius guarantees that the history of art will be

one of variety in response as much as agreement in valuation; constant upheaval in forms of artistic success; and, inevitably, great amounts of waste, academic on the one hand and mannerist on the other. This has the ring of truth,[45] something that every age ought to remember as it complains about its flood of second-rate art: there really is no other way in which the occasional works of genius, which tend to be the only ones we remember from past epochs, thereby making genius seem more prevalent in the past than in the present, could emerge.

To be sure, in the end Kant seems reluctant fully to embrace the implications of his own account of genius. Having analyzed genius in a way that guarantees a perpetual sequence of both experimentation and waste in the history of art, he suddenly asks what must happen when there is a clash between genius and taste, and asserts:

If anything must be sacrificed in the conflict of the two properties in one product, it must rather be on the side of genius: and the power of judgment, which in matters of beautiful art makes its pronouncements on the basis of its own principles, will sooner permit damage to the freedom and richness of the imagination than to the understanding.

In other words, "Taste, like the power of judgment in general, is the discipline (or corrective) of genius."[46] Kant attempts to justify this assertion, so reminiscent of Gerard's insistence that "to render genius complete, fertility and regularity of imagination must be united,"[47] by suddenly aligning genius with imagination, and taste with judgment or understanding, and then maintaining that in any clash between these faculties the latter must surely be privileged over the former. But since throughout his argument Kant has argued that both genius and taste depend upon harmony between imagination and understanding, this new alignment is unexplained. Kant's thesis that, if necessary, taste must clip the wings of genius is probably better understood simply as another expression of his basic commitment to the intrinsic value of agreement in judgment itself, one that has manifested itself at other points in his argument as well.[48] But, although Kant structures the whole "Critique of the Aesthetic Power of Judgment" as an explanation of how we can reasonably claim intersubjective validity in judgments of taste, he never explains why it is so important that we actually be able to attain such agreement. He thus leaves us free to make our own judgment that, if the innovation of artistic genius can come only at the

price of short- or long-term disagreement in our judgments of taste, the benefit may ultimately outweigh the cost.

3. THE VALUE OF ORIGINALITY

Kant's account of genius makes variety and upheaval in the world of art inevitable, but as we have just seen he hesitates to embrace the limitation on our expectation of agreement in matters of taste that would seem to follow. Is there anything that could make the variety, upheaval, and even waste of artistic effort that must accompany the workings of genius seem valuable rather than lamentable? Here we can turn to a figure not usually mentioned in discussions of genius, John Stuart Mill (though we should keep in mind that Mill saw himself as the heir of Coleridge as well as of Bentham). Mill did not write a treatise on genius like an eighteenth-century divine, nor did he include a chapter on it in a systematic treatise, like a nineteenth-century aesthetician. But he uses the example of artistic genius to illustrate his arguments for the value of freedom of thought and expression in the central chapter 3 of *On Liberty* (1859). Like Kant, Mill conceived of genius as originality that is exemplary in its ability to stimulate others to originality as well, and part of its value is precisely that it does this:

I insist thus emphatically upon the importance of genius, and the necessity of allowing it to unfold itself freely in both thought and in practice, being well aware that no one will deny the position in theory, but knowing also that almost every one, in reality, is totally indifferent to it. People think genius a fine thing if it enables a man to write an exciting poem, or paint a picture. But in its true sense, that of originality in thought and action, though no one says that it is not a thing to be admired, nearly all, at heart, think that they can do very well without it. Unhappily this is too natural to be wondered at. Originality is the one thing which unoriginal minds cannot feel the use of. They cannot see what it is to do for them: how should they. If they could see what it would do for them, it would not be originality. The first service which originality has to render them, is that of opening their eyes: which being once fully done, they would have a chance of being themselves original.[49]

Of course, that genius is a stimulus to originality beyond itself will be no explanation of its value unless originality is valuable in itself, and that is what the larger argument of Mill's chapter 3 aims to establish. His argument falls into two parts: one, actually the second, in which

this passage occurs, that originality has instrumental value; the other, that originality has intrinsic value. The argument that originality has instrumental value is simply that originality is the only source for new truths and practices, of which mankind is always in need: "There is always need of persons not only to discover new truths, and point out when what were once truths are true no longer, but also to commence new practices, and set the example of more enlightened conduct, and better taste and sense in human life."[50] This implies, along the way, Mill's recognition that both variety and change are inevitable features of the human condition, in tastes for art as well as in everything else, because the circumstances of individuals vary both within a particular period and over time, so that "at the maturity of his faculties" each individual must "find out what part of recorded experience is properly applicable to his own circumstances and character";[51] it could also be amplified, along the lines of Mill's argument in chapter 2, with the observation that new inventions in every sphere of human activity are necessary not only to help us discover new truths and practices and jettison those which are no longer valuable, but also to test and reaffirm those which are of continuing value. In these thoughts, it should be noted, Mill presumably does not use the case of artistic genius as just an analogue for creativity in more important areas of science and policy; it should surely be part of Mill's thought that new thoughts and practices important for human welfare can emerge through the fine arts as well as from anywhere else.

Beyond all this, however, Mill also argues for the intrinsic value of genius and originality, with a claim applicable to artistic genius as well as to any other form of human originality:

It is not by wearing down into uniformity all that is individual in themselves, but by cultivating it and calling it forth, within the limits imposed by the rights and interests of others, that human beings become a noble and beautiful object of contemplation; and as the works partake the character of those who do them, by the same process human life also becomes rich, diversified, and animating, furnishing more abundant aliment to high thoughts and elevating feelings, and strengthening the tie which binds every individual to the race, by making the race infinitely better worth belonging to.[52]

In other words, the sheer variety of human beings and their products is something worth contemplating, perhaps the greatest thing worth contemplating, quite apart from the value of any particular

productions – the sheer variety of human genius should be just as important to us as the value, intrinsic or instrumental, of any restricted canon of objects. This is perhaps Mill's most basic thought in *On Liberty*, and although he says nothing about the philosophical status of this premise, it might be suggested that it is itself an aesthetic thought – Mill's statement that it is through their variety and the variety of their productions "that human beings become a noble and beautiful object of contemplation" certainly exploits the terminology of classical aesthetics. But whatever the character of Mill's argument, it should be clear that the intrinsic rather than the instrumental value of genius, artistic or otherwise, lies precisely in the fact that it is a source of diversity rather than uniformity in human experience.

This passage of Mill might seem Emersonian in its elevated tone, but Mill's position is diametrically opposed to Emerson's. Emerson's thought is that every discovery of genius is a discovery of part of the single common human experience, the Over-soul that unites the individual souls of all. Mill's idea is that there is, at one level of abstraction, some one thing that is or should be common to all human beings – namely, their enjoyment of the spectacle of human diversity – but of course what is enjoyed *in concreto* is precisely the diversity rather than the uniformity of particular human experiences. There is no room for the thought of an Over-soul in Mill's empiricism, although there is certainly room for a common sense of the fascination of human diversity that could be developed by all enlightened persons.

Putting Kant and Mill together, then, we might conclude that genius, as exemplary originality, is an engine of diversity and change as well as of universal validity in art, as elsewhere, yet that this is not merely a fact about human history and experience to be observed or even lamented, but rather something to be celebrated – itself one of the fundamental sources of satisfaction in human existence. Kant undermines the confidence of both his predecessors and his successors that the exemplarity of originality can be simply equated with uniformity of thought and feeling, but Mill portrays this result as itself an object of aesthetic satisfaction.

Notes

1. l'Abbé Du Bos, *Critical Reflections on Poetry and Painting*, trans. Thomas Nugent (London: John Nourse, 1748).

2. Ibid., 2:1–2.
3. Ibid., p. 3.
4. Ibid., p. 5.
5. Ibid., pp. 7–8.
6. Ibid., p. 7.
7. Alexander Gerard, *An Essay on Taste* (London: A. Millar, 1759).
8. Alexander Gerard, *An Essay on Genius* (London: W. Strahan, 1774); facsimile reprint with modern introduction edited by Bernhard Fabian (Munich: Wilhelm Fink Verlag, 1966).
9. Kant's insistence that genius is manifest only in fine art, not natural science, is clearly intended as a reply to Gerard's thesis that genius is manifest in both; see Kant, *Critique of the Power of Judgment*, §57. However, this issue will not be central to the points I shall make about Kant below.
10. Gerard, *Essay on Genius*, pp. 7–8.
11. Ibid., p. 8.
12. Ibid., p. 54.
13. Ibid.
14. Ibid., pp. 56–7.
15. Ibid., p. 318.
16. Ibid., p. 323.
17. Ibid.
18. Ibid., p. 325.
19. Ibid., pp. 33–4.
20. Ibid., pp. 349–50.
21. Samuel Taylor Coleridge, *Biographia Literaria, with his Aesthetical Essays*, ed. J. Shawcross (Oxford: Oxford University Press, 1907; corrected edition, 1954), 1:59.
22. Ibid., pp. 59–60.
23. Coleridge, "On Poesy or Art," in *Biographia Literaria*, 2:256–7.
24. Ralph Waldo Emerson, "Self-Reliance," in *Essays: First Series* (1841), in Emerson, *Essays and Lectures*, ed. Joel Porte (New York: The Library of America, 1983), p. 261.
25. Emerson, "Self-Reliance," *Essays and Lectures*, p. 259.
26. Emerson, "Intellect," *Essays and Lectures*, pp. 422–3.
27. Emerson, "The Over-Soul," *Essays and Lectures*, p. 386.
28. Emerson, "The Over-Soul," *Essays and Lectures*, p. 396.
29. Kant, *Critique of the Power of Judgment*, ed. Paul Guyer, trans. Paul Guyer and Eric Matthews (Cambridge: Cambridge University Press, 2001), §46, 5:307; pagination as in *Kant's gesammelte Schriften*, vol. 5, ed. Wilhelm Windelband (Berlin: Georg Reimer, 1913).
30. Ibid., §46, 5:307.
31. Ibid., §53, 5:303.
32. Ibid., §49, 5:317.
33. I use this expression to leave room for the possibility that art may seek to satisfy otherwise than through beauty, for instance, through sublimity.

Kant himself sees sublimity as a characteristic of nature rather than art, but of course he is rarely followed in this regard.

34. Kant, *Critique of the Power of Judgment*, First Introduction, V, 20:211; published Introduction, §4, 5:179.
35. Ibid., Introduction, VII, 5:189–90.
36. Ibid., 190.
37. Ibid., §9, 5:217. The interpretation of this section is highly controversial. For my account of how it needs to be untangled, see "Pleasure and Society in Kant's Theory of Taste," in Ted Cohen and Paul Guyer, eds., *Essays in Kant's Aesthetics* (Chicago: University of Chicago Press, 1982), pp. 21–54. For a rejection of my account, see Hannah Ginsborg, "Reflective Judgment and Taste," *Nous* 24 (1990): 63–78.
38. Kant, *Critique of the Power of Judgment*, §46, 5:308.
39. Ibid.
40. Ibid., §45, 5:306–7.
41. Ibid., §42, 5:302.
42. Ibid., §47, 5:309.
43. Ibid., §49, 5:318.
44. Ibid.
45. Everyone will have their own favorite examples of artistic waste. My most striking experience of academic waste came at the Prado, where three rooms of splendid work by Velázquez are followed by twice as many filled with his lackluster imitators, and the half-dozen rooms of brilliant Goyas are followed by numerous and uninteresting Goyesques.
46. Kant, *Critique of the Power of Judgment*, §50, 5:319–20.
47. See note 13.
48. For example, Kant's exclusion of color and tone from the proper objects of taste simply because we are more likely to disagree in our responses to them than in our responses to spatial or temporal structure; see *Critique of the Power of Judgment*, §14, 5:223–5, and Paul Guyer, *Kant and the Claims of Taste*, 2d ed. (Cambridge: Cambridge University Press, 1997), pp. 199–210.
49. John Stuart Mill, *On Liberty*, in *Essays on Politics and Society*, vol. 18 of the *Collected Works of John Stuart Mill*, ed. J. M. Robson (Toronto and London: University of Toronto Press and Routledge & Kegan Paul, 1977), p. 268.
50. Mill, *On Liberty*, in *Collected Works*, 18:267.
51. Ibid., p. 262.
52. Ibid., p. 266.

5

The Inexplicable

Some Thoughts after Kant

Ted Cohen

When Kant turns to the question of how beautiful art can be created, he encounters a problem in need of a solution. The problem is created by Kant's own, earlier conception of how beauty is judged. Here is a brief, crude, oversimplified report of Kant's reasoning.[1]

It begins with Kant's argument that in judgments of beauty no rule is being applied to determine whether the object is beautiful. (In fact there is no *argument* for this in Kant's text, only the continued assertion.) Judging something to be beautiful, according to Kant, is profoundly different from judging something to be, say, a rose, or a flower. In judging something to be a rose or a flower or a novel, for instance, the judge is making use of a rule. Such a rule is what Kant calls a 'concept'. But when judging something to be beautiful, according to Kant, the cardinal feature of such a judgment is that the judge is not applying any predicate concept. Then, when Kant turns to a consideration of how beautiful objects might be made – made by human beings, that is, as opposed to beautiful natural objects – he implicitly invokes what might be thought of as a kind of Aristotelian understanding of "making." On this understanding, a maker – someone engaged in the deployment of "productive wisdom" – begins with a conception of the object-to-be, and then brings into existence an object adequate to that conception. At this point Kant argues that the maker of a beautiful object cannot be employing such a concept because it has already been established that any judge of the beauty of this object cannot be making use of a concept, and thus no concept is available to the maker. As it

stands, this argument is unsound: it is entirely possible that the maker is using a concept, but that this concept not be used by the judge. In fact, the maker will have to have some concept or other just in order truly to *make* something and not engage in random activity. It is only that this concept cannot be used to judge the beauty of what he makes. Thus one might create beautiful objects, as it were, peradventure.

It may seem that Kant is obviously correct about this matter, and that I am only introducing a confusion. To see the problem, consider this: according to Kant it is perfectly possible for there to be "determinate," "logical" propositions (explicitly not aesthetic ones, and certainly not judgments of taste) such as, in his own example, 'Roses in general are beautiful', and for such propositions to be true. If that is so, then it is at least possible that there be such propositions concerning made objects, objects of fine art. Suppose, for instance, that photographs of roses, perhaps made in some specific way, in general were beautiful. Then a photographer might well set about making a beautiful object, and he would do so by making a photograph of a rose. He would thus be using the concept *photograph of a rose* as the rule employed in what he was doing, but he would have good reason to suppose that the result of this rule following would be a beautiful object.[2]

It is not hard to correct Kant's argument, however, and it is clear enough what he has in mind. If we think of the maker as self-consciously setting out to make a beautiful object *as such*, then the model of making presupposed requires the maker to be making use of a concept of beauty, or at least a concept of, say, a beautiful tune or image or poem. And then Kant will be right to say that, if this were a possibility, then that very concept would be available for appraising the beauty of the result, and he has already declared that no such rule-governed appraisal is possible.

Then how does the beauty maker do what he does? In answering, Kant invokes the idea of "genius," which, at the start, he defines merely as the ability to make beauty.[3] So far, this is a stunningly empty idea: it is nothing more than a declaration that in order to make beautiful objects one must deploy the talent for doing that. (This is the sort of thing my friend and colleague Bill Wimsatt calls 'a wastebasket explanation'.) But Kant is aware of this, and attempts to supplement this so-far entirely empty description of genius with a constructive description, and this description declares that genius is the capacity to

produce "aesthetic ideas." Because these ideas are neither intuitions nor concepts in Kant's strict senses of those terms (in fact they are a kind of bloated intuition, an intuition too ample to be subsumed under any concept), they cannot be used in the judgment of the beauty of the object.

I have doubts that this thesis of Kant's can be rendered coherent, but I will let it stand.[4] What I would not like to see left standing is a further conclusion Kant draws when he declares that Newton's work does not evince genius. I am not objecting to the palpable absurdity in denying that Newton was a genius (whereas, according to Kant, Wieland was).[5] After all, this depends on what one means by "genius," and Kant is entitled to use the word as he has defined it, and Kant does credit Newton's work with requiring "however great a mind." But even as he has defined genius, his reasoning about Newton is a blunder. This is Kant's reasoning: as brilliant, original, and seminal as Newton's work is, it is entirely explicable in terms of concepts. Thus it is these concepts that Newton made use of in creating his work, and the use of such concepts is not the work of genius.

Kant's reasoning is flawed. From the fact (if it is one) that Newton's *Principia* is explicable conceptually, nothing whatever follows about how, in fact, Newton produced the work. Kant evidently does think that something follows, for he says "that Newton could show how he took every one of the steps he had to take in order to get from the first elements of geometry to his great and profound discoveries. . . ."[6] But nothing follows about the steps that Newton took, much less about any steps he "had to take." Newton's presentation of his discovery may or may not mirror his own initial reasoning. It may help in appreciating this fact to consider a wonderful observation made by C. S. Peirce concerning the ancient Greek discovery that the angles at the base of an isosceles triangle are equal. Peirce writes:

Now, everybody sees immediately from the symmetry of the thing . . . that the angles are equal. It is a triangle with the vertex at the center of a circle, and the other two on the circumference. It is evident the angles are equal. But, nevertheless, the Greeks had to demonstrate it, and this Euclid does by means of the singularly awkward proof, the celebrated *Pons asinorum* which has made so many boys conclude they have no capacity for Geometry because this proof, the first one of any difficulty in Euclid, leaves the proposition to their minds less evident than they found it.[7]

For a final example, I offer the experiences of my fellow graduate philosophy students of many years ago, for whom one of the more challenging tasks was to achieve at least some understanding of Gödel's Incompleteness Theorems. We were expected to be able to state the theorems, explain what they mean, and sketch at least some parts of proofs of these theorems. We did this, mostly, by following some proofs of the theorems offered by various commentators and teachers, and almost never did we learn the theorems from Gödel's own, original essays. When we had mastered the details of a proof, say, of the First Incompleteness Theorem, we might have inferred that Gödel himself went through the steps we had learned to go through in achieving our understanding of his theorem. But we would have made a mistaken inference. Later, when I had studied the Gödel paper itself, I was surprised at some features of Gödel's own exposition, especially where it differed from the proof as I had learned to give it. What this example shows is that from understanding a proof of Gödel's Theorem, however systematic that understanding may have been, I could not even infer how Gödel himself might have presented a proof of the theorem, and all the less could I infer how Gödel *came* to his discovery. In fact, even with Gödel's paper in hand I am still unable to infer how Gödel historically made his discovery.

What these examples are meant to show is that, given a complete explication of some theses, say Gödel's theorems or the equiangularity of the base of an isosceles triangle or propositions in Newton's *Principia*, it is in general an error to suppose that the discovery of these theses proceeded as the proofs do. And it is still a mistake to suppose that the author must have followed some particular series of steps in arriving at his discovery and that these steps must be capable of being articulated conceptually. Did Euclid think, at the beginning, to inscribe the triangle in a circle? Did Gödel, right from the start, formulate the idea of numeralwise expressibility? Who knows?

So Kant goes wrong in his argument about Newton. But I think he is only half wrong in his general thesis. Let us call the product of some scientist or poet X. Let us suppose further that this product is explicable, by which I mean, very roughly, that X can be demonstrated perhaps, or, if X is a lyric poem, that X can be explained, perhaps by being paraphrased. It will be a mistake to suppose that the creator of X himself went through the demonstration or paraphrase in arriving

at X. But what if, in some sense, X is not explicable: it cannot be proven, cannot be explained, cannot – in Kant's sense – be subsumed under concepts as a way of rendering it tractable. In such a case Kant might be exactly right in saying that we cannot attribute to the creator any rule-governed procedure he might have followed in arriving at X.

Kant thinks we can find an explication for any scientific or mathematical thesis, but not for any genuinely beautiful work of art, and perhaps he is right about that. Thus we can, at least in principle, explain the sense of many made objects, but if the object is beautiful art, in principle, we cannot give any explanation. We thus find the object, the beautiful art, sensible, coherent, and, if Kant is right, even agreeable, and we find ourselves permanently unable to explain why. And here is Kant's question: how can anyone make such an object?

There is something to the idea that the comprehension of a made thing is related to one's imagination of the thing's being made. Even if one does not uncover what actually went on in the mind of the maker, still, it helps to think of *why* and *how* the thing was made to be as it is. One way of explaining something is to present a story of how and why it might have been made, and therein, perhaps, to imagine making the thing oneself. It is perhaps not too great a stretch to suppose that in understanding X, I do something like imagining myself to make X, to think of why and how I might make it. Taken as a very general point, and left shamelessly undetailed, we might think of this as a way in which we understand a great variety of things that people produce, including works of art, scientific theses, and ordinary units of language. But in some cases we may be unable to find any explication of the thing itself, and thus, correspondingly, be unable to think at all concretely of the thing's being made. I believe this is how Kant thinks it is with beautiful art, those objects he calls the works of genius. His own examples are of symbolic representational works of visual art, and of lyric poetry. It will do here, I hope, to take as examples, figures of speech. I am one of those unreconstructed romantics who suppose that with a genuinely rich metaphor there is no way to render its significance in any other words, and certainly not in words entirely literal.

How do we understand ordinary words on ordinary occasions? No one has a complete and compelling answer to this question, but let us suppose that something happens along lines suggested by Paul Grice.[8] Someone wishes to communicate to you his opinion that the radiators

have been turned off, and he says, "I think the radiators have been turned off". It is because saying those words is an apt way of expressing that opinion (perhaps for reasons like those offered by Grice) that upon hearing those words you are able to infer (in some sense) the opinion that lies behind them, and this is to say that you can (in some sense) imagine yourself using those words, realizing that you would be using them in order to express that opinion about the radiators. But what if the words are not so ordinary? What if what has been said, or written, were one of these? –

> Do not go gentle into that good night.
> Bare ruined choirs, where late the sweet birds sang.
> He is a tabula rasa no one has written on.
> Miles Davis is the Picasso of jazz.
> Wagner is the Puccini of music.

Here, again, I think, one must do something like "figure out" what the author of these lines had in mind, but there is a difference: there seems to be no regular routine, no method, certainly no algorithm by means of which one might do that.

Grice himself does not propose that there is an *algorithm* for achieving understanding, certainly not in every case of ordinary language. One might assume, to begin with, that what a speaker means is what his words mean. When that assumption is blocked, one moves to the supposition that what is being communicated (what is being "implicated," in Grice's term) is something other than what the words mean, and one has then to make some inference to what the speaker means. This inference will not be algorithmic, but it will be at least loosely controlled. Notice, for instance, that when the speaker is being ironic, what he means is something like the "reverse" of what his words mean. The hearer will have to discover the possibility that the speaker's meaning is not what his words mean, and then he will have to try the possibility that the speech is ironical, and in doing this he will, virtually, apply a function to the words in order to arrive at their reverse, and, finally, see whether he can attribute this reversed-meaning to speaker.

So I am not suggesting that, even on a Gricean understanding, ordinary language is understood mechanically. I suggest only that there are much more determinate routines underlying that understanding than are available to be used when understanding metaphorical language.[9]

I know that this idea is probably too vague, and certainly it is tendentious, but what I am relying on is this: if you want to tell us you think the radiators have been turned off, you will find the words, as it were, already in place, however they came to be there. But if what you have to communicate is something carried by a rich, lively metaphor (any of the five earlier examples might do), you will not have found its words waiting for you. You will have had to find them, to make them up. In a word, you will have had to create them. It follows that your audience will not be able simply to look behind the words for whatever you might have had in mind, assuming that it is whatever it is that already goes with those words. They may well have to engage in an act of imagination, trying to place themselves in a position in which they, too, would choose those words. I have become persuaded that this is exactly what must be done, from time to time, in order to comprehend instances of figurative language, and also fully to appreciate some works of art, where one imagines oneself to be the artist; but there will be no routine way in which to do this.

Now of course there are ways of dealing with metaphors, and with works of art in general, but there is merit in the romantic idea that there are no formulas for doing this, and this mirrors the idea that there are no recipes for making them in the first place. Thus not only is something special required in the making of such a thing, but something special will be required in appreciating it. If a work of art is "original," significantly novel, then it will require some originality and enterprise on the part of those who can grasp it.[10]

If "creativity" is the capacity to make such a thing, then maybe there is nothing much more to say about creativity, and perhaps Kant was not wrong to offer that wastebasket explanation, declaring that genius simply is the talent for making those things that have no canonical explanations. And if we can give no explanation of the sense of a thing, neither will we be able to give any explanation of how it came to be made. I would not regret that. It is not only good to live with things we cannot domesticate: it is essential.

There is a freedom in this, both for the maker and for the appreciator. There is more than a little vagueness in the idea that regular, ordinary language, and routine making of canonical objects are activities carried out in accordance with rules. But to the extent that

this idea is compelling, it is equally significant that there are uses of language, and there are kinds of objects (notably, if not exclusively, works of art) that are not, in this sense, whatever that sense may be, controlled by the rules being followed, for there seems to be no comprehensive rule following. No doubt there were rules involved, for instance, when Mozart wrote the harmonies and key changes for *Don Giovanni*. But what rule can he have followed when he (perhaps in collaboration with da Ponte) found the idea that music is a kind of seduction and, therefore, that Don Giovanni should carry out a seduction by proxy, supplying the music himself while pretending that it came from Leporello? And of course there are rules of grammar that had to be followed when Dylan Thomas and Shakespeare wrote those metaphors cited earlier: there had to be word placement, number agreement, and all the rest. But what rules could have suggested that dying is going out into the night, or that the ruin of a choir loft is an aging man?

In the unfortunately neglected work of R. G. Collingwood there is an insistence that the activity of art is not confined to the creation of great works of art, but is an activity potentially available to us in general, even to those with no talent for the fine arts.[11] It is exhibited in every human act of *originality*, every success in finding the right words when there are no formulaic words available. And when one does this, whether one is Shakespeare or Mozart or simply oneself, one is acting in freedom, doing something unprescribed, perhaps using the language, but in ways not dictated by the language's own internal regulations. It is essential to realize that this freedom must be enjoyed not only by the one who makes an original thing, but also by any audience that succeeds in apprehending it.

Kant thinks genius is required for the creation of beautiful fine art, but he also thinks that it is not sufficient; taste is also required.[12] Without taste, the creator cannot tell whether his work is successful. Paradoxically, if I am right, taste is required for the appreciation of art, but it is not sufficient. The appreciator of fine art must also display at least a little genius. And this leads to the conclusion that not only should we acknowledge genius, even in Kant's sense, in Newton and Euclid as well as in Shakespeare and Mozart, despite Kant's hesitation, but we should also attribute at least a little genius to ourselves when we succeed in appreciating Shakespeare and

Mozart – and, perhaps, even when we understand a metaphor. I like to think so.

Notes

1. Kant's arguments are found in §§46–50 of the *Critique of Judgment*. All references to Kant are to this work. I shall refer to the Werner S. Pluhar translation (Indianapolis: Hackett, 1987) and quote from it, but will supply section numbers so that the original German, or virtually any translation, may be consulted. Nothing in this essay depends upon niceties of translation.

2. Kant's discussion of the relation between the general judgment (which, according to him, is not aesthetical) and the singular judgment (which is aesthetical) is in §8. In "Three Problems in Kant's Aesthetics" (*British Journal of Aesthetics* 42 (2002): 1–12). I have argued that Kant has no way of explaining the relation he believes connects 'This rose is beautiful' with 'Roses in general are beautiful'. For purposes of the current discussion, however, it is sufficient that Kant himself believes there to be a logical relation, so that from 'This X is beautiful' and 'Xs in general are beautiful', it follows, at least with some probability, that this X is beautiful.

3. Kant thinks that what he calls 'fine art', at least when it is successful, is beautiful. Thus the maker of fine art is making something beautiful, and it is this kind of making that requires genius. Kant's arguments appear in §§44–6.

4. Kant has a doctrine – famous, if not inscrutable – to explain how it is that ordinary intuitions fall under ordinary concepts. In the case of extraordinary intuitions and concepts, which Kant calls, respectively, aesthetical ideas and rational ideas, although there is no such "falling-under," it is still the case, according to him, that certain aesthetical ideas and rational ideas go together with one another, and also with canonical intuitions and concepts. I have described the problems in understanding this "going together" in "Three Problems in Kant's Aesthetics," and have argued that there are no solutions. Kant defines 'aesthetic idea' and 'rational idea', and speculates about their connections in §49.

5. Kant makes this comparison in §47. In the Pluhar translation you may also find a note explaining who Wieland was.

6. This remark is in §47, which is also where Kant mentions the greatness of Newton's mind.

7. This is from Peirce's "Lowell Lectures on the History of Science," available in many editions. About Euclid's proof Peirce goes on to say this: "It is, perhaps the most awkward and ineffective demonstration, not downright fallacious, that ever was given of anything. That is the reason John Stuart Mill found it especially adapted to illustrate his theory of reasoning." I think we should spend more time reading Peirce.

8. See Paul Grice, *Studies in the Way of Words* (Cambridge, Mass.: Harvard University Press, 1989), especially essays 2, 3, 5, 6, and 7.

9. I have argued that metaphor is significantly different from other kinds of language, qualitatively different, in "Metaphor," *Oxford Handbook of Aesthetics*, ed. Jerrold Levinson (Oxford: Oxford University Press, 2003), pp. 366–76. In particular, I have argued, and continue to believe, that something extra, something different must be done when one appreciates a rich metaphor than is required when one understands an ordinary, literal expression. In understanding an ironic expression, perhaps, one takes the literal meaning of the expression and applies some irony operator, thus, as it were, computing the ironical meaning. Nothing like this can be done with metaphorical expressions. The literal meaning of such expressions must be taken into account (unlike the case with idiomatic expressions), but there is no operator available to lead from the literal meaning to the metaphorical sense of the expression. It has been thought that all that is required is to convert the literal meaning of a metaphor into a literal simile, but this will not in general give the metaphorical sense.

10. An exceptionally useful discussion of this topic is Timothy Gould's "The Audience of Originality: Kant and Wordsworth on the Reception of Genius," in Ted Cohen and Paul Guyer, eds., *Essays in Kant's Aesthetics* (Chicago: University of Chicago Press, 1982).

11. R. G. Collingwood, *The Principles of Art* (Oxford: Oxford University Press, 1938), throughout, and especially chapter 6, §5, "The Artist and the Ordinary Man."

12. Kant develops this point in §50.

6

Creativity and Imagination

Berys Gaut

> The lunatic, the lover, and the poet,
> Are of imagination all compact.
> One sees more devils than vast hell can hold;
> That is the madman. The lover, all as frantic,
> Sees Helen's beauty in a brow of Egypt.
> The poet's eye, in a fine frenzy rolling,
> Doth glance from heaven to earth, from earth to heaven;
> And as imagination bodies forth
> The forms of things unknown, the poet's pen
> Turns them to shapes, and gives to airy nothing
> A local habitation, and a name.[1]

Shakespeare, one might suppose, knew what he was talking about. In so closely linking the poet's creative act to imagination he was giving expression to a belief long maintained in Western culture. It is a view most famously celebrated by the Romantic poets (and, as we shall see, by Kant, their rather unlikely progenitor). Shelley tells us that "Poetry, in a general sense, may be defined to be 'the expression of the imagination': and poetry is connate with the origin of man", indeed "poetry creates anew the universe".[2] And the link of creativity to imagination has a history that long predates the eighteenth century, as indeed Shakespeare's enunciation of it demonstrates. Leonardo in defending painting observed that "it is by manual work that the hands represent what the imagination creates".[3] The view is even embodied in our common beliefs and language: when someone is stuck for a new

approach to something, we might suggest that they use their imagination; and the term 'imaginative' is a near-synonym for 'creative'. This link between creativity and imagination is perhaps the most influential of the three traditional approaches to creativity – the others being the inspiration view (that the poet is literally the mouthpiece of the gods, and so does not know what he is doing, as enunciated in Plato's *Ion*, and given a secular twist in Freud's theory of the unconscious) and the derangement view (that the poet is a madman, also suggested in the *Ion*, and a view to which Shakespeare adverts).

The traditional linking of imagination to creativity invites a number of questions, which have been surprisingly little explored within contemporary philosophical discussion. I shall concentrate on two. First, is the traditional linking of imagination to creativity correct, and if so what kind of link is it? A second question arises if the link is validated: if the creative imagination exists, can we say anything about *how* it works, perhaps revealing something about its characteristic forms or modes of operation?

1. CREATIVITY

To answer our first question about the tenability of the link between creativity and imagination, we need to clarify the two concepts in play. Creativity might seem to be a kind or way of making something; but in fact the term has a slightly wider application, as in Joseph Schumpeter's phrase 'creative destruction'. Though the term has this wider modal sense, in which even destruction can be creative, the core sense, and the one with which we will be concerned, qualifies a particular kind of making; and creative making is what we call 'creation' in the fully fledged sense of the word. Plausibly this requires that the making be a production of things which are original, that is, saliently new.

But more seems to be required to be creative than simply salient newness; for we use 'creative' as a value-term, which refers in people to a kind of excellence or virtue, in the broad sense of 'virtue'. Creativity is the virtue exhibited most fully by genius. But is the mere possession of originality sufficient to make the original object valuable? Kant, in a related discussion about genius, holds that "Since nonsense too can be original, the products of genius must also be models, i.e., they must be *exemplary*...".[4] Kant's point is that originality can be exhibited

by nonsense, and by implication be worthless. Now had Kant been acquainted with modern academia, he might have been more struck by the thought that even nonsense is not often original. And I am inclined to think that originality has at least some *pro tanto* merit: that even original nonsense has some merit over received nonsense, since it evinces some intellectual stirrings in its utterer, and may even produce some intellectual movement in its hearer. Be that as it may, the cutting edge of Kant's remark remains unblunted: we think of creativity as possessing considerable merit, but even if originality as I have suggested has some *pro tanto* merit, that merit is surely not commensurate with the great value we place on creativity.

That being so, we should hold that creativity is the kind of making that produces something which is original and which has considerable value. The object has this value in part because of its originality, but mainly because of its other valuable features. So we think of Picasso and Braque as exhibiting creativity, partly because of the originality of their Cubist paintings, but mainly because that originality was exhibited in paintings which, considered apart from their originality, have considerable artistic merit. The production of artworks that have little or no artistic merit, considered apart from their originality, strikes us, in contrast, as empty and not really creative.

A third condition is required for creativity to exist; for it is possible to make something that is original and valuable, but for one's making of it not to count as creative. Suppose that you daub me all over with paint and imprison me in a dark room in which there is a primed canvas. I flail around for several hours, attempting to escape; my frantic thrashings cover the canvas in such a way that it becomes, unknown to me, a stunningly good abstract painting, significantly different in appearance from any abstract painting hitherto produced. I have inadvertently produced something valuable and original, but it would be wrong to say that I have done so creatively – I made it purely by chance.[5] Or suppose that I engage in a mechanical search procedure for some desired outcome, systematically working through all the relevant possibilities, and in the course of the search come across a result that is original and valuable. Again, the upshot of such a search procedure is not an instance of creativity, for the procedure adopted is a mechanical one.[6] So *how* the original and valuable product is made plays an essential role in determining whether the act of making it is

creative. And we must, at least, rule out cases of making by chance or by mechanical procedure, if an act is to count as creative. I will say that the making must involve *flair* by the maker to rule out at least these kinds of cases.

So creativity in the narrower non-modal sense is the kind of making that involves flair in producing something which is original (saliently new) and which has considerable value. Related accounts readily suggest themselves for the adjective 'creative' when applied to acts, people, processes and artefacts. A creative act is one that is the making of a saliently new and valuable thing by flair. People are creative, roughly speaking, when they have a trait disposing them to engage in creative acts. A process is creative when it is the producing of something valuable and original by flair (or, if we allow that a creative process need not always produce a creative outcome, when it is an instance of the kind of process involving flair that usually tends to produce original and valuable things). And artefacts (in a broad sense including the performance of acts) are creative when they are original, valuable and produced by flair. Originality, value and flair are the vital ingredients in creative making.[7]

2. IMAGINATION

The notion of imagination is more slippery to handle than that of creativity. Part of the problem is that it has a variety of uses, not always closely related to its core sense. In one such use, to say that I imagined such and such is to say that I falsely believed it, or to say that I misperceived something: for instance, to say that I imagined the coatrack to be an intruder is to say that I misperceived the coatrack as an intruder. In this use, imagination involves false (propositional or perceptual) beliefs. This usage is one that is at least partly in play in the passage from *A Midsummer Night's Dream*, for the lunatic and the lover are both in the grip of false beliefs and misperceptions. But clearly this usage is distinct from the sense in which we are asked to imagine that, say, grass is red, for we are not required to believe it to be so.

A second usage is that in which 'imagination' is used virtually as a synonym for the ability to engage in creative thought; it is the usage in which 'imaginative' is employed as a synonym for 'creative'. In this usage, there is a true but analytic and trivial connection between

imagination and creativity; and this use merits a deflationary account of the connection between the two realms. If this were all that there were to the connection, we would need to proceed no further.

There is a third use in which 'imagination' is employed to mean the same as 'imagery'. For instance, if I cannot remember how someone looks, I might be told to try to imagine her face, that is, try to form an image of it. Some philosophers have characterised imagination simply in this sense: Mary Warnock, for instance, claims that imagination is "*that which creates mental images*".[8] But there is a different (fourth) use of the term 'imagination' under which one needs to distinguish between imagery and imagination. In this sense, if I have remembered someone's face, it would be misleading to say that I had imagined her face; and also one can imagine a state of affairs without having any imagery of it. It is this usage that is the one which we will now target.

Imagery is a matter of the having of sensory presentations; but these images need not be instances of imagination. A memory image of the blue front door of my previous house involves a belief about that front door, not an imagining of it. The same is true of many dream images. Perception involves perceptual presentations of the objects perceived; and such presentations though arguably images are not imaginings of the objects perceived. So memory, dreams and perception involve imagery, but are not instances of imagination. The point, then, is that one cannot *identify* imagery with imagination (though, as we shall see, *some* images are imaginings).

Conversely, imagination need not involve imagery. If I asked you to imagine that gradually your brain cells were replaced by silicon chips, you need form no mental image of this process to comply with my request; indeed, if I asked you to imagine an infinite row of numerals, you *couldn't* form an (accurate) mental image of that row.

So imagination is conceptually distinct from imagery. What, then, is imagination? A suggestion mooted by several philosophers, and one I think is basically correct, is that imagining that such and such is the case, imagining that p, is a matter of entertaining the proposition that p. Entertaining a proposition is a matter of having it in mind, where having it in mind is a matter of thinking of it in such a way that one is not committed to the proposition's truth, or indeed to its falsity. In contrast, the propositional attitude of believing that p involves thinking of the proposition that p in such a way as to be committed to

the proposition's truth.[9] One can put this point in slightly different but equivalent ways. Instead of talking of entertaining the proposition that *p*, one can talk of thinking of the state of affairs that *p*, without commitment to that state of affairs' (actual) existence. Or some make the point in terms of unasserted thought: to entertain the proposition that *p* is to think of *p*, but without 'asserting' that *p*.[10] Since assertion is strictly speaking a speech-act, not a propositional attitude, 'assertion' here, I think, should be understood in terms of commitment to the truth or falsity of a proposition (alethic commitment) in the way just outlined. These equivalent ways of presenting the view all have an important corollary: it is possible both to believe that *p* and to imagine that *p*, since one can consistently have the two distinct propositional attitudes towards the same proposition.

Thus far we have given an account of propositional imagining – imagining that such and such is the case – for instance, that it is raining. But in addition to propositional imagining there is objectual imagining: imagining an object, such as a wet cat. The account can be extended smoothly to cover such cases: imagining some object *x* is a matter of entertaining the concept of *x*, where entertaining the concept of *x* is a matter of thinking of *x* without commitment to the existence (or non-existence) of *x*. Equivalently, we can talk of having an 'unasserted' thought of *x*, where 'unasserted' thought is construed in the way just mentioned, namely, in terms of thinking of *x* without commitment to the existence (or non-existence) of *x*.

Third, consider experiential imagining – the kind of case where imagining has a distinctive experiential aspect. Such imagining covers both sensory imagining (for instance, visually imagining the wet cat) and phenomenal imagining (for instance, imagining what it is like to feel soaking wet). This kind of imagining involves imagery, though we have seen that not all imagery is a kind of imagining. So what differentiates the two kinds of imagery? One might hold that visually imagining a wet cat involves having an image of a wet cat, and then thinking of that image that it is a mere imagining. But that would be false to the phenomenology of imagining, and also redundant. An image is a type of thought, possessing the hallmark of thought, namely, intentionality: an image is an image *of* something, and that thing need not exist, that is, the thought-content has intentional inexistence. A visual image is thus a kind of thought, and what makes it distinctively

visual is not its content but its mode of presentation, for I may think of how a wet cat looks without visually imagining a wet cat. When I visually imagine how a wet cat looks, the mode of presentation of that thought is visual. So what makes imagining sensory or phenomenal is the mode of presentation of the thought. The thought of the cat can be 'asserted' or 'unasserted' in the sense indicated earlier: in the former case the image may be a memory-, dream- or perceptual-image; in the latter case, the image is a kind of imagining. Thus, experiential imagining is a matter of phenomenal or sensory modes of presentation of 'unasserted' thoughts. Often when we talk of 'imagining' it is experiential imagining that we have in mind, which is a richer kind of imagining than the often minimal imagining involved in entertaining a proposition or the concept of an object. If someone says that he can entertain some proposition, but that he cannot imagine it, this shows not that imagination is never a matter of entertaining a proposition but that, in one usage of the term, to imagine involves an experiential aspect that goes beyond the minimal entertaining of a proposition.

Finally, there is what is sometimes termed *dramatic* imagining, imagining what it is like to be some person or imagining being in a person's position. This should not be thought of as a fundamentally distinct kind of imagining, for it is a structured composite of the other sorts of imagining previously mentioned. In imagining being in another's position, I have to entertain various propositions about his situation and entertain concepts of various objects, and may engage in both phenomenal and sensory imagining of his situation. The task is often a complex one, requiring considerable skills to be carried off successfully, perhaps even the skills of a great novelist. But to say that it is complex is not to say that it is irreducibly different from these other sorts of imagining.

3. MODELS OF CREATIVITY

Given these targeted senses of 'creativity' and 'imagination', what is the relation between creativity and imagination? To take the simplest case, is there any necessary relation between them?

Does a creative act require an imagining? Not so: Bertrand Russell reported how, when he was writing *Principia Mathematica*, he would frequently go to bed having failed despite much effort to solve a difficult

problem, but then wake next morning knowing the solution. Russell went from not knowing the answer to knowing the answer, without it seems any imaginative act on his part. A more subtle instance of this involves the chemist Friedrich von Kekulé, who claimed that he discovered the ring structure of the benzene molecule by dreaming in front of his fire of snakes devouring their own tails. This example does involve imagery, but being dream-imagery, and depending on the precise details of the case, it may well not have involved imagination: Kekulé while asleep may have believed that he saw snakes devouring their tails, and when he awoke, the image suggested his discovery to him.[11]

Conversely, does every imagining involve a creative act? One might hold that all imagination is creative in the sense that it can go beyond what is given to belief and to perception.[12] When I imagine a golden mountain, I am thinking of something which goes beyond my experience and my beliefs. But even so, this is not to make me creative in the sense defined earlier; for there need be nothing saliently new and valuable about my imaginings. When I peer over a cliff's edge I may, with boring and predictable regularity, just like countless other people, imagine being hurled down to the rocks below. What I imagine (luckily) goes beyond my experience and beliefs, but it is not in any even minimal sense a creative bit of imagining. The same is true of most fantasising: I may have the same fantasies as many other people, and my fantasies may be much the same each time I have them. Fantasising is a kind of imagining, but is rarely creative. Indeed, perhaps the simplest but most telling objection to Freud's influential piece "Creative Writers and Daydreaming" is that daydreaming, a kind of fantasy, is almost never creative, and thus is not a promising model for creative writing.[13]

There thus seem to be no necessary relations at the most general level between creativity and imagination. But perhaps by examining in more detail creative uses of imagination, we might be able to find some other, more modest connections. To do so, consider two models of how imagination might operate in relation to creativity.

3.1 The Display Model

The first of these models I shall call the *display* model. This holds that imagination operates as a way of displaying the results of creativity to the creative person, but that creativity itself operates through some

other mental capacity, perhaps in some other mental domain, such as the unconscious. The creative subject's unconscious, for instance, generates the creative idea, and this is then displayed to the subject through her imagination. In this respect at least, the display model is the heir to the traditional inspiration account of creativity, for that account holds that the creative person does not know what he is doing, and simply receives the creative result as a revelation, something that he cannot explain (as Plato tellingly argues of Ion).

One should not hold that the role of the imagination here is a necessary one in general, since, as we have seen in the cases of Russell and Kekulé, the creative idea can be displayed simply by forming a belief, or having an image. But, still, imagination would often have a display function. And that is plausible enough as an empirical claim.

However, the modest display model of the relation of imagination to creativity cannot give the whole story; for it makes imagination strictly speaking extraneous to the creative process. That process goes on in some other mental faculty, perhaps operating deep in the subject's unconscious, and then the result is displayed to the subject's consciousness through an imaginative act. It is as if imagination is just the recorder or scribe of creative processes happening elsewhere. Yet in Theseus' speech in *A Midsummer Night's Dream* it is imagination which bodies forth the form of things unknown, and the poet's pen operates as a transcriber of these imaginative acts. But on the display model the role of the imagination to creativity is merely peripheral; so we have not found the central connection between imagination and creativity for which we have been searching.

This point can be refined by distinguishing between two kinds of creativity, or perhaps aspects of creativity. *Passive* creativity occurs when the subject is unaware of the creative process, if any, which has occurred to produce the creative outcome. The outcome simply 'pops into the head' of the subject, as we say. The cases of Russell and Kekulé are like this. On a less exalted level, this kind of thing happens frequently: a solution to a thorny problem may come to someone when they are not dwelling on the problem at all, perhaps when they are on a walk or taking a shower. The display model fits this case well, at least when the medium for displaying the outcome is imagination rather than belief.

In contrast, *active* creativity occurs when the subject actively searches out various solutions, consciously trying out different approaches, and

in the course of this activity comes upon a solution. The solution does not emerge unbidden and unawares 'in a flash', but rather is the outcome (albeit necessarily the unforeseen outcome) of a sometimes sustained conscious process. Active creativity seems more common and important in the arts than passive creativity: a painter may for instance suddenly 'see' how his painting will look, but much of the subsequent work will involve scrutinising the painting as it is being made, imagining how it could be improved by altering it in various ways, trying out these changes, observing the results, making more alterations, and so forth. And this process may take the painting far away from its original imagined look.

In the case of active creativity, the subject uses her imagination as part of the creative process, so that imagination is not the recorder of an already completed creative process, but rather is a core aspect of that process. The role of imagination in active creativity is the locus of much of the attraction of the view that imagination is centrally involved in creativity, yet the display model signally fails to capture this role for it.

3.2　The Search Model

A different model of the relation of imagination to creativity appears more promising in giving imagination a role in the creative process itself: this is what I will call the 'search model'. According to this model, when one comes up with a new idea or invents a new object, one can be thought of as having worked through various possibilities ordered in logical space. The creative person has a strong, powerful imagination, capable of imagining more widely and deeply than most; her imagination is capable of grasping a set of the relevant possibilities and selecting from them the one most suitable to the circumstances. Thus the process of 'trying out' various approaches, which we have seen is the hallmark of active creativity, is to be understood in terms of considering or surveying the relevant portion of logical space, and the process of invention is that of choosing from one of the surveyed possibilities.

Like the display model, the search model contains an important element of truth, since it takes account of the way we actively create certain things. But it also suffers from a number of defects. Most important, it is misleading about a very important aspect of active creativity.

Contemplating Kasparov's creativity in playing chess, it is tempting to think that it lies in his ability to survey a wider range of the possible moves ahead than can anyone else. But this would be deeply mistaken. For consider Deep Blue, the chess computer that beat Kasparov in 1997. Deep Blue really does survey vastly more possible positions than any human could, and selects from them the one most likely to win the game. Deep Blue has in this sense a powerful imagination. But the problem is that it is the epitome of an *uncreative* way to play chess: it mechanically searches through the possible positions to arrive at the best. Kasparov, in contrast, plays chess creatively, but cannot do so by surveying the vast numbers of possibilities that Deep Blue does. Creativity is precisely not a matter of a powerful imagination, in the sense of an ability to search through vast numbers of possibilities.

It may be objected that Deep Blue does not have an imagination at all – to have an imagination requires having consciousness and an ability to reason, and a computer has neither of these things. This may well be true, but the form of the objection stands. For consider an idiot savant, who plays chess exactly like Deep Blue is programmed to do, surveying a similarly vast array of possibilities and settling on the best. This idiot savant – let's call him 'Shallow Pink' – has consciousness and reason, so he can and does have an imagination, which he deploys to survey a vast array of possibilities. But Shallow Pink, like his computational brother, plays chess in an uncreative, mechanical fashion.

There is something else to be learnt from this example. Let us return to Kasparov, who does play chess creatively. He may search through comparatively few moves ahead. But the ones he does survey are those which are likely to give him a significant advantage, and to be ones that may be surprising and original. Though he uses his imagination as part of the creative process, in trying out a range of selected possibilities, much of the creativity has gone into the prior selection of this small range of possibilities, rather than consisting in an ability to survey a vast array of them. And he may also use his imagination in seeing a current position as a variation of one with which he was previously familiar. So the difference between Kasparov and Shallow Pink does not lie in the fact that one uses his imagination and the other doesn't, for both employ their imaginations; rather the difference consists in *how* they use their imaginations. Kasparov uses his imagination creatively; Shallow Pink does not.[14]

This point shows that we should distinguish between imagination as a *source* of creativity, and as a *vehicle* for creativity. In being actively creative, in trying out different approaches, Kasparov uses his imagination, imagining different moves he might make. But though his imagination is a vehicle, or medium, for his creativity, it does not follow that it is the source of that creativity – that which explains why he is creative. His creativity is displayed in how he uses his imagination, but that in turn is explained largely by factors such as his vast experience, considerable knowledge of chess history, practised technique and sheer native talent. These are the things which allow him to use his imagination creatively.

Failure to respect the distinction between the source and the vehicle of creativity explains in part the Romantic hyperbolic inflation of the importance of imagination in the creation of art, and indeed of its significance more generally. Shelley, as we noted, held that poetry, the expression of imagination, is connate with the origin of man and creates anew the universe. He thought of imagination as the source of creativity, but what we have just noted is that the imagination can be employed in an uncreative, mechanical fashion, and so cannot in itself be the source of creativity. But Shelley did see something true and important – that imagination is involved in the creative process as, I suggest, the vehicle of active creativity.

4. IMAGINATION AS THE VEHICLE OF ACTIVE CREATIVITY

In being actively creative, the chess player employs his imagination in trying out various available moves ahead. The same use of imagination occurs in trying out different solutions to intellectual problems in general, and to trying out different ways to develop a painting, sculpture, novel, and so on. The painter and the musician are likely experientially to imagine their results, while the intellectual is likely to use propositional imagining; but both employ their imaginations. Imagination in such cases is the vehicle of active creativity, being that mental capacity which is used in being actively creative. If that is so, then we have found a connection between imagination and a type of creativity. The connection for which we shall argue can be formulated this way: imagination is peculiarly suited to be the vehicle of active creativity. That is, it is suited *of its nature* to serve as such a vehicle, suited because

of the kind of intentional state that it is. In this it differs from other intentional states, such as beliefs and intentions, which are not suited of their natures to be such vehicles.

We noted earlier that to believe a proposition is to be committed to its truth. Belief therefore aims at the truth; moreover, this end is *intrinsic* to or *constitutive* of belief: a propositional attitude counts as belief only if it has that end. (Of course, belief may not succeed in achieving this end – there are false beliefs – but belief is what it is because it has this end.) It is the fact that belief has the intrinsic end of truth that helps to explain Moore's paradox, the paradoxicality, for instance, of the assertion that "I believe that it's raining, but it isn't raining". To assert this is ipso facto to be shown to be irrational, since it is to assert that one is in a mental state which aims at the truth while simultaneously denying that the content of that state is true. Further, it is because belief aims at the true that it is properly responsive to evidence, that is, to reasons for holding something to be true.

Intention also involves a kind of commitment, but a commitment to action, not to truth. To intend to do something involves a commitment to doing that thing *ceteris paribus*, when one can. The intrinsic end or constitutive aim of intention is thus achievable action. And this helps to explain why it is paradoxical to assert, for instance, that "I intend to go climbing, but I won't when I can". Again, one stands convicted of irrationality in this instance, because one commits oneself to a certain action by saying that one intends to perform it, yet simultaneously denies that one will perform it when one can.[15]

Imagination lacks the intrinsic ends of belief and intention. To imagine something is, as we have seen, not to be committed to its truth (or falsity); thus it is not in the least paradoxical to say, "I imagine that it's raining, but it isn't". Nor does imagination involve a commitment to performing an achievable action: it isn't paradoxical to say, "I imagine going climbing, though I won't go climbing when I can". Imagination is free from commitments to what is the case and to particular actions. In fact, imagination seems to lack any intrinsic end at all – that is, any end that makes it the state that it is. Imagination thus exhibits a kind of freedom in this respect. As such, imagination is peculiarly suited – suited of its nature – to be the vehicle for active creativity, since one can try out different views and approaches by imagining them, without being committed either to the truth of the claims or to acting on one's

imaginings. Imagination allows one to be playful, to play with different hypotheses, and to play with different ways of making objects.

Since imagination lacks an intrinsic end, the ends of imagination are extrinsic to it: so one can use imagination for many different purposes without being irrational. (Contrast this with, for example, belief, where one cannot rationally simply choose to believe what it suits one to believe, because belief aims at truth and is consequently answerable to it.) In fantasy, the goal of one's imaginative project is to enhance one's own enjoyment, and the aim of this project determines what counts as a successful piece of fantasising. So, if despite my efforts, I keep imagining myself being embarrassingly humiliated, the fantasy has gone wrong. Alternatively, imagination can aim at learning something: here truth governs the imaginative project, but it is an extrinsic, adopted, aim of imagining, not its intrinsic aim. I may imagine myself in someone else's position *in order to* discover what she is feeling; but I do not believe that I am in her position. I can also imagine what I believe to be true; but when I do so, the aim of truth in my imagining is extrinsic. Creative uses of imagining, in contrast, need not aim at personal pleasure or at learning something. Nor need they aim at being creative: for one can be creative even though one does not aim to be so; indeed, it is likely that consciously aiming at being creative will to an extent be self-undermining, leading to a frenetic striving after shallow effects.[16] Creative uses of imagining are thus identified, not by their aims, but by their results (they produce, or are the kinds of imagining which often produce, a creative outcome). Creative uses of imagination need have no one extrinsic aim.

The claim that imagination is suited of its nature to be the vehicle of active creativity does not require that one always and necessarily employ imagination in being actively creative. Imagination, as we saw, is peculiarly suited to be the vehicle for trying out various options, because it is devoid of commitments to their truth or to acting on them. However, suppose that, instead of believing that the next option tried will be the correct solution, the creative person believes that *it is possible* that the next option tried will be the correct solution. Here the content of her belief does not commit her to the claim that the option is correct, so that her belief could be employed in being actively creative. But note what has happened: here the content of the belief mimics the feature of imagination that is crucial to explaining imagination's role

in active creativity, that it be free of commitments to what is actually
the case; the belief is now about the possibility of the correctness of the
option. So here the *contingent content* of one intentional state, belief,
mimics the *essential mode* of another, imagination. And this supports
our claim that imagination is *of its nature* suited to be the vehicle of
active creativity, and that belief is not. It is the nature of imagination
as an intentional state, free of commitments to truth and action, that
allows it to be the vehicle of active creativity, and this is not true of
the nature of belief. Individual beliefs, if they are employed in being
actively creative, do not do so by virtue of their nature as intentional
states, but by virtue of the fact that they have a particular content that
allows them to mimic imaginings.[17]

 Thus, properly understood as a point about the nature of imagina-
tion as opposed to other intentional states, the claim that imagination
is peculiarly suited to be the vehicle of active creativity is correct. It es-
tablishes a constitutive connection between imagination and creativity
that is the kernel of truth in the traditional linkage of the two domains.
It also has the merit of explaining the appeal of the derangement view
of creativity – that the creative person is literally mad. The actively cre-
ative person imagines various propositions and objects, but it would
be easy to confuse her imaginings with beliefs – we have already noted
that a common use of 'imagining' is in terms of falsely believing. And,
indeed, given a vivid enough imagination, it would not be hard for the
creative person to pass from vividly imagining something to actually
believing it. The derangement view of creativity can be thought of as
the degenerate offspring of the imagination view.

5. CREATIVITY AND METAPHOR

In answer to the first question raised at the start of this essay, we have
discovered two ways in which the traditional link of imagination to
creativity can be validated. First, the creative product is often made
known to its creator by its display in imagination; this is an empirical
claim. Second, and more importantly, we have argued that imagina-
tion is suited of its nature to be the vehicle of active creativity; this is
an a priori claim, holding that there is a constitutive connection be-
tween imagination and active creativity. We can turn now to the second
question mooted at the start: can we say anything about *how* creative

imagination works? Perhaps surprisingly, I think we can do so, at least in part. To approach this, let us turn briefly to Kant's account of genius, perhaps the finest extended account of creativity in the philosophical canon.

In sections 46–50 of the *Critique of Judgment*, Kant investigates the relation of art to genius, and of genius to imagination. Fine art, he says, is the art of genius, "the foremost property of genius must be *originality*" (175), and also the products of genius must be exemplary. Characteristic of genius is spirit, "the animating principle in the mind", which is "nothing but the ability to exhibit *aesthetic ideas;* and by an aesthetic idea I mean a presentation of the imagination which prompts much thought, but to which no determinate thought whatsoever, i.e., no [determinate] concept, can be adequate, so that no language can express it completely and allow us to grasp it" (313–14). Imagination in general, he says, is "a power to intuit even when the object is not present".[18] Reproductive imagination seems to be a matter of having memory images; productive imagination, to be a matter of sensory imagination. It is productive imagination that Kant has in mind in the passage about aesthetic ideas. But not just any exercise of the productive imagination is creative; indeed, Kant notes that we use this kind of imagination "to entertain ourselves when experience strikes us as overly routine" (314), namely, to fantasise. But when aesthetic ideas, a kind of presentation of the imagination, are involved, then creativity occurs (315).

Though much in these passages is obscure, it is clear at least that Kant links exemplary originality (creativity) to a kind of imagination, without holding that all uses even of productive imagination (experiential imagination in our terms) are creative. There are thus some striking points of agreement between Kant's account and the position developed so far. But there is also something new: Kant considers under what circumstances imagination is creative, and his answer is in terms of when it exhibits aesthetic ideas. Yet his characterisation of them is less than pellucid: whatever are these things which prompt much thought, but to which no determinate concept can be adequate?

One answer is suggested by his remark about productive imagination in general that it is "the originator of chosen forms of possible intuitions" (240). One might think of aesthetic ideas as the production of sensory forms that we lack the ability to describe adequately in

literal language: think of some of the sculptural forms of Tony Cragg
or the architectural forms of Frank Gehry, for instance. These are the
products of highly complex uses of spatial imagination, and they are
certainly examples of the creative use of imagination.

Though an attractive interpretation, this does not seem to be what
Kant has in mind in talking of aesthetic ideas. He cites as examples of
aesthetic ideas a "poet [who] ventures to give sensible expression to
rational ideas of invisible beings"; Jupiter's eagle with lightning in its
claws as an attribute of God; a poem in which Frederick the Great asks
us to leave our lives in the same way as the sun at the end of the day
"Spreads one more soft light over the sky"; and a line from a poem that
"The sun flowed forth, as serenity flows from virtue" (314–16). All of
these examples involve attributing to something that Kant thinks of as
the referent of a rational idea (invisible beings, God, death, virtue) a
property which it does not literally possess, but which can be fruitfully
attributed to it (a particular sensible expression, an eagle with light-
ning in its claws, the sun setting, the sun rising). In short, these exam-
ples involve a metaphorical attribution of a property to some object
which does not literally possess it. And that suggests that what Kant
has in mind by aesthetic ideas are metaphors. (Successful) metaphors
do prompt much thought, but what they say cannot be completely
paraphrased by any determinate, literal language; they involve a use
of imagination; and originality is a merit of a metaphor, as it is a virtue
of genius. Moreover, Kant holds that it is in the art of poetry that the
power of aesthetic ideas can manifest itself to the fullest extent (314),
and of course metaphors are most explicitly present in poetry, though
there are visual and other sensory metaphors too.

Kant's connection of creativity with imagination in its employment
of metaphor-making is intriguing, and captures an important insight.
Metaphor-making, I suggest, is a *paradigm* of creative imagination. To
rescue the concept of a paradigm from its Kuhnian multiple mug-
ging, I mean by a 'paradigm' no more (and no less) than something
to which we can fruitfully appeal in order to understand the phe-
nomenon in question, or an aspect of that phenomenon. A paradigm
in this sense is a heuristic notion, its application helping us bet-
ter to understand the relevant phenomenon. Metaphor-making is a
paradigm of the creative use of imagination, then, since it displays
how creative imagination can work especially clearly and so helps us to

understand creative imagination better; metaphor-making is also an instance of creative imagination.

A metaphor is an expression of imagination, since when I say metaphorically that x is y, I invite my auditors to think of, to imagine, x as y. If I say that men are wolves, I invite my auditors to think of men as wolves; the "thinking of" here is not a matter of believing that men are wolves, but rather of imagining men as wolves. Or to put the same point slightly differently, in employing the metaphor, I invite my auditors to take up a wolfish perspective on men, to consider men as if they were wolves.[19] Besides being an exercise of imagination, the making of a good metaphor exhibits creativity: it shows flair; and originality is a prime virtue of new metaphors, creating a striking new way of looking at or thinking about some otherwise familiar object. But metaphors can also be extravagant and unconvincing, and can misfire in various ways; a good metaphor in contrast must be apt, must seem appropriate to its object. In this respect the cognitive content of the metaphor is important: if there are properties literally possessed in common between the two items linked by metaphor, then the metaphor will prove apt. It is because men really do have some salient attributes in common with (the ordinary conception of) wolves that the wolfish metaphor is an apt one. So the making of a good metaphor exhibits creativity because it shows flair and originality, and exhibits the *value* of aptness, which in turn often rests on a cognitive insight.

So metaphors involve imagination and exhibit creativity when freshly minted. Moreover, these are not independent features of metaphors: rather, the making of the metaphor exhibits creativity *through* the use of imagination. The perspective we are invited to take up on the object is the perspective of imagination – we are to imagine men as wolves – and generation of this perspective is an instance of creativity. For in a good metaphor, concepts and domains of thought otherwise far removed from each other are brought into intimate contact, reconfiguring the familiar conceptual terrain into a place both hauntingly strange yet oddly right. Wolves and men, concepts otherwise not closely related to each other, are brought strikingly together, and we are asked to imagine men as wolves. Moreover, the making of a good metaphor is not just a piece of creativity achieved through an imaginative act; the metaphor also encourages, indeed guides, further creative acts, through its encouragement of its audience's active

search for the literal features that the object and its metaphorically as-
cribed predicate have in common (the elucidation of the metaphor),
and in its propensity to support the working up of related or cog-
nate metaphors guided by the original one (the elaboration of the
metaphor).

Metaphor-making, then, is a paradigm of creative imagination, for
in good metaphors an imaginative act brings together two otherwise
disparate domains, and in so doing invites us to look at some object
in an original yet apt fashion. As such it displays particularly clearly a
central way in which active creativity operates.

This claim may seem to fall to a fundamental objection. For it
seems to require that all instances of metaphor-making employ cre-
ative imagination. But surely that cannot be so: could not there be a
metaphor-generating Deep Blue or Shallow Pink, mechanically grind-
ing out metaphors, some good, some bad, some indifferent, and none
of them the products of a creative imagination? And if that is pos-
sible, then it seems that metaphor-making cannot be a paradigm of
creative imagination, since it need not even be an instance of creative
imagination.

However, there are strong grounds for resisting the possibility of
mechanically generating metaphors. In the case of chess positions,
there is a set of finite, determinate rules which, together with the cur-
rent position of the pieces on the board, specifies what future positions
are allowed for the pieces. It is the existence of these rules that allows
for mechanically searching through all of the moves ahead. There is
also a clear criterion for what counts as success – checkmating one's
opponent. But in the case of metaphors, there is no evident way to
list all possible metaphors, since there is no similarly specifiable set
of rules for what is to count as a metaphor. There seem to be no uni-
versal surface syntactic or semantic markers for an utterance's being
a metaphor as opposed to a literal utterance. Nor can one appeal to
the evident falsity of metaphors as one's criterion, both because there
are plenty of evident falsities that are not metaphors, and also because
there are metaphors that are literally true (for instance, "no man is an
island"). Nor would listing every sentence in English count as a way of
mechanically generating metaphors, since by performing this task, one
would be listing vast numbers of sentences that were not metaphors.
One might as well claim that one had found a way of mechanically

generating all truths, since one could generate a list of all English sentences, many of which would be true.[20] Add in the task of finding *successful* metaphors, and the difficulties of mechanical generation grow even more insuperable – though the existence of salient resemblances is one ground of success, it is not the only one, and in any case it is doubtful that there is any way of mechanically determining what is to count as salient for these purposes.[21]

I am highly sceptical, then, of the possibility of Deep Blue or Shallow Pink launching themselves on successful metaphor-making careers. But even if this were deemed possible, the claim that metaphor-making is a paradigm of creative imagination would not be materially damaged. For recall that this proposition is advanced not as a constitutive claim, grounding a universal a priori link between metaphor-making and creative imagination. Rather, it is proposed as a heuristic claim, a claim about how creative imagination, in one of its uses, can fruitfully be understood, thus illuminating how it operates. If, as the objection holds, metaphor-making is not necessarily an exercise of creative imagination, then a simple modification would hold that those instances of metaphor-making which are exercises of creative imagination are also paradigms of it. Thus restricted, the core of the heuristic claim would be undamaged. In such cases, metaphor-making would still display the process of creative imagination especially clearly. Through an exercise of imagination involving flair, such metaphors would bring together disparate domains into original and, if they were successful, apt connections. The product here illuminates the creative process; that is the core of the heuristic claim. Contrast this with, say, scientific or mathematical theorems. These may also be the products of creative imagination; but, unlike metaphors, they do not similarly illuminate through their structure the process of how creative imagination works. For they are generally deductively structured from some basic propositions. Yet what we know about the creative process of making them strongly suggests that they were not generated by deductively following such steps.[22] In such cases, unlike that of metaphors, the product does not illuminate but rather occludes the process of its creation.[23]

In addition to metaphor-making being a paradigm of active creativity, metaphors are also surprisingly common in many domains of creative thought. This is obvious in the case of literature and especially

poetry. But metaphors exist in other domains of art. There are visual metaphors, or visual works that function very like metaphors: Edvard Munch's painting *The Scream* is sometimes said to be, or to function as, a metaphor for the human condition, for instance.[24] And werewolves are an embodiment of the metaphor that men are wolves. Metaphors are not just found in artworks. It is also a significant feature of our talk *about* artworks that it employs metaphors. The language of art criticism is heavily metaphorical; indeed, even basic terms of musical appreciation, such as talk of tension and resolution, high and low notes, musical space, and so on, are metaphorical. And metaphors enter into our experience of artworks, conditioning it into a kind of imaginative experience.[25] Finally, metaphors are also of considerable, though more covert, significance in science. Many philosophical and scientific theories are literal developments out of metaphors. The human mind has been variously conceived in history as a kind of hydraulic mechanism (whence some of Descartes' and Hume's psychological theories derived), as a telephone exchange, and more recently as a computational system. Sometimes these models were taken literally, but often they were treated as metaphors that would help focus intuitions, and from which a more exact literal understanding of the phenomena could emerge. Similarly, atoms have been variously thought of as billiard balls, as little planetary systems, and as waves. Science often spins its theories from a metaphorical source.

Though I have stressed the surprising frequency of metaphors in our creative practices, let me emphasise that my principal point is that metaphor-making is a paradigm of the creative use of imagination, and that this does not rest on a claim about how pervasively metaphors are employed. Paradigms are still paradigms, even when they are very uncommon. Rather, what the pervasiveness of metaphors shows is that metaphor is very influential in our creative thought; metaphor is not just a paradigm of creative imagination, but its use is a very common feature of creative imagination. However, imagination's employment in metaphor-making is not the only kind of creative imagination. We have already noted that the works of Cragg and Gehry are the products of powerfully creative spatial imaginations, but while some of their works have metaphorical aspects (Cragg's suggestion of laboratory vessels in some of his sculptures, for instance), the creativity of their forms is not

exhausted by them. The claim that I am advancing purports to be only a partial answer to the question of how creative imagination operates.

Finally, it is worth briefly returning to Kant's discussion of creativity, which, I claimed, appeals to metaphors in talking of aesthetic ideas. We can now see that Kant's account has a significant defect. An aesthetic idea is characterised as a "presentation of the imagination which prompts much thought, but to which no determinate thought whatsoever, i.e., no [determinate] concept, can be adequate...". Kant's causal talk of "prompting" here is inadequate as a characterisation of a good metaphor, or indeed of a good idea in general, since even excruciatingly bad metaphors and ideas can prompt much thought – for instance, thoughts about how bad these metaphors are, about how shallow and predictable their authors are, about how this kind of thing is typical of a certain banality in our culture, and so on. The causal idea of prompting, and the quantitative test of "much thought", are inadequate standards of success in metaphor-making and of good ideas in general. A good metaphor doesn't so much *prompt* thought, as *guide* thought, asking us to think of one object in terms of something else; and its standard of success isn't the volume of thought it causes to gush from us, but the quality of that thought. For, as we have seen, a good metaphor must be apt, and a salient way in which it is apt is in fastening onto some previously overlooked features that two objects have saliently in common.

Perhaps it was Kant's hostility to the view that art can teach us anything (as opposed merely to stimulating our cognitive powers in free play) that prevented him from seeing this crucial point. But, in any case, it shows that the values necessary for creativity are in part cognitive ones. And in that respect Aristotle gives us a much better, albeit much briefer, account of the links between creativity and metaphor than Kant provides. Aristotle remarks in the *Poetics* that for a poet in respect of his use of language "the greatest thing by far is to be a master of metaphor. It is the one thing that cannot be learnt from others; and it is also a sign of genius, since a good metaphor implies an intuitive perception of the similarity in dissimilars" (*Poetics*, 1459a5–8).[26] The link of creative thought to metaphor, and of a good metaphor to sensitivity as to how things are, could not be put much better than that.

6. CONCLUSION

In investigating the question of the links, if any, between creativity and imagination we have seen that some of the supposed connections have rested either on the use of 'imaginative' as a near-synonym for 'creative', or from confusing the mere use of imagination in active creativity with the claim that the imagination is in itself the source of creativity. Nevertheless, we have also seen that there are genuine links between creativity and imagination. We have seen the plausibility of the empirical claim that imagination is an important way in which creative results are displayed to the creative person. More important, we have defended the existence of an a priori constitutive connection between imagination and creativity: imagination is suited of its nature to be the vehicle of active creativity. We then investigated the question of how the creative imagination operates, and returned a partial answer to this question. We defended the heuristic claim that a paradigm of active creativity is metaphor-making, for such activity clearly displays how one can use imagination in being creative, in bringing together previously disparate domains in a way that is valuable, particularly in inviting insights into these domains. The creative product here illuminates the creative process.

The upshot is that the traditional linking of creativity to imagination is correct. Though the relation is more complex than at first appears, there are substantive and important connections – empirical, constitutive and heuristic – between the two domains. Much remains to be learned about this topic, but I hope that I have at least shown that there is a rich and interesting set of issues to be investigated here.

Notes

Versions of this paper were read at Queen's University, Kingston, and the Universities of Aarhus, Sussex, McGill, Leeds, and Sheffield. I am grateful to the audiences on these occasions for their comments, suggestions and questions.

1. Shakespeare, *A Midsummer Night's Dream*, 5. 1. 8–17.
2. Percy Shelley, "A Defense of Poetry", pp. 498–513, at pp. 499 and 512, in Hazard Adams, ed., *Critical Theory since Plato* (San Diego, Calif.: Harcourt Brace Jovanovich, 1971).
3. Quoted in Peter Burke, *The Italian Renaissance: Culture and Society in Italy*, 2d ed. (Princeton, N.J.: Princeton University: 1987), p. 80.

4. Immanuel Kant, *Critique of Judgment*, trans. Werner S. Pluhar (Indianapolis: Hackett, 1987), Ak. 308 (pagination of the *Akademie* edition).

5. The stress here is on *purely* by chance; a creative procedure can involve serendipity, but for it to be creative one must exploit chance occurrences with flair – for instance, one must recognise the importance of an overheard remark for the solution of a problem. If the outcome occurs purely by chance, then the process is not a creative one.

6. A real-life instance of such a mechanical search procedure was Charles Goodyear's discovery of vulcanisation. Goodyear dropped a wide variety of substances (including cream cheese) into liquid rubber before hitting on sulphur as a vulcanising agent; see David Novitz, "Creativity and Constraint", *Australasian Journal of Philosophy* 77 (1999): 67–82 at 75. Novitz agrees that Goodyear's achievement was not radically creative, but on grounds somewhat different from those advanced here.

7. The above account of creativity could be further developed and refined. For instance, to allow for the possibility of independent discoveries, one could distinguish between a discovery being original as far as the discoverer knows, and its being the first time the discovery had ever been made; doing so would yield something like Boden's distinction between P- and H-creativity. For discussion of this, see the Introduction to this volume, section 2 (*b*).

8. Mary Warnock, *Imagination* (London: Faber and Faber, 1976), p. 10.

9. For this view, or variants thereof, see Alvin Plantinga, *The Nature of Necessity* (Oxford: Oxford University Press, 1974), pp. 161–2; Alan R. White, *The Language of Imagination* (Oxford: Basil Blackwell, 1990); Sabina Lovibond, *Realism and Imagination in Ethics* (Minneapolis: University of Minnesota Press, 1983), p. 198; Roger Scruton, *Art and Imagination: A Study in the Philosophy of Mind* (London: Methuen, 1974), pp. 97–8; and Nicholas Wolterstorff, *Works and Worlds of Art* (New York: Oxford University Press, 1980), pp. 233–4.

10. For instance, Roger Scruton, *Art and Imagination: A Study in the Philosophy of Mind* (London: Methuen, 1974), p. 97, holds that "Imagination involves thought which is unasserted...". Scruton thinks that further conditions need to be satisfied for a mental act to be an act of imagining, something which I do not believe.

11. It could be objected that apparent cases of creativity without imagination are really ones in which a person is imagining unconsciously – that this, for instance, was what Russell was doing when asleep. But it would be merely dogmatic to insist that this *must* be going on in all such cases, and the mere *possibility* that these cases do not involve unconscious imagining is sufficient to undermine the claim of universal necessity – that a creative act requires an imagining.

12. For instance, something akin to this seems to be held by Scruton in his "Imagination", in David Cooper, ed., *A Companion to Aesthetics* (Oxford: Blackwell, 1992), pp. 212–17. Scruton here distinguishes between imagination in the sense of the capacity to experience mental images, and

creative imagination, which involves the creating of mental contents which are not otherwise given to perception or judgement (p. 214).

13. See Sigmund Freud, "Creative Writers and Daydreaming", in *Critical Theory since Plato*, pp. 749–53.

14. This reinforces the point made earlier that the fantasist uses his imagination too, but rarely creatively; it is how a person uses his imagination that makes him creative.

15. Considerations of this kind are deployed in Peter Railton, "On the Hypothetical and Non-Hypothetical in Reasoning about Belief and Action", in Garrett Cullity and Berys Gaut, eds., *Ethics and Practical Reason* (Oxford: Oxford University Press, 1997), pp. 53–79.

16. Compare this with the 'paradox of hedonism' – that those who strive after only their own pleasure will likely be less successful at achieving this aim than those who do not have this as their explicit or sole aim; for the latter can access other sources of value and pleasure, such as friendship, which are closed to the motive hedonist. In similar fashion, sole concern with his own creativity is likely to blind the artist to other values, such as sound technique, insight and sensitivity; and as we noted in defining 'creativity', some other values are required if creativity is to occur.

17. One might suppose that one could also be actively creative in trying out various options physically rather than in imagination – for instance, a painter might try out various designs on a canvas, rather than imagining them. Could this also be an instance of active creativity without imaginings? Not so. The painter's activities would have to be controlled by his intentional states if they were to count as creative; otherwise they would be analogous to the paint-daubed thrashings-around in the dark room discussed in section 1. And if the painter's activities are controlled by his intentional states, then the issues to do with the nature of these intentional states resurface.

18. *Anthropology*, 167; quoted by Pluhar in his translation of *Critique of Judgment*, p. 91.

19. I am indebted for this point and several others in my discussion of metaphor to Richard Moran, "Seeing and Believing: Metaphor, Image, and Force", *Critical Inquiry* 16 (1989): 87–113.

20. Concerning the lack of surface syntactic and semantic peculiarities of metaphors when taken literally and that they can be true, see Ted Cohen, "Figurative Speech and Figurative Acts", *Journal of Philosophy* 72 (1975): 669–84, at 671. Cohen there, and also in Chapter 5 in this volume, questions the possibility of mechanically generating metaphors. He also holds that metaphors are good examples of what Kant may have had in mind by products of genius, though he does not directly connect metaphors to aesthetic ideas.

21. Mere resemblance will not suffice: as Goodman has taught us, any two things resemble each other, since there is always some property that they share; see Nelson Goodman, *Languages of Art: An Approach to a Theory of Symbols* (Indianapolis: Hackett, 1976), ch. 1.

22. Henri Poincaré gives an illuminating account of how during a sleepless night he discovered a fundamental mathematical theorem, a process of discovery that he expresses in terms of ideas arising in crowds and colliding, until some interlocked. The process of discovery was evidently very different from the structure of the formal proof eventually offered. See Henri Poincaré, "Mathematical Creation", in Brewster Ghiselin, ed., *The Creative Process: A Symposium* (New York: Mentor, 1952), pp. 34–42, at p. 36.

23. Even in the case of mechanically generated metaphors (if they are possible), there is a way in which their structure would still illuminate the creative process. For, even though *ex hypothesi* they would not be generated by creative imagination nor be produced by flair, they would still guide their audience imaginatively to link together two domains, and if the metaphors were successful, to discover original and apt connections between them and perhaps to elaborate the metaphors further. They would thus guide those who understood them through a process akin to the process of creative imagination that could have, but did not, produce them.

24. Some resist calling non-linguistic signs metaphors, for they hold that a metaphor must have a subject-term which denotes the object of the metaphor (e.g., men) and a predicate-term which attributes some property to that object (e.g., being wolves). But property-attribution can be achieved not just by linguistic means but by other methods, such as painting a property-instance (painting a wolf, for instance). Moreover, even though the object may not be denoted in all cases (the human condition is not denoted by Munch's painting), nevertheless the object of the metaphorical attribution can be *suggested* by visual means, as is indeed true of Munch's painting. So even if one were to insist that the lack of object-denotation means that one is not, strictly speaking, here dealing with a metaphor, nevertheless one can hold that certain visual signs function in a way very like metaphors, in inviting us to imagine a property of something which does not literally possess it. And the latter claim is all we need for present purposes.

25. For the point about music, see Roger Scruton, "Understanding Music", in his *The Aesthetic Understanding: Essays in the Philosophy of Art and Culture* (London: Methuen, 1983). See my "Metaphor and the Understanding of Art", *Proceedings of the Aristotelian Society* 97 (1997): 223–41, for a discussion of the role of metaphor in the understanding and appreciation of artworks.

26. Translation from *The Complete Works of Aristotle: The Revised Oxford Translation*, ed. Jonathan Barnes (Princeton, N.J.: Princeton University Press, 1984).

7

Explanations of Creativity

David Novitz

What sorts of explanations are best suited to the task of explaining human creativity? At first blush, it seems that the answer to this question must depend on whatever it is that puzzles us about creativity, but this is true only if those puzzles are coherent, and sometimes they are not.

For the most part, people are puzzled by the general nature of creativity: by the processes involved, by what it is that people do, by what happens in their heads, or by what natural endowments they must have, in order to be creative. There is also the sense abroad that if only we could uncover the general principles at work, we might be able to inculcate these processes and so foster creativity in others.

These issues are far from trivial, for human creativity is not just important; it is vitally important. It bestows on humanity at large an abundance of different ideas, techniques, and artifacts with which to meet the uncertain demands of everyday life. In so doing, it gives us a means of artificially ensuring not just the well-being but the survival of the individual and the group in the face of change. Plainly, then, what the world of biology does naturally for some species, evolved humans do artificially for themselves. In both cases, whether produced artificially or naturally, variety is the key to flourishing and to survival.

But what we, as humans, do artificially is itself a function of our bio-logical nature. Humans and humans alone, it will be said, have evolved in ways that enable them to process information in radically new and helpful ways; in ways that enable them to be creative. Perhaps, then, we should seek to explain creativity by exploring its biological basis, or

perhaps, at a somewhat higher level, by unpicking the principles that govern the biologically based cognitive processes that are responsible for our creativity.

This seems reasonable, but I am by no means convinced that this is the right way to go. Our interest in creativity is, after all, an interest in humanly created variety. The greater the variety of artifacts, ideas, and techniques that we can create, the greater the likelihood, come the day, of a device (or artificial adaptation) being available with which to meet our changing needs and purposes. Consequently, the more that is done, sometimes without rhyme or reason and just for the intrinsic delight of devising whatever is new and interesting, the better our chances as individuals, as a group, and as a species, of surviving and of flourishing in an inherently unstable environment. To some, therefore, it will seem that there can be no better way of explaining creativity than by exploring the creation of art; for it, we are told, is a paradigm of the human capacity to invent in ways that are richly imaginative and infinitely various. Oddly, I shall argue that the creation of art provides no special insights into human creativity, and the idea that it could betrays an important conceptual confusion.

It would seem, then, that at least part of what we call the problem of creativity is to find what sort of explanation would be proper to it. We know that human beings, or some of them, are richly inventive in ways that are of considerable value. At its broadest sense, we want to know what makes this possible. What is not clear is where we ought to look and what sorts of things we ought to consider in order to arrive at a satisfactory answer to this question. This is the problem that I address in the present essay.

1. STRUCTURES, PROCESSES, AND PRINCIPLES

One suggestion, favoured by some cognitive scientists, appears in a recent publication by Ronald Finke, Thomas Ward, and Steven Smith. According to it, human creativity is to be explained in terms of "answering cognitive structures and the processes that give rise to them".[1] At first sight, this seems promising. After all, human creativity is not creativity ex nihilo; there must be "inputs" that are combined or condensed or abstracted and recombined in ways that result in creative "outputs". On this view, the aim of such an approach is "to establish

general cognitive principles of creativity that apply across many do-
mains", so as to be able "to specify how one might go about thinking
more creatively".[2]

Thus stated, the aims of the "creative cognition" approach are
puzzling. Its authors suggest that there could be cognitive principles
which, if followed, could result in creative acts. The very idea is counter-
intuitive, for to follow or to apply principles is never to act creatively;
rather, it is to act mechanically – in a rule-governed way. There is and
can be no recipe, one wants to say, for creativity.

But there is more to be said before we can dismiss this approach.
It aims to explain creativity by exploring the cognitive structures and
processes responsible for it, and it aims to do so in ways that will deliver
broad principles of creativity – principles that we can follow in ways that
will help foster creativity in ourselves and others.[3] This much seems
true: we are a richly evolved species with an evolved mental structure
that most likely includes task-specific, information-processing domains
of one sort or another. And there can be little doubt that some of these
domains are involved in certain ways in human creativity. My doubt is
that the task, if it is one, of being creative could be confined to a
principled pattern of cognitive processes; hence that there could be
general principles of creativity that mediate this task.[4]

The problem is obvious enough: there are indefinitely many ways of
being creative, each starkly different from the other. Consider a few ex-
amples. A method of projecting a map, of playing chess, of adapting a
psychological theory, of painting, of developing a new vaccine, of using
a machine, of inventing the phonograph, of designing a chair, shoe, or
computer, of playing a game, of writing, sculpting, dancing, breaking
a code, of digging trenches, cleaning one's teeth, or replacing washers
in a tap, can all, under certain circumstances, be instances of creative
behaviour. What is more, each need not be properly thought out; it can
be stumbled upon and subsequently used. If there are any principles
that distinguish this diverse range of actions and activities as creative,
they will be highly abstract – much too abstract to explain the detail
of any particular cognitive process that we deem to be creative, and
much too general to regard as action-guiding principles productive of
creative human behaviour.

Take, by way of an analogy, the case of farming (that is, of being
agriculturally productive). There are, as anyone knows, a vast number

of actions and activities that are all instances of farming, from sowing seeds, to baling hay, milking cows, churning butter, building barns, mending fences, and so on. While it may be possible to offer some general principles that help to characterise this multifaceted occupation, it certainly is not the case that one will be able, by following such principles, to plough a field, produce bales of hay, a pint of milk, or a pound of butter. At best, such principles, if they exist, will enable one to distinguish the activity of farming from other activities, and in so doing will do no more than help delineate the concept of farming.

In just the same way, very general principles of creativity abstracted from highly diverse actions or activities will not, if adopted, enable one to be creative: to devise a new form of transport, a new style of painting, or a vaccine for Hepatitis C. At most, such principles will enable one to classify certain actions as creative, no more. They will help us to delineate the concept of creativity.

This, of course, should not be sneezed at. For, as we shall see more clearly later on, we cannot hope to offer a coherent empirical account of a creative act unless we also know what it is that distinguishes creative from non-creative acts. Although cognitive scientists sometimes seem impatient of it, conceptual clarification is of the first importance to any empirical investigation of our subject, if only because we need to know what that subject is before we can hope to explore it empirically.

There is little point, then, in seeking a generalisable or principled empirical account of creativity, hoping thereby to use it "to specify how one might go about thinking more creatively".[5] While we may indeed share certain evolved mental capacities that function as task-specific, information-processing domains, we need to see at least some of these domains as importantly malleable. Were this not so, it would be impossible to explain why different individuals process and use information differently; nor would it be possible to explain how any individual could have the capacity to adapt intellectually to new circumstances. Indeed, if such domains were too rigidly structured, individuals would lose their greatest evolutionary advantage – the capacity for creative innovation – and so would flourish only for so long as the environment remained fundamentally unaltered.

Such flexibility does not imply the absence of cognitive principles. If, however, there are such principles, the intellectual versatility needed for human creativity would require a profusion of higher-order

cognitive principles that mediate in various ways, and at various levels, the application of lower-order principles, and that do so in context-sensitive ways. So even if we suppose that there are cognitive principles pertinent to any particular creative act, there is no reason to expect that the same cognitive principles will apply to every other creative act. Rather, creative acts are, and have to be, realised or performed in a multitude of different ways; there is and can be no one mechanism, no one set of action-guiding principles, responsible for all of them.

For many of the same reasons, any attempt to explain creativity in general by appeal to causal mechanisms must fail. To use Hilary Putnam's words, creative actions are "multiply realized".[6] There is no reason at all to suppose that the causes of some of Leonardo da Vinci's more creative moments were identical to the causes of Mozart's genius, or the causes of Thomas Edison's inventiveness.

I am reminded here of the apocryphal story of Leonardo's father who hoped that he could, by simulating the conditions of Leonardo's conception, produce another child of similar abilities. The story is quaint, the misconception revealing. For Leonardo's behaviour was the causal product of many influences receding in layers of enormous complexity into the remote and unending past. These causes were so many, so distinctive, and so intricately related that he was, in respect at least of his causal structure, importantly different from other human beings. The same, of course, is true for Mozart and any other creative individual – which is just to say that a causal explanation of one person's creative acts, even if available to us, would not account for creativity in others. And if it would not, one has to wonder about the point of attempting to explain creativity in this way. It is not as if such explanations enhance our understanding of creativity in general. Nor is it the case that one could cultivate creativity through knowledge of these causes. Individuals cannot deliberately shape their own lives, or the lives of others, in ways that make all of the causal influences that bore on Leonardo available to themselves or to others. Most lie well beyond their rational control.

Attempts to explain creative behaviour causally, like attempts to explain it in terms of cognitive principles, appear to miss the boat. They do not explain the process of creativity in general; nor do they furnish the general guiding principles of creative processing. It will be recalled, though, that I began this essay with a deliberate foray into

the vocabulary of evolutionary biology, acknowledging then that the capacity of humans to be creative is an evolved capacity, a function of their biology; one, moreover, that works to protect and enhance human lives. This, of course, was meant to sow the germ of an idea, namely that creativity can perhaps be explained biologically. On this view, creativity is to be treated as an evolved capacity that serves a particular function, namely, that of enabling people to produce a large variety of new and different ideas (actions, devices, techniques) with which to protect and enhance human lives in the face of changing circumstances. It is this suggestion that I now wish to consider.

2. CREATIVITY, CONFORMITY, AND BIOLOGY

It is well known that any invention may misfire, may be less than useful, even harmful, and that in such cases what was done was of no value, and so not properly creative. This normative feature of creativity is something that cannot easily be captured in a straightforward causal explanation. Causal explanations are descriptive rather than normative; they state the antecedent conditions for a creative act, but it is difficult to see how they can capture and explain its value. In this regard at least, biological explanations hold out greater promise. For appeals to biological functions clearly import an element of normativity.[7] Parts of the body that have a function will either function properly or improperly, for closely allied to the notion of a biological function is the notion of a malfunction: a heart can function properly or improperly, and so on for every part of the body that has a function. For this reason alone, explanations of the human capacity for creativity that treat its organic base as a biological-functional kind, insofar as it plays a particular biological role, might seem to hold out explanatory promise in ways that purely causal (hence, physical) explanations do not. It, at least, can explain the fact that some of our artificial adaptations are wayward and useless.

Functional explanations of this sort cannot be properly informative unless we first know what a biological function is. Let us suppose, as is customary, that biological functions are best explained in terms of their evolutionary origin.[8] The view here is that variations within a species lead, via natural selection, to the evolutionary development of particular adaptations to the environment. They lead, that is, to the

development of specific bodily parts or organs, which, in their turn, can be said to have the function of facilitating survival, and which can be explained in terms of that function. Hence, for example, those genetic mutations among our very early ancestors that resulted, through natural selection, in the development of the opposing thumb, are thought to have bestowed a survival advantage on those who manifested this variation, and this gradually led to more humans with this bodily feature. Hence, on this view, the opposing thumb is to be explained functionally; its function being to allow the manipulation of instruments in ways that enable people to produce goods, defend themselves, build shelters – all of which facilitate human survival.

But how plausible is a biological-functional explanation of creativity? We can, of course, say – as I did at the outset – that creativity has the function of enhancing the quality of human lives and of facilitating survival. That seems roughly right, and certainly has a biological flavour to it, but it does not do very much to explain what it is that makes human creativity possible. If we want to give a fuller biological explanation, it would help to isolate certain organs or bodily parts, where this includes parts of the brain, that can work to the appropriate end. The trouble, we have seen, is that creativity cannot easily be located in any particular cognitive structure; nor, so far as I can see, is it itself the product of a single, neatly individuated, bodily part.

Earlier, though, I contended that our cognitive processes, and presumably, too, certain parts of the human brain, need to be malleable if we are to be able to explain the fact that individuals can devise new plans and devices with which to cope with changing circumstances. The way in which we process information plainly is not something that is firmly settled by our genetic inheritance. It is also the result of all sorts of external influences, as well as of repetition and reflective individual effort.

Perhaps, then, it is this malleability – the absence of fully specified "programmes" for processing information, and the resultant capacity to develop novel ways of processing and using information – that biological functionalism can best explain. Cerebral malleability, as I shall call it, could then be seen to have a function, namely, that of enabling humans to devise new methods of coping with changing circumstance, and this, it might be suggested, would come some way towards explaining human creativity.

As it stands, though, such a biological explanation is obviously incomplete. We know that people process and use information very differently, and that, as a result, they have different ideas, beliefs, and inclinations. We know, too, that were each of us to act on these differences and to pursue our peculiar inclinations and ideas, society would most likely disintegrate. It is, of course, our capacity to be socialised, and with it our ability to imitate and to follow the example of others, that prevents people from acting on their every inclination, and so prevents society from disintegrating. Ordered and regulated behaviour – what we could call "conformity" – is essential to a stable civil society, but the human capacity to learn the rules of their own society, to imitate the dominant behaviour, and so to become civilised is itself a function of the fact that the processing parts of the brain are not hard-wired in every respect. Cerebral malleability would therefore seem to have another and a very different function. For it, we can easily see, is not just the evolved source of our creativity, but is also the evolved source of our suggestibility – of our capacity, that is, to believe and be moulded by current trends, ideologies, and fashions of thought, to follow one's leader, to form allegiances, to think and to say and to do what others have thought and said and done. Although clearly in tension with one another, creativity and conformity take root, or so it would seem, in the same mental terrain; that is, in the fact that the information-processing parts of our brains are not pervasively programmed, but can be shaped in accordance with what we and others wish.

There is, of course, no a priori reason why one and the same part of the body cannot have two distinct, even exclusive, functions. Sweat glands, for instance, have the function both of cooling the body and of excreting waste products, but, clearly, a thoroughgoing explanation of how they perform these disparate functions cannot leave matters there. Each requires appeal to a different cluster of ideas (perhaps about related bodily functions, but also about evaporation and its causal effects) before it becomes possible to explain how sweat glands can both cool the human body and enable it to get rid of waste products.

In much the same way, if we are to have a reasonably informative explanation of how cerebral malleability performs the very disparate functions of promoting both creativity and social conformity, appeal will need to be made in each case to very different clusters of ideas.

In the case of creativity, though, these explanatory ideas are not themselves biological and physical, as they are with the disparate functions of sweat glands; they are social. And while it is true that our social natures must have a biological origin, it does not follow from this that it is always helpful to explain social behaviour biologically. Whether or not it is must depend on what it is that puzzles us about the behaviour in question. If you want to understand the anger of a crowd at a political protest, biological explanations will not be particularly helpful; a good deal of the explanation, if it is to solve your particular puzzle, will have to be social in nature. And much the same, I shall now argue, applies in the case of the explanation of creativity.

3. THE SOCIAL DIMENSION

We all know that to be too suggestible and to follow too closely the strictures of society prevents the sort of innovation that can be both life-sustaining and life-enhancing. We know, too, that it is a hallmark of closed and strictly regulated societies that they tend to curb human diversity and, with it, human creativity. And this tells us that without the right social conditions, within which the variable native potentialities of individuals can flourish, we are not likely to find human creativity. In most cases, there needs to be a degree of disrespect for orthodoxy, for rules, for sameness and conformity. People need to be guardedly unruly in their thinking and their behaviour, to question conformity, and in this way to retain whatever propensity they have for intellectual versatility.

Put thus, it is difficult to see how many of our puzzles about human creativity could be explained away by appeal, simply, to biological functions. For the organic functions appealed to in biological explanations of creativity are only realised in the right social conditions; conditions that will themselves need to be invoked in any helpful explanation of creativity. These have a complex social history – one, I would suggest, that is more informatively explained by appeal to social forces and trends than it is by appeal to biology.

For a long while – indeed, for overwhelmingly most of human history – the need for social order and stability was deemed to be paramount and human creativity was accordingly stifled. This, of course, did not remove the urge to do things differently; nor, given

the brute fact of changing circumstances, could it eliminate the need for new inventions, techniques, and discoveries. But the human cost attendant on such developments was often considerable, and it was a brave individual who ventured beyond the orthodox ways of a closed community.

The development of certain social spaces – most especially the university but also what we now call the art world – gradually, grudgingly, and only very recently afforded those who wished to depart from prevailing customs and dogmas a kind of protection. In the art world, this occurred haltingly and by degrees from the time of the Renaissance onwards. Until then, the Church more or less strictly proscribed artistic innovation, and it would take a further five hundred years for the notion of artistic license and the value of artistic genius to gain a foothold in the popular imagination. Academic freedom is of an even more recent provenance, having acquired such credibility as it now has in the Western world a little over a century ago. Nonetheless, such social spaces have been of the greatest value in fostering human creativity – not always without controversy and persecution, but at least with the expectation that departures from the tested and the tried will not always be treated with hostility and suspicion.

It is important to digress at this point, for if this rudimentary history is correct, it is as mistaken to see art as intrinsically allied to creativity as it is to see university education as intrinsically allied to unfettered inquiry. The truth, of course, is that for a good deal, indeed for overwhelmingly most of its long history, Western art has been in the service of one particular ideology and has, in consequence, been notoriously staid. The gradual and unplanned emergence of the right social conditions has allowed the demand for originality and, with it, the demand for creativity, to parade as the hallmark of modern and contemporary art. But artistic creation is not and has never been intrinsically creative; a good deal of it has been, and was expected to be, derivative. It exploited the hackneyed and the stale and the tired – usually religious motifs that had been rendered countlessly many times in the past, and which the medieval and Renaissance artist was expected to render countlessly many times in the future at the behest of the prince or the church.

For these reasons, a theory of creativity, whether philosophical or psychological, will not find any special insights by attending to the

process of artistic creation. What we make and in this sense create can be banal and derivative; it can also be destructive of certain values, institutions, and ideals. And in either case, we would refrain from describing the act (and the resultant artifact) as creative.[9] In point of fact, an interest in the creation of art usually only extends to that art which we also wish to praise as creative, not to art that we think of as banal. Given this interest, it would help to explain the creation of art by first explaining creativity, not the other way around.

So we cannot look to the process of artistic creation in order to explain human creativity. Nor, I have argued, are there any biological functions, causal mechanisms, or general cognitive principles that could themselves be sufficient to explain creativity. There is, we can now see, an important and complex social element that feeds into creativity. It is to this, not to cognitive processes or biological functions alone, that we should turn in order to offer a satisfactory general account of human creativity. I shall try to explain why.

4. REAL VALUE AND MALEVOLENCE

Earlier I spoke of the need for conceptual clarity when seeking to explain human creativity. The fact that acts of creation, or of making, are so often confused with creative acts speaks to this need; so, too, I have tried to show, do attempts to explain creativity biologically, or in terms of general principles abstracted from cognitive processes. In a recent article dedicated to analysing this concept, I defended what I called the Recombination Theory of Creativity.[10] According to it, an act will be creative if and only if it involves:

(1) the intentional or chance recombination of existing clusters of ideas, techniques, or objects – where this recombination is subsequently deliberately used or deployed; (2) in ways that result in something that is (or would have been) surprising to – hence, not predicted by – a given population; and, furthermore; (3) in ways that are intended to be, and are either actually or potentially, of real value to some people.[11]

It is not my intention to defend this analysis here; I have done so elsewhere, and the arguments that follow merely supplement my earlier efforts. What is pertinent to my current purpose, however, is the fact

that the second and third conditions of the analysis – the surprise and value conditions – capture intuitively important aspects of creative acts that depend crucially on facts external to the actor: on what other people expect or do not expect, and on what is of value to them. Of course, intelligent and motivated individuals can and will exploit their understanding of prevailing beliefs and values when acting creatively, but it is plain that such an understanding depends not just on their internal states and processes but also on states of affairs external to them. So, if the analysis is right, mental processes, like the particular biological functions of certain organs, can play only a part in an adequate account of creativity; they will not exhaust it.

But, of course, the analysis may not be right. I have insisted that in order to be creative, a recombination must subsequently be used in ways that are intended to be, and are potentially, of real value to some people. As I explained it, real value is always instrumental, so that an act will be of real value only "if it possesses properties that are of actual or potential benefit to sentient beings: that either do or can increase enjoyment of life, enhance security, health, prosperity, and so on".[12] But this emphasis on instrumental value, it is sometimes said, is wrong because the plainly creative act, say, of inventing a new weapon, although intended to benefit some people is also intended to harm others. This, it is contended, is why an act should be considered creative not on account of its instrumental value but on account of its intrinsic value: the cleverness, beauty, or elegance of the act.[13] If, furthermore, it were true that the value of creative acts is intrinsic to them, it would be more plausible to explain creativity solely in terms of the mental processes and powers of creative individuals. The intrinsic cleverness or beauty of the individual's actions could then be seen as the product solely of their own intellectual resources, and not of circumstances external to them. The claim, then, is that my notion of "real value" is deficient, that while a creative act must be of value, it must be of intrinsic, not instrumental, value.

While this claim has something to commend it, it is nonetheless quite seriously mistaken. For whatever else we expect from a theory of creativity, it must be able to distinguish destructive from creative acts. Acts that are deliberately harmful or malicious are properly thought of as destructive. However, such acts can be extremely clever, even if deviously so. Were it the case, then, that the value of a creative

act was wholly intrinsic to it, the inherent cleverness of a malevo-
lently harmful, hence destructive, action could render it creative. But
this consequence, I have suggested, is strongly counter-intuitive, for
it is a conceptual truth that creative and destructive acts exclude
and need to be distinguished from one another in any theory of
creativity.

As it stands, then, my account has one clear advantage: it disqualifies
an ingeniously harmful or malevolent act from being creative. It is im-
portant, though, to understand what this disqualification amounts to.
In particular, I do not wish to deny that the act of destroying something
can, in certain circumstances, be creative. Just as we must not confuse
the act of creating with a creative act, so we must not confuse the act of
destroying with a destructive act. One may destroy, yet do so creatively –
just as a scientist would were he or she to succeed in destroying the
AIDS virus in vivo, and just as Alan Turing did when he succeeded in
breaking the Enigma code. However, while the act of destroying can be
creative, no act (I have said) can be both destructive and creative; this
because both concepts have an ineliminable but mutually exclusive
evaluative component. Creative acts are valued positively because they
are intended to, and have the potential to, satisfy actual human needs
and desires. Destructive acts, by contrast, are valued negatively because
they malevolently thwart and confound human needs and desires. It is
for this reason that one cannot be creatively destructive, even though
one can destroy creatively, and even though one can deliberately and
maliciously create mayhem, harm, and chaos.

Despite this advantage, there are other reasons for thinking my
account deficient. For we all know that a recombination whose subse-
quent deployment has valuable and surprising consequences need not
be particularly clever, or beautiful, or interesting.[14] It is the intrinsic
cleverness, brilliance, delightfulness, or beauty – that is, the intrinsic
value – of the act that is missing in such a case and that inclines us to
think of the recombination as ordinary or banal, hence as less than
creative. If this is right, then we do have reason to alter my account in
a way that includes both instrumental and intrinsic value.

Let us say, then, that an act possesses the sort of value necessary for
creativity only if (1) it has properties that can be appreciated for their
intrinsic worth, and (2) because it is intended to be and is of actual or
potential benefit to some people. (This requires some minor revisions

to the analysis given earlier, but I won't pursue these here.)[15] It follows that a surprisingly clever recombination of ideas or techniques that appears, in addition, to be of instrumental value, yet is later found to be harmful and of no lasting benefit to anyone, will not be of the right sort of value and so will not be creative. This is why one can ingeniously create something – mayhem, confusion, or a mess, for instance – yet not be creative.

This still leaves me with our original difficulty, namely that a single, intrinsically valuable recombination can be intended both to harm and to benefit different groups of people. From Japan's point of view, the development of nuclear weapons during the Second World War was destructive; from the point of view of the United States and its allies it was creative. Hence, according to my account, it would seem that the act of inventing nuclear weapons was both creative and destructive – a conclusion that, by that selfsame account, is absurd.

How am I to solve this problem? Recall that the third condition of the Recombination Theory requires that a surprising recombination be used in a way that is "intended" to be of instrumental value to some people. In my earlier essay, I argued that the primary aim of the invention of nuclear weapons was not malicious but was intended to protect a particular community. Hence, since the motivating intention of the inventors was beneficial, since the invention was intrinsically clever, and since it did have the potential to benefit the people it was intended to benefit, it is rightly described as creative.[16] This solution is, I think, broadly correct. It recognises the role of individual intention or motivation in the ascription of value. Of considerable importance here is the fact that actual good was intended, even if it could be brought about only by harming others. Contrast this with the case where the same invention is motivated simply and solely by racial hatred. Here the act, although ingenious and so of intrinsic value, is nonetheless thoroughly malevolent, and for this reason is considered destructive rather than creative.

One thing to emerge from this is the fact that there are robust moral constraints on creativity, for an intentionally immoral act – one that is designed to hurt and to harm – cannot also be a creative act. But if this is so, and if it is also the case that the use made of a recombination must be surprising and of instrumental value to a community, then a general account of creativity will need to appeal to states of affairs

external to the individual. Appeal to internal cognitive processes, and to the principles that govern them, clearly will not be sufficient. And while an organ can have the complex biological function of enabling individuals to respond to social circumstances in new and different ways, those circumstances need a social explanation if we are properly to understand why the response is creative.

5. APPEALS TO GENIUS: A CONCLUSION

My quest has been to discover what sort of explanation will best enable us to offer a general explanation of creativity. My negative argument is that appeal to general cognitive principles will not serve; that, for almost the same reasons, a causal account cannot be given of creative behaviour in general. Appeals to biological functions, while useful, tell only a part of the story, for, as we have now seen, there are powerful conceptual reasons for thinking that any general explanation must appeal to social factors as well. And this, of course, throws doubt on those explanations of creativity which appeal, in the wake of Immanuel Kant, to what we fondly call genius. According to Kant, genius "is the exemplary originality of a subject's natural endowment in the *free* use of his cognitive powers".[17] And, for some, it is a short step from this to the widely held view that creativity resides solely in the cognitive or psychological capacities of the individual.[18]

There can be no doubt that those individuals who are capable of highly creative work are naturally talented. They have better powers of recall, are better able to formulate complex thoughts in words or in paint or in sound, can think more quickly, and are better able than others to grasp at a glance the implications of key assumptions and the advantages or disadvantages of particular techniques. But cleverness alone (we have seen) does little to explain creativity. It certainly can contribute to creative behaviour, but it can also contribute to, and partially explain, destructive behaviour, which can itself be clever and require remarkable powers of recall, quick thinking, and so on.

Contemporary appeals to genius tend to underestimate the contribution made by society to creative human behaviour. Kant arguably does not. He says that in addition to being the exercise of a natural

talent, an act of genius is "original" (arguably the surprise condition) and "exemplary" (which, if generously interpreted, amounts to something like the value condition). To this should be added the fact that, for the most part, creative behaviour depends on socially acquired bodies of knowledge, belief, and value – where this includes an acquaintance with relevant techniques and technology.[19] The creative acts of individuals, it would appear, are not simply of their own devising. On the contrary, just in order to use a recombination in a way that is intended to be of instrumental value, one needs to be a fully socialised human being, aware of the needs, the desires, and the expectations of one's fellow human beings.

There is another reason why appeals to an innate genius must fail as explanations of creativity. Creative actions do not always require a single human mind. Quite often in the field of science, but also in the case of many works of art – from opera and drama, through to cathedrals and palaces – creativity is the result of the interaction between minds, not the result of a single mind working in isolation.[20] The discovery of the structure of the DNA molecule, for instance, was the result not of any one person's thinking and experimentation but the work of a range of thinkers, the much-praised synthesis of which was the result of a dialogical process between their own and other ideas.[21]

According to the Recombination Theory, this should hardly come as a surprise. By its lights, it could well be the case that one person (or more) is responsible for a particular recombination, another responsible for deploying it in ways that are surprising, and yet another for using it in ways that are intended to be of real value. The result, according to this theory, is a creative act, but one that is not to be located solely in the agency and ability of a single person.

The key to creativity, I have argued, will not be found just by specifying the natural endowments that people must have in order to be creative; nor will it be found by specifying what must happen in their heads. An understanding of the concept of creativity helps us to see that creative acts can occur in many different ways, so that any general account of the phenomenon will not be able to specify a particular creative process – except, that is, in the most abstract and empirically uninformative terms.

Notes

My thanks to Jerrold Levinson, Cynthia Macdonald, and Graham Macdonald for their comments on earlier drafts of this essay.

1. Ronald A. Finke, Thomas B. Ward, and Steven Smith, *Creative Cognition: Theory, Research, and Applications* (Cambridge, Mass.: MIT Press, 1992), pp. 4–6. They propose to develop "a general approach to the study of creativity in terms of specific cognitive processes and structures".
2. Ibid.
3. See, as well, Thomas B. Ward, Ronald A. Finke, and Steven M. Smith, *Creativity and the Mind: Discovering the Genius Within* (New York: Plenum, 1995). This is a more popular work that explicitly sets out to engender creativity in others.
4. I have elsewhere considered and rejected Margaret Boden's attempt to expose the general processing principles of radical creativity. See David Novitz, "Creativity and Constraint", *The Australasian Journal of Philosophy* 77 (1999): 67–82. See also Margaret Boden, *The Creative Mind: Myths and Mechanisms* (Reading: Cardinal, 1992); and "What Is Creativity?" in *Dimensions of Creativity*, ed. Margaret Boden (Cambridge, Mass.: MIT Press, 1994), ch. 4.
5. Ibid. See also J. P. Guilford, "Traits of Creativity", in *Creativity and Its Cultivation*, ed. H. H. Anderson (New York: Harper, 1959) which explicitly sets out to cultivate creativity; and, more popularly, "Bring in the Clowns", *The Guardian Weekly* 20–6 (January 2000), which deals with attempts to foster creativity in management teams.
6. See Hilary Putnam, "The Nature of Mental States", in *Mind, Language and Reality: Philosophical Papers*, vol. 2 (Cambridge: Cambridge University Press, 1975).
7. See Graham Macdonald, "Introduction: The Biological Turn", in *Philosophy of Psychology: Debates on Psychological Explanation*, ed. Cynthia Macdonald and Graham Macdonald (Oxford: Blackwell, 1995).
8. Ibid., pp. 239–40.
9. The confusion between making and being creative occurs frequently in the literature. See, for example, Howard Gardner, *Extraordinary Minds* (New York: Basic Books, 1997), pp. 73–6, 83–6.
10. Novitz, "Creativity and Constraint".
11. Ibid., p. 77.
12. Ibid., p. 78.
13. Jonathan Dancy, Berys Gaut, and Alex Neill have made observations of this sort in discussion.
14. This, surely, was part of the problem with Charles Goodyear's discovery or invention of vulcanisation. Although achieved only with difficulty, and although its results were surprisingly beneficial, I have argued that it was too pedestrian and banal to count as fully creative. See Novitz, "Creativity and Constraint", pp. 74–5.

15. According to it, an act will be creative, if and only if it involves:
 (1) the intentional or chance, yet intrinsically valuable, recombination of existing clusters of ideas, techniques, or objects – where this recombination is subsequently deliberately used or deployed; (2) in ways that result in something that is (or would have been) surprising to – hence, not predicted by – a given population; and, furthermore; (3) in ways that are intended to be, and are either actually or potentially, of instrumental value to some people.
16. Novitz, "Creativity and Constraint", p. 79.
17. Immanuel Kant, *Critique of Judgment*, trans. Werner S. Pluhar (Indianapolis: Hackett, 1987) §49, p. 186.
18. This presumably is why Margaret Boden assimilates radical creativity to what she calls "psychological creativity" or "P-Creativity". See Boden, *The Creative Mind;* and idem, "What Is Creativity?", in *Dimensions of Creativity*, ch. 4.
19. On this, see Janet Wolff, *The Social Production of Art* (London: MacMillan, 1981).
20. Ibid. I believe that the same claim can correctly be made for any creative work of art, although I will not pursue this here.
21. See Robert C. Olby, *The Path to the Double Helix* (London: MacMillan, 1974). There can be no doubt that the innovative and highly creative thought that led to the discovery of the structure of the DNA molecule was not the fruit of a single mind; nor was it the result just of James Watson's, Francis Crick's, and Maurice Wilkins' endeavours. They certainly received the Nobel Prize for their work, but the dispute that followed this suggests that the contributions of Rosalind Franklin were simply overlooked.

8

Culture, Convention, and Creativity

Stein Haugom Olsen

I

"The lunatic, the lover and the poet", says Theseus in Shakespeare's *A Midsummer Night's Dream* (5.1. 8–18):

> Are of imagination all compact:
> One sees more devils than vast hell can hold,
> That is, the madman: the lover, all as frantic,
> Sees Helen's beauty in a brow of Egypt:
> The poet's eye, in fine frenzy rolling,
> Doth glance from heaven to earth, from earth to heaven;
> And as imagination bodies forth
> The forms of things unknown, the poet's pen
> Turns them to shapes and gives to airy nothing
> A local habitation and a name.

To this view of the poet I want to contrast those of a number of Victorian novelists who talked about their artistic productions in the terms of a very unromantic craft, such as making pastry (Thackeray),[1] calico making (as did George Eliot),[2] or the shoemaker's craft, as did Trollope. Here is Trollope's account of how he produced his novels:

As I had made up my mind to undertake this second profession I found it to be expedient to bind myself by certain self-imposed laws. When I have commenced a new book, I have always prepared a diary, divided into weeks, and carried it on for the period which I have allowed myself for the completion of the work. In this I have entered, day by day, the number of pages I have

written, so that if, at any time, I have slipped into idleness for a day or two, the record of that idleness has been there, staring me in the face and demanding of me encreased labour so that the deficiency might he supplied. According to the circumstances of the time, – whether my other business might be then heavy or light, or whether the book which I was writing was or was not wanted with speed, – I have allotted myself so many pages a week. The average number has been about forty. It has been placed as low as twenty and has risen to 112. And as page is an ambiguous term, my page has been made to contain 250 words; and as words, if not watched, will have a tendency to straggle, I have had every word counted as I went.[3]

The poetic activity as described by Theseus can without any sense of awkwardness be described as "creating". The word was originally used "of the divine agent" and had the meaning "To bring into being, cause to exist; *esp.* to produce where nothing was before, 'to form out of nothing' " (*O.E.D.*, 2d ed., 1992). And this in Theseus' words is what the poet's pen does when it "gives to airy nothing/A local habitation and a name". Seeing the artistic process in this way, the poet becomes godlike. However, "create" seems to fit far less well the activity that Trollope is describing. In his case, it would be more natural to say that he *produces* so and so many pages a day, and if we look around for another word having less strong connotations of a mechanical process, a word like "making" would seem to fit better the craftlike activity that he describes.

There are two ways of responding to the contrast between Theseus' poet and Trollope, the Victorian novelist. There is the Romantic response that takes two forms. In *The Saturday Review*,[4] the analogy between the shoemaker and the novelist became the object of sarcasm, and Trollope was accused of lacking imagination and of producing mechanical art.[5] In other words, Theseus' poet and Trollope the Victorian novelist do different things. Making is not creating. Another version of this response would be to insist that Trollope does indeed create, but in *An Autobiography* he misrepresents what he is actually doing. This kind of response is diagnosed in David Skilton's introduction to the Penguin edition of *An Autobiography*:

On the face of it *An Autobiography* stands as the record of a phenomenally fertile creative life which pays no attention to the process of creativity itself, and readers accustomed to narratives of genius suffering agonies and ecstasies in the cause of art wonder what Trollope is doing, and why he is writing his

story at all if he cannot summon up raptures of perinatal enthusiasm. Is *An Autobiography* simply an account of the triumph of Victorian practicality over Romantic or Aesthetic self-consciousness, and if so, how can it be judged in the end anything but a record of a bourgeois philistinism which denies the very art it creates?[6]

Again the assumption is that Theseus' poet is the model of the creative artist, and it is argued that Trollope, in spite of all his contempt for the myth of the aesthetic hero and "inspiration",[7] really did create in the way that Theseus' poet did.

II

The Romantic response is founded on a view of art that comes into being when the term "create" is transferred from the divine to the human sphere, more particularly to the making of the work of art. From the first occurrences in English of the terms "create" and "creation" at the end of the thirteenth century,[8] there is a period of almost two hundred years before this transfer begins. The first citation of a use of the term "creation" to mean "an original production of human intelligence or power; *esp.* of imagination or imaginative art" is from Shakespeare's *Macbeth* (1605), 2.1. 38, and does not refer to art: "Or art thou but A Dagger of the Minde, a false Creation, Proceeding from the heat-oppressed Braine?"

When the word "create" "was first used for man", says Allan Bloom in *The Closing of the American Mind*,

it had the odor of blasphemy and paradox. God alone had been called a creator; and this was the miracle of miracles, beyond causality, a denial of the premise of all reason, *ex nihilo nihil fit*. What defines man is no longer his reason, which is but a tool for his preservation, but his art for in art man can be said to be *creative*. There he brings order to chaos. The greatest men are not the knowers but the artists, the Homers, Dantes, Raphaels and Beethovens. Art is not imitation of nature but liberation from nature. A man who can generate visions of a cosmos and ideals by which to live is a *genius*, a mysterious, demonic being. Such a man's greatest work of art is himself. He who can take his person, a chaos of impressions and desires, a thing whose very unity is doubtful, and give it order and unity, is a *personality*. All of this results from the free activity of his spirit and his will. He contains in himself the elements of the legislator and the prophet, and has a deeper grasp of the true character of things than

the contemplatives, philosophers, and scientists, who take the given order as permanent and fail to understand man. Such is the restoration of the ancient greatness of man against scientific egalitarianism, but how different he now looks! All this new language is a measure of the difference; and reflection on how the Greeks would translate and articulate the phenomena it describes is the task of a lifetime, which would pay rich rewards in self-understanding.[9]

Bloom's point can be reformulated in the following way: the transfer of the term "create" from the divine to the human involves a whole new view of art that is embodied in what we may call the vocabulary of creativity, or, as Bloom would have it, in "The vocabulary of self, culture, and creativity".[10] According to Bloom this view was a "reaction to nature viewed as matter in motion, which can be conquered for the sake of man's needs", and it represented "a transcendence of nature altogether in the direction of creativity.... [This view] conquered the Continent, and came from Germany to England by way of men like Coleridge and Carlyle".[11]

One assumption central to the view of art as created rather than made, is that it is of the essence of art to bring something novel into being, not merely in the sense of bringing a new work of art into being, but in the stronger sense of not repeating what has been done before. The original application of the term "create" to the "the divine agent" with the meaning "To bring into being, cause to exist; *esp.* to produce where nothing was before, 'to form out of nothing' ", determines the connotations of the term and its cognates when applied to a human creator. The entry in the *O.E.D.* for "creation" as applied to something produced by man, runs: "An original production of human intelligence or power; *esp.* of imagination or imaginative art". The "bringing into being" has been transformed into "original", and this emphasis on the original and the novel constitutes a strong element in "create" and all its cognates when applied in the human sphere. This is perhaps nowhere clearer than in the definitions of creativity that occur in dictionaries and encyclopaedias. "Creativity", says the encyclopaedia of encyclopaedias, *Encyclopaedia Britannica*, is "the ability to make or otherwise bring into existence something new, whether a new solution to a problem, a new method or device, or a new artistic object or form". And in the article on creativity that follows this definition it is emphasized that "The single most important element in the creative process . . . is believed to be originality, or uniqueness".

A second assumption arising out of the transfer of the vocabulary of creativity from the divine to the human sphere is the assumption that the creative individual is an exceptional personality. In Bloom's words, creation was "the miracle of miracles" challenging the principle of causality and defying all reason. No ordinary person can bring about this miracle. How deeply this assumption is embedded in the vocabulary of creativity can again be demonstrated by a quote from the *Encyclopaedia Britannica* article that gives the appearance of summing up the results of recent research on creativity:

A creative person is usually very intelligent in the ordinary sense of the term and can meet the problems of life as rationally as anyone can, but often he refuses to let intellect rule; *he relies strongly on intuition, and he respects the irrational in himself and others.* Above a certain level, intelligence seems to have little correlation with creativity – i.e., a highly intelligent person may not be as highly creative. (My italics)

And in a paragraph on the creative personality the article goes on to say:

Many creative people show a strong interest in apparent disorder, contradiction, and imbalance; they often seem to consider asymmetry and disorder a challenge. At times creative persons give an impression of psychological imbalance, but immature personality traits may be an extension of a generalized receptivity to a wider-than-normal range of experience and behaviour patterns. Such individuals may possess an exceptionally deep, broad, and flexible awareness of themselves. Studies indicate that the creative person is nonetheless an intellectual leader with a great sensitivity to problems. He exhibits a high degree of self-assurance and autonomy. *He is dominant and is relatively free of internal restraints and inhibitions. He has a considerable range of intellectual interests and shows a strong preference for complexity and challenge.*

 The unconventionality of thought that is sometimes found in creative persons may be in part a resistance to acculturation, which is seen as demanding surrender of one's personal, unique, fundamental nature. *This may result in a rejection of conventional morality, though certainly not in any abatement of the moral attitude.* (My italics)

Given this view of the creative personality, a writer like Trollope, with his regular habits and conventional lifestyle, and producing his work in such a clocklike, regular manner, stands condemned.

III

Today the terms "create", "creation", "creative", and "creativity" tend to operate as what I shall call "critical primitives". Critical primitives are "primitive" in two ways. First, they are terms used to formulate fundamental problems concerning the nature and function of works of art: they are the terms used to define the problems with which aesthetics should concern itself. Second, they are primitive in the sense that they are terms used in critical and theoretical discussion without themselves having been subject to or becoming the subject of theoretical reflection: they are terms in which critical or theoretical insights are expressed, but they are not themselves used with critical awareness.

There are two potential problems with critical primitives. Critical primitives define a perspective, a way of seeing art that is beyond theory, and as such they appear partially to constitute the intuitions on which a theory is founded. Because they are embedded in theoretical discourse in this way, they have a deep inertia; that is, they are difficult to question and dislodge. This is a potential problem only, and it does not become a real one until the second problem materializes. Any critical primitive imposes ways of thinking about a problem and limitations on the theoretical discussion. Sometimes these ways of thinking may lead to an impasse or prevent new solutions from being suggested when the conclusions reached seem unacceptable or counter-intuitive. In this case the deep inertia of critical primitives becomes detrimental to theoretical reflection.

The deep inertia of the vocabulary of creativity can be seen in the defence of Trollope mounted by David Skilton. His argument in the above quoted passage was that *An Autobiography* misrepresents what Trollope does when he produces his novels. However, Skilton goes further than this. The answer he offers to his own question "how can it [*An Autobiography*] be judged in the end anything but a record of a bourgeois philistinism which denies the very art it creates?" is that Trollope not only has misrepresented the way in which he produced his novels (by suppressing all evidence of his "creative struggles"), but also has misrepresented himself as an uncomplicated and straightforward personality:

We are used to accepting Trollope's fictional versions of the world almost as though they were true, as though he was the 'giant' Nathaniel Hawthorne

compared him to, hewing out a great piece of the English countryside and putting it on display without its inhabitants being aware of what was happening to them (Chapter 8). Hawthorne's compliment turned out, intentionally or unintentionally, to have a barb. The implication that what seems to be the accurate reproduction of life implies a weakness of creative imagination has dogged Trollope's reputation ever since. Despite the fact that the gruff social exterior for which Trollope was famous accords ill with the delicate psychological analysis which is the speciality of his fiction, critics have frequently invited us to see him as a novelist who was a great realist because – and this can be paraded as an artistic weakness – he was completely and uncomplicatedly honest in real life. Yet our evidence for his simplicity is flimsy. We have the word of some of his contemporaries as to how straightforward he appeared to them, and of course we have his own word in *An Autobiography*. But what sort of credence should we give to this or any other aspect of Trollope's narrative of his own life? In any case, his own presentation of himself as trustworthy – even if true in the most literal sense – should not be applied uncritically to his narrative art, whether fictional or non-fictional. Even non-fictional narrative is 'invention' and all invention is unreliable to some degree. All narrators are liars, like the proverbial Cretans, and never less to be believed than when claiming to tell the truth.[12]

This whole argument is premised on the assumption that art is created and not made. Trollop's descriptions of his regular working habits, his emphasis on the craft, his dismissal of inspiration, and his presentation of himself as a well-balanced, rational, and, indeed, conventional person, is assumed *without any further discussion* to be at odds with his creation of good literary works of art. The alternative that there is really no need for authors to be creative personalities is not even mentioned, and therefore remains unconsidered. Here the malign effect of unquestioningly accepting the vocabulary of creativity manifests itself. The concept of creativity is taken as a critical primitive, and there is no reflection on the perspective built into the vocabulary of creativity when it is applied to art.

IV

It is arguable that both the assumptions embodied in the vocabulary of creativity, that it is an essential feature of art to present something novel and that the work of art is made by an exceptional personality, are problematic. From the first assumption follow the expectation that

art be original and the further assumption that originality is an indispensable requirement for great and even good works of art. However, if one looks at the development of, for example, various new genres in the history of literature, there seems to be little connection between originality and value. The Augustan achievement in the field of the novel was the use, on a large coherent plan, of "real" social material amplified and varied by following a longer or shorter period of the hero's life story, and by allowing a good deal of coincidence and digression. Its important technical innovation was the use of character and plot – not as mere episodes, though these abound – but as cause and effect artistically unifying an aspect of life. In the story told of the development of the English novel, the three great innovators are Daniel Defoe, Samuel Richardson, and Henry Fielding. There were a number of other novelists writing at the time, but these were the most original and those who exercised the most decisive influence in establishing the form.

Defoe took the travel narrative and the artless biography, both popular forms at that time, and transformed them into fictional narrative with a point and a purpose. He took the adventure story and raised it to greatness. For Defoe's characters, to live is to struggle for survival; the adventure becomes a metaphor for the struggle of life. Samuel Richardson, who was a London printer, was asked by two of his fellow printers to prepare "a little volume of letters, in a common style, on such subjects as might be of use to country readers who are unable to indite for themselves". Thus Richardson discovered the possibilities that the letter form holds for an epistolary story, a story told through letters. The letters give the reader dialogue, action and gesture, and dramatic scene. They also give the reader immediate self-analysis, like extensions of soliloquy. The author creates not in his own voice but projects himself into all his characters and plays them off against each other on a stage where he does not appear himself. The reader has to respond to significant variations of style in different letters in different situations. Richardson thus developed the means for deep psychological analysis that was to become such an important feature of the novel form. Henry Fielding reacted to the prudential morality in Richardson's stories and produced parodies of them. This led him to realize the necessity of a strong and coherent plot if the novel is not to fall apart into a series of unconnected episodes.

Defoe, Richardson, and Fielding were great innovators, but of the three only Fielding has been considered a great author. And his greatness is not due to the innovations he made, but to the use to which he put the plot and to his total presentation of human experience. Those recognised as the greatest of English novelists – Jane Austen, Charles Dickens, and George Eliot – appeared fifty to a hundred years later, and they were not innovators in the fundamental sense that Defoe, Richardson, and Fielding were innovators.

Much the same argument can be made with reference to the development of the English or Shakespearean sonnet. Named after its greatest practitioner, the form was developed by the earl of Surrey after Thomas Wyatt had brought the Italian sonnet form back to England from his travels. The adaptation of the Italian form to the demands of the English language was not Shakespeare's work, but that of a number of his predecessors, none of whom we are likely to come across today.

The second assumption is equally problematic. If the creative personality possesses the qualities attributed to it by the *Encyclopaedia Britannica* article, then there is no reason to believe that *all* artists or even all great artists have this kind of personality. The case of Trollope may to some not seem to carry enough weight as a counter-example, because he is arguably not among the greatest of the English novelists and one may attribute this, as Skilton reports that critics have done, to his lack of originality. However, it is not difficult to find cases of great artists who have been conventional in opinions, in habits, and in lifestyle. One obvious example is Henrik Ibsen, who had a conventional, bourgeois lifestyle and regular habits, including regular working habits. Here is Michael Meyer quoting notes made by Henrik Jaeger during a visit to the Ibsens in Fredrikshavn:

At the end of August the Ibsens returned to Frederikshavn, where Henrik Jaeger, busy preparing his biography of Ibsen, visited them and stayed for three days. He took detailed notes of their conversations, which remained unpublished until 1960:

> Henrik Ibsen's life follows an extraordinarily regular pattern. He rises at 7 in the summer, a little later in the winter; he dresses slowly and carefully, spends an hour at his toilette, then eats a light breakfast. At 9 he sits down at his desk, where he stays till 1. Then he takes a walk before dinner, which in Munich he eats at 3. If anyone wishes to visit him he will

be told that he is at home at 2.30. In the afternoon he reads; he takes his evening meal early, at 7. At 9 he drinks a glass of toddy and retires to bed. He eats with a hearty appetite and sleeps well. He spends the winter planning his books, the summer in writing; the summer is his best working time; almost all his books have been written in the summer; of those which he has published since he left Norway in 1864 only two, *The League of Youth* and *Emperor and Galilean,* have been written during the winter. When he begins to write a book he eats and drinks no more than the barest minimum; it inhibits him in his work; a small piece of bread and half a cup of black coffee are all he takes before sitting down to his desk. He smokes a little when working, otherwise not at all. He cannot understand how people who have to work can use stimulants; the only thing he can imagine that might be beneficial is a couple of drops of naphtha on a lump of sugar. In this respect he is like the caterpillar which ceases to take nourishment when it has to spin its cocoon.

In general he is regular to the point of pedantry; his day is divided according to the clock. These three days I have been living in his immediate proximity, slept next door to him and eaten at his side, we have lived by the clock from morning to night to a degree I could never tolerate indefinitely. One small example: each day when we have risen from the dinner table, he has walked over to the window and looked at the thermometer which hangs outside. To do so before sitting down to table, or to ask the servant what the outside temperature is, seems not to occur to him.[13]

Ibsen's status as a major artist is secure and there is no reason to doubt the accuracy of Jaeger's notes about his personality and working habits. It is thus difficult to avoid the conclusion that Ibsen's personality does not conform to the model of the creative personality. The plausibility of the Ibsen example also strengthens the Trollope case. For what the Ibsen example establishes is that not all great artists need to conform to the model of the creative personality. From this it follows that one cannot draw any general conclusions about the nature of the process of producing literary works of art. Different authors produce in different ways, and the artist does not necessarily possess that sort of creative personality which would constitute a basis for assuming that there is, for example, a more or less strong irrational element in the production of a literary work, that the production of great literary art involves an overstepping of boundaries, and so on.

There is also a broader historical argument that can be brought to bear to show the problematic nature of the two assumptions embodied

in the vocabulary of creativity. Prior to the late eighteenth century there was no premium on novelty in art and literature. In the eighteenth century a substantial part of the literature written was written in imitation of classical models, often simply transposing the subject of the classical poems to fit contemporary society and contemporary concerns. Sometimes, as in the case of Boileau's *L'art poétique*, the work in question came close to a straight translation (Boileau's work was essentially a free translation of Horace's *Ars Poetica*). Furthermore, translations had high artistic status, as, for instance, Pope's translations of Homer. It was part and parcel of the poetics of the time that imitation of the classical authors was necessary if one was to produce poems that had any lasting value:

> When first young *Maro* in his boundless Mind
> A Work t'outlast Immortal *Rome* design'd,
> Perhaps he seem'd *above* the Critick's Law,
> And but from *Nature's Fountains* scorn'd to draw:
> But when t'examine ev'ry Part he came,
> *Nature* and *Homer* were, he found, the *same*:
> Convinc'd, amaz'd, he checks the bold Design,
> And Rules as strict his labour'd Work confine,
> As if the *Stagyrite* o'erlook'd each Line.
> Learn hence for Ancient *Rules* a just Esteem;
> To copy *Nature* is to copy *Them*.[14]

If one accepts the assumptions embodied in the vocabulary of creativity, then the status and evaluation of the whole of the literary art of this period becomes problematic.

V

This discussion of the two assumptions embodied in the vocabulary of creativity points to the other possible response to the contrast between Theseus' poet and Trollope the Victorian novelist. This would be to accept Trollope's description of the way he produced his novels as true and accurate, but to insist that he is nevertheless doing the same thing as Theseus' poet. This response is really a reversal of the Romantic response, as it would involve questioning the appropriateness of the term "create" as a description of what Theseus' poet was doing. Such a response would be grounded on an underlying scepticism about the

usefulness of terms like "create", "creation", "creator", and so on, as descriptions of the poetic process.

Such a response is, I shall contend, necessary if one wants to undertake a discussion without prejudice of the role of convention and culture in the making of art and literature. As long as one adheres to the vocabulary of creativity, any discussion of convention in literature will run along lines that set up a conflict, or at least a contrast, between creativity and convention. Creativity becomes the overcoming of convention, the ability to break out of a mould and free art from the models of the past. This is the attitude to convention that appears in Romantic poetics. Artists of the Romantic period rejected the naturalisation of rules that neoclassical theorists took for granted. In his "Preface" to *Lyrical Ballads* Wordsworth rejects "the formal engagement" to conform to certain conventions that the poet enters into with his readers:

It is supposed, that by the act of writing in verse an Author makes a formal engagement that he will gratify certain known habits of association; that he not only thus apprizes the Reader that certain classes of ideas and expressions will be found in his book, but that others will be carefully excluded. This exponent or symbol held forth by metrical language must in different eras of literature have excited very different expectations: for example, in the age of Catullus, Terence and Lucretius, and that of Statius or Claudian; and in our own country, in the age of Shakespeare and Beaumont and Fletcher, and that of Donne and Cowley, or Dryden, or Pope. I will not take upon me to determine the exact import of the promise which by the act of writing in verse an Author, in the present day, makes to his Reader; but I am certain, it will appear to many persons that I have not fulfilled the terms of an engagement thus voluntarily contracted.[15]

By "the act of writing in verse" the author makes "a formal engagement" with the reader to conform to a set of conventions both with regard to style and content. However, these conventions are not grounded in nature but in the habits of a community at a certain time and in a certain place. The conventions are therefore contingent and unstable, and they consequently change from one period to another (from "the age of Catullus" to the age of "Terence and Lucretius, and that of Statius or Claudian"), and from one country to another (from classical Rome to England). The conventions are contingent in the sense that they can change and even be dispensed with altogether, without consequences

for the possibility of producing and appreciating literature and with-
out endangering the quality of the literature produced. However, con-
ventions are not only unnecessary to the making and appreciation of
literature. Wordsworth, in the "Preface", makes the standard point of
the Romantics: that there is a *conflict* between nature and convention
in art as well as in life, and that original art has to go back to nature –
and to unsophisticated nature at that – for its models, both with regard
to subject and style. The justification for this is that it enables the poet
to give a truer account of "the primary laws of our nature":

The principal object, then, which I proposed to myself in these Poems was to
choose incidents and situations from common life, and to relate or describe
them, throughout, as far as was possible, in a selection of language really used
by men; and, at the same time, to throw over them a certain colouring of
imagination whereby ordinary things should be presented to the mind in an
unusual way; and, further, and above all, to make these incidents and situations
interesting by tracing in them, truly though not ostentatiously, the primary laws
of our nature: chiefly, as far as regards the manner in which we associate ideas
in a state of excitement. Low and rustic life was generally chosen, because in
that condition the essential passions of the heart find a better soil in which
they can attain their maturity, are less under restraints and speak a plainer and
more emphatic language; because in that condition of life our elementary
feelings co-exist in a state of greater simplicity, and, consequently, may be
more accurately contemplated, and more forcibly communicated; because
the manners of rural life germinate from those elementary feelings; and, from
the necessary character of rural occupations, are more easily comprehended;
and are more durable; and lastly, because in that condition the passions of
men are incorporated with the beautiful and permanent forms of nature. The
language, too, of these men is adopted (purified indeed from what appear
to be its real defects, from all lasting and rational causes of dislike or disgust)
because such men hourly communicate with the best objects from which the
best part of language is originally derived; . . .[16]

For the Romantics artistic convention was problematic in a way
that it was not for the neoclassical authors. They therefore, like
Wordsworth, developed theories of convention that placed convention
externally to art itself, as artificial rules that *distort* representations of na-
ture. The reason why Wordsworth chose "low and rustic life" as both his
subject and the model for his style is that he considered "in that condi-
tion the essential passions of the heart" were themselves undistorted by
convention and expressed in a "plainer and more emphatic language".

The Romantic view of convention as arbitrary, irrational, artificial, and repressive, and as something that should therefore be challenged and overcome, has been powerful. Not only does it determine the premises for any discussion about the nature of the poetic process; it has also provided the premises for the attitude to convention that one finds in postmodernist literary theory, where convention again appears as something to be attacked and subverted. Since conventions have no basis in nature or reason and are thus arbitrary, their function can only be ideological: conventions conserve and protect the power of the hegemonic classes in society. It is politically necessary and morally imperative to undermine this hegemonic power, and this provides a political motivation for attacking convention. The problem with this view of art is that it forecloses, or at the very least discourages, any discussion of the constructive role that rules and conventions play in the making of literature.

Such a discussion needs to set up a conceptual framework that goes beyond that provided by Jon Elster in *Ulysses Unbound*, where the point of departure is how constraints are necessary to enhance creativity. This still ignores the social nature of artistic practice, and any account of how the conditions for the making of art are constituted will need to take that into consideration. In the following remarks I shall primarily refer to literature, and I am unsure whether the points I make can be generalised across the arts. If one wants to say something informative about the conditions for art making, it has to be said at a level sufficiently specific for its application to be clear.

The writing and reading of literary works is a social practice where the reader and the writer have different roles to play but where both are constrained by the same set of concepts and rules. The conditions for writing literature are thus the same as those for appreciating literature. The constraints on creativity in the writing of literature are determined by the same conditions that constrain appreciation of literature. The norms defining the practice as the practice that it is, are not conventions but rules; they are not arbitrary but necessary.[17] The practice may be arbitrary, but once the practice is in existence, the rules cannot be changed without changing the practice. In addition to the constitutive rules of the practice there exists a large and amorphous set of conventions that change over time but that at any one time determines how the goals of the practice are reached in single cases. These will be

conventions of genre, symbol conventions, plot conventions, stylistic conventions, conventions for characterisations and so on. These conventions can be changed, can be overcome, replaced, and the practice can be renewed through the adoption of new conventions. These conventions are not chosen by the writer but imposed on him by socialising him into a subgenre of the practice. The rules, concepts, and conventions of the practice provide, together with the cultural environment in which the author lives, the conditions for the making of a literary work.

It is important to see what this framework does not do. It does not exclude the personal, subjective, individual consciousness as the originator or creator of the literary work; the individual author has a strong position within this framework. Nor does it constrain creativity; it creates the condition for creativity. Outside the framework there cannot be any literary creativity. This is an important point because it assigns the right place to convention and rules in relation to creativity: not only is there no conflict between creativity and rules, but literary creativity is not conceivable without the rules.

The following point also needs to be made. Accepting that the activity of reading and writing literature is an institutional practice, one does not accept that the participants in the practice belong to any specific community with a social identity beyond that of being participants in the practice. There is thus no assumption built into the framework about the author's social or cultural background. This again does not mean that cultural and social environment does not place conditions on creativity, but that is a separate discussion.

Notes

1. See, e.g., his letter to Trollope, 28 October 1859, quoted in Anthony Trollope, *An Autobiography* (1883) (London: Penguin edition, 1996), p. 91: "Don't understand me to disparage our craft, especially your wares. I often say I am like the pastry cook, and don't care for tarts, but prefer bread and cheese; but the public love the tarts (luckily for us) and we must bake and sell them."

2. See George Eliot, "Leaves from a Note-Book", in *Essays and Leaves from a Note-Book*, Standard Edition (Edinburgh: William Blackwood, 1883), p. 290.

3. Trollope, *An Autobiography*, pp. 79–80.

4. *The Saturday Review* and its attitude to Trollope is summarised in David Skilton, *Anthony Trollope and His Contemporaries. A Study in the Theory and*

Conventions of Mid-Victorian Fiction, 2d ed. (Basingstoke, Hampshire: Macmillan Press, 1996).

> It consistently objected to art it considered to be 'unimaginative', and denounced Trollope's fiction as 'monstrously prosaic' – as showing merely a 'soberness of fancy coupled with a copious variety of detail'. Conscious of their social and intellectual superiority, the university men on the *Saturday* felt a deep scorn for any popular phenomenon, in literature, religion, dress or politics. Hence they looked down on periodical fiction in general. (p. 53)

5. Ibid., pp. 53–4.
6. David Skilton, introduction to the Penguin edition of *An Autobiography*, p. ix.
7. Referring to the methodical way of planning his writing as he describes it in the quotation above, Trollope says:

> There are those who would be ashamed to subject themselves to such a task master and who think that the man who works with his imagination should allow himself to wait till – inspiration moves him. When I have heard such doctrine preached I have hardly been able to repress my scorn. To me it would not be more absurd if the shoemaker were to wait for inspiration, or the tallow-chandler for the divine moment of melting. If the man whose business it is to write has eaten too many good things, or has drunk too much, or smoked too many Cigars, – as men who write sometimes will do, – then his condition may be unfavourable for work; but so will be the condition of a shoemaker who has been similarly imprudent. (*An Autobiography*, p. 81)

8. The following are the first citations in the *O.E.D.* of "create" and "creation": "**c1386** Chaucer *Pars. T.* 144 Al be it that God hath creat [3 *MSS.* created] al thing in right ordre'; **1393** Gower *Conf.* III. 91 To-fore the creacion Of any worldes stacion".
9. Allan Bloom, *The Closing of the American Mind* (New York: Simon and Schuster, 1987), pp.180–1.
10. Ibid., p. 181.
11. Ibid.
12. David Skilton, introduction to the Penguin edition of *An Autobiography*, pp. ix–x.
13. Michael Meyer, *Henrik Ibsen, Vol. III: The Top of a Cold Mountain 1883–1906* (London: Rupert Hart-Davis, 1971), pp. 89–90.
14. Alexander Pope, *An Essay on Criticism*, lines 118–40 in John Butt, ed., *The Poems of Alexander Pope. A One Volume Edition of the Twickenham Pope* (London: Methuen, 1963).
15. William Wordsworth, preface to *Lyrical Ballads*, in W. J. B. Owen, ed., *Wordsworth's Literary Criticism* (London: Routledge and Kegan Paul, 1974), p. 70.
16. Ibid., pp. 70–1.
17. This account is abstracted from John Searle, *The Construction of Social Reality* (London: Allen Lane, The Penguin Press, 1995), ch. 2, "Creating Institutional Facts".

9

Art, Creativity, and Tradition

Noël Carroll

1. THE PREJUDICE AGAINST TRADITION

Tradition has had a bad odor among artists of the twentieth century. And as anyone who has ever taught in an art department knows, antitradition rhetoric has seeped into the consciousness of many an undergraduate journeyman (and woman). When I taught film history, a required course for fledgling moviemakers, I was frequently asked by them why they had to take my course – why did they have to study film history? After all, Hitchcock never enrolled in such a course, and he turned out okay. Their basic presupposition seemed to be that somehow learning the tradition of their art form would impede or hamper or stultify the flowering of their natural creativity. This article of faith, moreover, is well precedented in the writings of many twentieth-century artists. Perhaps the Futurists are the best-remembered proponents of virulent anti-traditionalism. In the manifesto entitled "The Futurist Synthetic Theatre," Filippo Tommaso Marinetti, Emilio Settimelli, and Bruno Corra proclaim:

The Futurist Theatre is born of the two most vital currents in the Futurist sensibility...which are: 1) our frenzied passion for real, swift, elegant, complicated, cynical, muscular, fugitive, Futurist life; 2) our very modern cerebral definition of art according to which no logic, *no tradition*, no aesthetic, no technique, no opportunity can be imposed on the artist's *natural talent;* he must be preoccupied only with creating synthetic expressions of cerebral energy that have THE ABSOLUTE VALUE OF NOVELTY.[1]

So convinced were the Futurists that tradition threatened the creative potential of their natural talent that they urged: "Set fire to the library shelves! Turn aside the canals to flood the museums! ... Oh, the joy of seeing the glorious old canvases bobbing adrift on those waters, discolored and shredded!"[2] One suspects (and hopes) that this rhetoric was intentionally hyperbolic. However, the message is clear: tradition, as accumulated in libraries and museums, is the enemy. The enemy of what? Creativity.

Nor were the Futurists alone in their animus against tradition. Nunism (Nowism), as its very name indicates, also eschewed any connection with the past. In 1916, its polemicist Pierre Albert-Birot wrote:

Do we worship Isis, Jupiter, Janus, Jehovah, Christ, Boudha [*sic*], Moloch? No. Do we wear tunics, peplums, or armor? No. Do we speak Egyptian, Greek, Rumanian, Hebrew ... Roman or Chinese? No. So why should our arts be Egyptian, Greek, Rumanian, Gothic, Chinese, or Japanese?

Our idea, our costume, our language, is it the same as in the time of Louis XIV, Louis XV, Louis XVI? No. Why should our arts be the same? Is our ideal, our way of dressing or of speaking, the same as last century's? Does our time resemble that of our parents? No. So let's do as each people has done in each period of time, LET'S BE MODERN; let our works be the expression of the time in which they were born, these works alone are living.

ALL THE OTHERS ARE ARTIFICIAL
TO EACH TIME ITS ART.[3]

Moreover, this sentiment is, albeit more succinctly and more colorfully, echoed by Vladimir Mayakovsky, who recommends, "Throw the old masters overboard from the ship of modernity."[4]

It is hard not to detect a residue of earlier ideas about creativity in these twentieth-century manifestos. With their references to the modern, Albert-Birot and Mayakovsky, perhaps unconsciously, recall to mind the famous debate between the Ancients and the Moderns – that is, the eighteenth-century debate between those who emphasized the emulation of ancient models as the road to artistic excellence versus those who championed originality and natural genius.[5] Intimated by Addison, but then elaborated in greater detail by Edward Young, the Moderns' position contrasted imitation of traditional models with reliance on artistic spontaneity, leaving little doubt of the superiority of the latter approach.

Young writes: "An *Imitator* shares his crown, if he has one, with the chosen object of his imitation; an *Original* enjoys an undivided applause. An *Original* may be said to be of a *vegetable* nature; it rises spontaneously from the vital root of genius; it *grows*, it is not *made*: *Imitations* are often a sort of *manufacture* wrought up by those *mechanics, art* and *labour*, out of pre-existent materials not their own."[6] and: "[L]et not great examples, or authorities browbeat thy reason into too great a diffidence of thyself: Thyself so reverence, as to prefer the native growth of thy own mind to the richest import from abroad; such borrowed riches makes us poor."[7] Indeed, imitation of the tradition not only makes us poor, but proud, "makes us think little, and write much."[8] Though born original, Young says, we die copies.[9] That is, by emulating the canon, artists alienate themselves from their own sources of genius, and originality.

These ideas, of course, were then seized upon eagerly by the Romantics with their extreme emphasis on individuality and, through them, relayed to the twentieth century, when the notion that tradition is inimical to creativity, spontaneity, and originality became a recurring commitment, inspiring wave upon wave of avant-gardists with the conviction to overcome tradition and, as Ezra Pound says, "to make it new."

Undoubtedly, the tendency of nineteenth-century artists to model their own, allegedly Promethean creativity on God's[10] also reinforced the prejudice against tradition. For if God creates ex nihilo, so must the artist; but if artistic creation emerges from tradition, it comes from somewhere and is not sui generis. Moreover, God is a creator, not an imitator, where imitation is conceived to be essentially tradition-bound. So a godlike artist should not be tethered to tradition, no matter how sterling the exemplars gathered together in the canon of that tradition be. Likewise, the separation of the artist from systems of patronage placed a premium on the individuality of the artist. No longer charged by commissions from church and state, the artist was free to pursue his or her own aims – ones that expressed his or her own individuality – and to search out consumers with like interests in the marketplace. What the artist had to sell was her own individuality, her own subjectivity, and originality became her calling card. But to be genuinely individual, to be an authentic original, was to be autonomous, not a slave to a tradition, bound to it by imitation. Perhaps that is why

Schopenhauer characterizes genius as akin to childishness – as uncorrupted by the acculturation process which tradition represents. Maybe that is why Mozart is so often represented as a prodigy who remained perennially childlike.[11]

Insofar as the modern myth of creativity is tied up with ideas of originality, spontaneity, freedom, exorbitant claims to individuality, and the notion of artistic genius as thoroughly self-determining, it has little patience for the idea of an artistic tradition. Tradition stands in the way of creativity and artistic freedom by introducing something putatively not of the artist's own into the mix. If artistic creativity, properly so called, is the spontaneous outpouring of the authentic self uncontaminated by anything else, then tradition is its nemesis.

Instead of freedom, tradition is seen as a form of bondage to the past. Instead of spontaneity and utter self-determination, sympathy for tradition marks the artist as a person with a past, a past to which she is beholden. And whereas artistic creativity is associated with consummate originality, unconstrained by anything, the notion that the artist is beholden to tradition undermines his godlike individualism, his supposed power to give the rule to nature. On this view, appeals to tradition are always, essentially at root *academic* (in the pejorative sense of that term).

Something like this view of artistic creativity is widely abroad even today. It is probably the Ur-theory of artistic creativity in our culture, often masquerading under the name of self-expression. Undoubtedly, connected to this prejudice is the commonplace that art cannot be learned and that artists are born to their vocation rather than trained. And though never stated quite so baldly by professional philosophers, some of these tenets lie submerged in their theories as well. The purpose of this essay is to challenge the opposition that the Ur-theory presupposes between artistic creativity and tradition. I shall argue not only that its metaphysical conceits are outlandishly excessive, but that, in point of fact, tradition is and must be an important ingredient in artistic creativity, properly so called.

2. THE CASE FOR TRADITION

For the purposes of this essay, there are at least two senses of the notion of artistic creativity: the descriptive sense and the evaluative one. In this

section, I will discuss the descriptive sense and argue that tradition is indispensable to artistic creativity of this sort. In the next section, I will briefly examine the evaluative sense of artistic creativity.

In the descriptive sense, artistic creativity is simply the capacity to produce new artworks that are intelligible to appropriately prepared and informed audiences. A creative artist is someone who is able to carry on – to continue to produce new artworks. An uncreative artist, in this light, is someone who lacks the ability to go on producing new works of art – for example, a novelist with writer's block or a plagiarist. In this sense of creativity, the artworks in question need not be especially valuable. When we use the word "creative" to praise an artist or a work of art, we are employing it in the evaluative sense.

In the descriptive sense, an artist is creative if she is able to produce new artworks that elicit uptake from suitably prepared viewers, listeners, or readers; she is creative in the evaluative sense if those works possess a certain type of value (to be discussed later). But clearly to be called creative in the evaluative sense requires being creative in the descriptive sense, since if nothing is produced, then there is nothing to praise.

The pressure to create new artworks comes from several sources. First, inasmuch as art is intended to stimulate, command, and absorb the attention of audiences, some variation and novelty is requisite, lest the artist's work starts to blend, as they say, into the woodwork.[12] The artist renews attention to his production through change. The artist is also drawn to variation insofar as she is involved in a conversation with other artists – in effect, a conversation about the techniques and purposes of her art form – and, as in any conversation, she feels the pressure to add something new to the dialogue.[13]

Furthermore, the artist is virtually impelled toward change, because, as Hegel pointed out, as time goes on, the concerns, emotions, ideals, and so on of her culture evolve, and she must find new ways to express them. And last, the challenge to innovate also arises recurringly as new media and technologies for expression and representation become available. For these reasons, and others, art gravitates toward differentiation, variation, and innovation. Change is the name of the game; artistic creativity in the descriptive sense is the price of entry for the individual artist.[14]

This is not to say that every artist is a revolutionary. The kind of variation expected can come in small increments as well as large ones. An artist's output need not mutate enormously from work to work. Nevertheless, some variation from work to work is the norm. Thus, artistic creativity appears to be presupposed by the very vocation of the artist. But whence does this spring?

Because he denied that artists possess knowledge, Plato hypothesized that the source of artistic creativity is divine madness – the artist inspired by the gods or muses. But this conjecture is of little use to us, since there are no gods, and, in any case, Plato forgot to discount the possibility that artists, even if they lack knowledge about war, statecraft, and navigation, nevertheless possess knowledge of their art form. That is, though poets are not generals, as Socrates reminds Ion, they know how to represent generals. As Shakespeare shows in *Henry V*, they know how, for example, to portray the way in which a warrior-leader might go about rousing his troops. Moreover, there is no need to plump for a supernatural explanation of this knowledge. From a perfectly naturalistic viewpoint, one may hypothesize that the artist learns how to do this by studying the tradition of her art form.

Historically, a more palatable explanation than Plato's for the source of artistic creativity appeared in Longinus's *On Sublimity*. Whereas Plato/Socrates situated artistic creativity outside of the artist – in a genie, so to speak – Longinus relocated it inside the artist, in his natural, inborn genius. The artist, in other words, is her own genie. Genius, furthermore, is not taught, and this natural endowment is the prime cause of at least great art.[15] In Longinus, then, we find the germs of the avant-gardist repudiation of tradition rehearsed above, transmitted to the twentieth century through the influential writings of people like Edward Young and then, momentously, by Immanuel Kant.

Longinus's problematic was to weigh the competing claims of natural genius versus rules and precepts as sources of artistic creativity. In this, he was a trimmer. Though giving natural genius an edge in the matter, he also conceded a role for rules and precepts in the process of artistic creation – notably as curbs or brakes on natural excess. However, as the discussion ensued over the centuries, the rivalry between natural endowment versus rules and precepts as the source of artistic creativity turned into a zero-sum game. The font of artistic creation

was either nature or the rules, inspiration rather than perspiration, genius rather than the artificial or mechanical application of precepts. Moreover, this opposition of natural talent to rules of art explains in large measure the deprecations of tradition in the name of creativity that we hear from avant-gardists and undergraduate art students alike, since tradition, in their minds, is squarely associated with allegiance (generally assumed to be blind) to the rules and precepts of art.

The first argument against rules of art is fairly straightforward. There are no rules of art – no algorithms of composition that guarantee success in every instance. One cannot create artworks by the numbers. So it cannot be that artistic creativity is a product of tradition, conceived of as a body of rules, because there are no rules in the relevant sense. That is why artistry cannot be taught. Artistic creativity must hail from elsewhere. This, then, prompts the hypothesis that it originates in the artist's natural endowment, which should never be hemmed in by alleged, phantom rules.

A second argument looks to the history of art and notes that tradition, with its vaunted rules, has often been an impediment to creativity. Had Shakespeare abided by the so-called Aristotelian unities, we would not have had *King Lear* to enjoy today. Tradition, in this respect, is an obstacle to creativity. It chokes it and attempts to contain it. But history shows that great works of art, like those of Shakespeare and Beethoven, originate in the defiance of tradition and its supposed rules and instead rely upon natural genius, which today might also go under the name of the unconscious.

Both these arguments rest on what I will argue are misconceptions concerning the nature of artistic tradition. Both arguments associate artistic tradition with rules. But if there are no rules, the first argument, which we may call the no-rule argument, maintains, then there is nothing to learn from tradition and no way for tradition to nurture creativity. Moreover, the second argument, which we may call the genius-argument, adds that the things which are advanced as rules, like the Aristotelian unities, are really parochial norms that, as they become obsolete, shackle real creativity.

With respect to the no-rules argument, several things need to be said. First, there do seem to be some rules of art, or, at least, fairly reliable rules of thumb, such as Hume's recommendation that if an author wants to hold the reader's attention, he should make sure that there

is a secret in the story – that is, something the reader desires to learn – which keeps her turning the pages. In each art form there are rules of this sort that an artist may learn that will enable her to secure certain routine effects. Of course, these rules do not have scientific precision. Since artworks are very complicated, such rules have to be subtly coordinated with other factors. The rules cannot be applied mechanically. Their application requires finesse and judgment. But arguably these talents themselves are acquired by studying the tradition and its canon of exemplars.

Of course, the rules the skeptic has in mind may not be rules such as those for promoting effects, like suspense. What the skeptic denies is that there are rules which guarantee the production of masterpieces. This may be correct, and, in any case, no one knows what those rules might be. However, this is irrelevant to a descriptive account of artistic creativity. For such an account is only concerned with the contribution that tradition makes to the creation of new works, whether they be masterpieces or not. And it may be the case that sometimes, even often, traditional rules of thumb, supplemented by judgment, is what enables artists to produce new work – that is, to be creative in the descriptive sense. That is, after all, why visual artists learn color theory.

The no-rule argument may be right in its contention that there are no rules of art that are algorithmic, but this is also true in other arenas, such as morality and the law, where we are not disposed, in consequence, to deny there are rules. Of course, the skeptic may concede this and go on to modify his position by saying that if there are such rules, there are not very many of them, and, in any event, they are not very important. So even if tradition is a matter of such rules, tradition's contribution to artistic creativity dwindles to insignificance.

Now the skeptic may or not be correct about the number and import of such rules. However, even if he were right, his conclusion does not follow from this, because it is not clear that the only thing an artist learns from her tradition is a body of rules. That is, the conflation of tradition with rules, especially algorithmic ones, is invidious. For, as I will attempt to show in what follows, artists learn something more than rote formulas from their tradition and it is this something more that is indispensable to artistic creativity.

However, before turning to this issue, a few points need to be made about the second skeptical argument, the genius-argument. Like the

no-rule argument, it uses masterpieces – works by Shakespeare and Beethoven – as its primary intuition pumps. Thus, it is really concerned with artistic creativity in the evaluative sense, not routine artistic creativity in the descriptive sense. It may be the case that certain masterpieces defy period-specific rules, but that does not imply that period-specific rules do not sometimes abet the creation of new artworks, some of which may be very good, even if others are not.

Moreover, again like the no-rule argument, the genius-argument supposes that artistic traditions are to be construed as a body of rules, indeed, particularly rigid, static, and inflexible rules, rules that stand in the way of creativity as a logjam holds back the torrential, altogether sublime river. But this is the wrong way to conceive of an artistic tradition.

Artistic practices evolve for reasons we have already suggested. This evolutionary process involves expansion in new and future directions and the retention of past aims, values, and strategies that make evolving artistic practices of a piece with their predecessor practices. Tradition obviously plays a role in this process in terms of retention. But tradition also contributes to the expansion of the practice by informing artists about which variations in artistic production are intelligible ones, given the background of the practice.

That is, artistic creativity is not a matter of random variations. Artists need some sense of which variations will count as intelligible or relevant expansions of the same practice. That sense, in large measure, derives from their immersion in a tradition. Tradition, in this respect, is what negotiates the transition between the past and the future of artistic practice.

Tradition, in short, is not an inflexible barrier to change and creativity. It is a flexible resource for initiating relevant and intelligible changes within artistic practices – a resource that enables artists to create new work that remains within the boundaries of the self-same practices. In this regard, it is mistaken to view artistic tradition as an obstacle to creativity; rather it is an engine or catalyst that enables it to unfold.

So far I have criticized the two skeptical arguments that impugn the role of tradition with respect to artistic creativity. I have done so primarily by denying that their conceptions of tradition are accurate. But if this is to be more than a logical gambit, the burden of proof is

upon me to suggest an account of artistic tradition that supports the claim that it is an indispensable contributing factor to artistic creativity in the descriptive sense.

In his book *Ulysses Unbound,* Jon Elster points out that artistic creativity requires a way in which to delimit the number of options that confront the artist.[16] Too many options lead to paralysis rather than creativity: too many possibilities, without some way of narrowing down the field of alternative choices, will stop the artist in her tracks rather than promoting the production of new work. Elster emphasizes the importance of constraints, especially self-elected ones, for performing this filtration function. This is true enough. However, artistic traditions, which are not always best spoken of in terms of constraints, also operate as filtration devices. That is, filtration is requisite for artistic creativity, but self-elected constraints are not the only source of filtration. Tradition is another, indeed, a generally more pervasive one.

Tradition is the living past of a practice. It is indispensable for creativity in the descriptive sense, because it serves to fix the horizon of possibilities that lie before the artist. It focuses the artist's attention upon those options that will be intelligible – to both the artist and her audience – against the historical background of a practice.

Call these options live options. Artistic change and innovation emerge in the course of history. The artistic choices that will be intelligible at time T_5 are made possible, in part, by earlier choices in the practice. Presenting an upside-down bathroom fixture as a new work of art would not have been intelligible – would not have been a live option – in the court of Louis XIV, even if it had been signed by an artist. For such a gesture to be intelligible requires a background of doing and saying – of making and theory (or, at least, lore, history, and shoptalk).

That is, for a ready-made like Duchamp's *Fountain* to be intelligible as an artwork, it had to fit into the conversation of art in a way that was relevant,[17] and relevance, in this sense, is in large measure a function of previous stages in the conversation, which stages we may refer to as tradition. Moreover, the tradition not only serves to filter out live options, but since there is generally an array of live options, the artist's understanding of the tradition also enables him to assess them in terms of which ones are most apposite, given his circumstances. The tradition, that is, not only performs a filtration function with regard to artistic creation, but an assessment function as well.[18]

Artists acquire knowledge of the tradition in the process of learning their profession. They begin by imitating the past – not only models from the past, but routines, strategies, conventions, rules of thumb, past solutions to recurring problems, and so on. Imitation is the means by which artists are initiated into their vocation. Aristotle pointed out that imitation is a key source of learning, something readily confirmed by contemporary psychology. This is true not only for things like language, morals, and etiquette, but for art making as well.

Artists could not become artists unless they had something to emulate. This is not to deny that natural endowment may make a difference in the degree of facility they achieve. However, it cannot be a matter of natural genius "all the way down," as the antitradition rhetoric sometimes suggests, since such genius would remain empty and inert without models, strategies, conventions, and routines to imitate. And, of course, the source of these exemplars is the relevant tradition. To suppose otherwise is to buy into a metaphysical view of genius that is frankly exorbitant. It relies on a romantic myth of the individual self apart from society and socialization.

Artists begin to learn how to go on in their practice by imitation. There is, it appears, no other way. But here tradition, it should be noted, is not primarily a body of rules applied mechanically, as the antitraditionalists suggest, but rather a collection of exemplars that include not only artworks as models, but also routines, techniques, solutions to recurring problems, conventions, effects, and so on. That there may not be any algorithmic rules of art does not preclude the importance of tradition to artistic creativity, as the no-rule argument contends, since the tradition is primarily a diverse assortment of models to be imitated, with increasing finesse and judgment, and sometimes to be surpassed as the artist becomes more familiar with her trade. Even revolutionary choreographers begin by learning how to dance, often in the very style they will eventually come to oppose.

The enemies of tradition, of course, deny it a creative role exactly because they are suspicious of imitation. For them, however, the guiding notion of imitation is that of slavish or blind imitation. So, they conclude, if tradition is to a large extent a matter of imitation, then it is more of a manacle on creativity than an enabling factor. If journeymen (and women) are enlisted in their art form by means of imitation, putatively they will never be creative. The tradition will function

like a cast-iron template stamping out copies. But this is where the skeptic's error lies – in the assumption that an artistic tradition is rigid rather than flexible, strictly imperatival rather than suggestive, cast iron rather than plastic.

But how is this possible, if the imitation of exemplars plays such a large role in artistic education? Because an artist is not simply inducted into her practice by the imitation of models and routines. The artist learns more than that. She learns about the rationales behind those routines, techniques, conventions, and strategies, about the history of her art form; about those whom her teachers regard as illustrious predecessors to be emulated (and about those to be despised as disreputable); about the nature of their accomplishments (and transgressions) and the aims and values they embody; about what are taken to be significant breakthroughs and turning points in the practice, and about why those are important; as well as hearing about what are regarded as blind alleys and regressive tendencies in the practice, along with explanations of why this is so. She hears a great deal of criticism, positive and negative, and not only heeds what it says, but takes on board many of its implications and presuppositions.

The blossoming artist, that is, not only learns certain techniques of composition, initially through imitation, but that process is surrounded by talk – often less theory than a mix of history, folklore, art criticism, and practical rumination, though sometimes explicit theorizing as well. In learning about the techniques and routines of an art form, the artist, often indirectly though sometimes overtly, learns about the aims and values of her practice. As she learns, through imitation, the means of her practice, she also comes to understand its purposes, problematics, and points, as those are embodied in exemplars and commented upon by other artists in her circle, including both peers and mentors. Her education is not merely an affair of doing – of imitating exemplars. The doing is also accompanied with sayings, sayings which she hears from her teachers, or reads in commentary if she is an autodidact, and which she learns to say herself and to herself in the process of coming to understand the practice.

In acquiring knowledge of her tradition in this way, she not only learns about a plurality of different means for making artworks, but she learns about the plurality of various aims and values that these diverse means can serve. Different strategies may secure different aims

of an art form. For example, some strategies may promote harmony in music, while others arouse feeling. It is then up to the artist to attempt to amalgamate these disparate purposes, weighing them in variable combinations, or to pursue exclusively one aim rather than the other in her work. These are judgment calls the artist must make, guided, but not mandated, by her understanding of the tradition.

Thus, the artist need not slavishly imitate the past, but rather finds in the past as it is handed on (in Latin, *traditio*) to her a plurality of related but different aims, means, exemplars, and histories – networks of association – that she may employ in order to determine the way in which she will carry her practice and the practice forward. It is from this background of knowledge that she is able to recognize live options in the practice (the filtration function of tradition) and to assess which ones are most appropriate to her context (the assessment function). As she acquires knowledge of the tradition and command of its plurality of means and ends, the possibility of new combinations and new points and purposes opens up. If the artist is able to create spontaneously – automatically and seemingly without effort – that is because she has imbibed the tradition, making it her second nature.

Practices, artistic and otherwise, are "self-propagating histories of activities."[19] The vehicle for the propagation of artistic practices is the artist who in the process of learning and comprehending her tradition acquires habits – habits of making and habits of mind – that enable her to go on, to continue making new artworks.[20] However, since these habits can be acquired variably from different parts of the tradition by different artists, and since even the same artist's habits may be influenced by different strands of the tradition – strands that may even clash – the practice can and is likely to change, not despite its traditions, but because of them. Artistic practices do not issue forth the same old thing again and again, because the tradition itself is complex, often resounding with clashing voices and examples, and because those voices and examples must be interpreted by different artists, making different judgment calls, often while attending to different strands in the tradition.

Artistic creation involves the production of new works that are intelligible. Intelligibility here faces in two directions. The work must be intelligible to the artist and to his intended audience. In both cases, intelligibility, to a substantial degree, is achieved by connecting the

new work to the tradition – to antecedent exemplars, techniques, conventions, conversations, and purposes. This is most obvious in terms of securing audience uptake. If artworks were absolutely novel, as the Futurists urged, they would be incomprehensible to audiences.[21]

The artist must make contact with the audience in some common place, and that common place is the antecedent history of the practice, a.k.a. tradition.[22] But the tradition is also where the artist must look for her own self-understanding of her work, because that is where her habits of making and thinking come from, not from gods and muses as Socrates conjectured (or was he merely joshing Ion?).

Moreover, the artist's sense of the tradition is typically apt to converge with her intended audience's, since the artist is not only a maker: she too is a member of the audience – both with respect to the work of other artists, but also with respect to her own work, where she functions as its first viewer, reader, or listener. Stepping back from her own work, she surveys her choices and, using herself as a detector, contemplates its intelligibility and fitness for other audience members like herself, and then adjusts, assesses, criticizes, and corrects her work with these judgments in mind.[23]

In the process of becoming an artist, one introjects a tradition, incorporating some subset of its means, ends, techniques, rules of thumb, norms, stories, routines, exemplars, conventions, and so on, which then cross-pollinate and incubate[24] in often unique ways, and which afford the necessary background for artistic creativity.[25] With regard to some artists, this cognitive and emotive stock may be somewhat systematic and fairly explicit. But for most artists it will be a loose network of habits (of making and thinking), often only tacitly or unselfconsciously understood, and accessed fluidly and selectively as called for by contextual considerations. That is the reason why, as commentators have pointed out,[26] artists typically use the language of correctness – "That's right," "It feels right," or "It clicks" – to explain their choices, rather than adverting to rules applied algorithmically.

Tradition is indispensable to the creation of new artworks. This is most evident when artists work in inherited styles and genres in which they redeploy tried and true structures, varying only the content. For example, in the genre of the buddy film, one may vary or permutate the cast of characters in terms of their professions, races, genders, educational backgrounds, and so on, while still keeping the basic generic

structure of contrasting personalities (the odd-couple format) intact. This clearly counts as artistic creation in the descriptive sense, since it involves the production of new work that is intelligible. But it is also obviously creation within a by-now established tradition whose structural données the filmmaker repeats. Call this type of artistic creativity repetition.

At the same time, this is not slavish imitation, for with each repetition the filmmaker will have to make local adjustments, deciding what to emphasize, exaggerate, connect, diminish, balance, foreground, compare, subtract, contrast, and so on. Moreover, this sort of creation by repetition is not only present in the cineplex, but in the avant-garde biennale as well, where politicized installation pieces deploy a panoply of recurring devices – such as lists, videos, quotations, photos – for the same critical (often political) effect. However, the fact that artists often repeat stylistic and generic données need not count against the quality of the new artwork, since those traditional données can be reworked with varying degrees of ingenuity, insight, grace, facility, and pointedness.

It is also possible for an artist to repeat the traditional content of a genre or style while varying its structures. One of Stephen King's accomplishments has been to take the traditional material of his genre, as typically found throughout much of the twentieth century in the short story and comic book, and to reconfigure and expand it to the length of a full-scale novel by employing extended characterization and iterated suspense sequences. His book *Pet Sematary*, for example, is basically "The Monkey's Paw" made contemporary and replete with much more character psychology and color – not to mention more than over two hundred more pages. *Pet Sematary* is an instance of artistic creativity, but one that exploited King's knowledge of the traditional canon of his art form, while at the same time reinventing its prevailing structure.

Artistic creativity, then, may proceed from repetition – the repetition with variation of the structures and/or themes found in the antecedent tradition. But another process of artistic creativity is hybridization, the yoking together of two or more heretofore distinct styles or genres. For example, in *Apollo*, George Balanchine mixed together movements from jazz dance and from classical ballet, discovering through juxtaposition qualities and possibilities of movement previously unimagined in either dance form. Likewise, much

postmodern gallery art involves melding vernacular imagery with art-world critique. Clearly, artistic creativity of this sort requires understanding not only one's own immediate tradition but adjacent ones as well.

Hybridization is also relevant to the case of Shakespeare, the hero of the genius-argument. Skeptics rightly point out that he did not follow the Aristotelian unities. But he was steeped in theater tradition, from which he borrowed freely, mixing elements drawn from Roman models, including Seneca and Plautus, medieval theater (in terms of its their episodic structures), and Italian commedia dell'arte. Shakespeare was exposed to these different genres and styles in his apprenticeship, and after a sufficient incubation period they matured into the magnificent hybrids that, howsoever much they defy the rules, would not have been possible without the input of the theatrical tradition.

Of course, an artist may not only look at the range of different styles and genres in her own art form for creative inspiration; she may also look to the other arts and their traditions. Often artistic creativity results from interanimating art forms – from importing strategies, aims, and values from one artistic tradition (not necessarily of one's own culture) into another, in the way that postmodern choreographers attempted to implement the program of modernist painting in dance. We can label this process of creation "artistic interanimation." Moreover, artistic interanimation and hybridization are frequently recurring strategies when artists feel the pressure to rejuvenate their tradition. This is why, for example, Soviet theater artists in the twenties incorporated silent-film techniques in live performances.

In addition to repeating their generic données with variations, hybridizing their art forms by mixing styles, and interanimating art forms, artists also produce new work and transform their tradition creatively by amplifying it – by finding new solutions to enduring problems within the tradition. For centuries, Western artists were preoccupied with the problem of capturing the appearance of things; artistic creativity revolved around finding new ways to approximate the way the world looks. The artists who contributed to this project *amplified* the tradition by providing new means to secure aims already recognized within the tradition.

Likewise, in the film *M*, Fritz Lang solved the problem of how to integrate the fluidity of silent-film technique with the new technological

possibility of sound recording. He achieved this by using offscreen sound asynchronously or contrapuntally – by showing us one thing while we hear something else unseen. In this he was using an editing principle, namely, montage juxtaposition, which had been perfected in the silent-film period as a way of organizing the relation between the image track and the sound track. Lang thus solved a problem that was recognized as such within his practice, while also finding a way of expanding the resources of that practice that continues to influence filmmakers today.

Like repetition, hybridization, and interanimation, artistic creation by amplification also depends on tradition, since the problem and its criteria of solution are relative to the historical background of the practice. That is, tradition is where the problem and the criteria of what would count as its solution come from. In the case of Lang, the importance of tradition was double-barreled, since he not only inherited the problem from his practice, but found the solution there, too, in his creative rethinking and extrapolation of the poetics of montage.

Thus far, the creative processes canvassed – repetition, hybridization, artistic interanimation, and amplification – all emphasize ways in which artistic practices evolve in a continuous fashion. It should come as no surprise that tradition plays a constitutive role in this regard. But what about artistic revolutions – especially revolutions, like Futurism, that claim to repudiate tradition? If tradition is, as I allege, indispensable to artistic creativity in the descriptive sense, doesn't that hypothesis have to accommodate revolutionary artistic eruptions as well? For certainly artistic revolutions count as instances of artistic creativity. Indeed, for some they are paradigmatic cases. And yet many artistic revolutions are heralded as utter breaks from tradition – defiant repudiations of what has gone before.

It is undeniable, as we saw in the opening section of this essay, that revolutionary artists often repudiate tradition. Yet it is a curious fact about these repudiations that they generally repudiate only a selected portion of the tradition, usually the ensemble of techniques and values that congealed in and dominated the art world immediately prior to their own attempted revolution. Moreover, in repudiating that formation of the practice, revolutionaries generally claim the authority of other portions of the tradition – either specific earlier practices or

enduring aims or values of the practice – as a basis for their revolt. The Russian Formalists referred to this as "the knight's move."

That is, artistic revolutionaries hypostasize a period-specific coalescence of the tradition as The Tradition and repudiate it under that label, while, ironically, citing other strands of the tradition in their brief for artistic rebirth. This is analogous to the cultural reformer who denounces bourgeois morality as Morality for the sake of actually defending his own preferred recommendation for moral regeneration (such as the call for less sexual repression).

Yet it is not really tradition *tout court* that is being denounced in these cases, but rather a particular configuration of artistic choices. And, in fact, that configuration itself is typically attacked in the name of renewing the tradition, of returning to options and values that have allegedly and lamentably been suppressed, neglected, or forgotten under the dispensation of the reigning style. Thus, German Expressionists appealed to the precedent of expressive distortion found in medieval artists in their war with realism.

As previously noted, artistic traditions are complex in terms of their aims, means, and values. That is, artistic traditions may possess a multiplicity of aims, means, and values. To simplify drastically, theater involves both text and spectacle, word and image. In certain periods, one of these elements, and the values associated with it, may be perceived to have the upper hand, to the virtual exclusion of the other element. That is how Antonin Artaud saw the theater of his time. He regarded it as text- and word-dominated, Apollonian rather than Dionysian. Thus, he called for a theater of images to reinvigorate theater, citing earlier theatrical practices, like Balinese dance. Though vituperating the tradition of theater, his revolt can be better understood as an attempt to get in touch with vital elements of the tradition that he was convinced had been repressed under the regime of the well-made play.

Despite the fury of his manifestos and spectacles, Artaud invokes past practices of theater, and the traditional ends and values he finds embodied in them, to advance his radical innovations. Every avant-garde repudiation brings to light a legacy of ancestors. Often the avant-gardist names these predecessors explicitly, as Artaud did with reference to the Balinese.

But sometimes the invocation of the past is more general, taking the form of an appeal to an enduring, but still live, aim or value of art.

Thus Duchamp resorted to ready-mades to disrupt the art world's over-valuation of manual skill and sensuous beauty for the sake of reestab-lishing the artistic tradition's commitment to the intellect – to being thought-provoking – an enduring aim of art that Duchamp believed had been forgotten, or at least woefully undervalued.[27]

Moreover, this sort of process of repudiation and innovation often appears at junctures where a prevailing style or genre is believed to have exhausted its potential for further development. At that point, the artist looks backward – to the tradition – for a way forward.[28] But this re-sults, not in a slavish replication of the past, but a reinvention, since the artist will reinterpret the significance of the enduring aims and values of the tradition in light of recent history and his own circumstances.

Although it may seem oxymoronic to suggest that tradition con-tributes even to the radical revolutionary artistic process of repudi-ation, it should come as no surprise. For even avant-garde creativity requires intelligibility – both for the artist and her audience. There is no absolute novelty, again pace the Futurists, that is also comprehen-sible. In order to be understood, the relevant avant-garde innovation must be connected to something familiar to both the artist and the audience. In order to make sense, it must be an innovation relative to a familiar background, and that background, of course, is the artistic tradition. That avant-gardists themselves are aware of this is evinced by the way in which they speak out of both sides of their mouths: tongue-lashing tradition, but then citing traditional precedents and values in support of their cause.

Tradition plays an indispensable role in such processes of artistic creation as repetition, hybridization, artistic interanimation, amplifi-cation, and revolutionary repudiation. This entails that the notion that tradition is inimical to artistic creativity is false, since in these cases tra-dition is a constitutive ingredient in artistic creation in the descriptive sense. Thus, in its strongest version, the Ur-theory of artistic creativity is a romantic myth. The artistic tradition need not be an obstacle to creativity. It is a resource for engendering creativity that enables artists to filter out live options and to assess them. Because the tradition is rich – comprised of many projects and voices – it is a flexible resource, not a cage.

I cannot claim with certainty that the list of creative processes I have provided is exhaustive. There may be others. So I have not conclusively

demonstrated that the tradition is an essential ingredient in every sort of artistic creativity. But my list is comprehensive enough, I think, to warrant provisionally the hypothesis that tradition is indispensable to artistic creativity across the board. The burden of proof, then, is on the skeptic to adduce some process of artistic creation that operates without any input from the artistic tradition. Until then, it is reasonable to presume that artistic traditions are indispensable for artistic creativity in the descriptive sense.

3. ARTISTIC CREATIVITY IN THE EVALUATIVE SENSE

In the descriptive sense, the artist is creative when she produces a new work that is intelligible to the relevant audience. Probably most intended artworks are creative in this sense – that is, they have been created. However, this is not the only sense in which an artwork is said to be creative. The other sense is commendatory. To say an artwork is creative is not just to say that it has been created; it is to say that it is valuable in some respect. "Creative" is evaluative in this sense, because it tracks value.

Perhaps sometimes people use the word "creative" as a synonym for "good" – "The piece is so creative" just means "The piece is so good." But I presume that "creative" is generally a more specific accolade than "good." It is an attribution that would appear to have more descriptive content than "good" *simpliciter*. In its evaluative usage, "creative" connotes value. To say an artwork is creative is to claim that it should be highly valued. But for what reason? I suggest that it is the value the artwork has for the tradition in which it has been created.

We call innovations like Lang's deployment of asynchronous sound in *M* creative in the evaluative sense because of its contribution to the history of film (and TV). It was a particularly fecund intervention in the practice because of the resources it made available to subsequent generations of filmmakers. It was creative in the procreative sense – it was generative, it was fertile, it gave rise to many progeny. It was creative, in part, because its influence is so widespread. Lang perfected a technique that the vast majority of filmmakers have relied upon at one time or another in their careers. From a merely quantitative point of view, its significance has been immense. But it is also important from the qualitative perspective, for it made possible wondrous experiments

in the use of asynchronous sound, such as those of Godard. One thing, then, that we mean when we applaud an artwork as creative is that it has been bountiful – its consequences have been both copious and beneficial for the practice to which it belongs. This sort of creativity is obviously calculated retrospectively.

But, of course, this cannot be the whole story, since we are often disposed to call artworks creative in the evaluative sense before we are in a position to estimate their consequences for the tradition. In the case of historical achievements which had plentiful influence on the future that evolved in their wake, we estimate their creativity by attending to the branching lines of development they motivated. But what of works in the present, whose future is necessarily obscure to us, which we are also prepared to call creative? I want to propose that these evaluations, too, are, in an important way, also tradition-relative.

When we call a recent artwork "creative," we mean that it has recombined elements and concerns of the tradition in an especially deft, original, or insightful way. In this, it shows us the tradition and its possibilities more clearly, expansively, and perspicuously than earlier works. By boldly economizing his means of expression – paring down his cinematic resources primarily to a reliance on point-of-view editing – in *Rear Window*, Alfred Hitchcock disclosed to us in striking relief the central vertebrae of the classical mode of Hollywood narration. When *Rear Window* was first released, people were ready to call it creative. They did so, I submit, because it enabled them to see the tradition of filmmaking in a new light. It revealed to us how powerful a device the taken-for-granted structure of point-of-view editing really is.

One would not call *Rear Window* creative simply because it was effective in promoting suspense. Many suspense films do that without meriting the appellation "creative" in the evaluative sense. Nor was it creative in the evaluative sense because it reconfigured the tradition (by subtraction, so to speak); that alone would only warrant calling it creative in the descriptive sense. Rather, *Rear Window* possessed some added form of value. It illuminated a power of cinema that was there all along in the tradition for anyone to see, but which only Hitchcock had the simplifying nerve and discernment to spotlight. After *Rear Window*, we are wont to say that earlier film history never looked the same again. That is why it is appropriate to call *Rear Window* creative. It

not only reassembled the cinematic tool-kit in a novel way, but it made the structure of the tool-kit newly manifest. What was creative about *Rear Window*, indeed breathtaking, was that it enabled us to see afresh the tradition we thought we knew so well.

From the vantage point of historical hindsight, we call past artworks creative in the evaluative sense retrospectively as progenitors of subsequent developments, in terms of both the extent and the quality of what they have influenced. With contemporary artworks, we say they are creative when they re-collect the means and/or purposes of the tradition in a way that clarifies the tradition – in a way that brings its latent possibilities, commitments, and structures into the foreground. Works that stand the test of time with respect to both these criteria are the most worthy of the title "creative" in the evaluative sense. Perhaps when we call contemporary works creative, we are issuing a promissory note – a bet that they will be fruitful – given the clarity they have already brought to the tradition. We suppose, reasonably, that that clarity will have consequences. Though we may be wrong in this, that expectation is not without grounds. Nor need we withdraw the label "creative" from such works if they are genuinely brilliant reconceptions of the tradition, albeit infertile ones.[29]

The conception of artistic creativity in the evaluative sense that I have proposed centers on the place of the art object in an evolving practice.[30] Creativity is relative to the tradition in two different, though frequently related, ways. This view of artistic creativity contrasts with the perhaps more common view that creative artworks are the ones that flow from genius. That conception of creativity correlates it with certain inner, psychological processes – whatever happens when genius does its work. My conception of artistic creativity has more to do with the place of the artwork in outwardly observable social and historical processes – the evolution of the relevant art world. In this regard, my conception seems more plausible, since we have little access to the inner workings of genius. Indeed, our only way of locating artistic genius seems to be to begin by isolating creative works in my sense, and then to go looking for the psychological processes that coincide with them. I am not very sanguine that we would find any distinctive regularities here. But the fact that such an investigation would be parasitic on the conception of artistic creativity in my sense should be enough to take the most ambitious form of the romantic notion of genius out of the

race as a significant competing account of artistic creativity, even in the evaluative sense.

4. SUMMARY

Tradition and artistic creativity are often thought of as contraries by avant-garde artists and art students alike. I have argued that this is a mistake both with respect to artistic creativity in the descriptive sense and in the evaluative sense. Tradition is, I contend, indispensable to the day-to-day artistic creativity we see everywhere around us – the constant production of new works that are intelligible to prepared and informed audiences. As an artist prepares for her vocation, she submerges herself in her tradition, and what she takes from it incubates in ways that enable her to produce new works, works never before seen under the sun, which are, nevertheless, intelligible to her intended audiences.

Where the artist grapples with prevailing problems of the tradition, her creativity is flexibly controlled by critically interacting with prior products of the tradition so as to put herself in contact with recognizable problems and norms for their solution.[31] Where the artist seeks to revitalize her tradition by repudiating domineering predecessors and setting out in a new (generally *re*discovered) direction, she does so by appealing to aims and purposes abroad, alive, and acknowledged in the tradition, albeit as interpreted or reinterpreted, and given determinate content by her in virtue of her concrete circumstances.

Artists use the tradition to locate which options are live options for them to pursue, and to assess which of the possible live options make the most sense for them, given their context. Without such guidance as to how to continue to proceed, there would be no artistic creativity. That is why tradition is indispensable for artistic creativity and not its antagonist, as romantic propaganda might have it.

But tradition is not only relevant to artistic creativity in the descriptive sense. It is also relevant to artistic creativity in the evaluative sense – the sense where we intend to commend a work not simply for having been created rather than plagiarized, but for being an *extraordinary* creation. For the value of a creative artwork is the contribution it makes to the tradition either by its influence, quantitatively and/or qualitatively speaking, or through the way in which it clarifies the tradition,

or both. Artistic creativity is not identified in terms of the effectively occult operation of genius, but by how the artwork behaves against the background of tradition.

It may be hard to convince the art student communing with his own inner spark, like my filmmaking students of yesteryear, of this. But that spark will set nothing aflame unless it is fueled by tradition. So, if any of my former students are reading this essay, let me repeat: "You have to take my film history course. That's the bottom line. It's what you need, even if you don't believe it."

Notes

The author wishes to thank Berys Gaut, Sally Banes, Dale Jamieson, P. Adams Sitney, Philip Harth, Annette Michelson, and Lester Hunt for their help in the preparation of this essay.

1. Filippo Tommaso Marinetti, Emilio Settimelli, and Bruno Corra, "The Futurist Synthetic Theater," in *Let's Murder the Moonshine: Selected Writings of F. T. Marinetti*, ed. R. W. Flint, trans. R. W. Flint and Arthur A. Coppotelli (Los Angeles: Sun and Moon Classics, 1991), p. 135. This manifesto was initially issued in 1915.

2. Filippo Tommaso Marinetti, "The Founding and Manifesto of Futurism," in *Let's Murder the Moonshine*, p. 51. This was first published in the Parisian newspaper *Le Figaro* in 1909.

3. Pierre Albert-Birot, "Banality," in *Manifesto: A Century of Isms*, ed. Mary Ann Caws (Lincoln: University of Nebraska Press, 2001), p. 195 (my italics).

4. Vladimir Mayakovsky, "A Drop of Tar," *Manifesto*, p. 234. Mayakovsky's manifesto dates from 1915.

5. For an excellent discussion of this debate, see Peter Kivy, *The Possessor and the Possessed* (New Haven, Conn.: Yale University Press, 2001), ch. 3.

6. Edward Young, "Conjectures on Original Composition," in *A Collection of English Prose: 1660–1800*, ed. Henry Pettit (New York: Harper and Brothers Publishers, 1962), p. 394.

7. Ibid., p. 402.

8. Ibid., p. 400.

9. Ibid.

10. George Steiner, *Grammars of Creation* (New Haven, Conn.: Yale University Press, 2001), p. 22.

11. Kivy, chs. 5 and 6.

12. Colin Martindale, *The Clockwork Muse: The Predictability of Artistic Change* (New York: Basic Books, 1990).

13. The notion of art as a conversation derives from Jeffrey Wieand, "Putting Forward a Work of Art," *Journal of Aesthetics and Art Criticism* 41 (1983): 618.

14. Some artistic traditions may encourage more change than others. Some may even discourage change. My point is that, given the considerations rehearsed above, some change in all artistic traditions is virtually inevitable. The evidence for this is that even traditions that devalue change exhibit variation from work to work, from generation to generation, and so on. The preceding two paragraphs attempt to explain why this is.

15. Admittedly, Longinus was concerned with art of a high level of accomplishment and not routine creativity. However, since many people tend to use the notion of art honorifically, regarding as art only works of palpable achievement, it is understandable that the genius account is often appropriated as a description of the processes of ordinary artistic creation.

16. Jon Elster, *Ulysses Unbound* (Cambridge: Cambridge University Press, 2000), pt. 3. Elster's work is discussed at greater length by Jerrold Levinson in Chapter 10 of this volume.

17. See Wieand, following Grice, on conversation.

18. Tradition performs a filtration function for the artist by sorting live options from non-options. For example, painting in the manner of Bouguereau – that is, non-ironically, non-reflexively, or "straight" – is not a live option for a painter entering the art world today; it is an option foreclosed by the evolution of the tradition. However, the same tradition allows that appropriating Bouguereau's work allusionistically or reflexively is a live option; though this, of course, is not the only live option (the only non-non-option) available to the contemporary artist.

 In this regard, the tradition presents an artist with a gamut of live options at any given moment. In order to proceed, the artist must elect some of those live options over others. A contemporary artist may ask herself, "Should I explore postmodern pastiche or painterly abstraction?" To answer that question, the artist must reflect upon which live alternatives best serve her interpretation of the tradition. That is, the tradition enables the artist to *assess* which live artistic options most suit her understanding of and commitments to the tradition. The filtration function selects out live artistic options; the assessment function then enables the artist to weigh those live options in terms of what she finds most worthy of pursuit.

19. Theodore R. Schatzki, *Social Practices: A Wittgensteinian Approach to Human Activity and the Social* (Cambridge: Cambridge University Press, 1996), p. 137.

20. See Stephen Turner, *The Social Theory of Practices: Tradition, Tacit Knowledge and Presuppositions* (Chicago: University of Chicago Press, 1994), p. 121.

21. The claim that the intelligibility of artworks depends upon a backdrop of tradition raises the question of how the first artworks could have been intelligible, insofar as, *ex hypothesi*, there was no antecedent *artistic* tradition. I am very uneasy speaking about "first art," since I suspect that it is a logical fiction. However, supposing there was a moment when art first appeared on the scene, how would it have been intelligible, given the preceding account?

It does not seem controversial to conjecture that art, as we know it, emerged from related practices, such as ritual. These proto-artistic, overlapping practices – involving symbolism, representation, expression, decoration, and so on – themselves possessed traditions of making and thinking. Consequently, it is in virtue of the traditions of these proto-artistic practices that first art, if there was such a thing, would have been understood. See my "Art, Practice, and Narrative," in *Beyond Aesthetics* (New York: Cambridge University Press, 2001).

22. This is why artistic creativity cannot be simply a matter of self-imposed constraints. Self-imposed constraints can be completely arbitrary, like Georges Perec's avoidance of the letter *e* in his novel *La Disparition*; but the more arbitrary the self-imposed constraint is to the audience, the less likely will be its intelligibility to audiences. Inasmuch as audience intelligibility is involved in artistic creativity, common bonds need to be established, and shared traditions are the most natural means of securing them. Consequently, insofar as such bonds are necessary, and insofar as they are not available solely through arbitrary, self-imposed constraints, tradition is indispensable for artistic creativity. Nor does it seem correct to assimilate the notion of tradition to that of a constraint, since constraints are primarily negative, whereas traditions are generative.

23. The notion that the artist has a special aptitude for communicating intelligibly with her audiences by doing something that they do, only more effectively, appears in the theories of genius of DuBos, Gerard, and arguably Kant. But, whereas they think that this communication is universal in its reach, I would relativize it to prepared or informed audiences – the target audiences of the author, who, because they are like the author in pertinent respects, including sharing a tradition, enable the author to use her own responses to anticipate theirs. For relevant information about DuBos, Gerard, and Kant, as well as a penetrating genealogy of the concept of artistic genius, see Paul Guyer, Chapter 4 in this volume.

24. If creativity is vegetative, as Young suggests, then tradition provides the seeds.

25. What Gotz calls the preparation and incubation stages of creativity are clearly bound up intimately with the artist's immersion in her tradition. Insofar as these stages are necessary to the creative process, tradition is indispensable to artistic creativity. See Ignacio L. Gotz, "Defining Creativity," *Journal of Aesthetics and Art Criticism* 39 (1981): 299–300.

26. Ludwig Wittgenstein, *Lectures and Conversations on Aesthetics, Psychology and Religious Belief*, ed. Cyril Barrett (Berkeley: University of California Press, n.d.), and Monroe C. Beardsley, "On the Creation of Art," *Journal of Aesthetics and Art Criticism* 23 (1965): 291–304.

27. Perhaps the interest of contemporary artists in exploring beauty once again is a reciprocal reaction to the success of Duchampian anti-aesthetics and intellectualism.

28. As Artaud did with *Les Cenci*, through which he attempted to restore the Jacobean revenge play as a way of revitalizing the theater of his time.

Noël Carroll

29. One case I have not explicitly discussed is that of artwork which, because it is ahead of its time, goes unappreciated in its own day and, consequently, has little or no influence on subsequent developments. Given what has been said so far, must we deny that it is creative in the evaluative sense? I think not.

There may be two different cases here. Let me take them up one at a time. The first case is when the innovative work in question is a precursor of some other work (or works) that does (do) have a significant influence on what follows. In this instance, the relevant work is creative in the evaluative sense, because it is fecund, though its fecundity may be somewhat indirect. Nevertheless, it has a pertinent causal role in bequeathing the tradition benefits that were popularized by one of its descendants.

The second case occurs when the innovative artwork has no influence whatsoever. Such a work may still be called creative just in case it reworks the tradition and illuminates its possibilities in a particularly perspicuous manner. This may happen even if these possibilities are not exploited by subsequent artists. That the work is not appreciated in its own time does not preclude our calling it creative in the evaluative sense, if, with historical hindsight, we can see that it was, unbeknownst to its contemporaries, a particularly discerning reworking of the tradition. But, of course, it must be at least this. An unintelligible "original," both in its own time and ours, hardly counts as creative.

That is, I propose that we call this example creative on the same grounds that we call contemporary works creative whose consequences are yet unknown to us. Moreover, I prefer this solution to the case at hand – rather than going counterfactual and saying that the work is creative on the grounds that it would have had great influence if only it had had a sympathetic audience – because the complexity of the variables in play in art history render any such predictions little more than arm waving.

30. Other approaches that emphasize the value of creativity in terms of the place of the object in evolving practices include those of L. Briskman and Dale Jamieson; however, the weight given to the value of the object in relation specifically to tradition is my own. See L. Briskman, "Creative Product and Creative Process in Science and Art," in *The Concept of Creativity in Science and Art*, ed. D. Dutton and M. Krausz (The Hague: Martinus Nijhoff, 1981); and Dale Jamieson, "Demystifying Creativity," a lecture given at the NEH Institute on Philosophy and the Histories of the Arts, San Francisco State University, 1991.

31. Briskman, p. 148.

10

Elster on Artistic Creativity

Jerrold Levinson

1

The French novelist Georges Perec wrote a novel, *La Disparition*, in which the letter *e* was nowhere used.... This is an extreme example of the more general idea that artists may impose constraints on themselves in order to create better works of art. In Perec's case the constraints were entirely idiosyncratic. In other and more frequent cases the constraints take the form of conventions that define a particular genre. Although freely *chosen*, in the sense that it is up to the artist whether to submit to the laws of the genre, they are not *invented* by the artist. In still other cases the constraints are *imposed* from outside.... (pp. 175–6)

So begins Jon Elster's discussion of creativity and constraints in art in the third part of his recent book, *Ulysses Unbound: Studies in Rationality, Pre-Commitment and Constraint*.[1] I shall later return to *La Disparition* and indicate my differences with Elster regarding the virtues of Perec's singular novel, but I shall begin by exploring how far we might take the tripartite division of artistic constraints that Elster here suggests, into *chosen*, *invented*, and *imposed* ones.

Chosen constraints are ones adopted by the artist from a pool of preexisting styles, genres, or forms. *Invented* constraints are ones devised by the artist, to which the artist subsequently adheres. And *imposed* constraints are ones rooted in external conditions, whether physical or social or legal, that cannot be altered or evaded by the artist.

Some examples of chosen constraints are sonata form, sonnet, haiku, iambic pentameter; still-life painting, charcoal drawing; two-person play, comedy of manners; Greek temple, Roman arena. Some examples of invented constraints are twelve-tone composition, musique concrète, prepared piano pieces à la John Cage; collage painting, kinetic sculpture, ready-mades à la Duchamp, rayograms à la Man Ray; and absurdist theatre à la Beckett or Ionesco.

Some examples of imposed constraints, finally, are these: the maximum length of breath possible to exert in singing; the maximum loudness attainable in solo piano music; the maximum height of jump in dance; the rectangularity of shots in conventional film; the irreversibility of shaping in carved sculpture; the exclusion of live firearms in installation art; the prohibition of certain subject matters in PG-rated film.

With both chosen and invented constraints there is evidently an element of voluntary participation by the artist, whereas with imposed constraints this appears to be lacking. But it is worth observing that even with imposed constraints, the artist's agency is not entirely annulled. In the first place, the artist is still faced with the choice between various attitudes that can be taken to the imposed constraint. For example, cheerful acceptance, stoic resignation, angry defiance, or blithe near-obliviousness.[2] In the second place, the artist is always free to decline the gambit entirely, electing not to create subject to the constraint in question, and simply passing on or forgoing the art form or endeavor in which that constraint is unavoidable.

If an artist chooses a constraint, says Elster, he presumably believes that he will benefit artistically from having a smaller sphere of choice. This is a case of standard precommitment, and the constraint thus an *essential* one – that is, consciously one chosen for the expected benefits of it. In other cases a constraint is adopted or accepted, but not with an eye to reaping a benefit; it is then an *incidental* constraint. An incidental constraint may end up being of benefit, but such benefit is not the reason for its adoption or acceptance. And an incidental constraint may also evolve into an essential constraint, if endorsed by the artist for its expected benefits after initial adoption.

2

One of Elster's main themes is the contrast between choice *of* constraints at the outset of the creative process, and choice *within* constraints, which occurs throughout the creative process:

The creation of a work of art can in fact be envisaged as a two-step process: *choice of constraints* followed by *choice within constraints*. The interplay and back-and-forth between these two choices is a central feature of artistic creation, in the sense that choices made within the constraints may induce an artist to go back and revise the constraints themselves. (p. 176)

Elster's description has the ring of truth: there are undoubtedly phases in the process of creating works of art, and the phases may typically be related in the way that Elster proposes. But still, we must ask, if the artist is free to go back at will, at any point, and revise the constraints under which he had been operating, is it really useful to think of them as *constraints* rather than as, say, provisional guidelines, or working assumptions? Elster's idea of constraints as a constant and defining feature of the creative process seems somewhat too . . . constraining.

To be fair, Elster does acknowledge that there is an interaction between choice of constraints and choice within constraints in the making of art. An example he gives is this: "A writer may initially plan to develop an idea in a full-length novel, and then, finding that it will not sustain that format, turn it into a short story of thirty pages" (p. 201). Even so, Elster arguably underestimates the purely heuristic value for artistic creativity of mere opening moves or posits, ones not thought of as binding and thus not reasonably construed as constraints. The self-binding of an artist, in other words, is significantly unlike the self-binding which served as a paradigm in Elster's earlier studies of the rationality of precommitment, namely that undertaken by Ulysses in having himself bound to the mast of his ship as prophylactic against the sirens.[3] For Ulysses's self-binding was entered into (*a*) deliberately and explicitly, (*b*) categorically and unrevisably, and (*c*) with a definite objective in view. But the self-binding of an artist, if we consent to call it that, is typically (*a*) inexplicit or only partly explicit, (*b*) eminently revisable, and (*c*) often entered into with no very definite objective in view. In short, Elster's model of precommitment is unnecessarily inflexible, and does not sort well with the way artists actually go about creating works.[4]

3

Elster is explicitly committed to an account of artistic creation that sees it as a project of knowingly engaged in *maximization*:

> both choice of constraints and choice within constraints can be represented as a form of maximization. Specifically, artists try to *maximize artistic value*. (p. 178)

> The process of artistic creation is guided by the aim of *maximizing aesthetic value under constraints*. . . . Creativity is the ability to succeed in this endeavor. (p. 200)

The idea that artists seek to maximize aesthetic or artistic value[5] certainly has some plausibility. If agents are generally, to a rough approximation, utility maximizers according to their own, often idiosyncratic, utility functions, then it is not too big a stretch to suggest that artists are, to some extent and in some contexts, maximizers of the utility that corresponds to aesthetic or artistic value.

But is not Elster guilty of making the creation of art out to be a too predominantly rational affair? First, it is not clear that the maximizing aim stated above can plausibly be attributed to most successful artists, even at a less than fully conscious level. Whether based on express avowals, observable conduct, or the character of completed works, the evidence does not make such an attribution inescapable. Second, even those most committed to rational explanation of human behavior usually allow that there is some share of the irrational, or at least nonrational, in creative activity, as in related activities of a sexual or religious kind, with their not wholly scrutinizable bases. Now Elster might try to accommodate this by suggesting that acceding to a limited irrationality in the service of creative ends can be seen as a strategy that is overall rational, and perhaps even maximizing of aesthetic value, but surely this is to ascribe too calculating an attitude to artists who open themselves to the irrational in the name of art. In other words, though it is true that irrational methods are sometimes rationally chosen by artists – think of the "automatic writing" experiments of the Surrealists – surely not all irrationality issuing in something of artistic value has been deliberately opted for by the artist on rational grounds.

Third and most important, there are positive aims we have good grounds to ascribe to artists as motivating them which do not collapse

into that of maximizing aesthetic or artistic value. Some artists are driven to discover new relationships between elements of their chosen media, or new ways of expressing states of mind, or new techniques for achieving realistic representation, where their commitment to those goals as such overrides any direct concern they might have to maximize aesthetic value within given constraints. And the fact that in pursuing their artistic goals artists succeed in many cases in also maximizing aesthetic or artistic value does not invalidate the point I am making. In even simpler terms, we can say that artists are most often driven to make works *the works they want them to be*, whether or not they are seen to maximize aesthetic value, even by the artist's own lights.[6]

<div align="center">4</div>

Elster, like some other recent writers,[7] takes a fairly firm stand against originality: "I distinguish creativity (working within constraints) from originality (changing the constraints), arguing that the latter has no intrinsic relation to aesthetic value" (p. 180). He sustains that judgment even in light of this later, ostensibly approving gloss of what originality involves: "Originality . . . can be defined as a durable break with existing conventions rather than as a momentary departure from them. The emergence of free verse, nonfigurative art, and atonal music are obvious examples from the past century" (p. 224). Elster recognizes that originality in a work of art can coexist with greatness, and that the search for originality may even enhance the pursuit of creativity, but he remains opposed to the idea that originality can be part of the value of a work of art.[8]

Elster's judgment against originality per se, however, fails to recognize art making as an activity that, like most activities, involves the possibility of *achievement,* and the resulting artwork as the embodiment of such achievement, which makes the work logically and appreciatively inseparable from the activity that generates it. It seems incontestable that part of the achievement of some works of art is precisely the striking originality, whether of means, ends, or ends-in-relation-to-means, that they manifest. Such achievement belongs to the work, and not simply the artist who has created it. Once the achievement in question is solidified and secured, usually through the production of a series

of related works, then later works, however similar, do not partake of that achievement and do not exhibit that originality, hence are not as admirable artistically. The locus of originality in art is the historically rooted artwork itself, and neither the work's maker as an individual nor the work's abstractable form or detachable content. An artwork's original achievement, in the context in which the work arises, is part of what the work both is and does.

Arguments that originality is not an artistic value, moreover, tend to equate artistic value, or value appropriate to art as art, with aesthetic value narrowly understood, that is, value for sensuous-perceptual-imaginative experience directed on an object's aesthetic aspect. But the two are not equivalent.

Artistic value is a broader notion than aesthetic value, though it includes aesthetic value as its core. Clearly the experiential rewards afforded an audience by an artwork, and generally by design, are a large part of its value as art. But some of the value of an artwork is not rooted in its character as an object for perceptual experience, which it may share with portions of nature, but is rooted instead in its being a human artifact, in virtue of which it, say, displays originality, expresses singular attitudes, communicates moral insight, or influences in a positive manner artworks to come. These contribute to its artistic value, though not to its aesthetic value narrowly construed.[9]

5

Aristotle famously offered a criterion of *organic unity*, the essence of which is that a work possessed of such unity can only be altered for the worse. Elster, it appears, is inclined to accept Aristotle's dictum: "One piece of evidence for the view that artists are engaged in maximizing is the widespread belief that in a good work of art nothing can be added and nothing subtracted (Aristotle, *Poetics*).... Another piece of evidence is the widespread practice of artists of *experimenting with small variations* until they 'get it right'" (p. 202).

But Aristotle's dictum should actually not be so uncritically accepted. From the fact that in a good artwork *every* element plays some role in the functioning of the work or the emergence of its artistic content, one cannot validly infer that *only* those elements could have

served that function or have resulted in that artistic content. More generally, one cannot conclude that only the specific ensemble of elements that constitutes the finished work can be thought to optimize the value such a work might possess. This is because there may be *several*, equally effective ways of "getting it right," that is, bringing a work to successful completion once it has reached a certain point. The practice of trying out small variations need not be seen as a search for a unique local maximum. In fact, it need not even be viewed as a search for *any* local maximum, but might instead be seen as governed by a principle of "good enough," that is, as conformable to a *sufficing*, rather than *optimizing*, model of human behavior. Even if "getting it right" generally motivates the trying out of small variations of a work in progress, that may not require making it "best," but only, say, "really quite good."

The error of unqualified adherence to the doctrine of organic unity, which maintains that successful works of art are so finely tuned that no alteration in them can fail to have an adverse effect, is related to that involved in unrestricted allegiance to the principle of *aesthetic uniqueness*, which holds that any two perceptually different works of art belonging to the same genre necessarily differ in some aesthetic respect or other. But though close to true, that principle falls short of universal validity.[10] Although perceptually different artworks in a given genre necessarily afford different *experiences* – and perhaps even experiences that differ aesthetically, if the perceptual basis of an aesthetic property always comes within the scope of its appreciation[11] – that does not yet imply that the works *themselves* necessarily differ aesthetically. Think of two abstract, calligraphic paintings – say in the vein of Mark Tobey – where one is a mirror image, or else a slight internal rearrangement, of the other. Is it clear that these will differ at all in aesthetic impact, despite their being easily perceptually discriminable? Both such paintings might "work," so to speak, and in exactly the same way, and without inclining one to think that no other arrangement of similar elements could have "worked" as well.

6

Elster's discussion of the dimensions of value in temporal art forms, and their particular manifestation in the sphere of classic jazz, is in

my opinion the most satisfying and stimulating part of his inquiry into artistic creativity in *Ulysses Unbound*. I thus take the liberty of quoting from it at some length.

I distinguish between two sources of emotional satisfaction through the arts. On the one hand, *many* works of art can generate non-aesthetic emotions – joy, grief, and the like. On the other hand, *all* works of art, if they have any artistic value at all, induce specifically aesthetic emotions by means of rhythm, echoes, symmetries, contrasts, repetitions, proportion, and similar devices.... The specifically aesthetic emotions include wonder, amazement, surprise, humor, relief, and release. (p. 206)

In literature and music, sublime artistic effects are created when these two emotional effects go together and reinforce each other. As if by magic, the pleasure of a rhyme that falls into place adds to the poignancy of the words. Although the components are analytically separable, they are not experienced separately. (p. 206)

In the case of jazz, the non-aesthetic emotions in the listener are produced by music that has what I shall call 'emotional depth'. The aesthetic emotions can arise at two levels. At the simplest level, they are produced by music that possesses what I shall call 'taste'. At a more advanced level, the aesthetic emotions are produced by the 'story' told by the music.... (p. 247)

Taste – the sense of order, balance, proportion, timing – is an essential prerequisite for the production of the specifically aesthetic emotions.... Emotional depth refers to the capacity to generate strong non-aesthetic emotions in the listener. (p. 248)

Taste and emotional depth are only two of the relevant dimensions of quality in jazz. The third – and the only one in which jazz differs radically from other musical performances – is inventiveness in storytelling [p. 252]. The ability to 'tell a story' through melodic innovation is related to taste, but goes well beyond it. (p. 253)

There is much with which to agree in the above extracts, and the discussion from which they are drawn is unquestionably an insightful contribution to the aesthetics of jazz. Nevertheless, I have certain qualms.

My first qualm concerns Elster's claim that the storytelling dimension of a jazz solo, its ability to suggest, through its melodic, harmonic, and dynamic evolution, an abstract narrative of some sort, enters into the generation in the listener of aesthetic emotions but

not nonaesthetic ones.[12] This seems unwarranted. For the narratives that music can suggest are often themselves emotional ones, and it stands to reason that our response to an emotional sequence might be a further nonaesthetic emotion that would be appropriate to the sympathetic contemplation of such a sequence. For example, a solo conjuring up a narrative of trouble, followed by hope for that trouble's disappearance, leading only to the crushing of that hope, would naturally conduce to a feeling of sorrow or distress in a listener, apart from any purely aesthetic reaction on the listener's part to the rightness of the emotional narrative or its musical underpinning.[13]

My second qualm relates to the degree to which *taste*, characterized as a formal or configurational matter, and *emotional depth*, characterized as a material or substantive one, are entirely independent and summable dimensions of musical value, as is suggested by Elster's amusing diagram (p. 251) locating various jazz artists in a two-dimensional space whose y-axis is "taste" and whose x-axis is "emotional depth."[14] I think these dimensions are, pace Elster, interlocking ones, with a musician's formal sense of timing, proportion, and flow affecting the nonaesthetic emotions his discourse will be able to elicit. For example, the concision, clarity, and drive of John Coltrane's "Giant Steps," presumably the result of the great saxophonist's taste, have quite a lot to do with the bold, life-affirming confidence that the music expresses. And the relative structural freedom and relaxation of Coltrane's "A Love Supreme" is surely not separable from the serenely rapturous sense of the goodness of things that the music projects, especially in its first two sections.

In addition, we may note that the formal and emotional dimensions of musical value in jazz – or any other music – are arguably subordinate to another, overarching and non-summative, dimension of value that we can label "emotion-in-relation-to-form" or "content-in-relation-to-configuration."[15] That is, our ultimate judgment of the value of a piece of music arguably does not rest only on our separate estimations of the quality of its content and the excellence of its form,[16] but also, and most particularly, on the specific relation or fittingness of the former to the latter.

7

Elster has interesting things to say on the topic of precommitment to randomness or chance in the making of art:

each choice made in the creation of a work of art serves as a constraint on later choices. An artist may decide, however, to generate the constraints randomly rather than intentionally. (p. 242)

Thus Francis Bacon began his pictures by throwing paint at the canvas, so that the resulting blots would serve as constraints on the further work, limiting his freedom and presumably enhancing his creativity. Jackson Pollock's "poured paintings" may be seen as a variant of this idea. (p. 243)

But as regards the first of these cases, Bacon's accidentally produced blots need not be taken as constraints on, rather than prompters of, further creative decisions, since it is in the nature of the medium of painting that any such blots can be covered over or scraped off, if need be. And to a lesser extent that would be true in the case of Pollock's paintings as well.

Elster next turns his attention to the enfant terrible of modern music, John Cage:

To the extent that it relies on randomizing or on producing periods of silence, Cage's work is entirely unserious. The most charitable interpretation is that it is a gigantic and successful put-on. (p. 245) ... the use of objective or epistemic randomness to select *within* constraints has no aesthetic justification ... by *removing* choice rather than *restricting* it one destroys creativity rather than enhances it. (p. 246)

This strikes me as a fairly uncomprehending reaction to Cage's work as an artist, however one rates that work in the last analysis. Cage's creativity manifests itself, in part, in the astonishing variety of evocative means he devised to circumvent the operation of human choice at the level of sound selection, in the name of an individual quasi-Buddhist philosophy of music and life. The irony of Cage's work, though, is that his very distinctive personality shows itself, at a second level, through the specific range of means – dice, star charts, paper imperfections, the *I Ching* – he devised for the elimination of personality at the first level, and even through the very undertaking of the project of eliminating subjectivity or preference from music to begin with.[17]

Richard Wollheim, in a famous essay on art of the kind that consequently became known as "minimal,"[18] sketched a conception of "negative work" in art making, that is, the sort of work appropriate to the production of objects of unusual simplicity and relative absence of articulation. Such "negative work," suggests Wollheim, is largely a matter of decisions about what a piece will be like, ones involving "negative" acts such as renouncing, eschewing, withholding, or restraining, in relation to media, techniques, styles, or aims available in the artist's milieu. If it is possible for an artwork whose genesis predominantly involves "negative work" to exhibit creativity, then surely the creativity involved in some of Cage's more radical musical self-removals is of that sort.

Elster's skepticism about the value of avant-garde modes of art is not restricted to music: "[literary] modernism fails because it rests on an erroneous criterion of adequacy of a text to its object. Just as a flawed world is not better represented by a flawed text, a fluid or chaotic world is not better represented by a fluid or chaotic text" (p. 190).

But this blanket condemnation ignores, among other things, the *exemplifying* and *expressing* functions of a literary text, as opposed to its *representing* function per se. As Goodman and others have stressed, artworks mean in ways other than by representing.[19] Thus, a work of art may need to at least approach, if not wholly embrace, chaos and fluidity in order to exemplify or express, rather than just represent, those properties.

8

I return now to Elster's discussion of the experimental novel *La Disparition*, invoked at the beginning of this essay:

Preexisting or preset constraints enhance and stimulate the creative process.... Yet not all constraints will do equally well. The constraint of writing a novel without the letter *e* may not make the task of the writer more difficult than writing in the demanding form of *terza rima*. Yet the latter constraint, unlike the former, can contribute directly to aesthetic value, over and above the indirect contribution that follows from the focus-enhancing effect. Because rhythm and meter generate an organized form, they have intrinsic aesthetic potential; the absence of a given letter in the alphabet does not. (p. 209)

But one can argue that the systematic withholding of a certain letter, especially one as central to the French language as the letter *e*, gives by its absence a kind of form to Perec's text, though obviously not form in the sense of metric or rhythmic scheme. And that form, though it would be natural to describe it as negative, can even be expressed in a positive manner, as the requirement to craft intelligible sentences using only the vowels *a, i, o,* and *u.*

For most writers, having to write around the letter *e* would be an irritating distraction rather than a stimulation, an obstacle to be overcome rather than a challenge to be met. (p. 210)

That is no doubt true. But even so, it only means that willingly avoiding the letter *e* in writing would not, for most writers, be a spur to creativity. This says nothing, however, as to whether it was in fact a spur to creativity in a given case, namely that of Perec.

Recalling Elster's useful trichotomy of chosen, invented, and imposed constraints, we can ask whether the express avoidance of *e* in *La Disparition* counts as a chosen or an invented one. The question, in effect, is whether that sort of restriction *preexisted* Perec's writing of his novel, or whether in so writing it, and in writing it so, he *instituted* that sort of restriction on literary production. Though Elster seems inclined to treat *La Disparition* as a case of invention, there is actually reason to see it as a choice to operate in an existing category, that of the *lipogram*, but in a more thoroughgoing way than had been previously attempted. A lipogram is precisely a text produced under the constraint of eschewing a given letter or letters of the alphabet, and was a form much favored by the group of avant-garde French writers to which Perec belonged, the Oulipo, or "Workshop of Potential Literature."[20]

<div align="center">9</div>

Constraints like that adhered to by Perec in writing *La Disparition* are sometimes derided as purely arbitrary and unmotivated, and thus as issuing in nothing of any artistic worth. But if artistic creativity is, as Elster proposes, centrally a matter of operating innovatively within constraints, then how does one know which constraints are likely to give rise to artistic value and which not? Can there be a reasoned

prospective criterion of goodness of constraints, rather than the obvious retrospective one of judging them by their fruits?

These are difficult questions, which I am unsure how to answer. I want instead just to consider whether the success of Perec in crafting *La Disparition* should indeed be thought one without artistic point, a pure exercise in self-binding for its own sake.[21] I think not. For one thing, there is no reason to regard the skill, cleverness, and ingenuity of Perec in meeting the constraint he set himself as somehow beyond the pale of artistic appreciation. Surely we are practicing artistic appreciation when we admire the interest that Barnett Newman gave his paintings of very peculiar vertical format, roughly six feet high and four inches wide; or the elaborately constructed montage in the "Odessa Steps" sequence from Eisenstein's *Potemkin*; or the resourcefulness with which Mozart manages the voices in the sextet from *The Marriage of Figaro*; or the magnificence of Racine's alexandrines, unfailingly ten syllables to a line and a rhyme every time. Virtuosity, which broadly construed covers those cases and that of Perec, is unquestionably an artistic virtue, if not the highest of them, and is something appreciable for its own sake.[22] The interest of *La Disparition*, in other words, is surely not merely that which Samuel Johnson infamously allowed that the phenomenon of female sermonizing might be said to possess.[23]

But the interest of *La Disparition* may in fact go beyond the attention its virtuosic surmounting of challenges properly merits. This is due to special features of both the writer and the context of writing. Born in 1936, Perec was the child of Polish-Jewish parents who died during the Second World War, one in the Resistance and the other in Auschwitz; he was subsequently raised in a Catholic boarding school in the Isère during the Occupation. Is it too much of a stretch, then, to see *La Disparition*, published in 1969, as referring not only to the victim in the murder mystery it ostensibly relates, and not only to the letter *e* mysteriously banned from its pages, but to the disappearance from Europe not long before of millions of individuals as arbitrarily declared persona non grata as that unlucky vowel? Might not *La Disparition* be seen as a meditation on how easy it was to get rid of, or do without, six million Jews, as much as an exercise in getting rid of, or doing without, tens of thousands of *e*s? We know also that every one of Perec's published works is an exercise in a different style. Does this not fit all

too well with one who had to dissimulate and reinvent himself from the earliest age?

In any event, if such further dimensions are attributable to what might seem the purely formal stylistic exercises of a Perec, they give those exercises added value in virtue of the fittingness between content and form invoked earlier as a primary locus of aesthetic value.[24]

<div align="center">10</div>

Shifting to cinema for another case of chosen constraints of an ostensibly limiting sort, consider those with which Sidney Lumet operated in making his powerful film of jury deliberation, *12 Angry Men*: a single, sparsely furnished room; a fixed set of characters; a continuous segment of time; and black-and-white cinematography. Yet *12 Angry Men* is as transfixing and rewarding a film as cinema has to offer. Clearly in this case Lumet's chosen constraints – his form of provisional self-binding – was a spur to creativity rather than a shackle on it.

Some of Lumet's specific techniques for sustaining cinematic and dramatic interest given those constraints deserve remark: (*a*) focusing on different characters, and different character pairs, at different points; (*b*) temporarily subtracting characters through the device of exits to the restroom; (*c*) rhythmic but not mechanical varying of long shots, medium shots, and close-ups; (*d*) alternating of evidence-sorting and reason-weighing discussions, on the one hand, with character-revealing and tension-provoking personal encounters, on the other hand, so far as the pattern of scenes is concerned.

So Lumet's film fits nicely enough Elster's picture of artistic creativity as successful maneuvering within constraints. But it is worth observing that even if all artworks involve choices made within constraints of some sort or other – whether self-imposed or imposed from without, whether revisably or unrevisably adopted, whether conventional or idiosyncratic – there is a useful distinction to be made between artworks that *foreground* the fact of their operating under constraints, and those which do not do so, in some cases even managing to make us unaware of the constraints that governed their creation. In the first instance works are partly *about* their constraints, that is, about virtuosity or the surmounting of challenges, whereas in the second instance they are not. In the first category belong, obviously, *La Disparition;*

Hitchcock's *Rope*, shot so as to appear to be virtually one continuous take; and Machaut's rondeau "Ma fin est mon commencement", a tricky musical palindrome. In the second category, more likely, belong *12 Angry Men*, Coltrane's "Giant Steps," and the sonnets of Keats or Edna St. Vincent Millay – works produced within formal confines but which do not especially draw attention to them.

Twelve-tone music, the basic principle of which is that a given pitch cannot be repeated until all eleven other pitches of the chromatic scale have been sounded – a method that effectively destroys the feeling of tonality or key – is sometimes offered as a mode of musical composition that is too confining, one involving constraints that fetter rather than abet creativity. But it seems as if there are simply different cases here that make any such generalization suspect. For Schoenberg the method was a way to inject new local interest into old global forms associated with Brahms and his predecessors in the Viennese Classical tradition, an effort in which Schoenberg succeeded, notably in the Third and Fourth String Quartets, the String Trio, the Piano Concerto, and the Serenade Op. 24. For Berg the method was from the outset something to be intuitively modified and relaxed in the interests of dramatic expression, not a code requiring strict adherence, and yet it remains essential to the rigor and power of his twelve-tone masterwork, the opera *Wozzeck*. For Stravinsky, who came to twelve-tone music late and after much resistance, the method offered itself as something to selectively adapt and fuse with his preexisting neoclassical style, with perhaps greatest success in the ballet *Agon;* in other cases, for instance, the *Movements for Piano and Orchestra*, the results are arguably crabbed and less appealing. Finally, for some composers, like the American George Rochberg, twelve-tone music – or rather, its subsequent generalization, serial music – became an indirect prod to creativity by serving as an orthodoxy against which to rebel, leading to that music's total abandonment in Rochberg's largely tonal and pointedly neoromantic Third String Quartet.

11

One of Elster's examples of an externally imposed, yet ultimately fruitful, art-making constraint concerns the unfeasibility, prior to 1940, of recording popular music over three minutes in length, due to the

limits of the old 78 rpm technology. In relation to this he comments that "jazz improvisation at a high level of quality is so hard to sustain that the 78 record with three minutes' playing time was just about optimal" (p. 194).

To my ears, this sounds like a too convenient retrospective Leibnizian explanation. For my impression of even the best solos of the great jazz players in the thirties big bands, such as Coleman Hawkins, Ben Webster, Johnny Hodges, or Lester Young, is that those solos would in fact usually have benefited from being somewhat longer, that often they hardly get going before they are over. Certainly, there are many cases of mesmerizingly good improvised jazz solos extending over large stretches of time, for example, those by Coltrane and McCoy Tyner in "My Favorite Things", which last upwards of four minutes each. Is it not rather plausible to think we might have had even more sublime solos from Hawkins and Young had they been able to dilate, on occasion, for a minute and a half or even two?

12

Let us turn to two other examples, ones that, at least in broad outline, comport well with Elster's thesis. The first is the celebrated Laurentian Library vestibule of Michelangelo. Michelangelo, who had no formal training as an architect, accepted as a constraint to employ the vocabulary of High Renaissance architecture – columns, corbels, pilasters, balusters, pediments, niches, and architraves – but not to employ them in the traditional ways. Rather, he set out to use them, it seems, in pointedly illogical, that is, non-structurally justified ways, with the evident aim of more effectively stimulating the free play of the imagination in their regard. Michelangelo, untrammeled by habits he might have acquired had he been of the architects' guild, was instead free to create expressive form for its own sake: this anteroom, with its unusual somber white-and-gray color scheme, its high and narrow spatiality, its flowing and spreading staircase, and its constellation of familiar yet oddly deployed constructional elements, is one of the most imposing architectural ensembles I know. Its success indeed seems to be a function of adhering to certain constraints derived from the preexisting artistic culture, while simultaneously explicitly flouting others. As Vasari apparently said

of Michelangelo's architecture, "it broke the bonds and chains of common usage".[25]

A second example is Picasso's creation of the *Portrait of Kahnweiler* as a response to both a highly general, tradition-rooted Charge and a more specific, circumstances-involving Brief, in the terms of the convincing analysis of Michael Baxandall.[26] Picasso's Charge, suggests Baxandall, was the standard painterly one of producing an object with "intentional visual interest", while Picasso's Brief, largely self-assumed, was the three-pronged one of reconciling the claims of color and form, reconciling the claims of two-dimensional patterning and three-dimensional representation, and being true to painting as both cumulative process and completed image. According to Baxandall, this posited Brief, together with the assumed background Charge, explain much about how Picasso's portrait actually turned out.

Still, with both Michelangelo's vestibule and Picasso's portrait, there is a real worry as to whether our hypothetical reconstructions of the constraints under which and in response to which those works emerged are not merely "just-so" stories. Certain constraints are perhaps undeniable and documentable, particularly material and physical ones. Hypotheses about constraints at the discretion of the artist, however, seem more liable to be products of unfettered "backward thinking" in light of what actually results. The fact of usual underdetermination of hypothesis by evidence here urges caution, at least, as to the reliability of such speculative reconstructions.

Consider now a case of maximizing artistic value by *violating* a freely chosen constraint. This is contained in an anecdote told of Arthur Rubinstein during one of his first concerts in Paris in the 1920s. The first piece on his program, the then recently composed *Valses Nobles et Sentimentales* of Ravel, had not been well received, so after a second half consisting of pieces of Chopin that was rather better received, Rubinstein answered the clamor for an encore by playing the *Valses Nobles et Sentimentales* once again. Now the art in question here is, of course, a performing one, that of recital giving, and the constraint in question, which comes with the territory, is that encores be both shorter than, and other than, the pieces making up the main program. But arguably Rubinstein gave a finer recital on that occasion precisely by flouting one of the defining norms of the performing art he was engaged in. In the light of this last example, might we not judge

that, on balance, Michelangelo's Laurentian Library vestibule attains as much of its value through its creative violation of constraints as through its ingenious conformity to them? If so, then we have reason again to doubt the universal validity of Elster's favored model of artistic creativity as aesthetically fruitful choice within antecedently adopted constraints.

13

Is there a necessary connection between *creativity* and *problem solving*? Assume, for the sake of argument, that there is a necessary connection between creativity and constraints – that it is roughly as Elster suggests, a matter of value-maximizing choice within constraints. The question then becomes that of the relation between problem solving and constraints. Are all cases of constraints in operation cases of problems calling for solution? One reason to deny this is that a problem, unlike a mere set of constraints, has something like a principle of unity, being often a matter of resolving some conflict, or meeting some need, or finding the answer to a definite question. Another reason is that a problem has at least a prima facie claim on one's attention – it is something that, at least on its face, merits addressing. Thus it is a problem how to compose comprehensible and engaging music outside the bounds of tonality, or how to maintain the integrity of the picture plane without giving up blatant imagery – problems that were solved respectively by Schoenberg and Berg, on the one hand, and Johns and Dubuffet, on the other. But writing a poem of fifteen lines that employs the word "dog" in every line, or making a film that lasts fifteen minutes and costs less than $150,000, would seem to be cases of operating under constraints, but not really cases of solving problems. The two notions, then, should not be considered interchangeable.

14

By way of conclusion, let me turn from the sphere of fine art to that of applied art, and briefly ponder constraints on the design of chairs – those varied receptacles for our backs and bottoms. The case is well chosen, I think, to illustrate the reciprocity between constraints and creative activity conducted under such constraints, a reciprocity to

which Elster's analysis of creativity, however illuminating, seems insufficiently sensitive. For highly innovative chairs challenge, question, and refashion the very idea of a chair, subjecting its presumed necessary features – for example, possessing legs, being sturdy, having a seat, being articulated – to intense conceptual pressure.

Consider in this connection the intentional-historical theory of *artifact* concepts recently proposed by cognitive psychologist Paul Bloom.[27] Bloom's theory takes off from and generalizes upon my own intentional-historical theory of the concept of *artwork*, whose basic idea is that an artwork is something that is intentionally connected by its maker to a preceding practice or tradition of art making, possibly identified only through exemplars whose art status is taken for granted.[28] On Bloom's related theory, a chair, say, is not something of a certain circumscribed form or something fulfilling an unambiguously understood function, but roughly something intended to belong to the category of chairs as antecedently exemplified, that is, something intended for regard or treatment as preexisting chairs were regarded or treated.

The immense profusion of chairs displayed in the astounding book *1000 Chairs*, which presents "the most comprehensive survey of chair design from 1808 to the present",[29] not only makes Bloom's theory attractive, but makes a theory of that sort almost unavoidable, rendering inadequate any conception of chairs in terms of essential shape or structure or purpose. The assault on chairhood represented by the many outré examples of chairs in *1000 Chairs* might profitably be compared with the challenge to what a building is provided by the most envelope-pushing architectural offerings of postmodern architects such as Frank Gehry, Peter Eisenmann, and Rem Koolhaus.

Now Elster does, it is true, recognize a distinction between what he calls rebellion and revolution in art, which he glosses as follows: "Rebellions violate existing conventions, whereas revolutions abolish them and create new ones" (p. 223). What I am gesturing at in the case of chairs and buildings, however, is something in-between, neither the simple abrogation of existing rules for such things nor the institution of new rules in their place, but the forced reevaulation, by an ostensible chair or building, of what the rules for such things really were or are. Creativity, in short, is sometimes a matter or reconceiving or reinterpreting or reconstruing given constraints, and not always

a matter of either remaining inventively within them or abandoning them entirely.

Notes

Many thanks to the editors of this volume, Berys Gaut and Paisley Livingston, for their valuable comments on a version of this essay.

1. Jon Elster, *Ulysses Unbound: Studies in Rationality, Pre-Commitment and Constraint* (Cambridge: Cambridge University Press, 2000). Page references to this book in the text are given in parentheses.

2. A nice example of a fruitful attitude one might adopt toward imposed constraints is provided by the following anecdote, from liner notes by Harry Halbreich to Arthur Honegger's *Le Roi David* (*Erato* 2292-45800-2). Honegger, having been commissioned to write music for the theatre piece in question but chafing under the rather peculiar musical conditions the commission involved, asked his fellow composer Stravinsky for advice. This was the advice offered: "It's quite simple. . . . Act as if you had wanted exactly that ensemble, and compose for a hundred singers and seventeen instrumentalists". Honegger comments on this advice that it constituted for him "an excellent composition lesson: never consider the givens of a commission as something imposed, but on the contrary as a personally chosen stricture, or an interior necessity".

3. See, in particular, his *Ulysses and the Sirens: Studies in Rationality and Irrationality* (Cambridge: Cambridge University Press, 1990).

4. Michael Bratman, by contrast, offers a more flexible model of precommitment, one that is perhaps a better fit for the artistic case. Bratman stresses the need for rational agents to frame future-directed intentions that have a certain inertia or weight, yet not be bound to "pour good money after bad." See his *Faces of Intention: Selected Essays* (Cambridge: Cambridge University Press, 1999).

5. Elster is not too careful of this distinction, a matter to which I return below.

6. This observation – which I owe to Richard Wollheim – naturally abstracts from purely extrinsic or prudential considerations, such as might induce an artist to make a work a certain way to please a patron, secure a commission, or annoy a rival. In such cases the artist is, in a sense, making the work the way he wants it to be, but not for its own sake; in other words, he is not making quite the work he wants, qua artist, to make.

7. See, for example, Frank Sibley, "Originality and Value," *British Journal of Aesthetics* 25 (1985): 169–84; Bruce Vermazen, "The Aesthetic Value of Originality," *Midwest Studies in Philosophy* 16 (1991): 266–79; and, more evenhandedly, Paul Crowther, "Creativity and Originality in Art," *British Journal of Aesthetics* 31 (1991): 301–9.
 Sibley's argument against originality as such goes like this: "'original' is very commonly used of style, manner, technique, medium; Cubism,

Abstract Expressionism, Pointillisme, the twelve-tone system exemplify large innovations.... In themselves, these were extremely original but aesthetically quite neutral.... The value of such innovations is instrumental; it lies in what new aesthetic characters and values they render possible.... So the enthusiastic praise often lavished on works employing innovatory techniques [or] ... novelties of form or medium is misplaced unless these bring, or have the potential to bring, some new aesthetic character of value" (pp. 174–5).

8. There is some irony, finally, in Elster's opposition to artistic originality, given the reputed creed of Elster's main musical hero, saxophonist Lester Young: "You've got to be original, man."

9. For more on *artistic value* (in a broad sense) versus *aesthetic value* (in a narrow sense), see my "Art, Value, and Philosophy," *Mind* 105 (1996): 667–82. On a related, though not equivalent, distinction that can be made between the artistic and the aesthetic *properties* of works, see my "Artworks and the Future," in *Music, Art, and Metaphysics* (Ithaca, N.Y.: Cornell University Press, 1990).

10. See my "Aesthetic Uniqueness," in *Music, Art, and Metaphysics*.

11. See my "What Is Aesthetic Pleasure?" in *The Pleasures of Aesthetics* (Ithaca, N.Y.: Cornell University Press, 1996).

12. What precise distinction Elster has in mind by *aesthetic* vs. *non-aesthetic* emotions, it must be said, is not entirely clear. Some of those that he denominates aesthetic, e.g., wonder, can certainly be had in connection with objects that are not works of art. However, I will accede in the distinction as roughly drawn, taking it to be something like this: aesthetic emotions are ones characteristically had for or directed on the aesthetic aspects, including formal ones, of objects, most notably works of art.

13. For an emotional scenario of that sort, and its role in the generation of musical frissons, see the discussion of Scriabin's Etude op. 42, no. 5 in my "Musical Chills," in J. Davidson and H. Eiholzer, eds., *The Musical Practitioner* (Aldershot: Ashgate Publishing, 2002).

14. Though I agree with most of the critical judgments embodied in Elster's diagram, and concur in particular with the placement of Lester Young, Billie Holliday, Johnny Hodges, and Django Reinhardt in its favored upper-right corner, I would explain the relative undervaluation of Art Tatum, Sarah Vaughan, and Frank Sinatra, who though accorded high y-values are accorded only middling x-values, in terms of Elster's simply undervaluing certain *realms* of expression, namely the lithe/blithe/carefree, relative to others, namely the heavy/doleful/careworn. Only if "emotional depth" is narrowly equated with the latter does Elster's downgrading of Tatum, Vaughan, and Sinatra seem justified.

I should also note that Elster in fact recognizes that his two dimensions of musical value are not *entirely* independent: "Taste and emotional depth do not ... vary entirely independently of each other. Total lack of taste is incompatible with great emotional force" (p. 250). But I submit that he

still overestimates the degree of their independence, as I try to show in the text.

15. See my "Evaluating Music," in P. Alperson, ed., *Musical Worlds* (University Park, Pa.: Pennsylvania State University Press, 1998).

16. Understood here to include also its degree of inventiveness in storytelling, Elster's third proposed dimension of musical value.

17. "'Personality is a flimsy thing on which to build an art', Cage once wrote. Yet he himself seems to make his most direct and appealing impact through his own personality. . . ." John Rockwell, *All American Music* (New York: Vintage Books, 1984), p. 58.

18. "Minimal Art," *Arts Magazine*, January 1965; reprinted in G. Battcock, ed., *Minimal Art: A Critical Anthology* (New York: Dutton, 1968).

19. See his *Languages of Art* (Indianapolis: Hackett, 1976), and "How Buildings Mean," in *Reconceptions in Philosophy and Other Arts and Sciences* (Indianapolis: Hackett, 1988).

20. The name is a contraction of "Ouvroir de Littérature Potentielle."

21. This is a good point to mention that there has been, astonishingly enough, a translation – or really, a re-creation – of *La Disparition* in English. It is by Gilbert Adair and is cleverly titled *A Void* (San Francisco: Harper, 1995). Adair's work presumably has some of the virtues of Perec's, but not all, and arguably would have some that Perec's does not.

22. See Thomas Mark, "On Works of Virtuosity," *Journal of Philosophy* 77 (1980): 28–45.

23. "Sir, a woman preaching is like a dog walking on hind legs. It is not done well, but you are surprised to find it done at all."

24. The French *roman nouveau* of Alain Robbe-Grillet, Nathalie Sarraute, and others might be mentioned here as another example of an art form subject to self-imposed constraints – ones as Draconian in their way as those under which Perec worked – where the resulting stylistic spareness and sobriety of detail have expressive value. Robbe-Grillet's novel *La Jalousie*, for example, arguably expresses a world of individuals locked into their separate consciousnesses, their phenomenological identification with the objects of their experience suggesting a kind of ultimate isolation and alienation. But such expression is clearly a product of the severely detached and methodically descriptive mode of narration adopted by the author.

25. Quoted in H. H. Janson, *History of Art* (New York: Harry Abrams, 1962).

26. See *Patterns of Intention: On the Historical Explanation of Pictures* (New Haven, Conn.: Yale University Press, 1985).

27. "Intention, History, and Artifact Concepts," *Cognition* 60 (1996): 1–29.

28. See my "Defining Art Historically" and "Refining Art Historically," in *Music, Art, and Metaphysics*, and my "Extending Art Historically," in *The Pleasures of Aesthetics*.

29. Charlotte and Peter Fiell, *1000 Chairs* (Cologne: Taschen, 1997). Quote is from the back cover.

11

The Transfiguration of Classical
Hollywood Norms

On Von Sternberg's Last Films with Dietrich

George Wilson

1. INTRODUCTION

The question of originality considered as a criterion of value has vexed assessments of the artistic merits of classical Hollywood cinema almost from the outset of critical discussion of studio-produced movies. Since it was a characteristic mark of most of these films that they relied on standardized formulas of storytelling and on the familiar "personae" of well-known stars and character actors, and that they generally were framed within fairly conventional forms of narrative exposition, it was only in rare cases that a startling novelty of style or substance was among the obvious chief virtues of the works. What is more, the question of merit becomes peculiarly pressing when the movies are instances of one or another of the more hackneyed genres; instances where the plot, dialogue, and characterizations seem humdrum and even tacky, at least when judged by prevailing standards of taste. Such movies strike many viewers, whether they find them enjoyable or not, as woodenly predictable or downright silly. In cases of this sort, it is likely to seem absurd to suppose that any major form of artistic creativity lends special value to the work.

This sort of critical issue has arisen again and again concerning the films of many genre filmmakers such as Josef von Sternberg, Douglas Sirk, Nicholas Ray, and later Fritz Lang. The movies in question here include over-the-top melodramas (*Blonde Venus, Written on the Wind*), fantastic swamp flicks (*Wind across the Everglades*), and perversely opaque

Westerns (*Johnny Guitar, Rancho Notorious*). These are all works in which the literary merits of their scripts or the power of their acting, conventionally assessed, are limited and would not redeem them. Often it is possible to argue that these films contain worthwhile moments or elements, but, even when this is possible, it remains incredible that such rigidly contrived works might have been structured throughout by global aesthetic strategies that reconfigure their significance in a drastic way.

The idea that superficially unpromising genre movies may contain a subtle manifestation of the filmmakers' personal perspective is usually associated with auteurist defenses of Hollywood directors. These defenses have sought to demonstrate that directors sometimes *did* have enough degrees of freedom in the making of their movies to institute a level of sophisticated artistic creativity, even in projects whose narrative parameters were to a great extent preestablished. However, the issue of the range and character of creative expression in these movies should not be tied too closely to the stronger, characteristic theses of auteurism. There is no reason why whatever creativity has been exercised in such a film should not have been the product of collaboration among several of the participants in the construction of the work. Sometimes the director *will* have been the central figure responsible for the imaginative inventiveness; sometimes cooperative efforts will have been primarily responsible. Occasionally, I imagine, an intriguing and original framework may fall into place largely through fortunate happenstance. In any case, in this essay I am concerned with the possibility of rich, extensive artistic significance in outwardly problematic Hollywood movies, and not with the question of who gets credit for whatever hidden meaning might be present.[1]

Dubious as this claim of recessive large-scale signification might appear, I think that it can be sustained in a range of instances, including a number of the examples cited above. A particular instance of the claim is sustained when it can be shown, in detail, how suitable signifying strategies are present in the given film and how the strategies guide (potentially) a viewer's comprehension of it. And yet, in mounting such a defense – that is, in constructing a suitable close interpretation of the film – one is forced to think through matters that often are ignored, or at least are not adequately considered. Thus, one may discover that certain seemingly questionable facets of the narrative exposition or of the

mise-en-scène have been methodically fashioned for interesting and intelligible ends. Or one may learn that various customary forms and practices of genre filmmaking have been heightened, extended, and exaggerated to serve some novel function – to provide implicit "authorial" expression or commentary, for example. In other words, the central, distinctive creativity in such movies may depend precisely upon the systematic exploitation of their familiar narrative and narrational constraints – the very constraints that do the most to lend a formulaic character to their style and content. These matters will figure importantly in what follows.

Although, as I have noted, these questions have arisen repeatedly in discussions of Hollywood genre films, it is not easy to generalize about how the pertinent issues play out from one case to another. Therefore, in this essay, I want to achieve a certain sharpness of focus by investigating at some length one notorious case in which the issues surface pretty insistently – the last films that Josef von Sternberg made with Marlene Dietrich. Although this is a unique and singular instance, the movies in question paradigmatically raise the problems about heavily stereotypical Hollywood movies I have been trying to sketch, and the upshot of my examination of them will illustrate several of the general points I have just described.

In fact, the case of the Dietrich/von Sternberg movies is especially instructive. On the one hand, these are films that have seemed to epitomize much of what has been most deplorable in the products of the Hollywood "culture industry." For many critics, they exemplify a sleekly customized brand of kitsch, a brand that traffics, not so much in the sentimental or the moralistic, but in a highly aestheticized, mildly perverse depiction of the erotic. A widely influential legacy in the criticism of mass art has set this sort of voyeuristic kitsch (and other sorts as well) in stark opposition to the challenging creations of "high art." In particular, repetitive, undemanding genre pieces like these films are contrasted adversely with the abstract, experimental works of the modernist avant-garde.[2] But I will argue that these films, properly understood, actually show that the stark opposition is misconceived; or, at any rate, it is a mistake to assume that a pair of mutually exclusive categories has been clearly identified. Whether we allow that the culminating films von Sternberg made with Dietrich are "modernist" or "experimental" is unimportant, as long as we grasp that they bear

remarkable affinities, in their objectives and achievement, with works that are squarely within modernist or avant-garde traditions. As I will try to show, the films in question here invent an acutely self-conscious mode of cinematic narration and, correlatively, deploy tactics of self-reflexive inquiry into the nature of their own fabrication. They investigate aspects of the medium of fiction filmmaking and the conventions and practices in terms of which their own identity, as instances of a certain genre, has been established. On my view, it is these properties of the Dietrich/von Sternberg movies which establish their notable kinship to modernism in its more familiar guises.

There have been many earlier attempts to explicate the peculiar originality of von Sternberg's later films with Dietrich, and some of these have glimpsed the radical character of the enterprise. Probably, most accounts have appealed primarily to the conspicuous visual beauty of the motion-picture photography in the films. That beauty is unquestionable, but, if there is nothing more to add, their loveliness is not enough to lift the movies out of the realm of amusing, decorative camp. Some other more daring attempts have floundered, I believe, because they purport to locate the source of the movies' originality in an unprecedented semiotics (almost a metaphysics) of photography that their filming distinctively exemplifies. It is symptomatic of the confusion here that these bolder analyses tend to contain puzzling explosions of overheated philosophical prose. For instance, in *Style and Meaning in the Cinema*, Peter Wollen says:

Von Sternberg was virulently opposed to any kind of Realism. He sought, as far as possible, to disown and destroy the existential bond between the natural world and the film image. But this did not mean that he turned to the symbolic.... It was the iconic aspect of the sign which von Sternberg stressed, detached from the indexical in order to conjure up a world, a heterocosm.[3]

Wollen's remark is outstripped in semiotic ambition and sheer conceptual exuberance by the following assertions from Gaylyn Studlar's book on the director:

While symbolism might be a part of that [von Sternberg's] aesthetic, it is a metaphorical symbolism grounded on iconic signs, not formed out of arbitrary units..... Von Sternberg's film world creates a syntax that is analogical-topological and grounded in iconic representation.[4]

In both of these quotations, the authors seem to suppose that the significant but peculiar aesthetic qualities of von Sternberg's films (with Dietrich) derive centrally from a distinctive representational relation between the film image he creates and the objects and events that they depict – between his segmented image tracks and their photographic subject matters.

But these proposals are hard to grasp. The photography in these movies is certainly scintillating, and the editing is often elaborate and colorful. Nevertheless, neither the photography nor the editing establishes some unprecedented "iconic" link to the movies' photographed material. Wollen tells us that these films are fashioned from photographic images that are "iconic" but not "indexical." For him, this seems to mean that von Sternberg created images in which the natural "realism" of photography – its causal dependence on the visible world? – has been sundered. Studlar agrees that the films are 'grounded in' iconic images, and, for her, the ground-level image track exhibits an exotic syntax and supports the expression of "metaphorical symbolism." In fact, I do not really understand what either of these achievements would amount to. And besides, as I have suggested above, it seems wrong to try to define the central attributes of von Sternberg's overall cinematic style by focusing so narrowly on the formal and representational properties of the visual narration.

No doubt the style of the photography and editing plays a significant role in establishing the idiosyncratic character of the late von Sternberg/Dietrich films, but the systematic stylization of *the acting*, *the settings*, and *the staging* of the narrative action is at least equally important. And, of course, many critics have discussed the intricacies and oddities of these facets of von Sternberg's work as well. However, it is not obvious how adding a consideration of von Sternberg's arch handling of mise-en-scène, for instance, will reveal the level of fundamental artistic accomplishment that Wollen and Studlar envisage. Naturally, one might simply judge that their views about the originality and value of von Sternberg's films should be dismissed as baseless, but in my opinion that would also be a serious mistake. While I think that the formulations quoted above are badly confused, I share the overarching critical conviction of both writers that the von Sternberg/Dietrich films (their last three films especially) *are* distinctive and ambitious in their fiction making. More specifically, I agree with their implicit suggestion that

these movies somehow initiate an interesting self-referential project in which they explore aspects of the problematic ontological status of the fictions that they make.

Nevertheless, as indicated above, Wollen and Studlar are badly off the mark when they try to identify the foundations of von Sternberg's "self-conscious" cinematic narration. They fail to delineate the specific filmic materials and the expositional strategies that constitute that framework. Still, the issues here are tricky. If the challenge to do better is to be met in the present case, then there is a pair of tasks that need to be carried out in tandem. First, a certain amount of philosophical ground clearing is required to elucidate a conceptual apparatus in terms of which the special character of the self-conscious narration in these movies can be framed more adequately. The quotes from Wollen and Studlar do more to muddy the waters than to clarify. Second, these improved claims, both interpretative and theoretical, need to be given detailed, articulated support by paying close attention to the films themselves.

Here, I will *begin* by focusing on one striking narrational strategy that runs through all of the final three von Sternberg/Dietrich films. Having delineated this characteristic strategy in a fairly abstract way, I will offer some proposals about how the strategy can be construed as functioning within the broader narrative context of these movies. In dealing with *Blonde Venus* (1932) and *The Devil Is a Woman* (1935), I will be relatively brief. My discussion of these two films seeks mostly to specify the narrational strategy in question and to sketch the general type of function it appears, in both instances, to serve. In the last section of the essay, I will describe in more detail an occurrence of the same strategy in *The Scarlet Empress* (1934), and will offer a more extended analysis of how this segment is structured and how it works within the total film. This strategy represents an especially clear example of the way in which von Sternberg plays with conventional narrative forms to establish a certain degree of self-consciousness in his cinematic exposition, and it is illuminating to notice from the outset that it constitutes a strategy to which he recurs.

The course of this discussion will lead us to explore, at least briefly, some fairly general issues about "standard" modes of cinematic narration in classical film and to make some comparisons with

the less standard counterpart modes in these von Sternberg movies. However, this inquiry will not ask us to speculate upon the relations of von Sternberg's image tracks to the "iconic," the "indexical," or the "symbolic," and it will not encourage us to discern some special form of cinematic syntax in his work. Still, I think it will allow us to distinguish at least two important types of self-consciousness in film narration and to single out one of these as operative in von Sternberg's later movies. Finally, this approach will help provide a novel account of the remarkable "irrealism" that permeates the fictional worlds of these films.

2. A RECURRENT NARRATIVE STRATEGY

Let us start with a famous sequence from *Blonde Venus* in which the Marlene Dietrich character really hits rock bottom. Helen Jones, the character in question, has lost her husband, her lover, and her son. The loss of the husband is perhaps not such a big deal. He is, after all, played by a stifling Herbert Marshall, and, worse yet, he is the one who has vindictively taken her son away from her. But Cary Grant is the lover, and losing him is surely a calamity. Helen has sunk into poverty and prostitution, and she despises the little money she possesses because her husband has given it to her as a kind of payoff for the child. In the sequence I shall discuss, Helen is living in a miserable flophouse in New Orleans, and things couldn't get much worse. In fact, she announces to another denizen of this dead-end hotel that she is going to kill herself the following day. She staggers across the uncanny, smoke-filled lobby and pauses to pluck a card from a quartet of card players as she announces, "That's me! I'm the Queen of Hearts." Following those gnomic words, she arrives at the foot of a set of stairs. Here she turns and shouts back defiantly, "I'm leaving this dump. I'm going to find myself a better bed. Just watch!" The shot fades as she starts up the steps, and as Dietrich calls out, "Just watch!" we in the audience *do* watch while the camera tracks across the Atlantic Ocean, surveys in montage the Parisian skyline, and rediscovers Helen as the leading chanteuse in the whole of France. Now *that* is a steep rise in fortune! We should all have a career path like hers.

I have opened with this selection because it illustrates, in a fairly simple form, a local narrative manipulation that appears in all of von Sternberg's last three films with Dietrich – the type of strategy I want

to emphasize in the present discussion. Such a segment is marked by the following attributes:

1. The narrative segment is strikingly *elliptical*, and the narrative, odd as it may have been up to the point of the ellipsis, becomes, at that juncture, especially opaque and even enigmatic.
2. The elliptical segment depicts a general *transfiguration* of the character Dietrich portrays, a transfiguration that remains, to a significant degree, unexplicated.
3. The arbitrary, puzzling character of the narrative development is foregrounded stylistically and, in fact, is rather flaunted. Usually, this is underscored by visual punning and by related cinematic figuration.

All three of these conditions are satisfied in the selection from *Blonde Venus*, and I will say that it constitutes a *segment of minimally motivated narrative transformation*. As noted, I will examine two other instances of minimally motivated narrative transformation in von Sternberg's later work, one from *The Devil Is a Woman* and the other from *The Scarlet Empress*. I will try to explicate the ways in which these highly charged transitional sequences serve related narrational objectives in the last two films as well.

The segment from *Blonde Venus* deserves an extended analysis I cannot offer here, but some of the broader functions that it performs are reasonably plain.[5] First, it establishes an especially wayward shift in a story trajectory that has already shown itself to be amply erratic. Second, in this manner, it advertises the artificial nature of its driving mechanisms of plot and character. While many of the earlier dramatic developments have been almost languorously retarded, Helen's radical reversal of fortune in this moment is compressed, foreshortened, and absurdly expedited. Moreover, it is as if this glitzy visual condensation occurs in response to Helen's own invitation to "Just watch!" as she starts to climb the stairway before her – the stairway to success, it seems. In any case, I will argue at some length that the minimally motivated segments from *The Devil Is a Woman* and *The Scarlet Empress* play a similar role: they flag crucial junctures in a nonstandard narrative and offer some comment about how the nonstandard functions of the exposition ought to be construed. These segments, with their puzzling condensation of the action, do not *demand* that the audience

actively reconsider what they have just seen. It is easy enough to make some kind of *minimal* sense of the narrative developments and to proceed passively and without further hesitation from there. Nevertheless, they do *invite* reconsideration, and careful reconsideration can yield the indicated rewards.

It is my conviction that film scholars and critics have misunderstood von Sternberg's approach to *narrative* construction and, concomitantly, have misassessed the character of the filmic narration in his movies. These writers have a lively awareness of von Sternberg's well-attested indifference to the proprieties of narrative exposition. The plots of all of the von Sternberg/Dietrich films are pretty weird, and the acting in them is so strenuously stylized that the characterizations range from the merely oddball to the intensely zany. David Selznick once said contemptuously that von Sternberg's movies were about "... completely fake people in wholly fake situations."[6] Selznick was right about this, of course, but wrong to suppose that he had formulated the grounds for a negative assessment of the work. It is one thing to affirm correctly that von Sternberg repudiated various conventions and constraints of classical Hollywood storytelling. It is quite another matter to maintain that the detours and disruptions in his exposition of plot do nothing toward defining the "meaning" that those narratives may bear. Certainly, it *is* tempting to dismiss all questions about the significance of these bizarre, minimally motivated narrative episodes. After all, their most obvious immediate effect is to obscure the development of the characters and to muddle, at least briefly, the stories they enact. However, this is to assume that we know the kind of story it is the objective of the movies to be telling and to ignore the possibility that these minimally motivated segments may help to establish the evolving intelligibility of the films as a whole. So, first of all, this possibility *is* exactly what these segments *do* pull off, and I will explain this contention at some length, especially in connection with *The Scarlet Empress*.

Second, in all three movies, the stylization of the acting foregrounds the "actorish" quality of the performances and inflects them with a certain wry, self-conscious absurdity. This strategy is given particular emphasis by Dietrich's especially showy posturing in our elliptical fragment from *Blonde Venus* and by the abrupt and arbitrary transfiguration of self that it presents. Similarly, in all of these films, the excessive and

oppressive staging highlights the artifice of the narrative development and underscores the fact that the dramatic action has been shaped and distorted by causes outside the fictional world altogether. Again, the caricatured intensity of the melodrama in the *Blonde Venus* segment and the startlingly sudden transition from rags to riches – from Skid Row den to Parisian nightclub – accentuate the capricious nature of the story construction.

More specifically, by foregrounding the acting, the settings, and the staging for the audience, von Sternberg's films give unusual prominence to an essential ambiguity in the photographic representation of mimetic fictions; that is, the motion picture shot is simultaneously a shot of an actual actor in an actual location performing some actual behavior, *and* it is a shot of a fictional character in a fictional site performing the fictional action which the behavior represents. This ambiguity of photographic content is exemplified in any fiction film, and classical movies have often traded upon the ambiguity in familiar, sometimes complicated, ways. For instance, although the movie audience is normally meant to see the on-screen human figures primarily as the characters portrayed, viewers are also implicitly aware of the presence of the stars themselves and the attributes of character and personality that they have come to convey. This secondary awareness of the stars and their "personae" will usually be elicited with varying degrees of distinctness and intensity during the course of the drama. Von Sternberg is atypical only in the salience that this representational ambiguity takes on within his work and in the sorts of significance he builds upon it. I will argue later that the strategies of the odd narrative apparatus in his last two movies with Dietrich assign an almost thematic status to the ambiguity, and the minimally motivated transformations in the films instruct us in the issues and feelings that these narrative strategies express. This will take us some distance toward specifying the conspicuously innovative nature of the narration in these films.

The Devil Is a Woman is probably the movie in which von Sternberg's reflexive, self-conscious strategies are most directly exhibited. Because I have discussed this film at considerable length in *Narration in Light*, I don't want to spend too much space going over old ground.[7] However, the central, minimally motivated transformation is so enlightening for the purposes of this essay, I must examine it briefly.

In this film, Dietrich plays Concha, a Carmen-like femme fatale who entrances every man whom she encounters. The segment under consideration takes place in the upper room of a casino where she is with Antonio (played by Cesar Romero), a handsome young revolutionary with whom she is having her first assignation. The dramatic action occurs during a period of Carnival, so everyone is masked and in disguise. Antonio is keenly attracted to the glamorous Concha, but he is deeply leery of her as well. Another character, Don Pasqual, has earlier told him the torturous story of his own long, frustrating infatuation with Concha, and he has urged Antonio not to get entangled with her. Don Pasqual will make his own appearance in the scene. The character is played by Lionel Atwill, and it is widely recognized that Atwill was made up to bear a striking resemblance to von Sternberg himself. In some sense – intriguing to work out – Don Pasqual is von Sternberg's surrogate within the fictional world of the film. Early in the transfiguring sequence, Concha offers to tell Antonio's fortune from the cards, and she identifies several of the movie's characters with figures on the face cards of her deck. In particular, she identifies herself with the Queen of Hearts. (Helen Jones, it will be remembered, makes the same identification in the segment from *Blonde Venus* previously discussed.)

The two are interrupted by a masked messenger who bears a letter from Don Pasqual declaring his abiding devotion. Antonio is angered by the hypocritical duplicity revealed in Don Pasqual's letter, and he kisses Concha passionately. As they embrace, however, the doors to the private room fly open and Don Pasqual is revealed. Angrily he challenges Antonio to a duel with pistols and, meaning to demonstrate his marksmanship, he picks up the Queen of Hearts, plants the card in a window, and shoots it – his bullet piercing one of the pictured hearts that signify its suit.

Just after the shooting, two striking consequences ensue. First, the governor and his police materialize to shut down Carnival altogether. The celebrants are forced to strip off their masks, and the great masquerade is at an end. Second, it soon emerges that Concha herself has been mysteriously transformed. Up to this point in the story, she has apparently been impervious to any affection and has been content to control and manipulate the passions she inspires. But, after Don Pasqual's shot, she seems to have fallen genuinely in love with

Antonio, and it is *she* who begs *him* for his attention and favor. In
the first part of the movie, Don Pasqual has established the pattern
of offering to free Concha from some form of social constraint, em-
barrassment, or oppression, but always with the transparent motive of
thereby binding her to him – in marriage, for example. But now, after
Carnival has been ended by the gunshot, Concha seeks out Antonio
to plead that he take her with him out of Spain. As she makes the
plea, she wears the bullet-pierced Queen of Hearts over her own
heart.

Later, after Antonio is put in prison for dueling with Don Pasqual,
Concha is the one who goes on to bargain with the governor to have
him set free. Oddly reprising Don Pasqual's earlier pattern, she has
already struck a bargain with Antonio: she will intercede with the
governor for his freedom only if she is allowed to accompany him
to Paris. One has the sense that the transfiguration of her heart has
somehow been caused by Don Pasqual's act of shooting the Queen
of Hearts. This narrative reversal seems to be somehow the arcane
consequence of the pistol shot in the casino.

But then, how, if at all, is this causation supposed to be compre-
hended? The fictional world of *The Devil Is a Woman* is strange, but
nothing in it prepares us for a turn of events as metaphysically radical
as this. I take it that Don Pasqual *is* von Sternberg, or, at least, he is
his fictional delegate within the film. The story line, during the casino
scene, has reached a crux which is intolerable to Don Pasqual: Concha
is about to leave him once more, and this time she will desert him for
Antonio despite Don Pasqual's earlier rhetorical attempts, as the sto-
ryteller within the film, to block precisely that result. It is in Concha's
infallible power to land a callow fish like Antonio, and she is on the
verge of succeeding. Hence, I have proposed that Don Pasqual qua
von Sternberg intervenes. He is implicitly the master of the fictional
world, and it is therefore in his power to shape the remainder of the
drama as he sees fit. And, this is what he does by literally shooting an
image – in this instance an image of the Queen of Hearts – namely
an image of Concha, by her own accounting. Concha's position in the
game of love and seduction is thereby turned upside down. Because
of the shot, she is now as helplessly in the thrall of Antonio as Don
Pasqual has heretofore been in hers. And that is the revenge that Don
Pasqual effects: now she is brought to suffer as dreadfully as she has

made him suffer all along. The movie spins out the peculiar, somewhat baffling, consequences of this reversal of her role.

In the famous Daffy Duck vehicle *Duck Amuck* (Chuck Jones, 1953), the animator's brush and pencil appear, so to speak, as active "characters" within the cartoon fiction. To Daffy's utter confusion and consternation, the represented brush and pencil change him from one costume to another, switch his background settings, and, at one point, erase him entirely from the scene. Here the animated brush and pencil are the fictional agents that have been assigned the powers of Chuck Jones and his collaborators. In a similar fashion, I maintain, Don Pasqual is to be construed as the story-world surrogate for von Sternberg – the fictional agent in the film who assumes some of the director's actual powers to invent his own fate and the fates of his co-characters and to regulate the remaining course of the narrative. Neither *Duck Amuck* nor *The Devil Is a Woman* is a full-scale modernist counterpart of works by, say, Brecht, Beckett, or Pirandello, I suppose; but in both the cartoon and the culminating von Sternberg/Dietrich collaboration we do have a self-conscious form of narration that intrudes upon the causal coherence of the narrative events and humorously destabilizes the ontological status of the characters. However, there are hosts of ways in which cinematic narration can be self-conscious, and one would like to specify the Sternbergian mode of narrational self-consciousness somewhat more narrowly.

I imagine that everyone who has seen these sequences from von Sternberg has the sense that their normal, natural relationship to the fictional world of the film has been disrupted in some way. Some fundamental norm of standard movie viewing has been abrogated, but it is not at all easy to say what that norm is. Consider, in this connection, the following passage from David Bordwell's *Narration and the Fiction Film*. Bordwell comes close to articulating the basic cinematic conventions that are put at risk in our examples, but he obscures a distinction that is important in the present context.

By virtue of its handling of space and time, classical narration makes the fabula world an internally consistent construct into which narration seems to step from the outside. Manipulation of mise-en-scène (figure behavior, lighting, setting, costume) creates an independently existing pro-filmic event, which becomes the tangible story world framed and recorded *from without* [my italics].

The framing and recording tends to be taken as the narration itself, which can in turn be more or less "intrusive" upon the posited homogeneity of the story.... the fabula seems not to be constructed: it appears to have pre-existed its narrational representation.[8]

Now it seems to me that these remarks, helpful as they are, run at least two distinguishable considerations together and thus efface the difference between two "norms" of classical narration in Hollywood film. One of these norms *is* flouted in our von Sternberg movies, but the other one is not. It tells us something significant about the global narrational strategies in the von Sternberg movies to be clear about which is which.

On the one hand, Bordwell asserts that the characters, events, and situations of the diegetic world are presented in classical narration as having an existence and internal integrity that does not depend *at all* upon the filmmaking process. We will return to this point shortly. On the other hand, he also states that it is a part of the total fiction that these independently existing (albeit fictional) items and occurrences have been "framed and recorded" by some means whose character is itself left fictionally unspecified. As Bordwell puts it, these items and events are recorded "from outside," and this means for him, "from outside the world of the fabula." That, however, is a second and more restricted point. Although viewers properly imagine themselves seeing sights and hearing sounds belonging to the fictional world, the way in which these sights and sounds have come to be registered on-screen is assigned no determinate status within the work at all. In fact, it is fictional in the film story that no such recording actually took place. Nevertheless, for the movie audience, the edited results of the actual framing and recording is experienced as an audiovisual narration of the events portrayed, and the fictional constituents of the narrative are apprehended as the "pro-filmic subjects" of this cinematic "reportage." To paraphrase the end of Bordwell's remarks: the fabula seems not to be constructed by the framing and recording: it appears to have pre-existed its *photographic* depiction. Call this "the norm of the *photographic transparency* of the fictional world."[9]

It does not follow from adherence to this second, significantly qualified norm that the transparently depicted world of the film will not have been presented as a manifestly fictional construction, internally acknowledged as such. The film's diegetic substance may not appear

to be "independently existing" in Bordwell's full-blooded sense. Spectators can be asked to imagine that they are offered, by means of the image track, fully *objective* views of a world that is perceived (and is meant to be perceived) as an artifact of the filmmakers' construction through and through. Thus, what Bordwell calls "manipulation of mise-en-scène" may regularly leave foregrounded traces of the sensibility, intelligence, and personality that designed the style of the acting, the staging, and the lighting and fabula that they depict. In classical narrative film, it is ordinarily not self-consciously acknowledged, *within the fiction*, that the characters are fictions portrayed by actors, and it is not affirmed, directly or indirectly, that the dramatic situations are also fictions staged to advance the larger teleology of the tale. When this type of reflexive acknowledgment is absent, I will say that the narration satisfies the norm of the *ontological self-subsistence* of the fictional world.

Of course, there are delicate questions in this connection about what counts as a film's genuine self-acknowledgment that its diegetic constituents are fictive. After all, a lot of musicals, wacky comedies, and films of fantasy exhibit, in differing degrees, broad manipulation of mise-en-scène that arguably conveys at least some sly reflexive implications. *The Road to Rio* (Norman Z. McLeod, 1947), *The Pirate* (Vincente Minnelli, 1948), *Million Dollar Legs* (Edward Cline, 1932), *The Crimson Pirate* (Robert Siodmak, 1952), and *The 5000 Fingers of Dr. T* (Roy Rowland, 1953) are a few examples out of a large list of possibilities. It is probably unhelpful, in the present context, to try to establish a boundary in this region that firmly divides the late Dietrich/von Sternberg films, as I interpret them, from various brands of conceptually less ambitious fare. We *do* need to draw the general distinction between photographic transparency and ontological self-subsistence, since it is the latter form of self-consciousness, and not the former, that operates in our von Sternberg films. Perhaps we can afford to leave further refinements and finer discriminations of value for another occasion.[10]

Most classical narrative films predominantly conform to both of these norms, but the norms are different and come apart in special cases. For instance, films like *This Is Spinal Tap* (Rob Reiner, 1984) and *David Holtzman's Diary* (Jim McBride, 1967) discard photographic transparency but not ontological self-subsistence. The fictional worlds

of these movies are presented as if they existed independently of the represented filmmaking activities, but it is a key part of both movies' fictions that a camera was present at the narrative action and recorded, as a kind of documentary, the images presented on the screen.

As noted above, these same norms also come apart in a different way in the movies under study here. *Blonde Venus, The Devil Is a Woman,* and *The Scarlet Empress* all consistently accept the norm of photographic transparency. They operate within the fiction that the viewer is watching photographic (or better, photograph-like) shots of slices of their fictional world, although it is also fictional that no camera or other recording device was present in the fictional settings to register the dramatic activity they contain. However, the ontological self-subsistence of their diegetical worlds *is* disturbed over and over again. The artifice of the narrative circumstances and the fabricated nature of the fictional agents and their actions are repeatedly (if only implicitly) asserted, diagrammed in the exposed machinery of von Sternberg's patently synthetic mise-en-scène.

In any event, Bordwell's remarks ignore the differences between these classical norms and therefore do not distinguish the two corresponding modes of reflexive self-consciousness in film narration. For many purposes, this does not matter much. However, if we miss the distinction, we may be tempted to assimilate a narrower question (Is the movie's *photographic* representation of narrative self-conscious?) to a broader one (Is the movie's portrayal of narrative self-conscious *at some level of representation?*). I opened this discussion with quotations from Wollen and Studlar – quotations that are, in several ways, confusing and opaque. I have argued, on the one hand, that they are right to affirm that the von Sternberg movies make a drastic break with norms of representation in classical film. But they are wrong in trying to define the fractured norms as pertaining to the very nature of the photographic depiction the films employ. In other words, they seem to have fastened wrongly on the narrower possibility of transparency because they failed to grasp the pair of possibilities that the present distinction seeks to elucidate.

To clarify and elaborate my conception of von Sternberg's mature narrational strategies more concretely, I want to turn finally to a central sequence from *The Scarlet Empress.* So far, I have offered a rather schematic account of the role of the minimally motivated segments

from *Blonde Venus* and *The Devil Is a Woman*. In doing so, I have wanted to stress the similarity between the two selections and to elucidate the reflexive, narrationally instructive roles that both selections play. However, in the present instance, I will examine the internal structure of the elliptical transformation in greater detail, arguing that it constitutes a key moment in a whole sequence of narrative transitions, a sequence that depends importantly for its overall meaning on the "double level" of photographic content discussed earlier. That is, I will argue that *The Scarlet Empress* exploits, in a surprising, sophisticated way, the ambiguity of an image track that simultaneously depicts Marlene Dietrich (with her well-known screen persona) *and* the equally notorious character from history, Catherine the Great, whom she therein enacts.

It is precisely in this respect that von Sternberg's regular incursions upon the ontological self-subsistence of his fictional worlds are so distinctive. It is not just that the mise-en-scène is blatantly constructed to serve various "expressionistic" objectives. One might contend, whether rightly or wrongly, that the expressionistic world of, for example, *The Cabinet of Dr. Caligari* flouts the norm of ontological self-subsistence in this fashion.[11] But the methods and aims of stylization in *The Scarlet Empress* are not primarily expressionistic, in the most common sense. The latter film foregrounds broad issues of make-believe and performance, and its acting, settings, and staging are designed to represent the historical episode of Catherine's political career through metaphors of fictionality and histrionic contrivance. *The Scarlet Empress* also works very differently from *The Devil Is a Woman*, but both films share a vital use of these and related metaphors in defining their overall thematic concerns. Or so I will maintain.

3. *THE SCARLET EMPRESS*

The plot environment of the targeted segment can be minimally summarized as follows. Princess Sophia, played by Dietrich, has been brought to Russia to be married to the future czar – "the royal half-wit" Peter. By marrying Peter, the erstwhile Sophia becomes Catherine of Russia. In the first part of the movie, Dietrich portrays Sophia as an innocent virgin, shy and kittenish in demeanor. The performance in this stretch of the movie is fun and utterly preposterous. Dietrich seems to be more "playing with her role" than playing it. She is

conveyed to Russia by the incredibly handsome and utterly narcissistic Russian ambassador, Count Alexey. Thus, Alexey, as he is portrayed by John Lodge, comes across as a kind of gorgeous male counterpart to Dietrich. It is wholly natural, therefore, that the Dietrich character falls for him like a ton of bricks. However, just prior to the action in our minimally motivated narrative segment, Catherine has discovered that Alexey, apparently like everyone else at the Russian court, has been sleeping with her mother-in-law. She regards this as very bad news and reacts crossly. In anger and distress, she throws a locket containing Alexey's portrait out of her bedroom window and then runs down to the palace garden to retrieve it. It is nighttime as she searches, and as she finds the locket, she encounters a handsome young lieutenant of the guard in the dark. He, with no difficulty whatsoever, seduces her on the spot.

This opens an extraordinary sequence. As it proceeds, it is not always easy to say with real confidence just what is going on. The lieutenant announces at the very outset, "On a night like this, *anything* could happen." Given the various things that subsequently do happen or seem to happen, his remark comes across as a flagrant understatement. Catherine submits to the guard, and we see the token of her submission, the relaxation of her hands upon his back. That image then is dissolved into images, themselves intercut in dissolves, of huge bells ringing and mighty guns firing. At first sight, this appears to be a rather vulgar cinematic metaphor – an instance of the kind of ersatz Freudian symbolism that stands in for the act that cannot be shown in classical film.

And yet, wait a minute! Why is it that these shots of bells and cannons are gradually edited into shots of happy crowds out celebrating some momentous event? One has the brief impression that most of St. Petersburg is in a state of exaltation because Catherine has lost her virginity in the palace gardens. And yet, of course, that isn't right. As the sequence continues, it emerges at the conclusion of some exuberant montage that a considerable period of time has passed, and, in fact, the cheering crowds are celebrating the birth of a royal heir. But, even this realization is confusing. In the ensuing scene, it is the Dowager Empress Elizabeth who is shown in bed with a new baby, and she is the one who is receiving congratulations from a band of courtiers for *her* splendid achievement. It is, at this moment, as if Catherine's midnight

indiscretion in the garden had caused her mother-in-law to conceive a child. (This is not the kind of causal connection one would like to see raised to the status of universal law.)

Eventually this gets straightened out as well. We realize that nine months have passed. Catherine is the person who has mothered the infant. The Dowager Empress is triumphant because, thanks to Catherine, the royal line has been continued. Nevertheless, just this far into the sequence, the filmmaker has already established what seems to be an attitude of calculated playfulness concerning familiar standards of temporal and causal exposition. What is more, the last part of the segment is, if anything, more disorienting. First, we have the oddly moving and oddly uncommunicative scene in which Catherine lies in bed thinking her private thoughts. This is a rather characteristic moment in a von Sternberg film. The fact that Catherine's thoughts and feelings are veiled from view is visually signified by the veil-like bed hangings that blur and soften her unreadable expression. Clearly the reflections she is entertaining here are of some importance, since the camera lingers on her for an extended time, scrutinizing her impassive gaze. It is as if she were reaching some fundamental decision or conclusion, but we don't know what it might be. We do know from the action a moment before that her lover's locket has now been replaced by a jeweled political medallion, awarded to her for her splendid service to the state. Presumably she is partly contemplating the ironic lessons implicated in that exchange.

Soon afterward, we see Catherine emerging again upon the public stage; but the Catherine who emerges in this scene is by now dramatically transformed. Gone is the wide-eyed virgin princess of the first half of the movie, and in her place we discover an altogether different being – a startling metamorphosis of Dietrich's character. To put it bluntly, we discover the powerful, well-established star persona of Marlene Dietrich, the persona we know and love so well from her earlier movies made with von Sternberg. Suddenly, up on the screen, we have Catherine the Great rendered in the familiar Dietrich style. One has had the feeling all along that the "real" Dietrich has been withheld from us, hidden from us behind the implausible Princess Sophia facade. But, here at last, the real Dietrich, with very minimal motivation indeed, has been released into the story world. Sophia/Catherine has become the knowing, audacious, sexually exploitative figure who

ambiguously seems to promise uncharted possibilities and who is coldly and exquisitely in complete control. One of the movie's odd, old-fashioned intertitles explains that Catherine is presently consolidating her position in court and that she has "discarded all of her youthful ideals." This strikes me as another case of loopy understatement. Actually, it is more as if she had discarded the whole of her previous identity in the film. It is as if she had stepped, in the space of an intertitle, into an entirely new and yet oddly familiar role.

The transfigured Catherine is introduced to us conversing with a gray-bearded old man, and in this conversation she practices her new sexual and political sophistication upon him. In a particularly sardonic stroke, the old fellow is the head of the Holy Russian Church, although he really doesn't seem, in any way, to be out of his league in negotiating cynically with her. Like a second-rate mobster, he assures her that he has considerable control of "the political machine" at court, and, as he confides that assurance to her, he ostentatiously fingers the emblem of his grasp on power – the crucifix of the church. And Catherine, when she responds, likewise plays with the token of her newly realized power – the frothy, flirty handkerchief that she holds.

The obvious questions all this raises are: how is it that the Catherine character is so strikingly and abruptly transformed in this manner, suddenly stepping forth in this novel instantiation of the Dietrich persona? Why does this enormous change take place without any serious attempt at psychological elucidation or development? The transition here represents, of course, the central minimally motivated narrative transformation in *The Scarlet Empress*. And, again, I want to raise the question "What interpretative rationale, if any, can be offered for this delirious stretch of film?"

In point of fact, the story of *The Scarlet Empress* is structured around a whole series of transformations, each having stylistic similarities to the key example I have just described. For instance, all of these scenes of transformation are punctuated by more or less elaborate montage sequences, sequences in which shots of the great tolling Russian bells recur and mark the passage of time. Thus, we have: (1) the transformation of Catherine as a young girl into Catherine as a sexually mature young woman; (2) the transformation of the young Catherine, at her wedding, into the wife of the czar-to-be; (3) the central transformation of Catherine's passage from sexual and political naiveté

into worldly sophistication; (4) the death of her mother-in-law, which raises Catherine to a position of genuine political power and rivalry for political ascendancy with her husband; and, at the end of the movie, (5) Catherine's final and complete triumph – her apotheosis as the all-dominating Catherine the Great.

At each of these stages or stations in her development, there is little in the way of serious dramatic conflict. What conflict does exist is chiefly played out in terms of broad melodrama or farce. However, each stage is a stage in the rise to power of Catherine the Great, and each stage marks a type of worldly knowledge and experience she has to acquire in order for her dominance at the drama's end to be possible at all.

From the very beginning, *The Scarlet Empress* makes it clear that it means to invoke for its audience the Legend of Catherine the Great and the associated myth of her political and sexual omnipotence. In the dialogue and in the absurd intertitles, the idea is repeatedly expressed that she is a character who has a fated, legendary destiny to fulfill. She is, the very first intertitle tells us, "the Messalina of the North." In the opening scene, following this title, the young Sophia falls asleep listening to fantastic tales and legends of past Russian rulers, tales whose violent content the movie encapsulates in a burst of Vorkapich-style montage. Catherine, we are later informed, is "chosen by destiny," but she, the intertitles assert further, "is unaware of the fate that awaits her." When she leaves for Russia, she is instructed by her father "to be worthy of her glorious destiny," and so on, from various sources, in the same vein. The narrative, defined in stages, charts out the fulfillment of that preordained destiny.

In this connection, I believe, we need to distinguish between the flesh-and-blood person from history, Catherine the Great, and the fictional character of the same name, created by myth and popular lore. Naturally, the fictional Catherine of legend is, in some sense, "based upon" or "derived from" the historical figure, but they are separate entities nonetheless. (They are related to one another in very much the same way that St. Nicholas, the storied Christmas character, is linked to the historical Saint Nicholas.) I suggest that we are meant to see and comprehend Marlene Dietrich, in this movie, as playing the *already* fictionalized Catherine and not as attempting to reenact the "real" Catherine at all.

In other words, *The Scarlet Empress* drops the standard pretense of biographical fiction film that the filmmaking will take us back in time and show us a selection of the historical events in question. That dramatic ambition is altogether forsworn in the present case. Actually, in the movie biographies of the classic period this imaginative pretense was almost always pretty shallow.[12] When George Arliss played Disraeli in *Disraeli* (Alfred E. Green, 1929), or Dolores de Rio played Madame DuBarry in *Madame DuBarry* (William Dieterle, 1934), they were cast for their roles principally because it was supposed that they carried with them, from other films, the kind of screen persona that would plausibly sustain the intended, usually stereotyped conception of the historical individual in question. Of course, this is just a special instance of the still more ubiquitous practice of conjuring up a major dramatic character on the basis of the star's already acquired motion-picture image. As usual, von Sternberg pushes this common moviemaking practice to its limits. While Catherine is seen reflected in the "Dietrich" figure, Dietrich is revealed to be a "Catherine" counterpart, and each of the two "roles" is played off against the other during the remainder of the film. This is an especially nice example of the way in which familiar, problematic dramatic devices were used by von Sternberg but were exaggerated, made especially salient, and exploited as a content-bearing stylistic motif.

Moreover, in this movie, it is very much the von Sternberg/Dietrich *version* of the legend of Catherine the Great that we are offered. And this version is idiosyncratic and highly stylized, constructing the figure of myth in its own terms of delirious parody and satirical fantasy. The character of Catherine is marked specifically as a creation of the filmmaking, erected from the bare framework of the fable of Catherine the Great, and is elaborated, in the movie's second half, in terms of the daunting screen persona of Miss Marlene Dietrich. If this interpretative proposal is right, then we already have some reason why we might expect *The Scarlet Empress* to deviate from our ordinary conceptions of the continuity of the self and of plausible dramatic evolution. The movie aspires to be, it seems to me, a kind of exemplary tale concerning the will to sexual and political power and, as such, its narration is fully prepared to abstract from ordinary ideas of psychological reality.

In fact, a moment early in the movie raises a brief uncertainty about the ontological status of its narrative, albeit playfully and in passing.

That is, it is unclear at an early juncture whether the film is supposed to be recounting a piece of history, a legend, or Catherine's private fantasy. In the very first scene, Princess Sophia is ill, and, as the scene closes and Sophia falls asleep, her father is reading her tales of past Russian rulers. Sophia's image is then dissolved into the beginnings of an incredible montage of pillage, torture, and oppression, and these horrendous incidents are depicted as illustrations in a book whose pages appear to be turning on the screen. The last of the "illustrations" shows a half-naked man being swung as the clapper in a huge, tolling bell, and this shot dissolves into a visually rhyming image of a teenaged Sophia being pushed by her companions in a garden swing. This image of Sophia (Dietrich's first appearance in the movie) surely represents a return from the montage to the main story, but, in visual terms, it is continuous with whatever it was the preceding montage had presented – a young girl's dream? anecdotes of violent Russian history? or cautionary fairy tales of cruelty? That is, nothing formally marks a definite point where the action reemerges from the hallucinatory segment of the montage, and the formal indeterminacy this suggests is wholly appropriate to the preoccupations and strategies of the larger film. It is equally unclear what kind of "reality" the movie as a whole presents.

The Scarlet Empress takes almost no interest in the "realistic" depiction of any of its characters. Louise Dresser plays the empress like an egregiously belligerent fishwife from 1930s Brooklyn. And, as Andrew Sarris once pointed out, Sam Jaffe's portrayal of Peter renders him as a kind of malignant Harpo Marx. As I observed in *Narration in Light,* all of these characters are presented, so to speak, as automatons made of flesh.[13] They all are driven, in the most crudely determined ways, by lust or greed or the will to power. The movie draws a broad contrast between the human characters, who seem devoid of significant emotional and spiritual life, and the huge statues by which they are constantly surrounded. The statues appear in poses of religious ecstasy and world-weary despair. They assume the postures of agony, shame, and grief. And these are states of mind and soul which the human characters seem largely incapable of experiencing.

If this film, whose scenes are obsessively filled with statues, dolls, and carved figurines, has an emblematic equivalent for the characters it portrays, these would probably be the grotesque mechanical

figures that intermittently appear. One of them strips off its garments at midnight, a second pounds another with a club, and the members of a third group creep around in sinister circles, each tracking down the one ahead of it.[14] The metaphorical linkage of human behavior with the idea of the mechanical is extended in various other directions. For example, as I mentioned earlier, the old priest speaks anachronistically of "the political machine" in court that he controls. And, at the conclusion of the famous marriage scene, an intertitle reports that "the machinery of the wedding ceremony" grinds on to its conclusion.

It is not simply that the characters surround themselves with artifactual representations of human beings – the statues, dolls, paintings of human forms and faces, and mechanical figures; there is at least an equal emphasis on the theatricality of self-presentation and the continuous "audience" scrutiny to which these dubious histrionic outbursts are subjected. When Count Alexey comes to fetch her from Germany, Sophia is subjected to a cold, critical inspection by the members of her own family. And, arriving in St. Petersburg, she is poked and peered at from all quarters in the court. A kind of culmination of this motif occurs at the spectacular marriage of Peter and Catherine. Here Catherine is offered up as the subject of a vast ceremonial spectacle and as the object of Alexey's private and penetrating stare. Moreover, at the same time, she is marrying a goggling idiot who stares blindly around and through her during the ceremony. (The complexities of vision in this scene deserve a section of their own.)

Similarly, much attention is devoted to the various roles that the main characters themselves undertake or, alternatively, to the roles that others expect or require them to perform. The central conflict between the Dowager Empress and Catherine lies in this range. On the one hand, Empress Elizabeth repeatedly demands that Catherine learn her proper role as a royal Russian wife. That role demands the observance of established forms of duty, submission, and female enticement. Above all, it demands an outcome – the breeding of male heirs. On the other hand, Catherine's successful acquisition of supreme power depends, as she herself remarks, upon mastering a very different role. Catherine must learn the highest arts of sexual politics, at least as von Sternberg conceives of these. She learns the maneuvers of ambiguous sexual promise and the payoffs of strategic sexual manipulation. She

acquires freedom from romantic illusion, and she learns to wear the countenance of self-control and to wield the power of the dominating gaze. At the end of our highlighted segment, she tells the priest: "You need have no fears for me. Now that I know how Russia expects me to behave – I like it here." Somewhat later on, she adds, "And I am taking lessons [in the expected behavior, she means] as quickly as I can."

One lesson that Catherine apparently has to learn is given by her formidable mother-in-law. Elizabeth humiliates Catherine by having her prepare the way for the entrance of Count Alexey into her (the empress's) boudoir. Now, this piece of cruel instruction is quite effective. The humiliation leads to Catherine's seduction; and her seduction leads, as we have seen, to the crucial transformation of the Dietrich character. What is more, the transfigured Catherine actually replays this same scenario later, recasting Alexey in the role that she originally had played. In fact, it is my proposal that her subsequent transformation is itself to be conceived as her self-conscious adoption of a radically new role. Seen in this fashion, its minimally motivated nature makes an obvious sort of sense. Normally, we do not expect that a person's character, outlook, and sensibility can alter so swiftly and extensively. But if we assume that the fictional characters in *The Scarlet Empress* are largely empty of any significant core from the very outset, then it is not implausible that the canniest among them should drop one role that isn't playing very well and take up another better suited to her needs and circumstances. This is what I make of the musing Catherine, veiled by the delicate curtains around her bed. I see her as making just this sort of calculation about the content of her future performances.

At one juncture, the empress says to Catherine, "We women are too much creatures of the heart," and Catherine has to comprehend the hypocritical posturing expressed in such a speech. And this is just one facet of the expertise in histrionic self-presentation she acquires. In the course of the whole movie, Catherine's progressive acquisition of her fated role as "Catherine the Great" demands the blurring or, perhaps, even the obliteration of many standard roles, and gender roles are definitely among those left behind in the rubble. Czar Peter progressively rages and dithers more and more hysterically as Catherine grows correspondingly more assured and self-controlled. This double transformation culminates at the instant when Peter, in his billowing

white robe and flowing white hair, is struck down helplessly before the crucifix in his bedroom. And, at this moment, Catherine, mounted on her white stallion and wearing her white soldier's gear, takes her place upon the throne. Even Count Alexey characterizes these changes in theatrical terms. "Exit Peter. Enter Catherine," he announces, and the revolution (of several kinds) is now complete. In the world of *The Scarlet Empress*, Catherine enjoys an almost alchemical mutability, a power available to "those extraordinary people" (this is Alexey's phrase) who have the intelligence to discern their theatrical options and go on, as Alexey says, "to create their own laws and logic." He means, of course, the laws of conduct and the logic of high style.

4. CONCLUSION

I have maintained at some length that both *The Devil Is a Woman* and *The Scarlet Empress* exhibit a sophisticated mode of self-conscious narration and self-reflexive content, but I suspect that there will be lingering doubts about whether it is plausible to presuppose that von Sternberg really possessed the requisite level of philosophical sophistication and cared about such experiments in form. However, there certainly is evidence that von Sternberg was attracted to these odd configurations of narrative and narration, and aspired to investigate them in film. For example, we know from his autobiography, *Fun in a Chinese Laundry*, that he had plans to make a movie of Luigi Pirandello's *Six Characters in Search of an Author*, and that he failed to do so only because he was unable to obtain the rights to the play.[15] Now Empress and Devil do not exhibit the same overt, self-conscious concern with fictionality and related topics that one finds in *Six Characters* and in certain other products of early modernism. Nevertheless, as I have tried to establish, there is an broad, important affiliation between the relevant modernist works and von Sternberg's final films starring Dietrich. Von Sternberg, we also know, took great pride in being a friend of Max Reinhardt, and there is every reason to suppose that he was acquainted with a range of the theatrical experiments in the early part of the twentieth century that broke with conventional forms of dramatic narrative. And many of these productions also experimented with various forms of non-naturalistic acting, abstract and/or symbolic staging, and the expressive possibilities of sets and lighting. It is unfortunate that in his

autobiography and in interviews von Sternberg was so grudging about admitting that he learned much of anything from anyone, or that he was significantly influenced by specific antecedents and contemporaries. Nevertheless, we can be sure that he was acquainted with some range of avant-garde work in theater and cinema, and the thematic preoccupations I have attributed to his last two Dietrich films are not at all beyond his ken.

Of course, von Sternberg's own artistic experiments were conducted in the seedier confines of Hollywood romance and melodrama; he was not, after all, directing experimental productions for the sophisticated theater in Paris, Rome, or Berlin; he was making motion pictures for Paramount Studios, and he was employing one of that company's hottest, most valuable properties. These movies were expected to play profitably in Bangor, Maine, and Boise, Idaho, and it is amazing to me that von Sternberg got away with making movies as excessive and outrageous as he did. Actually, by the time he and Dietrich were making their last two films together, Paramount had pretty much given up on his ability to continue to turn out massive popular successes like *Morocco* (1930) and *Shanghai Express* (1932). The studio was eager to transfer Dietrich into more reliable hands, and von Sternberg was very much aware of the situation. Letting their contractual commitments to him play out, the bosses at Paramount allowed him relative freedom in making *Empress* and *Devil*. No doubt this was more a matter of resignation on their part than deference to his artistic aspirations. Whatever the reasons, von Sternberg delivered the most complex and carefully crafted movies of his career.

These films are the stunning result of two conflicting forces: von Sternberg's elaborate, sometimes pretentious artistic impulses, for one, and the commercial pressures under which he worked, for the other. If my interpretations of the movies are correct, then what is most striking about them is the complexity and ambition of their artistic objectives, especially when those objectives are matched against the superficial poverty of the literary resources with which the director had to work. I have emphasized the fact that the three films I have considered are very much movies that belong to certain genres, genres which fairly often veered toward the tawdry and the dumb. In the first place, many movies that fall within these genres contain implausible and murky plot connections, and the same movies commonly

involve characters whose changes of heart and mind are, to put it mildly, imperfectly explained. For this reason, the segments of minimally motivated narrative transformation in the von Sternberg films do not stand out egregiously in the context of their genres; and, in point of fact, these segments are reasonably understood to be von Sternberg's own reworking, as a kind of strategic ellipsis, of the incompleteness or vagueness featured in so many genre movie story lines. Second, I have elaborated the ways in which Dietrich's "star" persona was utilized to complicate the identity and ontological status of that celebrated female figure on the screen. And this, I have argued, represents an intricate use of the ubiquitous Hollywood practice of casting parts in terms of the actors' preestablished identities as well-known stars. Third, it is an equally familiar fact that sets and staging in certain types of Hollywood studio films are often designed less to achieve, say, a high level of dramatic verisimilitude than to create an engaging context of visual spectacle. Von Sternberg's strong proclivity for spectacle and painterly visual design is probably the most celebrated feature of his work, but I have not focused a great deal on this much noticed aspect of his late work. Rather, I have argued that his curious narratives have an extremely articulated structure and convey a much richer thematic content than his commentators have supposed.

It is a fascinating aspect of the Dietrich/von Sternberg films that, bizarre and stylized as they unquestionably are, they are not, on the surface at least, more bizarre and stylized than many other films from the same genre and period. This is exactly the reason why the case of von Sternberg is so fascinating, on the one hand, and so hard to argue persuasively, on the other. It would be instructive in this regard to compare von Sternberg's work with that of his contemporary at Paramount, Cecil B. de Mille. Rated simply on a scale of narrative flamboyance, *The Scarlet Empress* and *Cleopatra* (1932) and *The Sign of the Cross* (1934) might tie. Indeed, the fantastic fictionality of the de Mille movies would make it a tricky matter to explain why the fictional worlds of *Cleopatra* or *The Sign of the Cross* count as ontologically self-subsistent, in the sense I have defined, while the world of *Empress* does not. Unfortunately, I don't think there is any short way of arguing that there is more method to von Sternberg's madness than there is to de Mille's. What we know of de Mille's personality, character, and interests does not hint

at avant-garde aspirations, and I think it is preposterous to imagine that close interpretative scrutiny of his films would uncover anything like the density and richness of late von Sternberg. In particular, one does not find, for example, a methodical effort to stylize the acting of the whole ensemble in relation to one another. One does not discover a regular playing off of the visuals against the dialogue, and conversely. And, one does not encounter fragments of mischievous unreliability in the visual narration. In other words, one would not find evidence of any systematic aim of highlighting the fictionality of the characters and the capricious nature of the narrative action. Still, these are only my impressions of the matter, and nothing can replace the hard labor of interpretive examination and comparison.

No matter what such a comparison might reveal, I want to stress one last time the extent to which von Sternberg adopted and adapted the typical apparatus of his chosen genres, shaping, reworking, and exaggerating these materials in the service of his own highly wrought, personal projects. Where others have thought, with some justice, that these well-worn devices of the Hollywood storytelling apparatus normally limited or compromised the movies that incorporate them, von Sternberg employed the very same resources, after his own fashion of course, to construct the self-conscious narrational frameworks I have tried to elucidate in this essay. When the subtlety and audaciousness of von Sternberg's cinematic projects are set beside his quite ingenious use of otherwise dubious materials, it becomes clear that these films he made with Dietrich constitute the products of an amazing artistic balancing act. They are, to my mind, among the more spectacular instances of sheer formal inventiveness in the history of the Hollywood cinema.

Notes

I have read different versions of this paper to various audiences: the Conference on Film and Cognitive Science, held at the University of Copenhagen in May 2000; the Meetings of the American Society for Aesthetics, in October 2000; the Humanities Institute at Northwestern University, Johns Hopkins University, Ohio State University, and the University of Southern California. I would like to thank all of these audiences for their comments and suggestions. I am especially indebted to Berys Gaut, Paisley Livingston, and Victor Perkins for their extensive, encouraging remarks, and I am grateful also for sage suggestions from David Bordwell, Marshall Cohen, Greg Currie,

Karen Hanson, Doug Pye, Diana Raffman, Murray Smith, William Taschek, and Gideon Yaffee.

1. However, in the case I will be considering in this essay – that of von Sternberg's final three movies with Dietrich – I believe it was the director who was the central creative force. The evidence for this claim lies in the nature of the complicated design of these films, which I will be discussing in the bulk of this essay, and in everything we know about von Sternberg's quite stringent control of his soundstage.

2. I am thinking, of course, of the critique whose most famous instance is "The Culture Industry: Enlightenment as Mass Deception," by T. W. Adorno and Max Horkheimer (see their book *Dialectic of Enlightenment* [New York: Continuum Press, 1990]) and has been repeated, with variations, by hundreds of others. See also T. W. Adorno, *The Culture Industry: Selected Essays on Mass Culture* (London: Routledge, 1991) and Clement Greenberg, "*Avant-Garde* and Kitsch," in *The Collected Essays and Criticism*, ed. Justin O'Brien (Chicago: University of Chicago Press, 1986). For a helpful overview and critical discussion of these and related critics of mass culture, see Noël Carroll, *The Philosophy of Mass Art* (New York: Oxford University Press, 1998).

3. *Signs and Meaning in the Cinema* (Bloomington: Indiana University Press, 1969), pp. 136–7.

4. *In the Realm of Pleasure: Von Sternberg, Dietrich, and the Masochistic Aesthetic* (New York: Columbia University Press, 1988), p. 90. Although the quoted formulation and some others like it in the book seem confused to me, I think there is significant overlap between my conception of what von Sternberg has wrought in his Dietrich films and the conception that Studlar develops.

5. For an interesting discussion of the film and the history of its making, see Peter Baxter, *Just Watch! Sternberg, Paramount, and America in 1932* (London: British Film Institute, 1994).

6. I have been unable to locate a source for this quotation, but even if Selznick did not utter quite these words, they express bluntly the plain man's characteristic response to the Dietrich/von Sternberg movies.

7. *Narration in Light* (Baltimore: Johns Hopkins University Press, 1986), pp. 145–65.

8. David Bordwell, *Narration and the Fiction Film* (Madison: University of Wisconsin Press, 1986), p. 161.

9. I offer a much longer discussion of photographic transparency (although not using this phrase) in " *Le Grand Imagier* Steps Out: The Primitive Basis of Film Narration," *Philosophical Topics* 25, no.1, (Spring 1997): 295–318.

10. It would be a difficult and delicate task to provide a reasonable clarification of the character and the extent of the "self-acknowledgment" involved in films that are *not* ontologically self-subsistent in the intended sense. For a bit more on this, see my remarks in the final section.

11. Here again, a longer discussion of the idea of "reflexive self-acknowledgment" is needed. In an expressionistic film, I am supposing,

the acting, sets, and staging are meant to symbolize or, in any event, to express certain generalized psychological states or conditions or, alternatively, to represent a certain broad metaphysical conception of the world. *In* so doing, it is plausible that they *thereby* acknowledge (call attention to) the status of the film and the world it portrays as fictional constructions. But, in these cases, the acknowledgment is a by-product of and incidental to the primary symbolic or expressive enterprise. In *The Scarlet Empress* and *The Devil Is a Woman*, I am arguing, the fictive status of the characters, their actions, their circumstances, etc., is both foregrounded and made a part of the very subject of the film. So this suggests a narrower sense of "reflexive self-acknowledgment," but it is not a sense that is easy to spell out explicitly. A range of possible distinctions in this vein deserve to be explored.

12. For a helpful discussion of this and related issues concerning Hollywood film biographies, see George F. Custen, *Bio/Pics: How Hollywood Constructed Public History* (New Brunswick, N.J.: Rutgers University Press, 1992).

13. *Narration in Light*, pp. 96–7.

14. There are several places in the movie in which the behavior of individual characters takes on a strange, mechanical character. For example, this occurs when Sophia meets Alexey in the stables, grabs hold of an adjacent, suspended rope, and, as if she were hypnotized, sways slowly back and forth while exchanging badinage with Alexey. However, the most striking case occurs during the marriage ceremony. As Peter stares glassy-eyed at the incredible wedding scene surrounding him, his head jerks mechanically around from one position to another without, it seems, even registering the presence of his bride beside him.

15. *Fun in a Chinese Laundry: An Autobiography* (New York: Macmillan, 1965), p. 48.

List of Contributors

Noël Carroll, University of Wisconsin at Madison, U.S.A.

Ted Cohen, University of Chicago, U.S.A.

Berys Gaut, University of St. Andrews, U.K.

Paul Guyer, University of Pennsylvania, U.S.A.

Peter Lamarque, University of York, U.K.

Jerrold Levinson, University of Maryland, College Park, U.S.A.

Paisley Livingston, University of Copenhagen, Denmark

Patrick Maynard, University of Western Ontario, Canada

David Novitz, formerly University of Canterbury, New Zealand

Stein Haugom Olsen, Lingnan University, Hong Kong

George Wilson, University of California, Davis, U.S.A.

Index

DATE DUE			